Politics in Developing Countries

Politics in Developing Countries provides a clear and reader-friendly introduction to the key factors and themes that shape political processes in developing countries. Achieving development outcomes such as reducing poverty and inequality is only possible through efficient governance, well-planned policies and careful allocation of resources, but often politics in developing countries has been identified with mismanagement, corruption, conflict and repression of dissent. This book assesses the politics of developing countries in the period since decolonisation, focusing on the ways in which states have or have not worked to the advancement of their citizens' interests. Key topics include:

- Colonialism and its legacy
- Ethnicity and nation building
- Governance, corruption and the role of the state
- Poverty and the political economy of development
- Aid and outside influence.

Drawing on a range of case studies from around the world, *Politics in Developing Countries* looks at the consistencies and variations between developing countries, examining why some have forestalled political change by liberalising their economies, and others have actively stifled calls for change. Wide-ranging and engagingly written, this introductory textbook is perfect for students of politics and international development, as well as for those with a general interest in the challenges faced by countries in the Global South.

Damien Kingsbury holds a Personal Chair in the Faculty of Arts and Education, is Professor of International Politics in the School of Humanities and Social Sciences and is Director of the Masters of International and Community Development course at Deakin University, Australia.

Politics in Developing Countries

Damien Kingsbury

Routledge
Taylor & Francis Group
LONDON AND NEW YORK

First published 2019
by Routledge
2 Park Square, Milton Park, Abingdon, Oxon OX14 4RN

and by Routledge
52 Vanderbilt Avenue, New York, NY 10017

Routledge is an imprint of the Taylor & Francis Group, an informa business

© 2019 Damien Kingsbury

The right of Damien Kingsbury to be identified as author of this work has been asserted by him in accordance with sections 77 and 78 of the Copyright, Designs and Patents Act 1988.

All rights reserved. No part of this book may be reprinted or reproduced or utilised in any form or by any electronic, mechanical, or other means, now known or hereafter invented, including photocopying and recording, or in any information storage or retrieval system, without permission in writing from the publishers.

Trademark notice: Product or corporate names may be trademarks or registered trademarks, and are used only for identification and explanation without intent to infringe.

British Library Cataloguing in Publication Data
A catalogue record for this book is available from the British Library

Library of Congress Cataloging-in-Publication Data
Names: Kingsbury, Damien, author.
Title: Politics in developing countries / Damien Kingsbury.
Description: Abingdon, Oxon ; New York, NY : Routledge, 2019. |
Includes bibliographical references and index.
Identifiers: LCCN 2018042220 (print) | LCCN 2018049572 (ebook) |
ISBN 9781315099453 (eBook) | ISBN 9781138297173 (hardback) |
ISBN 9781138297210 (pbk.) | ISBN 9781315099453 (ebk.)
Subjects: LCSH: Developing countries--Politics and government.
Classification: LCC JF60 (ebook) | LCC JF60 .K57 2019 (print) |
DDC 320.9172/4—dc23
LC record available at https://lccn.loc.gov/2018042220

ISBN: 978-1-138-29717-3 (hbk)
ISBN: 978-1-138-29721-0 (pbk)
ISBN: 978-1-315-09945-3 (ebk)

Typeset in Baskerville
by Taylor & Francis Books

For Rae, with whom I have shared many adventures, from mountains, jungles and an assortment of semi-functioning towns and cities, to hill tracts, deserts and refugee camps, with many more to come. Thank you for being my steady moral compass, companion and love.

Contents

List of figures		viii
Acknowledgments		ix
Foreword		x
1	'Development' and 'politics' in developing-country contexts	1
2	Colonialism and its legacies	20
3	Ethnicity and nation-building	34
4	Authority and democracy	49
5	Poverty and the political economy of development	64
6	Aid, influence and development	81
7	Economic structuring and trade relations	96
8	The Beijing Consensus versus the Washington Consensus	111
9	The military in politics	124
10	On democratisation	139
11	Timing and sequencing of political transitions	155
12	Sovereignty and strategic relations	170
13	Critical reflections on politics in developing countries	186
Bibliography		196
Index		217

Figures

5.1 The IHDI is calibrated according to these factors 77
5.2 Graph illustrating the statistical association between corruption and IHDIs 78

Acknowledgments

I would like to acknowledge the support of Deakin University, and the collegial and creative research environment it has created. I would also like to acknowledge the fortnightly questioning by the Australian Broadcasting Corporation's Jon Faine and his colleagues I have been privileged to be given the opportunity to respond to, which has, since 2003, required me to think more widely, deeply and – necessarily – quickly about global politics than my comfort zone would ordinarily allow.

I would especially like to thank my academic mentor, Professor John McKay, for his wise comments, criticisms and suggestions on a draft of the manuscript, as well as those of two anonymous reviewers. I would also like to thank my former colleague from *The Age* newspaper, Ken Haley, for his editing of a draft of the manuscript. All errors of fact, interpretation or style remain, however, entirely my own.

Some parts of this book were, in a different form, previously published in media outlets (in which instances the author retains copyright).

Foreword

There is a map on the wall of the room in which this book was written: it is of 'Asia', ranging from northern and eastern Europe, down to north-east Africa and across the Middle East and the then Union of Soviet Socialist Republics (USSR) to Southeast Asia and Japan. It reflected a rather inclusive understanding of 'Asia', a term which has always said more about the beholder than the beholden.

Maps are useful, not just for locating places in relation to each other but for the stories they tell, of what exists and why, how things change and, again, why and how things might evolve. Judging by the obvious historical changes, this map looks to have been printed in 1950. It tells a story of a large swathe of the world that, in the middle of the 20th century, looks vastly different – unimaginable, almost – to that of the first quarter of the 21st century.

The map tells a story of change, in many respects economic but, in more absolute terms, a story of political change. Most of the countries identified on this map did not exist some ten years previously (five more were to come into existence after that time), and those that did, mostly existed under very different political circumstances.

Most of those countries on this map, and still the majority in the world, are developing countries. Such countries frequently have less than positive political records, with varying levels of political participation, representation, accountability, transparency and effectiveness, ranging from the casually inept through to the sometimes brutally authoritarian.

As the political theorist Guillermo O'Donnell would remind us, positive political performance – in his words 'democratic consolidation' – is not a given (O'Donnell 1996). Many countries never achieve that state and those that do remain vulnerable to compromise, decline, collapse or overthrow. Because some countries have been politically successful, that does not mean they will always be so, or that others will necessarily be. Politics is, therefore, a process of building and maintaining institutions: failure to engage in supporting such a project can, and often does, result in systemic failure.

This book is not about global politics, although its reach encompasses the globe: that is by circumstance rather than intent. Similarly, it does not intend to canvass the issues of 'developed' – i.e. the first wave of industrialised – countries, sometimes classified as OECD countries, although it touches on some of them given that the OECD has acquired a broad and inclusive reach. Importantly, too, the politics of developing countries cannot be considered without also considering the impact and influence of developed countries, through colonialism, the effects of struggles for liberation and wars of independence; the shaping of the successor states to colonies; consequent economic, political and strategic relations; and the formation of global political and economic paradigms.

This is not to say that developed countries do not share some of the burdens of developing countries – they do. They do so in terms of poverty and inequality of distribution of

Foreword xi

income, of strategic insecurity and continuously striving to climb up rather than slip down the ladder of development. All the while they are increasingly confronted by the limits of a 'growth' paradigm, of expanding populations, of ever-increasing expectations and, perhaps not least, of global mobility and interconnectedness. These are for developed countries, however, what has been glibly if accurately referred to as 'First World problems'.

Even the perspective of this book is from its author's acknowledged position of privilege. This privilege is marked by a passing grasp of the global language, English (and the presumption to consider it as such), as well as a life free of fundamental need, granted the opportunities of education and a safe and secure environment in which to pursue it. The availability of time to explore, read, think, discuss and write is a reflection of privilege, a consequence of the luck of being born in one place and not another.

Recognising that, this book is intended to consider some of the political issues that face developing countries, and the various ways in which they sometimes respond. If the orientation is sometimes questioning or critical it is because, despite often negative prior structural circumstances, some outcomes flow from acts of volition rather than the imposition of circumstance. This is not, however, to engage in the politics of self-congratulation. Developed countries could undoubtedly do with much significant improvement, from reducing the gaps between the haves and have-nots – the greatest such gap in the world exists in the exemplar among developed countries, the United States – to reducing consumption, waste and inefficient and unsustainable technologies and their environmental repercussions, to being more constructive global citizens in recognising that language, culture and geography are highly permeable distinctions in an increasingly globalised world.

No single book in this field can be comprehensive, given the number of developing countries and the variety of issues they face for a similar variety of reasons. This book is not comprehensive and there will always be questions as to why one matter or illustration was addressed but not another. That is simply a consequence of following one's nose, and the limited knowledge that any one person is likely to have. It may, however, be possible to identify some of the more compelling political issues and sketch some of the commonalities between countries, citing examples, as well as some of the particularities that illustrate the directions in which politics can be taken, or inadvertently go. I hope this book has done that, despite its gaps and other shortcomings.

1 'Development' and 'politics' in developing-country contexts

On the edge of the commercial district of a provincial capital there is a hotel of four levels, the ground floor of which houses a restaurant serving cheap food from behind a wire fence topped with razor ribbon. The hotel was regarded as the height of modernity when it was built in the 1980s but, in the 21st century, is looking markedly faded and worn. Its plumbing system is more reliable than most, although the water issues in spurts, in spasmodic response to the impulses of a ground-floor pump.

The street outside is busy during the day, with a jumble of poorly maintained cars, motorbikes, wooden carts and many people, about half of whom are going somewhere and the other half trying to eke out a living selling mobile phone credit, pens, fruit or trinkets. Most of the people here are recent arrivals, from the villages where the families have become too large, the land with too many people and the opportunities for work next to non-existent. They speak the *lingua franca* with varying degrees of fluency, given they are a polyglot people brought together by the state executing the administrative role of the former colonial power.

The street sometimes sees flashes of wealth when a new car, sometimes a European model, glides past. The economic gulf between the opulence of the car and the life lived by its owner and that of the people on the street is vast. This is a country that has an elected government, only it has almost a monopoly on politics, and being close to a minister or senior party member enhances opportunities for government contracts and, hence, wealth. Documented evidence is rare but it is widely believed that government members receive kickbacks for the favorable awarding of these lucrative contracts. This is all, however, very far removed from the daily lives of people on the street.

What is closer to their lived experience is poor education, courtesy of low levels of government investment in that sector, in keeping with neo-liberal prescriptions about governments cutting spending. Likewise, health care is lacking, so that preventable chronic illnesses remain prevalent among the poor, with elites able to use private clinics or fly out to see specialists elsewhere. On the street, average life expectancy is shorter, women and babies die more often in childbirth or soon afterwards and options for a different type of life are practically non-existent. The government promises development, a better future. For most, however, that future remains disappointingly distant.

This could be any provincial town in any developing country anywhere in the world. Its political processes, though differing in scope and style, are broadly common.

Politics

Politics is usually understood in relation to government, which is how political processes manifest most obviously for most people. Indeed, the origins of the word 'politics' refers to

2 *Development, politics in developing countries*

the governance of cities. However, politics – or what is political – is actually the employment of power or capacity to achieve particular ends or to privilege particular interests or objectives over others.

Arguably, the dominant form of interest is economic, in the wider sense, implying people's material preferences and needs, in turn shaping how they are able to live. Decisions about economic matters, such as distribution, opportunity and alleviation (or imposition) of scarcity are among the most 'political' and will very often be contested. It is through this contest, which identifies interests across groups of people, that group identity is formed, usually manifested as a political movement, organisation or, with a particular agenda, a political party.

What distinguishes politics in developing countries from politics in developed countries is not an absolute, and the problems encountered by one may well manifest in similar form in another. However, developing countries do face a confluence of problems that can be said to distinguish them from most developed countries. In particular, developing countries necessarily face greater economic challenges (this being a key definition of their status), resources are often more scarce or less able to be accessed and poverty tends to be greater in both relative and absolute terms. Moreover, the opportunities for political processes to develop around 'rules of the game', so that there is a regulated and agreed method for the resolution of competing interest demands, is usually less fully formed and more vulnerable to fracture or dissolution.

This is often complicated by developing countries having been carved out of territories that may include people who do not share common identity bonds or who may indeed even be antithetical towards each other. Such common bond that they might have shared may not have lasted much beyond shared opposition to prior colonial rule and exploitation, the consequences of which also inform the subsequent political approaches and opportunities. One might even go back further and suggest that pre-colonial models of political relations also reverberate in post-colonial societies, in terms of pre-colonial competition and conflict, as well as in seeking more culturally 'authentic' (if sometimes reified) models for social organisation (e.g. see Akyeampong, Bates, Nunn and Robinson 2014).

In such cases, the organisation of political power and its distribution of material benefits can be skewed in favor of groups on the basis of ethnicity rather than common economic need, which may set up types of rivalries rarely seen in developed countries facing fewer economic challenges and usually a greater sense of social cohesion. Having less time than most developed countries in which to develop rules and institutions through which to mediate competing interests, and set against more austere and often urgent sets of circumstances, politics in developing countries is frequently beset by tensions that are less apparent in developed countries. It could further be suggested that earlier attempts to resolve some of the fundamental challenges of developing countries have been undermined by a global shift towards a neo-liberal economic agenda which, while having overseen economic growth in many areas, has also produced greater economic inequality both within and often between countries.

All of this begs the question as to whether the politics of developing countries is in some way fundamentally distinct from politics in developed countries and, hence, needs to be considered employing a different set of referential tools. This book identifies some of the key ways in which the politics of developing countries is different in terms of orientation and emphasis from that of developed countries.

Coming from what is intended to be a prior, first principle set of assumptions about the nature of power and its application, developing countries are not given a pass to be

understood in their own – usually quite varied and often inconsistent – terms. Such relativising of understanding politics has two fundamental problems. The first is that it assumes a commonality among developing countries that can be understood in its own terms that is fundamentally different to that of developed countries. The second assumption is based on a relativisation that does not allow analytic closure; there is no logical point at which the devolution of exceptionalism ends.

The first assumption fails in its lack of understanding of politics as a field in which there is a continuum of challenges and typologies rather than, at some arbitrary point, a fundamental disjuncture. That is to say, the type of politics may vary, but the subject remains politics. The second assumption acknowledges – indeed privileges – relativism but fails to acknowledge similarity. Differences do exist, but not so much so that they manage to escape from the overarching subject field. And, at least as importantly, the bounding of the subject field implies that 'difference' cannot be used to rationalise the diminution of a host of political markers. Were it the case that 'difference' implied its own (necessarily unlocatable) political markers, so many developing countries would not have undergone many of the political changes they have, from the sloughing off of dictatorships or authoritarian governments, to accountabilities for gross corruption and human rights violations.

Development

Development, it is said, when it is working properly, promotes justice, reduces poverty and builds environments for people to lead productive, creative and fulfilling lives. These outcomes are intended to be achieved, to the extent they can be, through thoughtful and careful government policies and planning, using available resources. Yet in developing countries this is only partly, or not at all, the case. This is often less because resources are non-existent than because of how they are prioritised and often made unavailable.

'Development' has historically been seen in overwhelmingly, and often exclusively, economic terms. The origin of the term in this context was in reference to 'economical development', first used in 1860 in relation to the then young colony of Victoria in what is now the Commonwealth of Australia (Cowen and Shenton 1996:175). This followed the effective collapse of the gold boom which had seen the colony's (non-indigenous) population increase from fewer than 100,000 in 1851 (SMH 1851) to more than a half a million just seven years later (Searle 1977:382). Similarly, the income of unionised skilled workers rose from 8 shillings a day in 1851 to 40 shillings within three years (VIG 1851:5; Cowen and Shenton 1996:176).

The relevance of this discursion on a developed country's colonial past is to demonstrate the origins of the idea at two points. The first is that 'development' was understood primarily in economic terms. The second was that it was also seen as a form of 'progress' (Cowen and Shenton 1996:12–18). In 1855, colonial Victoria was allowed its own parliament (albeit with a landed and essentially undemocratic upper house) following a rebellion by gold miners at the Eureka Stockade, on the Ballarat goldfields, the year before. The rebellion had a number of causes, principal among them the imposition of what was for many a burdensome mining licence attendant upon an authoritarian approach to efforts to enforce its collection.

Many of the 'Eureka' miners were recent immigrants, and some were refugees from the European liberal 'Revolutions of 1848' (all of which failed),[1] with many others being either exiles from the failed English Chartist movement or converts to the then radical Chartist ideal of a secret vote for all men. From around 1850, trade unions had begun to form in

4 *Development, politics in developing countries*

Victoria, and in 1856 Victorian workers founded the first trades hall council, with its stonemasons' union winning the world's first eight-hour day that same year. These pioneer working-class heroes construed 'development' as not just about overall economic growth but including liberal progressive social and political values. That is to say, the origins of 'development' were inherently political.[2]

Since World War II, the idea of development has taken on a particularly economic tone, led by the United States' efforts at rebuilding Europe and Japan after that war's destruction, employing industrialisation along with, eventually, 'democratic' politics. However, the emphasis was on industrialisation, particularly as the idea became applied to newly independent former colonies. In this respect, notions of development, and their critique, have tended to shun the political, even though it is political decisions – or the lack thereof – that determine development outcomes.

In one sense, then, 'development' as it has come to be understood was simply intended to imply economic growth or growth in per capita gross domestic product (GDP), which, in turn, would find a way of being distributed throughout a society and thus raise most people's standards of living. The earliest means of achieving this development was intended to bring the process of modernisation to new or developing countries. In many respects, this concept continues to underpin policy in many developing countries. The initial intention was that these developing countries emulate the West (developed countries) to industrialise and then 'take off' (as demonstrated, over five stages, by Rostow 1960:4–16).

Not only did this process of industrialisation and 'take-off' fail in many, perhaps most, cases, but the definition of development in these terms has come to be identified as too prescriptive and too limited. Various development paradigms came and went, and they are still doing so. Where a program is successful, it is usually a consequence of being applied by developing countries themselves. The most recent of these cases have focused on 'governance', implying that clear and consistent rules around financial probity and orderly processes are fundamental to successful development. One could also suggest that such qualities also constitute 'development' in its political sense. The failure to understand 'development' in this more political sense has, moreover, been shown to curb the economic growth that initially defined it.

A further, if still largely material and apolitical, way of measuring 'development' has been through the increasingly broad range of human development indicators (HDIs), which include such yardsticks as infant and maternal mortality, life expectancy, education, access to potable water, adequate nutrition and other 'quality of life' measures, as well as per capita GDP and the distribution of available wealth.

None of these paradigm shifts in approaches to development since the middle of the last century has provided a 'magic bullet', with those that promised one among the least productive. The advantages and drawbacks of global markets – putting a premium on financial responsibility; strong or weak central planning; intrinsic economic potential or the lack thereof; participatory and bottom-up versus top-down approaches; and pro-poor versus pro-growth models – have each played a role in advancing, or hindering, development. From the 1980s until around 2010, the inherently political, perhaps ideological, neo-liberal paradigm was dominant, and it remains so in many markets, under the generic rubric of the 'Washington Consensus' (Williamson 2004).

The ten key principles associated with the Washington Consensus are: avoidance of large fiscal deficits relative to GDP; ending government subsidies in favor of key pro-growth, propoor services such as primary education, primary health care and infrastructure investment; broadening the tax base and reducing marginal tax rates; market-determined, positive

interest rates; a competitive exchange rate; removal of restrictions on imports; encouraging foreign direct investment; privatising state enterprises; deregulation of market activity; and, finally, guaranteeing legal security for property rights (Williamson 2004:3–4).

This Washington Consensus implies a reduction of government deficits relative to GDP, a related reduction of government subsidies and other payments (including on education and health care), broadening the tax base and cutting top-end tax rates, the market determination of interest rates and floating currency exchange rates. Along with these policies came the opening of markets to global trade, the reduction of tariffs and other trade restrictions, relatively open external investment and the privatisation of state-owned enterprises, or SOEs (Williamson 1989). These policies also aligned with the IMF and World Bank's 'structural adjustment programs' (SAPs).

SAPs are lending regimes aimed at persuading borrowing economies to align their governments' revenues with its expenditure and at producing long-term economic growth. The IMF is generally responsible for financing the stabilisation of a given economy, with the World Bank responsible for transforming its structure. Key characteristics of SAPs accord with the precepts of neo-liberalism enumerated above. Cuts to education and health spending hard-wired into SAPs have led to criticism of the programs, prompting the World Bank to shift focus, with targeted countries now urged to develop SAPs as a means of poverty reduction (Bird 2001).

This, in turn, runs counter to an earlier conception of development that, while retaining its economic focus, insisted on qualitative as well as quantitative changes to social structures and did not shy away from the introduction of new ones (Dowd 1967).

Although not formally part of the Washington Consensus, it was often suggested that such a paradigm necessarily ran in tandem with 'democratisation'. The pairing of the two was seen, in some quarters, to represent a 'post-ideological' world, teleologically identified as 'the end of history' (Fukuyama 1992). This argument was, however, more a blind for neo-liberalism, with little emphasis on political substance or its translatability into previously undemocratic political contexts.

The Washington Consensus faced three hurdles. In some cases it was applied but did not produce the desired outcomes: indeed, it made many people poorer. Secondly, many governments rejected the model as being financially onerous and ideologically driven. Even where economic development proceeded, this was very often due to longer-term government planning that involved more state investment rather than less ('developmentalism' or 'state-directed capitalism' – Halper 2010:103–134), rather than neo-liberal economic prescriptions as such. Again, this did not imply any particular political modelling to achieve such outcomes. The third obstacle, however, constituted the biggest challenge of all to the Washington Consensus – and that came from a competing paradigm that has become known as the Beijing Consensus.

The importance of the Beijing Consensus, which is more or less the economic and political model adopted by post-Mao China, lies in the challenge its economic success has posed to the hegemony of the Washington Consensus and its assumed dominance of the industrial West (Halper 2010). Rather than being specifically prescriptive, the Chinese model, as it was also known, was perceived as offering a 'pragmatic' route to stable economic growth, involving state-led or -run enterprises, a strong export orientation and the redirection of state resources as required (Hasmath 2014).

Insofar as the Beijing Consensus model addressed non-economic factors, it relied on the idea of political continuity (usually in the form of authoritarianism) rather than representative pluralism. This, in turn, largely meant keeping active political power out of the

6 *Development, politics in developing countries*

hands of the people while, in some instances, allowing the window-dressing of elections (in this category Singapore remains a prime example).

The most common intended meaning of the term 'development', then, has concerned economic and material issues. Political issues have played second fiddle or been disregarded altogether. 'Development' describes both the economic method and the rationale of many developing countries. To the extent that political processes are addressed at all in developmental terms, normative 'political development' has been excluded from the debate (for elaborations, see Huntington 1968; also Kingsbury 2007a). The key exception to this has been Sen's reliance on participatory elections to help ensure good governance and thereby promote conceptions of 'freedom' (Sen 1999b:35–53) or 'capabilities'. This implies reasoned individual and social control over circumstances rather than vice versa (Sen 1989). That is, 'economic prosperity is no more than one of the means to enriching lives of people' (Sen 1989:42).

In large part, the politics of developing countries has, almost from the outset, been identified with mismanagement, corruption and, all too often, repression of dissent. This has often reflected the prior colonial power's negative judgment of its vassal's prospects for independence or, during the Cold War, which side of the overriding ideological battle particular countries aligned themselves with. But such perceptions have also reflected the lived experience of developing countries. Some countries have battled unequal market forces, while others have all too often squandered opportunities – due to poor management capacity or corruption – and exhibited a low tolerance for dissent and opposition.

Perceptions of post-colonial performance have ranged from a state's doing 'quite well' to 'not very'. Almost no developing countries are ideal in all categories and, indeed, if they were 'ideal' they would not be in the 'developing country' category. In part this identification of politics in developing countries results from a global media industry that readily reports bad news but, given the character of what constitutes 'news', rarely reports more positive events. These media channels apply particular sets of 'news' values to stories they present to general audiences. Regardless of the detailed knowledge of specialists and government agencies, these values shape not just understandings but responses to events in developing countries.

Thus the identification of developing countries with adverse processes or outcomes has stemmed from the too common realities of political failure, repression and a lack of accountability.

Mirroring critiques of how audiences in developed countries viewed developing countries, the oft-claimed universality of the normative value of 'democracy' is openly disputed by some, usually on 'cultural' grounds. Even so, the content and application of 'democracy' are so widely varied that the term all but ceases to have meaning unless defined at the outset. Again, assuming a more or less common understanding of what 'democracy' means – entailing universal suffrage in the regular, competitive selection of government – its use as a rhetorical device often strays far from any meaning consonant with that understanding.

Universalism or competing values?

When considering politics in developing countries, a particular world view and agreed set of values tend to be assumed. This world view is generally implied as universal, that there are social or individual goods commonly understood as such and that there are correlating negatives. There is general rhetorical agreement, for instance, that corruption is a negative, but there is much less commitment to actually instituting effective anti-corruption measures, much less an agreed understanding of what constitutes corruption as opposed to traditional patron–client relations.

It is a question, then, whether it is possible to employ a set of universal values, such as 'democracy', civil and political rights, and rule of law, when trying to understand politics in developing countries. The further question is whether different world views, manifesting as cultural difference, imply a conditionality the perspectives on understanding politics across a range of contexts.

In trying to answer such questions, there are three sets of issues. The first concerns the quality of being human; the second concerns the logic of power; the third concerns the circumstances of sometimes conflicted circumstances in which decisions are made. If human beings share a common physiology, then all people have similar fundamental physical needs. This includes the basics of adequate nutrition and shelter, and the equal value of health care. But, as Filipino jurist Jose Diokno noted (1981:54), food and shelter alone are not enough, since 'many prisons do as much'.

Beyond basic physiological needs, people have consistent psychological responses to negative stimuli (allowing for individual tolerance). There may be minor variation between individuals, but alienation, fear and trauma apply commonly in like circumstances. Not least, the intended effect of such conditions derives from a similarly common set of motives: compulsion, fear, hatred, ignorance, greed and psychosis. These factors are the handmaidens of unrestrained power, which can arise when other, more benign political structures collapse or are removed, for example in cases of civil war or major natural calamities.

These issues assume that politics is or can be played out in the abstract, not subject to real-world considerations or constraints. Where a territory later defined as a sovereign state has a pre-colonial or colonial legacy of imposition or exploitation, where scarcity is a present factor in determining the allocation of economic resources and/or where there is a limited history of social cohesion, political decisions are rarely abstractions and overwhelmingly address immediate and concrete circumstances.

In such circumstances, and especially where the 'rules of the game' are poorly established or understood, notions of limited political competition and hence participation have been employed to limit the possibility of inter-communal violence. This can be seen in dominant party states, such as South Africa, in which such competition that exists is usually within the party rather than between parties, or in East Asian states in which economic development and modernisation has been prioritised over political freedoms. The mechanisms for political control in such circumstances may be relatively benign but, where there are real tensions, may quickly turn authoritarian and even brutal. This may then, in turn, establish new grounds for dissent, implying further repression and so on, variations of which have become institutionalised in many developing states.

The next question then arises as to whether the circumstances in which these qualities manifest themselves become acculturated and accepted as 'normal'. If acculturation is an effect of resolving social dissonance, for example by accepting a situation because of incapacity to change it, that does not then legitimise the situation but rather explains its continued existence. If that incapacity is caused by unequal power relations, the situation is not one of culture as such but of politics. This is not to deny the capacity for acculturation to political methods and values, but it is to clarify that its explanatory method is primarily political, not cultural. This further helps to understand that what might be called 'culture' is politics in disguise.

Post-colonial experiences

In the immediate post-colonial period, many decolonised states had opted for a plural democratic or other 'liberating' system as methods of government in which civil and

8 *Development, politics in developing countries*

political rights were implied. However, the post-colonial experience was commonly beset by multiple similar problems. The first of these was that removing the colonial yoke did not automatically produce all – or in most cases even many – of the benefits liberation was supposed to guarantee. In this, expectations very often grossly exceeded capacity, which was often reduced rather than enhanced by the act of independence.

The rhetoric of most movements for statehood revolved around the promise that, once the colonial power had gone, the resources exploited by that power would benefit the people. That is to say, once independence was achieved, the people who had committed themselves to the liberation movement would be wealthier. The prospect of liberation often created heightened, sometimes quite unrealistic, expectations around its benefits. In practice, this has rarely been the case, and especially not in the short or even medium term (see, e.g. on sub-Saharan Africa, Killick 1992:47).

The common post-colonial experience has been one of political failure, especially in cases where plural democratic structures that had often taken decades to formulate and refine in western countries were expected to take immediate hold in post-colonial countries. In cases where states have been constructed on top of multi-ethnic identities, incorporating distinct, competitive or sometimes even hostile ethnic groups, competition for scarce resources and maintenance of political power have frequently led to the establishment of ethno-specific patron–client relations to the exclusion of other ethnic groups, usually but not always minorities.

Added to the destructive impacts of wars for independence, colonial investment and skills usually deserted the former colony, and incoming administrations often had little if any practice at running a state. Rather than independence delivering economic benefits, its immediate consequence was more usually economic decline (see Hirschmann 1987; Cornwell 1999; Englebert 2000; Luis 2000). This has, in turn, given rise to compromised forms of administration bearing labels such as 'patrimonialism, neo-patrimonialism, corruption, prebendalism, rent-seeking, predatory state or "belly politics"' (Medard 1996:78). Where states struggled to build basic institutions, provide services and hew to one consistent development path, the political distractions of competitive, pluralist politics in which power was not assured were often unwelcome.

Set against often arbitrary and fractured polities fighting increasingly desperate internal battles, in many cases it has been a convenience and arguably a necessity for political elites controlling the levers of power to abandon or violently repress pluralist democratic or other emancipatory processes in exchange for the 'stability' of one-party or one-person authoritarian rule. The functional claims of plural democracy or other forms of actual liberation were thus frequently discarded as impeding expedient political practice, e.g. authoritarian regimes at one time or another have presided over most African and Latin American states, the Middle East but for Israel and Jordan and much of Asia but for India and, arguably, Malaysia and possibly Singapore (the latter two restricting political competition through internal rules and processes and sometimes termed 'soft authoritarian').

The political economy of development

In significant part, politics can be reduced to the allocation of resources. One principal paradigm is whether such resources that might be available are accumulated by an economic elite and shared through that accumulation being used to grow (supply) the economy. This model proposes the use of labor as a key element of the process, thus creating general economic well-being and economic distribution through employment creation. The

main competing paradigm is whether such resources that might be available should be more widely distributed from the outset, with resultant economic activity (demand) leading to economic development by generating supply to meet that demand. In both cases, politics can be understood through the prism of how it preferences or orders the allocation of resources and of who benefits from such allocation, essentially the basic Right/Left political dichotomy.

The interests of those who control the levers of political and economic power, and the degree to which they are representative and accountable, play a central role in determining the balance between these competing economic paradigms. That is, an economic system reflects the economic preferences of a political party or bloc: how that party or bloc is chosen or maintained is central to understanding the relationship between economics and politics in developing countries.

A fundamental distinction exists between understandings of political economy. They can be broadly described, in the first instance, by whether the political system necessarily reflects the economic system (a conventional Marxian analysis) and might be said to have applied, at different times, to Central American states such as Honduras, El Salvador and Nicaragua (not to mention other Latin American states from time to time) as well as Thailand and Myanmar. In the second instance, the question is whether the economic system reflects the political system (public choice analysis), as may be understood to apply in Vietnam, Laos, Cambodia, Singapore and Malaysia.

The former proposition implies economic ordering of political affairs, or a structural relationship between economic models and political systems; the latter implies that political structures are shaped by popular decision-making processes (e.g. elections or directives) which in turn shape the economy. Both approaches possess varying degrees of usefulness as explanations of differing political and economic circumstances, in particular politico-economic jurisdictions.

This approach to understanding the relationship between politics and economics does not, though, include the all too common accumulation of state resources by political elites in what has been termed 'booty capitalism' (Hutchcroft 1998) and consequent 'elite state capture' or predatory politics. Further, political and economic elites may work on behalf of interests external to the state but from which they also benefit, if to the exclusion of many or most others ('comprador elites'), within an exploitative cycle of economic dependency on external markets and investment (see Baran 1952; Gunder Frank 1967; Cardoso and Faletto 1979, among many others of the 'dependency' school). Such a view, which held that the structural relationship between capital and negative exploitation is inevitable, was widely critiqued following the export-based economic success of a number of developing countries, particularly in Asia. The 'dependency' approach was later modified to explain some instances of economic success, including more generalised economic growth, while continuing to highlight the exploitative character of global capitalism (e.g. James 1997).

Regardless of the various reasons for specific economic successes, it has been relatively easy for governments presiding over economic prosperity to ascribe it to their political method. This they frequently relate to on a specific 'cultural' heritage (even as they attribute economic weakness or failure to external influences and hence factors beyond their control). When economic success is ascribed to a political style that owes nothing to the western capitalist paradigm, with its attendant ideas of plural democracy as well as civil and political rights, the successful state is liable to credit its cultural values, and its national pride, for countering the cultural ignominy to which it points as a product of colonial imposition. China is one of the more pronounced examples of this return from 'ignominy'.

10 *Development, politics in developing countries*

Thus an exceptionalist claim that initially reflected unity, in this case around economic success, has come to also be adopted by governments that could claim neither a cultural affinity nor, in many cases, economic success. What they do often claim is legitimacy for an authoritarian political model. Indeed, for many post-colonial one-party states, rejecting plural democracy and civil and political rights has become a further method of asserting a non-colonial state identity. For such states, the common claim is that economic efficiency or other forms of material development take precedence over democratic processes and civil and political rights. Where the 'luxury' of democracy or civil and political rights is to be granted, or returned, it is often claimed that this will only follow the establishment of prerequisite economic success.

It has been argued that people will not care about political representation if they do not have enough to eat. Yet making political representatives accountable is not only the best mechanism for ensuring basic needs are catered to but such a system of accountability is more likely to create an environment in which economic activity flourishes (see Howard 1983, also Sen 1999a). The assumption that democratisation is contingent upon economic development – the 'rice before rights' argument or 'full bellies thesis' – has been undermined by many post-colonial states having neither 'rice' nor 'rights'.

The further assumption of structural determinism between economic development and democratisation has since been contradicted by economically successful Singapore failing to democratise while Indonesia and the Philippines both returned to forms of democracy despite being in the depths of economic crisis. Indeed, economic crisis may constitute one of the 'shocks' that can lead to regime change, in this case away from unrepresentative rule, e.g. Bolivia (1980), Peru (1980), Argentina (1983), Uruguay (1985) and Brazil (1985) (see O'Donnell and Schmitter 1986 on transitions, drawing heavily on Latin American case studies). Post-Soviet states in eastern Europe also democratised, in part as a default position occupying its own place in the larger historical process that precipitated the economic and political collapse of the Soviet Union.

Myanmar's move towards a civilian-led government in 2015 resulted in part from a longer-term economic collapse compounded by the devastating effects of Cyclone Nargis (2008). Haggard and Kaufman (1997) note that transitions may but do not always lead away from authoritarian rule, citing the examples of Thailand (1983, not sustained), Turkey (1983), South Korea (1986) and Chile (1990), while Taiwan voluntarily if tentatively democratised between 1979 and 1996. The democratisation of many sub-Saharan African states has been attributed to a range of reasons, demonstrating that, while 'push factors' such as the collapse of the Soviet client-state system may have assisted, it was far from being the only influence in this 'second liberation' (Salih 2005:10).

On the conditions for democratic transition, Di Palma noted that economic instability, a hegemonic nationalist culture and the absence of a strong, independent middle class all impede transition from an authoritarian political model towards a more democratic one (Di Palma 1991:3). But, as Sen (1999a) noted, there is no necessary link between political forms and economic development (see also Przeworski 1995; Barro 1996; Przeworski et al. 2000; Papaioannou and Siourounis 2008).

In short, while aspirational claims to liberal values struggle to gain common adherence, often due to vested political or economic interests, more authoritarian claims against those values are also beset by contradictions. This is, perhaps, best understood as the dynamics of evolving political processes, particularly in developing countries, which rarely follow a linear, or indeed permanent, path.

Nation and citizenship

A factor – and for many developing countries, perhaps the key factor – in the success of a state is the extent to which it is at peace with itself. This is very often not the case in developing countries comprising multiple, distinct and hostile ethnicities or where the values usually associated with citizenship, such as equality before the consistent application of just law, are notable by their absence – or where the situation is characterised by both cases combined.

It is commonly assumed that people who live in a particular developing country are members of a nation and that they live in a 'nation-state'. However, this assumption is often incorrect, in as much as it forgets the origins of most developing countries and misunderstands the meaning of the term 'nation-state'. To clarify, a 'nation' is a politically bonded group of people who share a sense of unity, usually around a common language, culture, sometimes religion and who possess usually more or less contiguous territory (see Armstrong 1982; Smith 1986b; Gellner 1983). This definition is sometimes termed 'ethno-nationalism',[3] to distinguish it from 'civic nationalism', or a political bonding around agreed civic values such as legal equality, acceptance of electoral outcomes and so on. Ethno-nationalism is distinct from the tribe, which may have social institutions but which will be informal and, while it may have an association with a given territory, is usually not formally delineated, with the territory shifting depending on prevailing conditions (Fried 1975; Singh 1982; James 2006).

As societies become more complex, nations also cohere around cultural and religious institutions, political authorities such as a local chief or lord and, eventually, a greater regional ruler. In any survey of the evolution from local to wider and more formal organisation there are, broadly, three theoretical approaches to understanding nation formation.

The first theory of nation formation can be categorised as 'primordialist', reflecting an emphasis on language, culture and so on (see Gellner 1983; Horowitz 1985; Smith 1986b; Petersen 2002). This theory posits that a people will cohere around a common language through which they communicate on mutually relevant issues. According to this approach, the bond will be especially powerful if it occurs within a largely contiguous and spatially compact territory which can further enhance the sense of local significance and, in the case of pre-modern language formation, help create and perpetuate linguistic norms within the community. For communities with language in common, it helps to shape the shared world view or culture, which may also cohere around a common religious belief system (see, for example, Nuyts and Pederson 2000). This, in turn, helps create a 'natural' or 'organic' bond within the group.

There is little doubt that sharing a common language and culture within a common geographic zone coalesces three powerful influences on social cohesion and that, at one level, they could suffice to constitute or at least contribute to the idea of 'nation'. This would be especially so if the term were understood in its original, Greek sense of ethnicity (*ethnos*) usually translated as 'nation' and, in the commonly cited passage from Herodotus (8.144.2), meaning 'of the same blood', 'speaking the same language' and possessing 'the same habits of life'. However, the term 'nation' (*natio* – to be born of) did not come into use until the medieval period, a university coinage intended to distinguish groups of students, by which time it was beginning to take on the connotation of a collectivity ruled by a law familiar to each of them, thus implying an institutional function.

This association with law then leads to a more 'instrumentalist' understanding of the meaning of 'nation' (see Smith 2001; Taras and Ganguly 2010). National institutions can

12 *Development, politics in developing countries*

be informal, with tacit social agreement or conventions about form and procedure, particularly in political processes but also in respect to more generalised notions of social interaction, including manners or other unenforced social codes of conduct. An instrumentalist understanding of nation might, then, also include civic values and institutions, the rule of law and codes both legal and social. Also commonly present within this paradigm are notions of equity and civic equality, and civil society institutions such as interest groups, political parties, guilds or unions.

The idea of territorial contiguity may also be included under the idea of instrumentalism in that a nation requires an element of institutional cohesion to maintain its conventional claim to sovereignty. But the association with territory also links back to primordialist notions of nation, such as ancestor worship, spirit of place, the father/mother-land and so on. It may also include nationalist claims that arise out of a specific nation-building exercise or a nationalist political program. This then leads to the idea of the nation as constructed, an idea that presupposes national identity that is, to a considerable degree, manufactured (Anderson 1983; Hobsbawm and Ranger 1983; Taras in Bremmer and Taras 1997:687; Hobsbawm 1999). Claims to 'nationalism', particularly where the 'organic' bond was historically weak or damaged by the imposition of colonialism, are often more strident, reflecting an insecurity at their weak foundations. Such strident claims to 'nationalism' may be used as a tool for state assertion and, predicated on an organic assumption (or claim), can quickly devolve to assertions of a type of mob identity which is easily vulnerable to manipulation for state or other political purposes.

Elements of a constructed national identity may include standardising or imposing a language, particularly on groups that previously either did not share the 'national' language or spoke a distinct dialect of it; formalising history and embellishing mythology by way of explaining a common and usually glorious past; along with other markers or symbols of cohesive identity including a flag (and swearing allegiance to it), a national song or anthem and other symbols and rituals designed to bond a people around a common idea of loyalty.

All three of these elements – common language, a shared historical meta-narrative and allegiance – are emphasised and activated to promote unity, or a coalescing of disparate social elements in the face of adversity and, *in extremis*, in the event of war. A common threat or enemy draws on and enhances primordial sensibilities, requires a high degree of social and institutional organisation and compels a relatively high degree of uniformity with strong emphasis on myth and symbols and narrowly delineated loyalty (May 2002; Kingsbury 2007a:51–53; see also Erikson 1968). Elements of each explanatory factor are found in the formation of most contemporary nations.

Where these factors are not in relative balance, or where one or more are relatively under-developed or missing, there is a correspondingly high likelihood of dysfunction within the nation rather than cohesion. It is also worth noting that group or national identity is not static but moulded and re-moulded by changing circumstances and needs, reflecting both internal group considerations – such as what works well or what a society might agree upon as a core value – and externally imposed ones such as a challenge or threat, or shifting material or economic circumstances.

Moreover, new groups cohering around a new or previously unarticulated 'national' agenda can come into being, especially where foundational elements of group identity pre-exist. Examples of this phenomenon include a cohesive Tamil identity, and the Islamisation of Mindanao, although there is considerable evidence that Acehnese national identity existed in one form or another for several hundred years before the emergence of Acehnese separatism within the Indonesian state. West Papua displays elements of national identity

Development, politics in developing countries 13

based on a common Melanesian heritage, although tribal and specific ethnic identities also remain strong, while in Timor-Leste a national consciousness began to develop in the early to mid-1970s but strengthened considerably after the Indonesian invasion of 1975. In each case, there is an element of conscious construction of the idea of 'nation' through an overt nationalist program.

Where one or more of the three basic elements of nation formation are diminished or absent, obstacles to unity may occur. In the case of arbitrary state creation, for example in a post-independence colony, primordialism may be relatively undeveloped, as is normally the case where previously separate or mutually hostile groups have been compelled to come together under colonial rule. This description holds for Sri Lanka, where once mutually hostile kingdoms were subsumed under Portuguese, Dutch and then English colonial polities, and eventually granted independence as the unitary state of Ceylon; likewise for Indonesia where many pre-colonial polities (e.g. Aceh before 1873) or politically unorganised territories (e.g. West Papua) were brought together under Dutch colonialism, with the post-colonial invasion and incorporation of then Portuguese Timor into the Indonesian unitary state. The Philippines was a collection of locally ruled polities until the Spanish occupation, although Mindanao was not subsumed and incorporated until the arrival of the U.S. military following the 1898 Treaty of Paris, and even then absorption within the U.S.-controlled Philippines was strongly resisted.

Throughout Southeast Asia and parts of Central Asia, states were organised around capitals, with authority concentrated at the centre and receding the further from the centre the supposedly subject citizens lived, in what has been described as a 'mandala' (circle) model of state organisation (see Tambiah 1976:Ch. 7; Wolters 1999:27). This 'circle' model of the capital-centric state also applied in much of pre-colonial sub-Saharan Africa, where the cost of trying to control peripheral territory or a sphere of influence was greater than the benefit envisaged from doing so. In these states peripheral communities were allowed to be largely self-governing or to choose allegiances (Thornton 1977:526; Herbst 2014:46–49, 55–57).

The colonial project was nowhere more pronounced, especially in the later 19th and early 20th centuries, than in the 'Scramble for Africa'. Colonialism in Africa had become so heated that, by 1884–1885, European political leaders agreed to convene a colonial conference in Berlin comprising fourteen countries whose self-appointed mission was to formally define areas of 'exclusive ownership'. As a means of turning the scramble into an orderly process, the conference endorsed the mechanism of 'flag-planting' powers notifying other countries upon the assumption of power or establishment of a new protectorate (Berlin Conference 1885: Articles 10, 34, 36, 37). After the conference, the 'scramble' took on its complete form so that by 1914 all of Africa was under European colonial rule but for Liberia (nominally sovereign but under U.S. protection) and the Ethiopian Empire (although it lost Eritrea to Italy).

The Berlin Conference thus set the stage for the delineation of Africa's colonial and hence post-colonial borders, including common borders around disparate peoples and, in some cases, dividing common peoples (Touval 1966; Wesseling 1996). Herbst (1989; 2014:97) argues, however, that while such borders were artificial, within the context of problematic demography, ethnography and topography the creation of such borders was a rational response to territorial control, as was their maintenance by post-colonial governments. Had post-colonial governments based their claims to sovereignty on the territory they actually controlled, most of them would have shrunk, while rearranging borders based on ethnicities would likely have resulted in wars (Herbst 2014:103). The partition of British

14 *Development, politics in developing countries*

India in 1947, for example, did not (immediately) lead to open war but did displace more than 10 million people and cost the lives of at least several hundred thousand (Talbot and Singh 2009:2).

The state

The 'state' in its modern sense is a relatively recent political phenomenon for many developing countries, with pre-colonial polities being organised along lines that bear little resemblance to the state as it is now understood. A 'state' is, in this sense, a delineated geographic area claiming sole authority to the extent of that territory, defined by its institutions, its claim to statehood and recognition of that status. 'Nations' will often seek to establish a state to represent their collective interests, hence the term 'nation-state'. In such an arrangement, both the state and the citizens have a duty to each other: the state to protect and promote citizens' interests, in return for citizens performing duties and obligations to the state. Such arrangements are most successful, and most fully comply with a sense of justice, when entered into and maintained voluntarily. The freedom to enter such a relationship implies some degree of commitment to uphold it.

The state, as generally understood in the contemporary (post-Westphalian) sense, refers to a specific delineated area (Smith 1986a:235) in which a government exercises (or professes to exercise) political and judicial authority, and claims a monopoly over the legitimate use of force (potential or actual violence) up to the extent of its borders. Within a given territory, the state can be identified by the presence and activities of institutions that define its functional capacity. In other words, the area of the state defines the functional sovereign reach and integration of its 'embedded' (Evans 1995) 'explicit, complex and formal' agencies (Krader 1976:13). The keystone of state sovereignty is that its cohesiveness and continuation are central to its validity. Put simply, to assert sovereignty, the state must continue to exist. States therefore almost always oppose any challenge to their established existence, from without or within their declared borders.

International recognition is also a common criterion for achieving statehood. Not only must the state have a capacity to enter into international relations with other states, such other states must also recognise its right to exist. Importantly, in cases where assertions to national identity also seek to establish a state, their success or failure often hinges on the amount of support they receive from other states (India's support for Bangladesh being a case in point). Except where external states have an interest in diminishing another state, they generally support the state system status quo (UN 1945:1.2:4).

While a state claims authority within its borders, along with a monopoly on the use of force, it normatively does this on behalf of its citizens, as a manifestation of their political will. This implies a social contract between the state and its citizens, in which the state can expect, and compel, compliance, commanding a duty to comply; while citizens can expect the state to reflect and represent their interests. In reality, many developing countries, including the case studies mentioned in this work, have or had incomplete control of their territory, or their institutions have not always functioned, much less functioned well, throughout their entirety.

Such social contracts as exist between developing states and their citizens are frequently undermined, compromised or arbitrarily changed to suit the needs and interests of ruling elites. This has been the case in Sri Lanka in relation to both the division between its privileged elite on the one hand and much of its peasantry and urban labor on the other (manifested as student-based rebellions in 1971, 1987–1989) and the division between its

Development, politics in developing countries 15

Sinhalese ethnic elite and its Tamil minority (1983–2009). Indonesia's political and economic elite has historically channelled the political and economic resources of the state to a small section of the population of Jakarta, with local elites linked into this centralised network.

In Indonesia's case, this has led to regional disaffection, not least in Aceh and West Papua, compounding disaffection over the method of the latter's incorporation, as was the case in Timor-Leste. So, too, the political and economic elite of the Philippines has plundered the state to its own benefit, perhaps most arbitrarily in the lands occupied by the Muslim population of Mindanao, with the deliberate purpose of easing population and economic pressures elsewhere (notably in the Visayas).

Where states have low levels of institutional capacity, the delivery of services to their citizens tends to be inadequate, often grossly so, and these states typically resort to basic forms of compulsion to retain control even in the face of consequent dissent. Notwithstanding this fact, many states represent multiple ethnic or national groups and, assuming they do not establish other criteria around which to bond, such as civic values, they may experience tensions between groups vying for representation within the state.

As noted, almost all developing countries have their origins as colonies, where they were not directly colonised as 'protectorates' or had their internal processes and borders shaped by colonial influences. What are now developing countries largely came into being after World War II, primarily between the late 1940s and late 1960s (with some stragglers in subsequent decades). The key exceptions to this phenomenon are the states of Latin America, which achieved independence between 1804 and 1825 (with the exception of Cuba, which achieved independence as a result of the Spanish–American War in 1898).

Most countries that came into being as a result of having been colonies retained their colonial shape, under the principle of *uti possidetis* ('as you possess'). What this meant was that the territory of the colony – in 'possession' of the colonial power – transferred 'possession' of that territory to the successor state, regardless of the colony's ethnic or geographical integrity. The difficulty with this was that, while much of the indigenous administrative structure could be retained, or redeveloped, the new state had its colonial boundaries defined by colonial convenience – a river, mountain range or simple straight line – rather than ethnic or 'national' cohesiveness. This had the effect of bringing together separate, sometimes mutually hostile ethnic groups, with explosive potential when one of them had been used by a colonial power to control or repress another. The conflicts in Rwanda and Sri Lanka are but two examples of the consequences of such a policy. The creators of other states did not necessarily intend to sustain a minority in power, but that also eventuated in countries such as Syria and Bahrain as well as, until the early 2000s, in Iraq and Nepal.

Very often, independence was the result of struggles for liberation from colonial powers, including armed struggle. Where armed struggle was instrumental in developing countries achieving independence, independence forces were usually self-funded and politically active, meaning they were often embedded in the post-independence economy and political processes. Many post-colonial states, particularly in Africa and parts of Asia, continue to reflect this paradigm, where militaries remain only partly answerable to civilian governments and from time to time can and do operate independently of them.

Where militaries have regarded themselves as 'guardians of the state', even if primarily for rhetorical purposes, they have tended to retain an active political role or assume a right to intervene in political processes. Examples of politically potent militaries can be found in Iran's Revolutionary Guards, Myanmar's Tatmadaw, Indonesia's Tentara Nasional Indonesia, in Thailand and in numerous African states including Algeria, Egypt, Gambia, both

16 *Development, politics in developing countries*

Congos, Zimbabwe, formerly in Turkey and from time to time in several Latin American states. Indeed, almost every country that has undergone a coup at one time or another has suffered from the complex of the military assuming itself to be the state's 'guardian' or final institutional arbiter rather than the government it has chosen to oust. Between 2010 and 2016 alone there were thirty-two coups or attempted coups, overwhelmingly military-led, the first of them on 18 February 2010 in Niger and the last at the end of 2016 in Algeria.

Though often militarily led, the advantage of liberation struggles was that they provided a common goal of liberation and a methodology for achieving it around which often otherwise disparate groups of people could rally. Once that goal was achieved, though, the formerly colonised people tended to retreat from the common struggle and re-focus on their ethnic or tribal group. This has been especially so in time of economic hardship, increased competition for scarce resources and a reversion to political and economic patron–client relations.

Citizens of new states often had the obligations and duties that such a status conferred upon them, as well as full legal rights within a given (often varying) political order. But in many cases they did not, and often still do not, enjoy the active rights and privileges usually associated with the term 'citizen'. Typically, where developing states comprise mixed and sometimes competing ethnic communities, some citizens from a dominant group may secure more 'citizenship' than others from a subservient or marginal group, for example gaining preferential access to education or government employment.

Where citizens do enjoy (or wish to enjoy) rights, they can exercise them through being politically or socially active, joining civil society organisations such as trade unions, religious and student bodies or specific-interest pressure groups. But governments, or state institutions such as the police or army, have shown variable levels of readiness to tolerate public protest and dissent. As a rule, the more open and accountable a country's political system, the more tolerance it shows.

More secretive and unaccountable systems may permit a modicum of protest from quarters aligned with the government or the state in key areas (such as ethnicity or religion) while critics from an unaffiliated or opposition group or body receive less tolerance or are even repressed. An example of this phenomenon was in post-liberation Zimbabwe, when the Ndebele-dominated Zimbabwe African People's Union (ZAPU) staged a localised protest against the domination of post-independence politics by the ethnic-majority Shona-dominated Zimbabwe African National Union (ZANU). That protest, between 1983 and 1987 in the Ndebele territory of the three western provinces of Matabeleland, was met with a military crackdown by the army's North Korean-trained Fifth Brigade, which was loyal to ZAPU Prime Minister Robert Mugabe. The crackdown, known as *Gukurahundi*, included mass shootings and resulted in the torture and deaths of thousands of Ndebele men suspected of involvement in anti-government activity.

The hostilities ended with a peace settlement between ZAPU leader Joshua Nkomo and Mugabe and the joint creation of the Zimbabwe African National Union-Patriotic Front (ZANU-PF) (see Dorman 2006 for further examples of post-liberation conflicts in Africa). This type of situation illustrates how, in post-colonial or post-liberation states, constituent members of the state are formally citizens but in terms of relative equality of access to state institutions, including political representation and protection under its laws, 'citizenship' has often been unequally distributed in practice rather than treated as a unifying agent.

This then raises questions around the 'rights' of citizens to participate in political life, who determines those rights and the responsiveness and accountability of 'representatives' to the needs and desires of citizens. It may be a norm of all societies that politicians'

Development, politics in developing countries 17

responsiveness in these spheres is deficient. What often marks developing countries, especially in the political sense, is the depth of that deficiency.

Post-colonial states may develop a sense of common national identity in multi-ethnic societies, and a number of developing countries have done so by standardising a common language, valorising the liberation struggle and forging 'nation' creation myths and forms of refining or re-writing history to create a supposed unity where there might not have been one (Hobsbawm and Ranger 1983; Abizadeh 2004). This phenomenon has been particularly successful in European states, such as France and Italy, and has been employed with increasing success in developing countries such as Indonesia, Timor-Leste, Madagascar and to an extent India and Bangladesh, to cite some examples. In tandem with active and open citizenship, the creation of a new national identity can, in more ideal circumstances, produce a 'civic nationalism' or cohesion around a national ideal based on a core set of civic values such as the rule of law, political participation, representative government and non-ethno-specific unity (Tamir 1993; Kymlicka 1995; Miller 1995). Among developing countries this could, in principle, include South Africa, India and Brazil.

Yet, where a national or dominant language and its attendant culture are specific to one ethnic group (e.g. Kenya and the Bantu group of languages) but not another (e.g. Kenya's Nilotic group of languages) and/or where common commitment to civic values is weak (as it is in varying degrees throughout sub-Saharan Africa), ethnic groups can tend to foreground ethnicity as their key marker of identity. If the ethnic group has specific grievances, such as imposition of a dominant language, economic exclusion or cultural repression, this can then result in dissent, which in turn may lead to varying degrees of further reaction or repression (e.g. the Tamil minority of Sri Lanka, Kurds in Turkey and Iraq). Where that dissent (and repression) has a geographic focus, such as a 'homeland' or other ethnically identified territory, consolidation of that dissent can spark challenges to, and degrees of separation from, the state. While many developing countries do not have armed separatist or other non-state organisations, many others do. Such armed non-state groups can in turn bring the military back into domestic affairs and hence into domestic politics (Desch 1999) and, over time, damage the efficacy and reach of state institutions, even triggering incipient state failure.

Conclusion

The process of development in developing countries is, necessarily, central to their ability to function on behalf of their citizens. Yet how this should happen, does happen and why, and how this is understood, remains contested. Regardless of the rationales powerholders might employ, the structural circumstances in which developed countries function do define the framework for opportunities and capacities, even as they establish material limitations.

Within a given framework, what appears fundamental is how development is driven by political processes. They, in turn, reflect both the structural circumstances that such countries have inherited and issues of volition involving the styles and preferences of powerholders or other elites.

These styles and preferences then raise questions about what is and what should be. Assuming some commitment to normative aspirations or values, the issue arises whether they are or can be based on universalist assumptions – that all people work from the same basic precepts on what constitutes 'good' and its opposite, or whether the cultural characteristics of particular groups necessarily imply different or even competing conceptions of the 'good' and its opposite. How this question is decided in turn informs what is and is not

18 *Development, politics in developing countries*

'good', appropriate or allowable, or in some cases illuminates what is founded upon fact rather than convenient claims.

In part, what is 'good' or allowable can reflect values derived from international norms and conventions, often articulated during anti-colonial struggles but faring less well when faced with the exigencies of competing claims set against limited capacity. These can also be mixed with 'traditional' values, such as 'consensus' decision-making or mutual effort and mutual reward as often reflected in subsistence-agriculture communities.

The program of a developing-country government may also reflect the role of patron–client relations in maintaining political power and group-specific patronage exclusive of other groups. Where this is based on ethnicity, it may lead to inter-communal conflict, especially where a sense of common national identity has not yet been established or is contested. Similarly, whether a government favors the more general distribution or accumulation of resources may also precipitate political tension and potential for conflict, depending on who benefits and who does not.

Finally, the capacity of a government and state institutions – and their commitment or lack thereof to transparency, accountability and the rule of law – exerts considerable influence on developing countries' political processes. To that end, the nature of those processes in developing countries is critical to the overall development project, quite apart from being a good – or the lack of a good – in its own right.

This book

Having set out what is hoped are some of the basic precepts of politics generally and how that applies to developing countries, this book now moves to explore the idea of 'othering' and the colonialisation that accompanied such understandings of the world. The consequences of colonialism were and remain profound and, arguably, continue in a range of more or less subtle political and economic guises.

The next chapter considers the role and impacts of ethnicity, language and nation-building on the politics of developing countries and how these qualities, often in direct response to the colonial experience, have sometimes set up challenges to the coherence of post-colonial states. This, then, devolves to how developing-country states have come to order themselves and why, the role of civil society in such states and the exercise of authority, and the extent to which those imply or reflect legitimacy.

If developing countries are denoted by their economic under-development, notably by their relative and often absolute poverty, it can be argued that there are structural reasons for this. These, in turn, reflect conscious decision-making by domestic and international elites, and the propagation of particular economic policies and sets of economic relationships. To this end, the international community has attempted to ameliorate under-development and poverty through aid programs. It is suggested, however, that while most aid programs are well intentioned and some aid programs do achieve positive, long-term outcomes, the record of the delivery of aid is, at best, patchy. Aid is used for a variety of reasons, only some of which are principally aimed at improving the lives of others. It does not always or even often work, it often does not – and cannot – address core development issues and it may actually create more, if different, type of problems than it solves.

More important, and which is addressed in the following chapter, is the question of economic structuring, trade relations and sustainability. The manner in which developing countries are often required, through limited choices, to engage in unequal trading relations can place them in a structurally unbalanced economic relationship which benefits larger

Development, politics in developing countries 19

and more powerful economies at their expense. Not only is this expense economic, but often in order to meet basic economic necessities, developing countries compromise, or are obliged to compromise, their water, air and land resources in ways which damage the lives of their people and which are not sustainable.

In reaction to the many shortcomings of the international system, and the norms, rules and values that inform them, a number of developing countries have moved out of the orbit of the developed world paradigm, particularly that expressed by the U.S.-led neo-liberal economic and political model. Seeking an alternative development vision, some developing countries have been persuaded by China's economic development within the context of a one party state, in what has been dubbed the 'Beijing Consensus'.

Another key alternative to the common development paradigm, as explored in Chapter 9, is where militaries decide that either the state is not functional or that it does not function to adequately suit particular interests. This is particularly likely where the state faces internal military challenges, implying a domestic role for the military. It may also occur where the military sees itself as the guardian of the state, or where it is aligned with – or against – particular political actors.

The question then, addressed in Chapter 10, is how and in what circumstances do states controlled by militaries or other authoritarian forms of government manage to transition away from such control. This then raises the larger question, addressed in Chapter 11, of political transitions, and in Chapter 12 concerning how sovereignty functions within the context of strategic relations.

These issues are not exclusive to developing countries, but they are more commonly experienced by them. Such issues do reflect, as earlier noted, an interplay of developed and developing countries and, concluding the book, an attempt to understand and to critically reflect on the status of developing countries in their own right. But, to understand how developing countries came to be, we must first turn to what they came from.

Notes

1 The only first-hand account written of the rebellion was by Raffaello Carboni, who had previously participated in the Italian nationalist campaigns of 1848.
2 The author was born, and continues to live, in Victoria, but the illustration of Victoria as an early, if not the first, example of economic development was previously noted by Cowen and Shenton in 1996 (pp. 164–176).
3 The argument has been put that the term 'ethno-nationalism' contains a redundancy, given the etymology of the term 'ethnic' which derives from *ethnos* ('nation') in ancient Greek.

2 Colonialism and its legacies

Following from the brief discussion of colonialism in the Chapter 1, this chapter considers in more detail the impact of colonialism on what came to be developing countries. Inevitably, this process had a profound impact on how colonised societies were subsequently organised, with traditional methods either broken or bent to suit colonial interests. This was accompanied by the territorial organisation of peoples into colonies (later states) with 'hard' borders that seldom corresponded to pre-existing polities.

This changing of traditional patterns of social organisation, and the construction of new polities, have affected the capacities, process and methods of post-colonial states. They have also left a lasting legacy in the ways post-colonial and other developing states have engaged with the West, as in the character of their subsequent economic and strategic relations.

How the West has rationalised its understanding of non-western countries as 'other', exemplified by the critique of 'orientalism', has defined much of their relationship, including trade, war, colonial exploitation and post-colonial economic and strategic relations. In particular, the creation of colonies and their evolution (or often revolution) as independent states has overwhelmingly been based on the principle of *uti possedetis* (as you possess) (as outlined in Chapter 1).

This brought together sometimes quite disparate peoples under a common rule, with 'hard' territorial borders which in most cases had not previously existed and largely reflected colonial convenience rather than ethnic or national unity. Upon independence, former colonies adopted the outward contours of the political models and institutions of developed or industrialised countries. The key distinctions between them were those capitalist, sometimes (nominally) democratic states which tended to align, strategically, with the West; and single-party states which usually aligned with what was then the Soviet Union or, less commonly, China. The political systems employed by these newly independent developing countries were those bequeathed to them (usually in cases of peaceful transition) or, more commonly, were in response to pre-existing colonial arrangements.

Particularly where independence movements were marked by violence, colonially defined ethnic relations and responses to declarations of independence often left a deep imprint on the political orientation of the post-colonial state. That is to say, states born of violence in which the military has played a leading role in obtaining independence have often remained susceptible to the continued use of violence and to military influence, or interference, in their political processes.

Orientalism and colonialism

'Orientalism' was a term originally used to describe the influence on arts, design and literature of usually romanticised South and East Asian, Middle Eastern and North African

Colonialism and its legacies 21

cultures. But its more dominant interpretation has become the West's wider, patronising understanding of these broad territorial categories. This particular critique of 'othering' – defining the other not in its own terms but usually as 'lesser' in western terms – was largely reflective of colonial and then post-colonial relations, between technologically developed and less technically advanced states. This gap initially advantaged western states in their colonial enterprises, and later did likewise for those same states in economic relations with their ex-colonies.

In each phase, the 'Orient' or the 'other' was contrasted with the economically superior West, as the inferior 'East' or 'other'. This idea paralleled the idea of 'race', which did not effectively exist prior to colonialism but which subsequently came to define it. The essentialist, self-congratulatory perception of 'othered' races helped rationalise the colonial enterprise (Osborne 2002:79), through often 'civilising' religious missions which traveled from being 'exemplars of ideal piety in a sea of persistent savagery' to 'ideological shock troops for colonial invasion' (Andrews 2010:663). This latter orientation found an echo in a pseudo-scientific form of social Darwinism that judged, through 'slogans, propaganda, crude theatre' and late Victorian understandings of progress (Crook 1998:1) as 'white' people having evolved to be superior to non-'whites' in what McCarthy described as a hierarchical ordering of difference (McCarthy 2009:69–95). In each case, the overwhelming motive for colonialism was profit, most commonly extracted from colonised peoples at a very high price to them. Colonial violence was extensive and often brutal, leaving an acculturated legacy of, in many cases, localised violence as well as a deep resentment towards former colonial powers.

That such colonialism was rationalised in terms of cultural superiority only deepened that resentment (see Fanon 1961 and Rodney 1972 for expressions of this angry resentment). Echoes of this world view continued into the more transparent post-colonial period as the status of post-colonial and developing states was fixed within the context of international trade and strategic relations, perhaps exemplified by U.S. President Donald Trump's otherwise controversial description of 'othered' African states as 'shitholes'.

Perhaps the most telling critique of the West's rationalisation of colonialism and its ensuing engagement with post-colonial countries was expressed by Edward Said in his somewhat controversial book *Orientalism* (1978), which at the outset posited 'oriental' countries, focused principally on Arab nations but more or less applicable to all colonised lands, as 'other' relative to the West (see also Bevan 1952:61 regarding the presumed positive impact of western ideas on the 'Orient'). Western knowledge of the world, which has tended to dominate global discourse, broadly posited non-western, colonised or post-colonial countries as essentially irrational and psychologically weak. If, in many instances, there was militant resistance to colonialism, the soon-to-be colonial subjects were regarded as barbarian and aggressive, at least until they were subdued. In both instances, 'other' people were, by definition, 'uncivilised' and in need of the West's 'civilising' mission. 'Even when they took a scholarly interest in oriental cultures', Ferguson said of western scholars in a slight act of understatement, 'perhaps they did subtly denigrate them in the process' (Ferguson 2008:xxii).

By way of contrast, western colonial powers have been portrayed as rational and psychologically strong (Said 1978:65–67). In reality, the singular advantage of western colonial powers was technological and industrial, which created markets for colonial-sourced goods and provided the unifying psychological profile (nationalism) and the means (including, from the late 1880s, the first practical machine gun, used the devastating effect against African warriors from Zimbabwe to Sudan) by which such trade could be compelled.

22 *Colonialism and its legacies*

In contrast to a self-perception of superiority, the West has its own history of irrationality, reflected in hugely destructive wars of religion, combative nationalism and destructive international competition, and its arguably intentional ignorance of the complexities and developments of such 'othered' countries. Yet understanding non-western countries to be disorganised and vulnerable rationalised a framework for rampant and often brutal exploitation, the diminution or complete removal of self-determination in colonised countries and a sometimes more nuanced post-colonial exploitation. The removal of any meaningful semblance of self-determination of colonised peoples was based on colonial convenience, rarely if ever taking into account the needs, affiliations, differences or interests of the colonised.

A post-colonial version of Orientalism, or a patronising paternalism towards post-colonial and developing countries, can also be seen in early development theorists' understandings of how such countries could and *should* 'develop'. Initial models advocated copying western notions of industrialisation (later touted as free-market industrialisation) and democratisation, articulated most clearly in its first iteration by Rostow (1960) but triumphally reprised by Fukuyama (1992) in the wake of the Cold War.

The initial, Rostovian version of this post-colonial development model comprehensively failed and was replaced by a series of other models and critiques, whereas Fukuyama's version was confronted by the Asian financial crisis of 1997–1998 and then the Global Financial Crisis, or Great Recession, of 2008 onwards. Later, globalised dominance of neo-liberal trading relations has also been challenged by the rise of a global, explicitly anti-western, agenda exemplified by the failure of conventional state structures and the rise of armed non-state actors (usually, if not always accurately or helpfully, referred to as 'terrorists'), not least those organised around *Salafi* jihadist principles.[1]

Notably, colonialism re-ordered the structure of local economies to suit colonial requirements, usually around the exploitation of natural resources including both agricultural produce as well as mineral resources. Transitioning in many cases from subsistence agriculture and small-scale manufactures, pre-colonial economic models were upended and commonly replaced by large-scale resource exploitation, employing large numbers of local workers as usually poorly paid employees, *corvée* (unpaid) laborers in lieu of taxation and in some cases as indentured laborers or slaves. While these economic models commonly brought great hardship and displacement to colonised peoples, they did provide a platform for new types of social and then political organisation. This was, in some cases, to provide foundations for subsequent political organisation. Similarly, colonial guilt at the appalling conditions of many laborers led to 'enlightened' policies around education, notably in the early 20th century, allowing for the first time for colonised peoples to employ western political thinking about nationalism and independence. In the interim, however, the profound disruptions to traditional ways of life was, in many case, permanent, and what evolved was hybrid models of social and economic organisation, too often reflecting the more negative aspects of pre-colonial patron–client relations along with the more negative aspects of colonial and post-colonial social disruption, clientist supplication and the long-term structuring of low-value extractive and commodity-based industries.

The western lesson for colonial peoples was that their future lay in 'westernisation' and 'modernisation', by adopting the values, habits and prejudices of their erstwhile colonial masters. Dispensing with 'primitive' beliefs and superstitions, and adopting a teleological 'rationality' and modernist institutions, summed up as learning to be 'European' – a world view exemplified by Voltaire[2] – was seen as critical to the modernising project, under which 'Oriental' peoples came to reject and, internalising a western perspective, often despise their

Colonialism and its legacies 23

own 'Orientalism' and its historical legitimacy, thus driving a wedge between modernising developing-country elites and their populations.

This was nowhere more apparent than in the creation of a new class of educated developing-country elites from recently traditional pasts. Such elites came adrift in the failures of development and the related non-fulfilment of the modernising promise, but they had also forfeited community and belonging. Intellectual liberation became, and was seen to become, just a mechanism for a different, more organised form of exploitation. The cult of rationality became as much a myth as the beliefs it was supposed to replace (see Adorno 1991:6).

The personal and social anger that grew from this ahistorical disjuncture, aided by masses of less educated but equally uprooted and displaced peoples, fed into a counter-narrative to modernisation (e.g. see Rhanema 1998 on Shariati). This counter-narrative has privileged tradition, often in extreme forms, as a key source of personal and social legitimacy and an antidote to the extremes of modernisation that served to displace it. Thus, rejection of local westernised elites as a manifestation of an alien westernism has been a key marker of an increasing number of socially and psychologically displaced people in developing countries. This has been manifested in the rejection of democratic political processes and, in some cases, in non-state violence.

Where the local westernised elites have responded with repression, this has increasingly led to militant disruption, such as the 'Arab Spring' of 2010–2011, the rise of jihadist organisations in the northern part of sub-Saharan Africa and the Sahel and the move towards more 'traditional' reifying (reductionist) forms of belief in countries such as Turkey, Indonesia, Pakistan, Bangladesh, Sri Lanka and Myanmar. It also continues to fuel a revolutionary impulse promoting radical alternatives to the nature and control of the state in Nepal, parts of India, Colombia until 2017, the Philippines (cf. the Communist Party of the Philippines/New People's Army/National Democratic Front) and, arguably, Thailand in response to the 2014 coup. At least some of these movements, while their trajectory may not always be linear, can be seen to reflect Rousseau's ambivalence towards, and sometimes rejection of, institutionalised inequality in the 'rational' commercial state in favor of the romance of natural emotion not yet sullied by the self-serving institutions of a presumed civilisation (Rousseau 1992).

Where the 'rational' state model has failed or is overthrown by a disrupted pre-existing model that cannot reform itself (as occurred, for instance, in Iran), an environment of anarchy ensues. This can be seen, for instance, in limited and diminishing state control in Afghanistan, the functional fragmentation of Iraq and Syria, the division of Libya between competing factions and Somalia, where the 'Transitional Federal Government' managed only a semblance of order after intervention by the African Union Mission in Somalia (AMISOM) but where the state remains fragile and civil war continues. The 'rational state' model has also failed in specific areas within states, among them Nigeria, Mali, the Democratic Republic of the Congo, Pakistan and South Sudan.

Unsurprisingly, where the post-colonial West has intervened in their disputes, such movements have been quick to blame the West as the original cause of its problems, accusing it of imposing unequal financial and trading relations lending support to developing-country elites. This is most evident where western countries have renewed or developed a physical, often military, presence, as in (but far from being restricted to) Saudi Arabia and other Gulf states. Israel is seen as a stark and seemingly permanent reminder to neighboring states and peoples of the capacity for western imposition, while external intervention in Iraq and Syria has led to a sharply anti-western, anti-state backlash in the form of *Salafi* jihadist organisations.

24 Colonialism and its legacies

The case of the DRC

Many are the countries that experience problems deriving from their legacy of colonialism, including internal conflict, low levels of development, ideological rivalries, ethnic tensions or external interference-cum-intervention. A number have elements of each of these problems, but a special few have all of these plus their own distinct character. The Democratic Republic of the Congo (DRC or DR Congo[3]) falls into the latter category, with direct impacts upon its citizens as well as state stability.

Although long a source of victims for the Zanzibar slave trade, the Congo was one of the last parts of Africa to be explored by Europeans, primarily due to indigenous resistance beyond the Congo River's first cataract, 160km inland from the Atlantic, making the waterway impassable. Henry Morton Stanley was the first European to explore the region, in the 1870s, meeting David Livingstone in the town of Ujiji, on the shores of Lake Tanganyika. Despite Stanley's promotion of the region as a rich site for colonisation, European interest remained limited until King Leopold of Belgium, having failed to secure other colonial possessions, employed Stanley as his agent. Through a series of dissembling manoeuvres, Leopold acquired the Congo as a personal fief at the 1884–1885 Berlin Conference.

Although promising a 'civilising' mission under what was erroneously referred to as the 'Congo Free State', Leopold's rule resulted in great barbarism by Belgian trading companies coercing unwilling inhabitants to work for them. This was exemplified by hangings, beheadings and the frequent cutting off of hands, an atrocity so widespread that the collection of hands was used to make up for shortfalls in the supply of the main commodity, rubber.[4] Various reports indicate that starvation and disease during the Free State period (1885–1908) killed anything from 20 per cent (Vellut 2005:9) to half (Hochschild 2005, see also Weisbord R. 2003) of the population of some million people.

Such was the scandal of the Congo Free State that the Belgian parliament assumed control of the colony, as the Belgian Congo, in 1908. Direct, hierarchical rule set against a large, urbanised workforce spawned an anti-colonial resistance movement after World War II. But the movement was split by factionalism and, upon achieving independence in 1960, the country almost immediately descended into a series of ideologically, regionally and ethnically driven civil wars, pushed along by external interests, in what was known as the Congo Crisis.

In 1961 the crisis led to a coup, a Soviet-supported rival government, the death (probable murder) in 1961 of UN Secretary-General Dag Hammarskjöld,[5] a Maoist uprising, UN intervention, elections and another coup in 1965. This second coup established Joseph Mobutu as dictator until 1997. Mobutu was supported by the U.S. as a strategic ally against Soviet influence in sub-Saharan Africa. However, after the collapse of the Soviet Union in 1991, as was the case with many other countries, U.S. support declined and the country moved towards an electoral system of government.

Spurring on the decline of Mobutu's dictatorship was conflict in neighboring Rwanda which, in 1996, led Rwandan Hutu militias to flee to what was then eastern Zaire, where they formed an alliance with local government troops against ethnic Tutsis (the ethnic group they had been battling in Rwanda). The Rwandan and Ugandan armies responded by invading Zaire and, allied with local opposition forces led by Laurent-Désiré Kabila, thus began the First Congo War. The following year, Mobutu fled the country, and Kabila became president.

Kabila asked Rwandan troops to leave, but instead they moved to the east and launched a new ethnic Tutsi-led rebellion which, along with a Ugandan-based rebel army, led to the

Second Congo War, which Zimbabwe, Angola and Namibia entered in support of the government. Kabila was assassinated in 2001 and succeeded by his son, who called for UN intervention. This led to peace talks, power-sharing and the country's first multi-party elections in 2006, which Kabila won. But Tutsi rebels embarked on another conflict, with Rwandan troops entering the Congo in 2009 to end the rebellion. Some of the rebels later joined the Congolese army while its political wing became a new party and the country's main opposition. In 2005 complicating matters even further was the southward drift – from what was then southern Sudan and Uganda – of the Lord's Resistance Army,[6] which survived by raiding local villages (Turner 2013).

In 2012 some of the troops who had integrated in 2009 rebelled, that conflict ending the following year. Meanwhile a group based in the southern mineral-rich province of Katanga also revolted, while two ethnic groups warred with each other in eastern Ituri province. It was estimated that, as a result of war and related famine and disease, almost 4 million people died between 1998 and 2004 (HRW 2009). In 2013 the UN sent another military force to make peace in the country, ending the era of fratricide. Amid an uneasy peace, Kabila stayed on as president beyond the constitutionally mandated two-term limit with the elections being deferred (Taylor 2016). At the time of writing elections were scheduled to be held in December 2018, but there was no absolute certainty they would be.

The peace was shattered in December 2017 when an armed group attacked UN peace-keepers in North Kivu province, killing fifteen Tanzanian and five Congolese soldiers, and wounding fifty, the second deadliest attack on UN peacekeepers ever, with only the 1993 attack on Pakistani peacekeepers in Somalia killing more troops. The attack is believed to have been perpetrated by the Islamist Allied Democratic Forces (IADF), which originated in western Uganda but operated across the border from their base in the Ruwenzori Mountains and in the Semliki Valley straddling western Uganda and eastern North Kivu (Oakford 2017). Congolese soldiers were also suspected of having committed earlier attacks sometimes ascribed to the IADF. As a consequence of the DRC's 'mesh of conflicts', in 2013 in the country's east alone there were nine major armed groups among twenty-nine in the whole nation (IRIN 2013); and the number of internally displaced persons had reached a record 4.1 million by 2017, almost that of Syria (Stearns and Vogel 2017), where a devastating civil war had raged since 2011.

The DRC may be an extreme example of the repercussions of colonialism and post-colonial turmoil, but it does illustrate the direct impacts of untrammelled colonial process and the potential fragility of post-colonial states, especially when subjected to external interference. In different ways, but at times similarly bloody, the histories of many other post-colonial states stand as an indictment of colonialism, for example as reflected in the bloodshed that continues (at the time of writing) to wrack Syria, Iraq, Afghanistan and South Sudan, if only to note some of the more prominent examples.

What is a 'nation'?

There are competing definitions of what constitutes a 'nation', but perhaps a definition that can attract broad agreement is that it is a bonded political group within a broadly defined territory. The term 'nation' is sometimes used where the 'state' is meant. In this aspect, a 'state' may be confluent with, but is functionally and analytically distinct from, 'nation'. The order, method and sequencing of forging the nation and forming the state contribute directly to the relationships that exist between the constituent members of each. Where nations exist they may aspire to statehood; where states are established without a pre-existing

26 *Colonialism and its legacies*

national base, they will commonly seek to develop a cohesive constituent political society (Gellner 1983:110).

The idea of what constitutes a nation combines a number of criteria that overlap other forms of social formation but are, for the purpose of the exercise, understood differently. A 'nation' is often understood as related to but distinct from an ethnic group, which corresponds in part with the idea of a tribe – a tribe being more than a band of people but not (yet) constituting a nation. Tribal status relies on two general criteria: the first is that a tribe is usually based on a kinship group in which members will tend to know one another directly or have a relatively close familial or social link to one another; the second criterion is that groups identifiable as precursors to nations tend to cohere out of mutual necessity, through either protection of a particular social group or transactionally via exchange, trade or mutual assistance.

Where this is relevant to colonialism is that many post-colonial states have attempted to construct a 'national' identity from disparate peoples, often with limited success. Similarly, disparate peoples forming bonded political groups within post-colonial states may undermine the sense of civic unity that a functional state usually requires.

Civic opportunity

Cases such as that of the DRC exemplify, among other things, what might be regarded as a deficit of 'civic opportunity'. 'Civic opportunity' might be described as the opportunity a state has to act in fulfilment of the obligations it owes its citizens, for example to respect them equally under the rule of law; to provide equity in access to resources; and to recognise and respect pluralism in multi-ethnic societies. Such civic opportunity, not having been bequeathed to the successor post-colonial state, may not reflect it as an independent political entity.

Such civic opportunity might be most reasonably achieved through a state that encourages, or at least allows, participation in political processes; the representation of constituent state members in decision-making bodies such as a parliament or other form of legislature and executive; and a fairly high degree of transparency and accountability, all functioning under the equal and consistent rule of law. The opportunity of a state, especially of the multi-ethnic post-colonial kind, to fulfil its civic function towards its citizens may initially be limited by the widespread detriments of wars of liberation: capital flight, the damage to infrastructure, reduced institutional capacity of the successor regime and, in some cases, being required to accept debts that the colonial power had accrued (a burden that fell to Indonesia after the era of Dutch colonialism).

By way of contrast, the regimes and political elites of many post-colonial states often come to power promising 'liberation' and with heightened expectations about living conditions improving once exploitative colonialism is a thing of the past. Allied with the often common struggle for independence, an immediate post-colonial regime often enjoyed a 'honeymoon' period in which the constituent members of the state not only welcomed it but were often prepared to give it time to get affairs of state in order. But, in the examples this section is dealing with, there was no 'honeymoon' period for their disaffected minorities: in each case disaffection existed either before or immediately after the post-colonial state's inception.

There are, broadly, three theoretical approaches to understanding civic opportunity. These focus, respectively, on modernism, transitions and mechanisms. Each offers a causal explanation for how civic opportunity might present itself or be developed. In each case,

Colonialism and its legacies 27

civic opportunity is equated with democratisation or democratic opportunity, and this book employs that rationale without recourse to further debate on democratic types, democracy's shortcomings and so on.

Following the beginning of post-World War II decolonisation, the idea of 'modernism' was deeply influential, drawing as it did on the economic, political and social experience of the developed West and, implicitly, on the mechanistic logic of Marxist political economy (even if development modernists would be unlikely to accept the association). The basic principles of modernist development theory are that development is driven by economic capacity, which in turn proceeds along a given linear path.

According to Rostow, traditional or pre-colonial societies are based on subsistence agriculture, the development of extractive industries and savings and investments, increases in productivity and the creation of surpluses, with the early stages of industrialisation linked with primary industries along with further savings and investments, technological progress and then, once 'take-off' arrives, are characterised by the growing diversification of industry into manufacturing and service sectors along with high levels of production and consumption (Rostow 1960). As the society in question progresses along this linear path, it will be assisted by an increasing emphasis on literacy, rule of law and, eventually, democratic processes underpinned by a sizeable middle class (see also Huntington 1968 who, although criticising this scenario and emphasising the importance of social mobility and literacy, nonetheless was firmly within the modernist camp; also Acemoglu and Robinson 2006:Ch. 3).

Few states actually developed along these lines, and those that did appeared to respond to specific circumstances.

> The assumptions of modernization theory that liberal democratic regimes would be inexorably produced by the process of industrialization were replaced by a new preoccupation with how the state apparatus might become a central instrument for both the repression of subordinate classes and the reorientation of industrial development.
>
> Stepan 1985

None of the examples cited developed along this linear modernist path, since the failure of the political outcome of 'modernisation' contributed preponderantly to the related failure to implement equitable mechanisms of social organisation. Recognition of development's non-linear character spurred further analysis of processes leading to civic outcomes, principally political 'transitions' from authoritarian governance to more representative and accountable forms.

The period of regime change features the most intense political flux, marked by both opportunity and threat. Where there is opportunity, it is often understood as the resolution of a negative (usually associated with the end of a chaotic or dysfunctional government or dictatorship). Even where new forms of government may have the external characteristics of democracy (such as in the Philippines in 1986, or Indonesia in 1998), partly or completely hidden components may compromise the capacity of the general population to participate meaningfully in political affairs or to be genuinely represented (see O'Donnell 1996 for discussion on this broader topic).

So, where regime change is in a democratic direction, it is often procedural rather than substantive. Beyond this, regime change need not, in and of itself, tend towards a normatively more desirable or participatory outcome. Although the tendency towards the end of the 20th century and early in the 21st has been for regime change away from authoritarian models, such change can also impose non-democratic or authoritarian rule (see Chapters 10

28 *Colonialism and its legacies*

and 11 for more detailed discussion of this phenomenon). In the period 1999–2006, examples of regime change resulting in a shift favorable to authoritarianism included Pakistan, the Central African Republic, Sao Tome and Principe, Guinea-Bissau, Haiti, Mauritania, Nepal and Thailand, not to mention attempted coups in many other countries.

In Indonesia, after the ousting of Suharto in 1998, once leftist forces were marginalised and weakened, the political agenda quickly reverted to control by conservative elites, while the election as president of the reformist cleric Abdurrahman Wahid by an anti-Suharto, if conservative, coalition resulted in his being ousted by those same elites less than two years later.

In the case of the Philippines, public protest against then President Marcos and the blatant falsification of election results, connived at by sections of the military, led to his replacement by electoral opponent, Corazon Aquino, the widow of Marcos' murdered former adversary, Senator Benigno Aquino. While Corazon Aquino came to power on the back of a popular protest movement (known unreflectively as 'people power'), she in fact ushered in elite rule mirroring that of the oligarchic pre-dictatorship era. Under Aquino, the Philippines' elite structurally excluded genuine open participation in politics, despite the semblance of an open electoral contest, and returned to squabbling over the spoils of state. In Indonesia, by contrast, the resignation of Suharto in 1998, and the weakening of the highly centralised state apparatus he and the military had constructed, led to a rash of genuine political reforms under his immediate successor, Habibie. A reconsolidating status quo elite and destabilisation of the state under Wahid's reformist presidency contributed to his downfall and replacement in mid-2001 by Megawati Sukarnoputri, who favored both the status quo elite and the military. Of particular transitional note was the role played by military 'softliner' Susilo Bambang Yudhoyono, first as the leader of the reform faction within the Indonesian military in the early 1990s, then emerging as a leader of dissent towards the then president, later as a political actor and finally as president himself.

A distinct approach to understanding opportunities for civic change is through 'causal mechanisms', examining processes and episodes, or the 'cogs and wheels' actuating them (Hedstrom and Ylikoski 2010:49–67). Under this approach, the particular mechanism is not so important; context is everything. One causal mechanism is the relationships between participating entities and their relevant properties. The questions asked in such an analysis are: How do those properties interact? How are they organised? And what influences them? As an explanatory method, the causal-mechanisms approach offers some useful insights in specific cases, but it is probably inadequate for constructing a reliable theoretical model to comprehend the process of achieving civic opportunity.

What does appear to be consistent across case studies is that post-colonial societies tend to experience heightened competition for resources, a high and often increasing degree of patron-clientism and a proclivity for responding disproportionately to criticism or protest – often portrayed as attacks on the state. These disproportionate responses are often violent.

Civic failure

Where the state is unable to fulfil its function around 'civic opportunity' and where it is otherwise no longer able to fulfil its other institutional functions, it may be said to have 'failed'. While there is a significant body of literature on the subject, the circumstances which lead to civic failure and violent social divisions remain imperfectly understood (see Chandler 2010 and Richmond 2011 for critiques). Kaufmann et al. (2010) chart indicators of political stability and the absence of violence as part of a larger governance project,

Colonialism and its legacies 29

relying on secondary data. Yet they do not chart the factors that lead to such instability and violence or its absence. Most of the research on causes undertaken to date has focused on sub-Saharan Africa (e.g. see Collier and Sambanis 2007a, with South and Southeast Asia lumped in under the term 'Other Regions').

Rarely discussed is the failure of former colonial countries to establish and then leave in place a well-developed understanding of notions of civic responsibility, much less a body of practice. Indeed, colonial powers have often been in the habit of retaining their governing authority through non-civic methods right up until the time they were forced out. As a result, very often there was no 'handover' of political responsibility and, even where there was, conceptions of civic responsibility were shallow and seldom outlasted the immediate political generation.

Arguably foremost in the causal field is Collier's work on the 'conflict trap' (Collier 2009). He draws heavily on statistical data to establish a link between per capita GDP and propensity for instability and conflict. Collier's quantitative reliance is limiting, which he acknowledges by having to guess about causal relationships. Importantly, too, his references to Southeast and South Asia are cursory and, in some cases, inaccurate, notably in relation to Timor-Leste where he incorrectly claimed army protesters attempted a 'coup' (Collier 2009:79) and in describing Sri Lanka's 2002 ceasefire as a 'peace settlement' (Collier 2009:74), an error repeated five pages later where he said the island state had 'made it to peace' (Collier 2009:79).

Also widely employed, Berdal and Malone's 'greed and grievance' thesis (Berdal and Malone 2000) – which Chapter 10 examines in more detail – postulates a causal relationship between overt economic motives and intra-state instability, again focusing primarily on Africa (see also Collier and Hoeffler 2000; Bodea and Elbadawi 2007). Collier et al. (2003) provide a wider study on the propensity for, and duration of, civil wars but turn on its head the central idea that 'poverty increases the chances of civil war', noting that civil war increases poverty and hence makes a return to civil war likelier (p. 53). Overlapping with some of the case studies (Timor-Leste, Aceh and West Papua), Braithwaite's twenty-year survey 'Peacebuilding Compared' (2010a) demonstrates a link between low levels of economic and political development, in which governmental notions of state responsibility and civic duty were, at best, poorly understood.

Not all social division is negative. A modernist approach to social division sees as healthy the organisation of social forces within an agreed, non-violent framework based on shared group interest. Industrialisation, urbanisation, class formation and democratic contest under an agreed civic model are part of what can be called horizontal distinction. In this, socioeconomic groups band together into generally representative blocs, usually according to economic rather than ethnic interest. As a result, while there are social divisions, rather than being primordial in character they tend to divide society between its richer and poorer members, each group advocating policies best suited to its own interests and endorsing those policies as the most economically sustainable. Competition between these groups, usually divided into two broad sets of agendas, is commonly marked by institutional civic codes of mediation, such as elections, to avoid the alternative of class warfare whereby, in most cases, both parties would end up losing.

Horizontal difference is not, however, always mediated through agreed civic codes, which in one of the case-study countries resulted in high levels of civil violence. Sri Lanka has seen two student-led class-based rebellions against its government, in response to what was seen as a legacy of colonial privilege by a ruling elite at the expense of the country's vast impoverished majority. The first rebellion was in 1971 (Cooke 2011:Ch. 4), the second

30 *Colonialism and its legacies*

in 1987, even though its proponents have claimed that the former revolt was prompted by a government bid to suppress the Janatha Vimukthi Peramuna (JVP, or People's Liberation Front). The first uprising left around 15,000 people dead and the Sri Lankan government imposed emergency rule which lasted for six years. The second rebellion led to more than 50,000 deaths and the further imposition of emergency rule (Cooke 2011:365–367). Rather than become more responsive to poorer people's needs, the Sri Lankan government increasingly became a vehicle for the entrenchment of free-market and upper-class economic interests.

In the Philippines, an entrenched ruling elite, largely a legacy of Spain's variant of colonialism, had dominated the country's political and economic life since the colonial period, alienating a largely landless or otherwise marginalised peasantry and a smaller urban working class or underclass. Although the Philippines had an electoral system, it had been rigged through violence, vote-buying and fraud to ensure there would be no effective voice for the country's poor. The Philippines' first rebellion, the communist Hukbalahap Rebellion (1946–1954) was grounded in the resistance against Japanese invaders during World War II, but extended into the post-war period in the face of political manipulation and failed economic reforms.

Although defeated by a combination of limited reforms and an extensive military campaign, the Philippines' corrupt and iniquitous political and economic system led the Communist Party in 1969 to re-launch a rebellion that has continued through various phases and is still active at the time of writing. In both Sri Lanka and the Philippines, what could be categorised as radical verticalism was based on a failed civic model. With civic failure alienating constituent members of the state based on class, and a high level of patron–client relations and ethnic preference, it was unsurprising that both countries also underwent significant ethnic rebellions.

Substantial evidence exists to identify weak institutional capacity as a major factor in state fragility or collapse, promoting conflict or a reversion to conflict in Africa's so-called post-conflict societies (e.g. see Collier and Sambanis 2007a; 2007b). This is especially so where states comprise distinct ethnicities, and an ethnic group with access to power and resources privileges its own to the exclusion of others, usually ethnic-minority groups. This then helps to create social division along ethnic lines, or 'vertical' division. Where lack of access to economic opportunity is the driving force for grievance, incentive for ethnic conflict can take the form of a desire to redress economic inequality or capture economic opportunity at the expense of other societal components, including the ruling group (Berdal and Malone 2000; Collier and Hoeffler 2000; Collier et al. 2003; Bodea and Elbadawi 2007). Collier (2009:53) emphatically concludes that civil war increases poverty, which in turns raises the likelihood of a return to civil war.

Although, as previously mentioned, most of the research in this field has centred on Africa, considerable evidence supports similar conclusions elsewhere. Sri Lanka's slide into ethnic civil war was a direct result of disenfranchising its Tamil minority and of the discriminatory and often aggressively chauvinistic policies of the Sinhalese-dominated government, whereas separatist conflict in Mindanao stems directly from the Philippines' 'Homestead' program (1903–1970s), described by the government itself as a 'mode of acquiring alienable and disposable lands of the public domain for agricultural purposes' (GRP 2003). Under this program, landless Christians were given land in what was then predominantly Muslim Mindanao and in so doing disenfranchised the Muslim 'Moros' who, though they had prior possession of the land, commonly lacked formal deeds proving ownership. Not until 1997 did the Philippines government pass an Indigenous Peoples'

Colonialism and its legacies 31

Rights Act which helped traditional landowners secure formal title to their land, by which stage the depth of Moro separatists' disillusionment with the government was entrenched.

Similarly, Acehnese felt aggrieved that not only was a promise of special autonomy following the Darul Islam rebellion of the 1950s and early '60s never fulfilled but, under the New Order, Acehnese were displaced by predominantly Javanese 'transmigrants'[7] as well as denied economic opportunities from the exploitation of natural resources, notably liquefied natural gas, within Acehnese territory. In West Papua, indigenous Melanesians have consistently been denied equality of access to state resources; frequently been removed from their traditional lands to make way for resource extraction or migration from western Indonesian islands; suffered extensive human rights abuses with claims many tens of thousands of lives have been lost; and otherwise been profoundly discriminated against by ethnic Malays, and consistently saddled with the lowest human development indicators in Indonesia. A low-level rebellion against the central government has, unsurprisingly, been sustained since soon after Indonesian occupation in 1963 (Fernandes 2006).

East Timor faced the twofold problem of an Indonesian invasion in 1975, initiating twenty-four years of brutal occupation and the directly related deaths of over a quarter of the pre-invasion population; and then, after achieving independence, coming to the brink of civil war over riven political and ethnic loyalties in 2006. East Timor reflected a clear case of failure of the state, or its mentor (the United Nations), to build enough capacity to tackle the needs of its citizens. A breakdown of state order compelled the UN to return, maintaining a substantial presence for the next six years (see Kingsbury 2009:Ch. 6).

In each case, a lack of state capacity aligned with repression and/or economic exploitation of minority peoples led directly to grievances that triggered rebellion. Resistance to unequal incorporation into the state was heightened rather than assuaged by a high degree of state constructivism, forced upon minority populations in each of our case studies. Also without exception, the state's ideological program of 'nationalism' was alien to the disenfranchised minority, who were required to learn a new, foreign language that represented exploitation and repression. At the same time the alienated minority were placed under immense pressure to accept the incorporating state as constituting a bonded national entity, in which dissonance between state requirements and national claims is subsumed until it is no longer tenable. At this point, the build-up of such dissonance can manifest itself in group violence against the state, its representatives and symbols.

In each case study, vertical division or division between ethnic groups is attributable to a series of factors that militate against the formation of a bonded political identity. The preexistence of tribalism or clan loyalty, if more widely constructed in the case-study countries, highlights primordial ethnic distinctions and relatively closed social systems based on loyalty and patronage. This tends to breed patron-clientism, in which benefits accrue on the basis of favors and loyalty to a powerful tribal figure rather than on the basis of non-ethnic equity. Decision-making is essentially non-participatory. Through civic exclusion, one ethnic group dominates the rest, and this inhibits the emergence of more regularised civic methods of social organisation.

Where the opportunity for a transition to a more civic model presents itself, this may fail in some cases by reason of inadequate preparation, the absence of prior institutional capacity, or a combination of both. Even where these factors are present, inadequate habituation – the lack of long experience with such structures – may spell doom for civil-society institutions.

Mechanisms upholding civic order work where there is a cohesive pre-industrial multi-ethnicity based on the functional rule of law, equity and civic equality. The common alternative, producing civic failure, creates a vacuum filled by the state's resort to

32 Colonialism and its legacies

compulsion or force (which is familiar to the community or, again, one might say they are habituated to such displays of power against them), yet inevitably the compelled community will perceive a disjuncture between state illegitimacy and vertical political loyalty and, finally, in the grip of alienation, will retreat to the ethnic (or vertical) with consequent calls for the establishment of a new state that more accurately reflects the cohesiveness of their geographically specific ethnic group. In this development, ethnic unity may well be achieved, but there is no guarantee a state can or will move to establish a viable sense of civic unity. Failure to establish civic unity in a multi-ethnic state can and often does incite minority claims to further devolution, thus re-creating the cycle of compulsion and violence, and may lead to the state's fragility or collapse.

Conclusion

This chapter has canvassed the creation of colonies and considered aspects of post-colonial political systems, including elements of economic and political relations. It has focused on colonialism's legacy of multi-ethnic nation-states, and the problems they can face because they lacked prior unity or a common understanding.

Where little or no sense of common purpose obtains, and the state is unable or unwilling to fulfil its responsibilities to citizens equitably, the stage is set for conflict between the state and either its citizens or ethnically defined groups of nominal citizens.

While motives for conflict can vary, in such cases fragility and vulnerability to conflict can have a compounding effect, predisposing a state to the eruption of such conflict, in some cases almost as a default position. There is little doubt that individual and group decision-making styles contribute to the possibility of conflict, but the political and economic legacies of colonialism can remain long after independence, crippling state responses to civic demands and even predetermining various types of state failure. It is not a given that post-colonial states will fail. But the political circumstances that attended the birth of these states, along with their (limited) capacities and occasional aspirations for good governance, combined with the divided character of group identities within the state, may each – and most powerfully in combination – limit its normative political development and shape the way it responds to opportunities and challenges. This then goes to issues of ethnic identification and nation-building, the substance of the next chapter.

Notes

1 '*Salafism*' is a strictly literalist, austere and puritanical version of Sunni Islam which seeks to emulate the social mode of living of the first three generations after the Prophet Mohammed ('the forefathers' – '*al salaf*'). '*Jihad*' means to 'strive' or 'struggle', and includes both personal struggles for faith as well as struggles for Islam and, 'of the sword', against non-believers. '*Salafi jihad*' is a term used to describe an international politico-religious ideology manifested as war with unbelievers to achieve social and political transformation of states and interstate entities.

2 'Voltaire' (François-Marie Arouet) was a, perhaps *the*, key Enlightenment thinker whose prolific works posited freedom of religion, the separation of the Church and state, freedom of speech and other social and political freedoms. While Voltaire challenged key assumptions underpinning the state as it was, at the same time he championed the 'progressive' state. In contrast, the other key Enlightenment thinker, Jean-Jacques Rousseau, saw the 'rational' or corporatist state as structurally unequal (see his *Discourse on the Origin and Basis of Inequality among Men*) and argued that the power to make laws should be (only) in the hands of the people (the 'general will'). The two philosophers initially began as colleagues and friends but inevitably clashed over competing world views. Voltaire can be seen as a forefather of, and metaphor for, the modern capitalist or corporatist western

state and the globalisation of commerce and values. Rousseau's anti-Establishment tendencies, were a forerunner of radical and revolutionary movements and a metaphor for the legitimacy of the local and grounded. Voltaire's philosophy tended to privilege top-down rational 'civilisation' while Rousseau's perspective favored bottom-up change and rejection of corporatist state 'civilisation'. In developmental terms, Voltaire equates with the contemporary West while Rousseau represents the 'anti-West'.

3 Not to be confused with Republic of Congo, which has a separate colonial and post-colonial history.

4 A shortfall in rubber production could be ascribed to a reluctant workforce, the punishment of which actually created the putative cause for which they were being punished.

5 Hammarskjöld's aeroplane crashed near the border of Northern Rhodesia (today's Zambia) as he was *en route* to the Congo to negotiate a ceasefire between 'non-combat' UN forces and secessionist Katangan troops. Despite having a decoy plane, it was widely believed Hammarskjöld's plane was shot down and the UN has investigated this theory (UNSG 2017).

6 Initially established with the aim of turning Uganda into an officially Christian state, the LRA later descended into a directionless cult movement around its leader, Joseph Kony.

7 The term was used by the Indonesian government to describe intra-state migrants.

3 Ethnicity and nation-building

Introduction

While all states are, to some extent, arbitrary in their geographic scope, as noted in the two previous chapters most developing countries tend to have more arbitrary boundaries as a consequence of their common prior existence as colonies. The boundaries of such colonies reflected the needs and conveniences of colonising powers rather more than reflecting a pre-existing cultural or territorial identity.

All colonised territories reflect this arbitrary boundary phenomenon to some extent, but the states of Africa perhaps reflect them most strongly. In what was known as the 'Scramble for Africa', European powers raced to carve out areas of control in respective parts of the continent from the later 19th century until just prior to World War I, by 1914 leaving just the Empire of Ethiopia and Liberia[1] as independent.

The era of colonialism carved territories out of vast swathes of the non-European world. These territories were initially trading stations such as those dotted along the coast of Africa, India and Southeast Asia but, as colonial powers expanded their economic interests to include more thoroughgoing exploitation, increasingly as whole territories. In parallel with European state organisation, colonisation took on a Westphalian form, with colonies having defined (if often expanding) borders. Defined to suit the coloniser's convenience, such borders often reflected the capacity for a colony to expand rather than prior tribal or ethnic unity. The upshot was uncontrolled, independent, contested border areas or, in some cases, rival groups being brought under single rule, for example the 'tribal' areas of Pakistan, the India–China frontier and so on.

After World War I, several colonial governments initiated more humanitarian policies towards colonised peoples, in part to facilitate local administration and commerce, but also in response to a growing disquiet in many home countries over colonialism's excesses. Indeed, many colonial subjects fought in that war, and learned that their colonial masters were not necessarily better on the battlefield than they were. Better education was a key outcome for many colonised peoples, leading to a more articulate and organised questioning of the whole colonial enterprise. This in turn led to the establishment of the first 'nationalist' independence movements. World War II further weakened many colonial powers, demonstrating to their far-flung subjects that the era of colonialism was coming to an end.

As previously discussed, anti-colonial independence movements, which became widespread after that war, were usually predicated upon the principle of *uti possidetis* ('use of property' or 'as you possess', and usually incorporating *ita possideatis* – 'and continue possession'). Hence, post-colonial states were usually based upon colonial boundaries, meaning

Ethnicity and nation-building 35

that their relatively arbitrary character was transferred to the successor state. In some respects, anti-colonial claims alleging illegitimacy of the territorial colonisation were transferred, along with aspects of repressive colonial law, to successor states.

The establishment of Pakistan remains a prime example of such a state, where the dominant Punjabi ethnic group coexists with many smaller groups. The drawing of India's north-western frontier with Afghanistan brought under British and hence Pakistani administrative control what were to become the north-western Federally Administered Tribal Areas. These areas, with links to Afghanistan as close as those with what was to become Pakistan, traditionally recognised no central authority and have remained restive and a source of intra-state conflict under Pakistan just as they were under the British.

Similarly, the four princely states of Balochistan came under colonial British 'protection' and, between 1947 and 1955, agreed to join with Pakistan under an autonomous arrangement. This arrangement has since been superseded and Balochistan has, over the period of its incorporation, experienced five anti-Pakistan insurgencies (in 1948, 1958–1959, 1962–1963, 1973–1977 and from 2003 until the present time). The creation of an independent Burma in 1948 brought together previously separate or hostile groups under ethnic Burmese majority domination, leading almost immediately to intra-state conflict that, in one form or another, has continued without respite ever since.

Perhaps the most obvious examples of arbitrary post-colonial state construction were in the Middle East, as a result of the 'now moribund' (Gunter 2017:189) Sykes–Picot Agreement of 1916, which divided up a large section of the defeated Ottoman Empire. Despite coming at the height of World War I, in which the post-war future was not guaranteed, there was enough confidence abroad to assume that the Allied powers would retain colonial dominance and expand into that space once occupied by their adversaries, the Central Powers, including what was then the crumbling Ottoman Empire. The agreement created British and French spheres of control and influence determined the approximate shape of the multi-ethnic successor states of Syria and Iraq.

Both became multi-ethnic and multi-religious states. Syria's population is dominated by Sunni Arabs (*c.* 74 per cent), Kurds and Turkmen, with about 13 per cent being Shia Muslims (belonging to the further sub-groups of Alawites, Twelvers and Ismailis). About 10 per cent of the Syrian population is Christian, with Druze and other, smaller sects making up the balance. Iraq's population, by contrast, is majority Shia (*c.* 64 per cent), with the next largest segment Sunni (*c.* 31 per cent) and Kurds next (*c.* 17 per cent). Other, smaller minorities make up the balance. Neither country is religiously or culturally cohesive and neither can be said to have ever constituted a 'nation' in any unified sense of the term.

While the histories of what are now known as Syria and Iraq can, broadly, be defined by the ancient cultures that once dominated their respective regions, their history in connection with the modern world began with Islamisation, being subsumed into the Ottoman Empire and then cast adrift by the break-up of that empire. With the Ottoman Empire being a belligerent in World War I, Syria briefly became a kingdom when the Hashemite Faisal who, after leading the Arab Revolt against the Ottoman Turks, occupied the then newly captured city of Damascus in 1918. After the occupation, he reigned just four months, until in 1920 the newly minted League of Nations conferred a mandate on the French to govern the Syrian territory. What was to become Iraq was allocated to the United Kingdom. The largely arbitrary and largely straight-edged border between the two countries was closely based on the Zone A and Zone B border of post-war French and UK spheres of influence. These *de facto* zones extended beyond the lands under mandated control that became the core of the two states. In assuming responsibility for this territory, the

36 *Ethnicity and nation-building*

French excised Lebanon from the larger Syrian area, so as to cultivate good relations with the area's Christian majority, and ruled over Syria as an internally fractious multi-ethnic protectorate (Stearns and Langer 2001:761).

Faced with the inclusion of various ethnic groups within a single colony, European powers – particularly the British – commonly gave certain minorities preference in recruiting administrative employees in order to gain the favor of otherwise often persecuted groups. This set up ethnic rivalries that often festered until they surfaced in post-colonial settings. Such favoritism as between Tamil and Sinhalese ethnic groups – each once part of independent and often hostile kingdoms, speaking different languages and following different religions – was the key underlying contributor to the country's Tamil separatist rebellion (1983–2009), while the Rwandan genocide of 1994 also has its roots in a reaction to colonial incorporation and ethno-specific privilege. Post-colonial (and post-communist) conflict based on competing ethnic identities has also wracked Sudan, the Democratic Republic of the Congo, Angola, Nigeria, Uganda, Georgia, Azerbaijan and Moldova, among many other post-colonial countries.

Reacting to signs of subversion by separatists, violence is the rule, not the exception (Nurbati 2011).

> The difficulty that democracy finds in resolving issues of community emphasizes the importance of national unity as the background condition of the democratization process. The hardest struggles in a democracy are those against the birth defects of the political community.
>
> Rustow 1999:24

Hence, if the state in which democracy is to become embedded is not based on a bonded political community in the first instance, or is based on coercing distinct and antagonistic groups into reluctant cohesion, it will continue to revisit this problem until or unless it is adequately resolved. This then raises the question of the nature of the modern – Westphalian – state.

The Westphalian state

The Westphalian state is, and has for the past three and a half centuries been, the standard state model to which all other types of state have been subordinated. The Westphalian model implies state sovereignty within specific and generally fixed borders, to the exclusion of external powers. A functional state exercises authority to the limits of its borders and, in principle, that authority should be relatively evenly distributed. That is to say, a functional state should not exercise full state control over some areas while its authority over others is diminished (see Linz and Stepan 1989; Schmitter and Karl 1991; Valenzuela 1990).

This Westphalian ideal does not conform to the experience of many developing countries, partly because of limited state capacity, especially beyond the capital or key cities, but more often because the borderlands of many developing countries did not previously exist or were regarded as a shifting no man's land and so have remained porous and, at best, only loosely controlled.

The advent of the Westphalian state coincided with the signing of the 'Peace of Westphalia' in 1648. This accord ended, at a stroke, two long-running wars – the first being the Thirty Years War over religious divisions, fallout from the fragmentation of the Holy

Ethnicity and nation-building 37

Roman Empire and rivalry between France and the Hapsburg dynasty. The second conflict was the Eighty Years War, which culminated in Dutch independence from Hapsburg Spanish rule. While this peace established a number of norms and principles around sovereignty and non-interference, its most enduring quality has been that of sovereign borders. From this time, and particularly during the late 19th century, defined borders became the key and common identifier of modern states.

Prior to this model, states often had overlapping areas of sovereignty or suzerainty, while borders were often poorly demarcated. Beyond Europe, with limited exceptions such as China and Vietnam, states (or polities that functioned as states) seldom had defined borders, with their hinterlands often remaining in a condition of abandonment, flux or contestation. The extent to which a state held sway over territory increased or decreased according to the power it could exert over a region, relative to that of neighboring states. In many cases, tribal or ethnic groups operated as federations or loose national groupings across given regions, but without formal geopolitical structures. Neighborly rivalry or conflict was common and certain inter-ethnic conflicts became longstanding or ritualised, with high degrees of institutional memory and symbolic meaning. A, perhaps *the*, common marker of ethnicity is language; where languages are distinct and separate, usually so too are communities.

Language

The key bridge across socio-political divides is language. According to settled linguistic theory, language not only expresses one's culture but, by framing and expressing the concepts it employs, it helps defines one's culture. People may respond to situations emotionally, but they conceptualise through the use of language or thinking that is informed by ideas expressed in words. This does not imply a deterministic relationship between language and either culture between language and conceptualisation but it does imply symbiosis (Ahearn 2011).

It has been suggested by linguistic relativists that language is so culturally specific it is effectively impossible to translate from one language to another and retain full meaning (Sapir 1944; Sapir 1956). There is some validity to that proposition, in that translations are usually approximate or require the translator to use the available terms of the language being translated to, trying to find equivalences and groups of words that adequately replace a single word. Even people who speak fluently in languages other than the one they were born into find it challenging to switch between languages without altering their thought processes. Those required to learn multiple languages rarely become really proficient in any of them, particularly without a great deal of concentrated education and dedication. But translation is possible, obviously, or else linguistic relativism would not have been able to determine the meaning of the languages they were exploring. For most people, though, shared language is a marker of belonging. Equally, when it is not shared, language is a marker of separation or being 'on the outside'. Even as language use cements the social status of cultural 'insiders', it marks differences in custom, attitudes, behaviors and, most critically, values.

Where two language groups first meet, they define each other by their difference. Language groups soon become the principal entities for organising society to secure resources such as land and water access. Two (or more) such groups competing for the same resources necessarily leads to competition and they may, depending on the necessity or relative scarcity of the resource, come to blows. Notions of 'us' and 'them' can and often do manifest quickly, and seldom positively.

38 *Ethnicity and nation-building*

Given that most post-colonial states were constructed with little regard for the interests of the colonised, consideration of such matters was rarely, if ever, at the forefront of colonial thinking. Consequently, many language groups, even those that had attained the trappings of polities or states when the colonialists arrived, were squeezed into the unitary space of an administered colonial territory. Sometimes, administrative criteria separated speakers of the same language on either side of a colonial (the future post-colonial) frontier.

With colonial powers giving little or no thought to group differences, and the potential for active hostilities, post-colonial states that inherited the colonial territory were immediately confronted by this difference. So it has been common for multilingual states to establish an official language (or, less commonly, two or more official languages).

English – a global lingua franca – is the official language of fifty-five countries (most of which also have common local languages), the *de facto* official language of four more and is the official but not primary language in seven other countries. Spanish is also an official language in twenty-two countries as well as a lingua franca, particularly in Latin America, as is Portuguese in ten countries.

Examples abound of where language has been a key political issue in developing societies, but Sri Lanka is among the most stark. Having undergone Portuguese, Dutch and then English colonial administration, the island remained divided among majority Buddhist Sinhalese, Tamil Hindus and Tamil Muslims, along with smaller groups of Catholics and Protestants. Under English colonial rule, English was the language of administration, with Tamil Hindus prominent among the colony's administrative class.

Upon decolonisation in 1948, militant Sinhalese Buddhists sought to reject vestiges of British rule and, in 1956, they introduced the 'Sinhala Only Act', making Sinhalese the official state language and automatically excluding Tamil-speakers and English-speaking Tamils. Aligned with notions of national exclusivity, the decision drove a deep wedge between the Sinhalese and Tamil populations, with attempts at resolving growing tensions met by growing Sinhalese militancy and, eventually, Tamil militancy (Smith 2009:91–92).

There had been numerous acts of organised violence, particularly since the mid-1970s, but the events of 1983, known by Sri Lankan Tamils as Black July, amounted to a semi-official pogrom in which up to 3,000 Tamils were murdered and about 150,000 made homeless. This event is widely seen to have marked the beginning of the Sri Lankan civil war between militant Tamil organisations, eventually dominated by the Liberation Tigers of Tamil Eelam (Tamil Tigers), and the Sri Lankan government (Kingsbury 2012b:64–65). More than 100,000 people died as a result of the conflict, with around 40,000 killed in the last months of the war in 2009. This war, and its conclusion, demonstrated a clear failure to build a common nation from distinct ethnic groups and, indeed, consolidated those distinct identities as becoming 'national' in their self-understanding.

Nation-building

A 'nation', as noted in Chapter 2, is commonly described as a group of people sharing a bonded political identity, usually within a given territory. Commonly found within this framework is a complex set of social interactions concerning collective experience, values, power relations and strategic assessments, sometimes immediately experienced in more intimate communities and sometimes understood or imagined in larger, more complex ones. A nation instinctively craves a state within which it can protect and develop the mutually reinforcing collective. But *a priori* is the question of how nations come to be.

Ethnicity and nation-building 39

There are two main schools of thought on this: the first takes what might be described as an organic view, where the idea of nation emerges from a politically bonded people having already cohered around a common language, culture and history or myths. The second view sees national identity as a creation of the state. Very few, if any, nations come into being without some form of conscious shaping of identity. Conversely, attempts to create nations from disparate peoples often fail due to their artificiality and, in certain instances, the arbitrariness of their invention.

In part, too, the idea of 'nation' as it is understood today is fairly modern. Still, the existence of nations as conscious creations does not imply that they are whisked into being from nothing or that the so-called first wave of nationalists in the 19th century were working on a project that lacked resonance with the people who were to become the nation so defined. Parallel, too, with the idea of nation was the idea of a state to represent it: that a politically bonded people in a given area should have control (sovereignty) over that territory and institutions to manifest that control.

The organic view of 'pre-existing' nationhood has also been described as primordialist or essentialist. Its proponents have argued that nations evolved out of the sharing of common-language stories and creation myths (see Armstrong 1982, also Smith 1986b). There is seen to be a distinction between the pre-existing nation and the project of nation creation, manifested as nationalism.

The constructionist view of nation-building places great weight on a conscious process of myth creation, language standardisation and territorial control by the state (Gellner 1983). Use of standardised and shared communication is said to create a sense of community that is otherwise unknown but is 'imagined' (Anderson 1983).

According to this view, whether people feel they are members of a bonded political community is more important than whether, objectively, they are. A theorist might argue that a sense of nationalism among, say, members of a separatist organisation was created fairly recently and that it rests on myths and interpretations of history that are difficult to sustain. But that argument will be irrelevant if the sense of bonded political identity exists for the purposes of the separatist project. Theorists have argued that a nation presupposes a common language and a territory spanned by shared institutions. Yet if the people occupying that territory do not feel a bonded sense of shared identity, then no number of claims to nationhood can will a nation into being for those who do not share, or at least accept, its premise.

This begins to define the status of developing countries and the degree of success they have had in representing or creating a sense of bonded political identity. Unless a people are content to be ruled by authoritarian processes, such a sense of unity is necessary, as such unity 'must precede all other phases of democratization' (Rustow 1970:35). Unless a sense of common bonded political identity can be constructed which bridges such differences as might exist, a 'nation' may implode, which in turn leads to dissent, communalism and the potential for fragmentation and associated discord – a common story among developing countries. In short, without such unity a country may be doomed to authoritarian governments in perpetuity.

The state that represents not just the 'nation', but that may incorporate several 'nations', risks internal challenge or dissent. This is not a necessary outcome, as multi-ethnic states can voluntarily exist: indeed, voluntary inclusion is the strongest method of securing that inclusion. The most successful method of nation-building is through a well-resourced state providing its citizens relative equality of representation and high levels of civic equality. Where resources are scarce, a state might resort to less subtle (more authoritarian) methods of securing inclusion.

40 *Ethnicity and nation-building*

Standardisation of a single language is the most powerful common marker of a nation, a means of common communication within the nation and a vehicle for the state's conveyance of 'national' myths and symbols. If such symbolic markers apply to 'the state' rather than the community, it may imply the type of state being referred to, i.e. it is 'statist' and bureaucratic-authoritarian in approach.

Nations initially tended to cohere around language or culture groups but, with the advent of colonialism, they came to include multi-ethnic societies. Of those states whose imperial experience was as multi-ethnic colonies, India is one of the more successful, bringing to its several dozen most significant ethnic minorities a largely cohesive sense of overarching 'Indian' identity. China, too, has been notably successful in unifying a number of its fifty-six recognised (largely southern) minorities around a predominantly Han national identity, although its western minorities in Xinjiang and Tibet remain outstanding examples of resistance to that incorporation.

Compelled multi-ethnic societies have, however, sometimes been less successful in building cohesive multi-ethnic nations. Groups in India that have resisted compulsory inclusion include peoples in the northern state of Jammu-Kashmir and the north-east regions bordering Myanmar, notably Nagaland.

The establishment and propagation of an official (and therefore most widely communicated) language has been one key method of overcoming ethnic difference. Despite Javanese speakers being overwhelmingly its largest language group, Indonesia, for example, adopted the regional (and significantly less complex) trading language of Malay as its national language (Bahasa Indonesia).

India recognises a number of languages, but Hindi is its official standard, along with English as a common administrative and educational language. Arabic is the official tongue of twenty-six countries, existing alongside former colonial or local languages in half of them. Attempts to create a united pan-Arab state having failed, trans-Arab nationalism has arisen but with most success around the cultural marker of religion, which has brought together Arabs from various states in common causes, perhaps the best known one being *'jihad'*.

The experience of the Arab world in the early 21st century was one of marked division, principally between religious groups as another key marker of ethnic identity. Where ethnic groups fail to cohere, or where circumstances conspire to drive apart separate groups that had lived in relative harmony with each other, minor groups in territorially distinct areas may seek to separate, to establish their own state to better reflect their (proto) national identities.

Separatism

Sometimes – indeed often – the nation-creation project does not succeed in uniting what are sometimes disparate peoples behind a common or unified cause. As discussed in Chapter 2, this can lead to calls for separation from the 'parent' state. The powerful emotions that produce the call for 'independence' have not diminished, with well in excess of 100 independence movements active at the time of writing. Indeed, since the end of the Cold War, visible independence movements have increased. Perhaps the number of movements overall is unchanged, though, as many were previously clandestine.

Those powerful emotions can drive people to extremes, in some cases including killing and dying. Yet, for the high price often paid, independence movements are rarely successful and their outcomes usually fall well short of their aspirations. Unilateral declarations of independence usually provoke a heavy-handed response from the government. This, in almost textbook style, increases support for independence.

Ethnicity and nation-building 41

Independence movements commonly start with a small number of idealists, yet quickly grow when central governments respond with repression. In such circumstances, the desire for 'freedom' takes root and flourishes. Thus central governments' first responses to secession bids are critical to their outcome.

Of existing secessionist movements, many have produced bloodshed and trauma well in excess of possible practical gains. Despite the relative popularity of secessionism, very few such movements are ultimately successful, while the costs of imposing a nominal unity on a country can be high for both parties. With high costs and limited chances of success, secession movements are rarely about pragmatism and more about fervor. Even with popular support, secessionists rarely have the political or military capacity to impose their will on the state from which they would secede. Such limited exceptions as there are to this rule have relied on either external intervention, e.g. Bangladesh and Kosovo, or agreement by a weakened parent state, e.g. Eritrea and South Sudan. Timor-Leste achieved independence on the back of both factors.

Having overcome the daunting odds of achieving independence, the success of post-secessionist states has, on balance, been poor. Bangladesh has struggled between periods of incapable civilian government, military coups and a state of emergency. Eritrea, since winning independence in 1991, has been an authoritarian one-party state with no political activity allowed. Neither could be held up as an exemplar for the politically successful developing country.

Kosovo, which could be considered a developing country based on the UNDP's Human Development Index or its per capita GDP, has been marked by divisive ethnic politics, while South Sudan has been wracked by ethno-political fighting since attaining independence in 2011. Timor-Leste was a successful democracy, yet only survived intact due to international intervention ending civil conflict in 2006, and once again it faced a serious political challenge when the program of its newly elected minority government was voted down in 2017.

Despite a commitment by the Organization of African Unity to 'the inalienable right of all people to control their own destiny' (OAU 1963), African states have since been strongly opposed to the creation of new states. In this respect, self-determination was intended by the OAU (later the AU) to apply only to states that were still colonies, not to the peoples of post-colonial states. To that end, African states have largely steered clear of supporting secessionist movements in other African states.

The most significant instance to the contrary was when Tanzania, Zambia, Gabon and Côte d'Ivoire supported a breakaway state of Biafra in Nigeria, during that country's civil war of 1967–1970. In 1969, however, the OAU rejected the legitimacy of secessionist movements and endorsed the continuation of existing states, specifically of Nigeria (OAU 1969). The creation of breakaway states Eritrea (from Ethiopia) and South Sudan (from Sudan) was not due to external African support for their independence claims but to the outcome of civil wars reflecting the involuntary inclusion of territories into larger states and the post-colonial loss of regional autonomy.

Kurdistan

Of the world's separatist movements, one of the most notable is Kurdistan. It has long been said that, with around 35 million people, Kurdistan is the world's largest nation not to have its own state. A Kurdish state could be viable, with a potentially sound oil-based economy and a very capable military, if it were not divided between Turkey, Iran, Syria and Iraq (Gunter 2017:20–21).

42 *Ethnicity and nation-building*

When President George W. Bush's United States-led coalition invaded Iraq in 2003 under the pretext that Iraq had failed to dispose of 'weapons of mass destruction', there was little thought given to its unintended consequences. These consequences were recognised earlier by the administration of Bush's father, President George Bush Sr. Despite providing (air) cover for the creation of the Kurdistan Regional Government (KRG) in northern Iraq, the U.S. was circumspect in its support at this time (Gunter 2017:157). U.S. support for the KRG came to the fore when Turkey refused the U.S. access to air bases from which to attack Saddam Hussein's Iraq in 2003. The KRG had no such qualms and, in doing so, made a powerful if impermanent ally.

Of the many mistakes made by the U.S.-led coalition in Iraq, beyond the invasion itself, two stood out. The first was that the invading forces dismantled the state apparatus built around the Ba'ath Party of dictator Saddam Hussein, meaning that state functions disappeared and were very slow to be rebuilt, while many unemployed Ba'athists and soldiers who had been dismissed from their posts were galvanised into armed opposition.

The second major mistake was that, after a resurgent armed opposition, the U.S.-led coalition abruptly withdrew its forces before a viable state could adequately consolidate, leaving an exclusivist Shia-dominated government in place, effectively excluding and persecuting the country's formerly dominant but minority Sunni population (Kilcullen 2016). This in turn exacerbated the country's sectarian division along converging religious and geographic lines, with the south being dominated by Shias, the centre by Sunnis and the north-east by Kurds. In 2013, Sunni Muslims quickly morphed, through a series of organisational structures and names, into the 'Islamic State' (IS) group, quickly moving into Syria and establishing what it claimed to be a new 'caliphate' (for IS's origins see Kilcullen 2016, also Gunter 2017:178–179).

With the removal of effective central authority, Iraq quickly disintegrated as a unitary state, with Kurds in the north-east consolidating their self-proclaimed autonomous region led by the KRG, which boasted an independent military force, the Peshmerga (meaning 'to face death') (Phillips 2015:97–124).

So, too, in Syria, where the country's central control crumbled under a late addition to the 'Arab Spring', resulting in the establishment of dozens of separate anti-government militias within a few broad groupings: the non-aligned Free Syrian Army (FSA); the Al Qaeda-linked Tahrir al-Sham; IS; and the Kurdish-dominated Syrian Defence Force (SDF). In practice, two wars were underway in Syria at this time: the first between Bashar al-Assad's government and all militant opposition; the second between IS and, as their collective enemy, Assad's government, Tahrir al-Sham, the FSA and SDF.

Between 2014 and 2016, IS occupied a large swathe of often inhospitable lands across the centre of Syria and Iraq, demolished a section of the sand berm border between the two countries (and, in so doing, dispelled the fallacy of colonial borders) and established two capitals – one at Raqqa in Syria and a second at Mosul in Iraq. By early 2017, however, Russian, U.S. and allied air power in Syria added to U.S. and allied airpower in Iraq, in combination with potent Kurdish ground forces, had greatly diminished IS's control over a vast swathe of territory across the two countries.

Mosul was Iraq's last major set-piece battle against IS and further stamped the authority of the Peshmerga on Iraq's Kurdish north. Set against an expected victory in Mosul, the KRG held an independence ballot on 24 September 2017. That ballot returned an overwhelming vote in favor of establishing an independent Kurdistan. The independence vote authorised the KRG to enter into negotiations with the Iraqi government in Baghdad.

Ethnicity and nation-building 43

Iraq's military, backed by Iranian Revolutionary Guards, responded to the Kurdish vote by capturing the city of Kirkuk and nearby oil fields which the Peshmerga had held since 2014. The move on Kirkuk was met with little resistance; the Peshmerga withdrew from the city after a few sporadic skirmishes. That retreat was seen by observers as strategic. Kirkuk has become an increasingly ethnically mixed city and hence regarded as no longer part of the Kurdish heartland.

Similarly, as the Battle for Raqqa was entering its final phase, the Kurdish People's Protection Forces (YPG) component of the SDF proved itself as Syria's most formidable military force. The YPG was thus able to establish a *de facto* autonomous state of Rojava (Western Kurdistan) along Turkey's southern border.

As far back as 1948, the U.S. Central Intelligence Agency noted that Kurdish forces would continue to revolt in the region and that Turkey had a security problem with rebelling Kurds going back to the 1920s, with two further attempts to establish independence in the 1940s. According to the newly established American spy agency, Kurdish insurrectionists would pose a continuing threat to the balance of the Middle East state system (CIA 1948:1, 2). In Iraq's Kurdish north, the KRG struck a deal with Turkey not to support either the outlawed Turkish Kurdish Workers Party (the PKK) or a Kurdish state in either Turkey or Syria in exchange for its own future (Gunter 2017:189). While Ankara tolerated the KRG at a distance, when the U.S. sought to formalise the establishment of a 30,000-strong YPG-dominated 'Border Security Force' Turkey invaded.

Apart from the ancient kingdom of Corduene, which survived from the first century BC until towards the end of the Roman Empire, a united Kurdistan had not existed, although there had been many separate Kurdish principalities in the same region. Before Syria's civil war, the U.S. National Intelligence Council – the intelligence community's centre for long-term strategic analysis – acknowledged that an independent Kurdish state could come into being by 2030 (Ekurd.net 2012). As one consequence of the Iraq and Syrian wars, that possibility significantly increased with the challenges posed to post-World War I borders.

With a cohesive national identity, a formidable fighting force and control of some of Iraq's richest oil and gas fields, Iraq's Kurds had most of the key ingredients necessary to succeed in their claim for independence. But they also faced a number of hurdles, which continued to stymie their aspirations for independence.

The first problem was that they were politically divided. The governing pro-independence Kurdistan Democratic Party (KDP) is traditionalist – some say feudalistic – while the Patriotic Union of Kurdistan (PUK) had a strong (originally pro-Soviet) left-wing orientation. The KDP and PUK fought a three-year civil war from 1994, ending only with U.S.-sponsored reconciliation (see Gunter 2017 for discussion of Kurdish divisions and factionalism). PUK co-founder Fuad Masum was the President of Iraq at the time of the separatist vote.

The second problem was that both the Iraqi military and the Peshmerga were supplied by the United States. The U.S. favored a united Iraq, albeit with some Kurdish autonomy. It disapproved of Iraq's heavy reliance on Iranian 'militias' (i.e. Revolutionary Guards) and recommended they leave Iraq. But, given that it controlled the flow of weapons to both of the parties in dispute, it could decide the outcome according to its own strategic interest, which was not that of an independent Kurdistan. The U.S. similarly withdrew support for the YPG, preferring to retain its Turkish alliance within NATO.

A third obstacle confronting Iraqi Kurdistan's claim to independence is that it is land-locked and, while it has oil and gas, it cannot export these commodities without Baghdad's cooperation. Of the two pipelines that extend beyond its territory, the one through Iraq

44 *Ethnicity and nation-building*

and Syria has been destroyed while the other – via Turkey – could easily be closed. The fourth, and perhaps most compelling, problem facing Kurdistan's bid for independence has been the lack of an international sponsor to provide it with a lifeline of *matériel*, which is a common requirement if an independence movement is to have much chance of success.

Finally, with conflict breaking out between Iraqi and Kurdish forces, Iraq showed itself willing to intervene should an independent Kurdistan look like becoming a reality. Not surprisingly, the KRG stepped back from its immediate independence claims, and focused instead on consolidating its autonomy within a functionally federated Iraq. Given that the KRG has been independent in all but name, continuing its autonomy would be a viable policy.

Kurdistan could continue to pursue independence, but would likely have a more viable economic future as an autonomous state within a federated Iraq. This appeared to be confirmed when, after no other country had recognised the Kurdish claim for independence a little more than a month after the vote for independence, Masoud Barzani – having succeeded his father as leader and weathered many battles – resigned as President of Kurdistan and head of the KRG in a bid to defuse Iraq's aggression.

Even when successful, therefore, the cost of independence can be highly destructive warfare, a downward economical spiral afterwards and independence leaders failing to make the transition to wise politicians and capable administrators. The skills needed to win independence are not those required to rebuild and run a successful state. Summing up, then, the record of secessionist movements' success stories is lamentably thin. The rhetoric of freedom and reward usually translates into a reality with little of either.

Yet what is now more an urgent necessity for most other secessionist movements is a fairly high level of regional autonomy. Loosening the ties that bind can ease tensions and make states more stable, if in federated or similar form, rather than trying to retain tight control, only to spur resentment. Given their vast differences, the fate of the handful of successful separatist movements cannot be taken as predictive of a particular outcome. But the drivers of separatism, and the impediments to achieving independence, are universally shared, even if a high level of success is not.

A failed success: South Sudan

One example of state creation that not only failed but never looked likely to succeed was that of the former British colony of Sudan. The creation of the country reflected a complex overlay of regional and colonial influences harking back several hundred years, in which the northern part of the post-colonial state was overwhelmingly Arab and Islamic, while the South was more a mix of animism and Christianity among largely pastoralist sub-Saharan peoples. The south of Sudan had been separately administered by the colonial British until independence, when they were merged as part of the UK's broader policy of retaining or establishing strategic bastions, in this case as a viable counter to Egypt and to the expansion of pro-Soviet interests.

Southern Sudanese representatives argued that they had inadequate representation or autonomy under this arrangement, highlighted by northern leaders limiting their commitment to a federal structure ahead of independence in 1956. Even before the country had been granted independence, members of the Sudanese Defence Force mutinied in the south and, though defeated, established a rural insurgency which, in 1963, evolved into a separatist revolt. The unstable government in Khartoum was ineffective in suppressing this, having lurched from an elected government to a military coup by 1958, to Islamist administrations after 1966 and on to further military coups in 1969 and 1971. The

southern separatists were similarly beset by internal, often ethnic, divisions until 1971 when they merged to form the Southern Sudan Liberation Movement (SSLM).

Despite reaching an agreement with the northern government in 1972 to give the south greater autonomy, the pact's internal inadequacies, its termination by President Jaafar el-Nimeiry, his nationwide imposition of shariah law and revocation of southern Sudan's autonomy, sparked a return to civil war. This civil war became one of the longest-lasting of modern times. Taking nearly 2 million, mostly civilian, lives and marked by extensive violation of human rights, it ended in a 2005 peace agreement that restored autonomy to the south for six years with an independence referendum promised at the end of that period. In 2011, South Sudanese people voted 99 per cent in favor of independence. But by 2013 South Sudan was itself plunged into civil war.

The new conflict involved at least seven armed 'self-defence' groups in nine of its ten states, displacing tens of thousands of people. The civil war began over the ethnic Nuer claim that the Dinka-dominated government was plotting to stay in power indefinitely, had not fairly represented or supported all tribal groups and had neglected rural development.

The protagonists and immediate causes of the conflict were well known. In mid-July 2013, ethnic Dinka President Salva Kiir sacked his government following a power struggle within the Sudan People's Liberation Movement/Army (SPLM/A). In the face of a claimed attempted *coup d'état* in mid-December 2013, ethnic Dinkas in the presidential guard began disarming their ethnic Nuer colleagues, who were linked to former vice-president Riek Machar. This led to tit-for-tat killings that quickly spiralled out of control.

South Sudan fell apart so quickly after independence for inter-linked reasons. The first of these besets most newly independent states comprising more than one large ethnic group. With most political institutions still poorly formed and the new state's economy not developed enough to create economic classes upon which to base political parties, politics tended to cohere around tribal and language groups.

Political leaders developed patron–client relationships with supporters whose loyalty was purchased with financial rewards. Patrons and clients alike thus began to see other ethnic groups as constituting not just a political threat but a challenge to their economic survival. Competition for economic resources is most acute when the state relies on a narrow income base: South Sudan is the most heavily oil-dependent country in the world, with oil receipts accounting for 98 per cent of its income. There were, effectively, no other sources of wealth to be distributed.

Even in cases where there is little or no prior internal conflict, such a setting is ripe for internal conflict. In the case of South Sudan, its factions also had a pre-independence history of open conflict. Machar joined the SPLM/A in 1984, but in 1991 fell out with then SPLM/A leader and ethnic Dinka John Garang over whether southern Sudan, as it then was, should remain part of a secular, democratic Sudan or become independent. Favoring full independence, Machar formed the splinter group SPLM/A-Nasir, based in the oil-rich north-east of South Sudan. This split precipitated a number of massacres and a famine that left tens of thousands dead.

Despite his earlier pro-independence leaning, six years later Machar reached a peace agreement with the Sudanese government and was made head of the South Sudan Defence Force: in 2000 he formed a new militia, the Sudan People's Defence Force/Democratic Front. In 2002 he re-joined the SPLM/A as a senior commander. When Garang died in a helicopter crash in 2005, Kiir assumed leadership of the SPLM/A. It then appeared that Machar's primary interest from the outset had been to establish his personal authority over the separatist movement, leading to the tribal violence of 2012 that within a year had tipped the South Sudanese back into civil war.

46 *Ethnicity and nation-building*

To observers it seemed all but impossible to create a permanent solution to a complex ethnic, regional and economic problem within the context of an ethnic majority controlling the levers of state power. This was one conflict that could have benefited from an autonomy arrangement for the minority (in this case the Nuer). For that to be viable would necessitate a regional revenue sharing agreement, given that most oil production occurs in the north of South Sudan, which is under Nuer control. Additionally, peace would require a further agreement with smaller ethnic groups also involved in the fighting.

South Sudan's politics would continue to be dominated by tribalism, patronage and a narrow economic base, keeping it fragile. But such an agreement could at least bring about an end to the killing, the resumption of oil exports and the rebuilding of this still very under-developed state. Without a comprehensive political agreement, a ceasefire seems improbable, and warfare is likely to keep consuming what is, at the time of writing, the world's youngest state.

In October 2015, President Kiir issued a decree establishing twenty-eight states – their boundaries set largely along ethnic lines – in place of the constitutionally established ten there had been up till then. Several opposition parties and civil society challenged the decree's constitutionality so Kiir took it to parliament for approval as a constitutional amendment. In November that year the South Sudanese parliament endorsed creation of the new states. At the time of writing, more than 300,000 people have been killed in the civil war, with almost half the population of 12 million displaced, a quarter of them to neighboring Kenya, Uganda and Sudan. A ceasefire and a power-sharing arrangement was agreed to in 2018, although doubts remained about whether it could succeed in the longer term.

South Sudan's experience illustrates some of the challenges that beset sub-Saharan Africa at independence, being a 'patchwork' nation containing few sizeable areas with an outright ethnic majority.

There has been some difference in political terms between African states, between countries with numerous small ethnic groups and languages and those with just two or three large competing groups. In Tanzania, for example, there are more than a hundred Bantu tribes plus some non-Bantu groups, with the result being that no one tribe has felt that it could dominate the state and none has felt particularly threatened by any other. This is in contrast to neighboring Kenya, where two dominant groups of roughly equal size have fought bitter electoral battles for power. Similarly, in Nigeria the three dominant groups – Hausa, Yoruba and Ibo – have been in perpetual conflict.

In much of Africa and Asia, there is little or no shared historical mythology to serve as a foundation for the nation-building project (Smith 1986b:258), while economic development has been largely unsuccessful – particularly in Africa – for most of the post-independence era. In each case, this establishes the preconditions for developing countries' failure to attain their initial objectives of unity and development, and comes to shape how the state eventually functions *vis-à-vis* its own people.

The South Sudanese won, if imperfectly, their struggle for independence and the Iraqi Kurds look to have at least some hope of such an outcome. Not so for another minority ethnic group, the Rohingyas of western Myanmar, whose status is that of a stateless people, being stripped of Myanmar citizenship in 1982.

Rohingyas

When Aung San Suu Kyi's National League for Democracy was elected to government in November 2015, a wave of relief swept across Myanmar, and the world, that after decades

of repression better times would soon arrive. For many citizens of Myanmar there has been positive change, even if most of it occurred before those elections. But, for Myanmar's Rohingya minority, the change was all for the worse.

In August 2017 members of the Arakan Rohingya Salvation Army (ARSA) attacked twenty-five Myanmar border posts in the country's west, killing more than 100, mostly border police. In response, international aid agencies which had been assisting tens of thousands of displaced Rohingyas are now pulling out all non-essential personnel.

ARSA commander Abu Ammar Jununi said the attacks were in retaliation for Myanmarese military harassment and blockades of Rohingya villages. Militant activity along the border between Bangladesh and Rakhine state had been mounting since 2012 when deadly riots and clashes took place between the Rohingya Muslim minority of around 1.3 million people and the state's 3.2 million-strong Buddhist majority, the latter aided by the military. About a million Rohingyas had previously fled Myanmar. The Rohingya have long been persecuted by Myanmar's Buddhist majority and, in an arbitrary act of government in 1982 lost their status as citizens. Since then Rakhine's Rohingyas have been increasingly marginalised, denied access to basic services, beaten, raped and killed.

There was some belief that, with Nobel Peace laureate Aung San Suu Kyi effectively leading the country, she would intervene to end the discrimination. But Suu Kyi has continued the official policy of denying Rohingyas citizenship and forbidding use of the term 'Rohingya', claiming that those who self-identify by that name are actually immigrants from Bangladesh. Many outside Myanmar who had pinned high hopes on Suu Kyi's leadership have been deeply disappointed. What they ignore is that Suu Kyi has to balance overwhelming ethnic Burman racism towards Rohingyas, compounded by the Tatmadaw (Myanmar's military's) anti-Rohingya policy, against majority opinion in what is a still a fragile and slowly evolving democracy.

Myanmar may have had semi-democratic elections and put in place a civilian-led government, but its military still has veto power over the government. The country's constitution requires that the military retain a quarter of parliamentary seats and, more important, the military-dominated National Defence and Security Council could remove the elected government at any time for any reason. As well as having to balance these reactionary forces that still play out in Myanmar's domestic politics, Suu Kyi – and this is a point many have forgotten or perhaps never knew – is nothing if not her father Aung San's daughter and, as such, an ethnic Burman nationalist. When Suu Kyi has said that the name 'Rohingya' cannot be uttered in Myanmar, she has sounded as if speaking from personal conviction.

The claim that the Rohingyas are actually Bangladeshis was used to exclude them from citizenship and, hence, rights within the country in 1982. Some people identifying as Rohingya did cross into the country, then known as Burma, during the Pakistan Civil War of 1971 which saw Bangladesh (until then East Pakistan) secede from Pakistan as an independent state. But the vast majority of Rohingyas are descendants of people who have lived in the area for at least 600 years, more than 300 years before the region's incorporation into the pre-colonial Burmese Empire. Others are descendants of laborers brought to then colonial Burma by the imperial British.

Under international law, Myanmar is their home. Having lost citizenship, they are now a stateless – and persecuted – people. Alienated from the Republic of the Union of Myanmar, embittered Rohingyas have been gravitating towards radical Islamism since the mid-1990s. Around 1994, and again in 2000, a small number of them met other Southeast Asian Muslims under the auspices of what became known as Jemaah Islamiyah.

48 *Ethnicity and nation-building*

Some Rohingyas were taken to sympathetic Muslim states and given military training. The rise of ARSA and its subsequent attacks against Myanmar were, therefore, predictable. Perhaps the only surprise is that it has taken so long for more radicalised Rohingyas to fight back. The problem was, ARSA's attacks lent legitimacy to Myanmar's narrative of them not being 'Burmese', leaving aside that the country already had several other unresolved ethnic insurgencies and no other group's members were proscribed in this way. Because of its radical Islamist associations, ARSA also risked being listed as a terrorist organisation.

With Bangladesh closing its border to fleeing Rohingyas, and the military and ethnic Burmans in Rakhine stepping up their attacks against Rohingya civilians, their predicament looks as though it will get worse before – and one is forced to add *if* – it gets better. In a rational world, this situation is one where the UN Security Council would step in. The problem is that China, which has a veto power on the council, is the country that remains closest to Myanmar and its government.

Myanmar's Rohingyas hold the dubious title of 'most persecuted people in the world' (see *The Economist* 2015). Over time, that has consistently been the case. It does not appear likely to lose the title in the foreseeable future.

Conclusion

This chapter has considered how fixed and often arbitrary borders often unite distinct language groups into a single state, which has sometimes inhibited the development of 'organic' ethno-nationalist sentiment. Where such a sentiment has now arisen as a consequence of geo-cultural association, states have in some instances nurtured a sense of 'nationalism' by promoting a common language and developing a particular understanding of a shared history (however manufactured that may be).

Such a project is more likely to be successful where states strive to treat their citizens equally under the consistent and fair rule of law. Where the spirit of equity and law to guarantee it are absent, or where the state is repressive, the nationalist project is likely to elicit resistance, leading in some cases to claims for a separate state (or states).

States lacking a cohesive political identity tend to have less successful politics. This often reflects faulty political processes in the first place, a factor militating strongly against national cohesion. These states generally have a higher incidence of military involvement in civilian affairs, devote above-average quantities of their resources to security issues and are rarely seen as desirable sites for investment, which often limits their potential for economic development.

Thus a vicious cycle is established, whereby a lack of cohesion becomes self-perpetuating. This, in turn, begins to define the political character of the state. None of these phenomena is an absolute but the strong correlation among them in countries with authoritarian or unstable governments is inescapable. Whether a state becomes authoritarian, or is able to preserve or achieve democratic outcomes, is the focus of Chapter 4.

Note

1 Liberia was founded as a colony for freed American slaves, so while not under a colonial power may still be considered to have been a colonial territory.

4 Authority and democracy

Most developing countries have a relatively low level of state capacity and, indeed, low levels of state capacity may be understood as a marker of development status. It has been argued that state capacity along with state autonomy – independence from self-serving political actors or state capture – have been essential for the developmental state to take decisions in the interests of the whole state and its people rather than being captive to particular interest groups (see Evans 1995, also Woo 1999, Amsden 2001 and Wade 2003).

Often coming from low levels of post-independence education, technical capacity and financial resources, newly independent states have frequently struggled to meet popular expectations. This is especially so when state capacity may actually reflect a decline in capacity in the immediate and sometimes longer term in the post-independence period. This is set against the routine rhetoric of independence that colonialism is the source of all problems, that expropriated wealth will be more widely shared and that there will be other benefits, often usually unspecified but highly anticipated. The failure or inability of newly independent developing countries to deliver on expectations can lead to high levels of disappointment, alienation and protest.

Further, as previously noted, developing states may not resonate with their citizens due to failures of inclusion, equity or rule of law, and hence not establish the legitimacy of their administration. This then raises doubts, and potential challenges, over state authority.

Such challenges are, within the legitimacy of a state framework, often represented by civil society groups, which may act as an alternative opposition or catalyst for potential political change. But states – in particular those with low levels of institutional capacity – may regard an active civil society as not a legitimate form of socio-political expression or the sign of a 'loyal opposition' but as a dangerous challenge to their authority. This can especially be so where, following a successful independence movement or regime change, the regime in question has defined itself as the 'legitimate' representative of the people. So constituted, challenges to its authority are 'illegitimate' and hence intolerable.

In conventional terms, the state can be said to be an internationally recognised sovereign territory able to enter into relations with other states, internally defined by having a population (defined as 'citizens') and institutional functions, including a government (see Montevideo Convention 1933:Article 1). A further defining characteristic, says Weber, is that the state has, or normatively claims to have, a monopoly on the legitimate use of force or 'violence' (1948:1). In this sense, 'violence' means the power of the state alone to enforce, or assign the enforcement of, laws as well as maintain a military force. In the same passage on state power, he writes, 'The right to use physical force is ascribed to other institutions or to individuals only to the extent to which the state permits it'.

50 *Authority and democracy*

This issue is particularly important in developing countries where there is weak rule of law or where the way the state 'permits' the use of violence can be delegated to non-state groups. Examples of this form of authorising violence include: the anti-drugs crackdown in the Philippines under President Rodrigo Duterte and the use of private armies by regional officials in the Philippines (particularly in Mindanao); Indonesia's use of civilian militias loosely organised under local military command (thus deflecting accountability for illegitimate army violence as in Timor-Leste's 1999 ballot for independence); Iraq's civil war (notably Shia militias' actions in support of the central government); the pro-government Janjaweed in the Darfur region of western Sudan and eastern Chad; the 'National Defence Force' which acts as an auxiliary to the Syrian army; and a plethora of paramilitaries throughout Latin America.

In each case, adherence to rule of law by these groups has been lax by the often already casual legal standards of the state. In many cases, such militias employ tactics and methods that the state could not legitimately adopt in pursuit of its political goals.

Within this definition, states can be internally organised (including as a unitary model, which is highly centralised) or follow a federated or confederated model, in which the state incorporates a number of sub-states or quasi-autonomous provinces or regions. The extent to which a developing country is centralised may reflect its ability to marshal limited resources in the most efficient manner, or may be a mechanism to restrict or control restive regional populations.

Within this framework, states may be politically organised via any of several forms of government, such as a republic, constitutional monarchy or pure (absolute) monarchy. While the type of political system employed within a state may change over time, the state itself generally does not, or such change is not contingent upon its political system. In developing countries, as their economies transition (or don't) from an agricultural basis, systems of government may also transition. Like the economies with which they are associated, such political systems may be hybridised, reflecting elements of (usually non-standardised) traditional political and legal methods as well as more 'rational-legal' (Weber again) models of political organisation.

Similarly, on the question of a state's purpose, views differ. Some contend it must first and foremost represent its citizens' interests, whether they be those of an elite or an oligarchy, and whether or not it is essentially plural (usually democratic and liberal) or singular (non-democratic, authoritarian or totalitarian) in character. Developing countries run the gamut of political types, but have historically tended to default to more centralised and authoritarian models as a means of maximising cohesion in what might otherwise be a relatively disorganised socio-political context. But, again, the character and purpose of the state do not go to the question of its territorial organisation.

If a defining feature of the state is its institutions, then the state bureaucracy is arguably at the centre of such institutions. The bureaucracy administers the government's program, and both state functions and policies are carried out by it. Bureaucracies are necessarily focused on process, slowing output to the extent that sometimes they hinder, rather than facilitate, the functions of government. This is especially so where governance is fairly weak, capacities are limited and inertia is less risky than action.

At one level this can be said to apply to all bureaucracies, indeed to be in their nature. Yet bureaucracies in developed countries, while inconsistent, tend to be relatively efficient at implementing government programs. In some other countries – especially where corruption or nepotism is a factor (e.g. Andvig 2008; Dimant 2014; Forson et al. 2016) – they tend to be slow, extremely inefficient and, in many cases, inept (e.g. Ekpo 1979; Brautigam and Knack 2004).

As Herbst noted in relation to African states:

> There is no better measure of a state's reach than its ability to collect taxes. If a state does not control a territory, it certainly will not be able to collect taxes in a sustained and efficient manner. At the same time, a widely distributed tax base helps guarantee consolidation of the state by generating a robust revenue stream.
>
> 2014:113

Generally (though not exclusively), developed countries reap a significantly higher proportion of tax as a percentage of GDP than developing countries, with the gap usually being quite marked. This reflects the state's revenue-collecting capacity as well as the state-building and maintenance purposes to which tax is put. Interestingly, a high correlation is reported between tax measured as a percentage of GDP, judicial efficacy and government integrity (as well as measures of economic 'freedom') (Miller and Kim 2017).

Legitimacy

The structure and organisation of the state raise the question of its legitimacy. Legitimacy can mean the extent to which a state includes its citizens in decision-making, or to which there is a reciprocal relationship between the citizens and the state, the relative equality of its representation and whether dissenting groups regard it as legitimate, together with the potential consequences of such a disposition.

Anti-colonial rhetoric has routinely included appeals to 'freedom' and 'democracy'. In practice, 'freedom' and 'democracy' have often been limited, or become limited. As early as 1957 Memmi noted that the relationship between coloniser and colonised was symbiotic and that, as a result, post-colonial regimes often reflected authoritarian colonial practices. 'Once violence is used, it is used again. Even the idea of an opposition – internal or external – is a difficult concept for many' (Gumede 2007; see also Fanon 2005 [1961]:Chs 2, 3).

Material benefit has in most cases been restricted and rarely equated to what was originally promised – or unrealistically expected. Wars for independence are destructive, colonial investment and skills usually desert the former colony and the incoming administration often has little if any practice at running a state. Rather than independence delivering economic benefits, the more common sequel is economic decline.

In sub-Saharan Africa, whoever controlled the capital of a given country tended to be regarded as the legitimate government, at least for the purposes of external recognition. This runs contrary to the 'Tobar Doctrine', under which international recognition should be withheld from governments that come to power through regicide, rebellion or a *coup d'état*. This 'doctrine' was first enunciated by Ecuador's former foreign minister Carlos Tobar in 1907. Despite its adoption in two treaties intended, under international pressure, to limit revolutionary and coup-instigated political instability in Latin America, it was widely viewed within that extensive region as inviting external interference in sovereign affairs and, hence, not widely adopted (Stansifer 1967). The 'doctrine' was largely inspired by Ecuador's own political instability and quick succession of governments throughout the 19th century, culminating in a liberal revolution and government of which Tobar was, briefly, a representative. Within two decades of the Tobar proposal being advanced, Ecuador had undergone another military coup.

52 *Authority and democracy*

In Africa, harking back to pre-colonial governance, authority resided in the centre, with the periphery often quasi-independent and not deemed worth fighting over.

> When the early post-independence leaders began to be overthrown by their militaries in the 1960s, the assignment of sovereign authority to those who controlled the capital was an easy rule to guide diplomatic recognition in what could often be murky situations of competing leadership claims ... African leaders still countenance extraordinary violations of human rights and poor governance in the name of sovereignty.
>
> Herbst 2014:xxi–xxii

Just as colonialism was a capital-centric enterprise, so successor states exercised little control over rural areas. 'As a result, nationalist politics in the 1950s and 1960s were very much urban affairs' (Herbst 2014:17).

Post-independence, many sub-Saharan states exhibited signs of instability, with a number of post-colonial governments either changing systems to limit political competition or being overthrown by military coups which in turn limited political competition. Indeed, sub-Saharan Africa has proved the world's most coup-prone region, with eighty successful military coups (101 failed coups) since 1956. Most of these were in the equatorial or northern equatorial region. The number of coups started to fall in the 1990s and plummeted in the 2000s. Some states also faced insurgencies, which over time became a more destabilising phenomenon.

Latin America's reputation for government instability began in the 19th century, but the 20th proved no better. Between 1907 and 1966, Latin America experienced 105 military coups, with an upsurge in the 1970s preceding a decline over the past four decades.

There is no single reason why coups happen or predictor of their likelihood. But certain factors make some countries more prone to them than others, perhaps key among them being a prior history of having coups as a means of changing government (Belkin and Schofer 2003). Some key factors that have recurred over time include the size, political role and grievances of the army; the size, character and success (or, rather, failure) of the economy; the strength or weakness of civil society; and external factors such as regional 'contagion', (unsuccessful) wars and external provocation. The decline in the number of coups can broadly be attributed to wider acceptance (or imposition) of a rules-based system of national and international governance (Frantz and Stein 2017).

State institutions

Institutions, as they have traditionally been understood (for example by Fukuyama 2004), tend to develop a quasi-independent capacity and sense of self. In government, the exercise of power strengthens a sense of institutional relevance and capacity along with the self-regard of those individuals who hold power.

Merely by dint of their existence, the self-maintenance (and expansion) of institutions may take precedence over the function they were initially designed to undertake, especially where there are low levels of capacity, oversight or accountability. This is particularly the case for bureaucracies (Weber 1948:338–341). The key yardstick for bureaucratic accomplishment is a suite of performance assessment criteria set against 'stakeholder' interest – stakeholders being the main parties concerned in the implementation of policy. But that yardstick can easily become overshadowed, and policy implementation stifled, by the self-referential character of many bureaucracies.

While institutional self-affirmation can account for bloated and slow-moving bureaucracies, it can also account for the political role of organisations such as the military, police or intelligence agencies, each of which tends to be more politically active in developing countries. Having established a reputation for comparative organisational efficiency, with the sole legal capacity to employ violence on behalf of the state, these institutions often come to develop a 'culture' or world view which explains and rationalises not just their continuing role but the orientation of such a role (for example, as reflected in the myth of the post-revolutionary 'people's army', public order etc.). Economic benefits in employment and promotion, quasi-official business and corruption that can accrue to institutional employees may discourage them from adapting to changed circumstances. As a result, these institutions often develop into a considerable force for reaction.

The role of institutions has been identified by the World Bank, among others, as central to the fate of development projects, particularly in their more bureaucratic sense. In other words, the capacity of states to use aid, deliver its benefits and sustain development is seen by the World Bank, and many others, to vest in the institutions of state. This thesis was first developed by Huntington (1968) and later addressed by Fukuyama (2004). Good governance is an IMF second-generation conditionality, typified by proper decision-making processes, accountability, transparency, probity, property rights and legal frameworks that are both just and stable ('Commission for Africa Report: Our Common Interest' 2005:28–35).

After his earlier foray into determinist normative claims of the inevitability of democracy and free-market capitalism in developing countries, Fukuyama appeared to recognise that liberal-democratic capitalist outcomes in developing societies were not a given. Responding to his own country's assertion of military power, the post-millennial Fukuyama recognised two sets of closely related problems. The first was that the United States had intervened in the affairs of other states (most notably Panama, Lebanon, Somalia, Afghanistan and Iraq) with the explicit intention of ending undemocratic regimes and in most cases, at least rhetorically, ending support for terrorist organisations and those countries' related military capacities (for example, 'weapons of mass destruction'). Local populations did not automatically see the benefits of a 'democratic' system of government when it appeared to be imposed and represented an alien ideology. More to the point, it was difficult to establish a democratic framework in states that did not enjoy the range of institutions that allow democracy to exist, much less flourish. The lack of such institutions was in most cases responsible for a degeneration of states to the point where they were permitted, or were powerless to prevent, the existence of terrorist organisations.

Secondly, it was a failure of state institutions more generally that provided fertile ground for the establishment of organisations that might be seen as antithetical to political development, e.g. the Taliban in Afghanistan, or the Islamic Courts Union in Somalia. Beyond this, the lack of capacity or performance of state institutions was increasingly seen as a key reason why such states remained mired in under-development. This shift to a focus on state institutions began in entities such as the World Bank after the collapse of the Soviet Union, which cemented the shift from communitarian-bureaucratic systems of government (code for 'communism') towards free-market liberal democracy across eastern Europe. The initial impediment in these regime transitions was a lack of institutional capacity. This was mirrored in parallel transitions from authoritarian forms of government towards more open and, for a while at least, increasingly democratic forms in developing countries such as the Philippines, Thailand, Indonesia, Argentina, Nicaragua and Chile. Yet not all countries simply accepted a conventional democratic model and indeed some of them, or their leaders, sought to explain and legitimise their undemocratic rule by appealing to a competing set of values.

54 *Authority and democracy*

The state and democratisation

Even before the unravelling of state socialism, Stepan – reflecting on the relationship between state and society with reference to degrees of freedom – noted the putative if changing focus of the state from economic to political development:

> The assumptions of modernization theory that liberal democratic regimes would be inexorably produced by the process of industrialization was replaced by a new pre-occupation with the ways in which the state apparatus might become a central instrument for both the repression of subordinate classes and the reorientation of the process of industrial development.
>
> Stepan 1985:317

Development of what have been called 'bureaucratic authoritarian regimes' – associated with, if not necessarily responsible for, economic development (seen as industrialisation) in a number of developing states ('developmental states') – has also fragmented and inhibited potential political opposition. This raises the question of type of authoritarian models; while they all share common characteristics of relative closure of political space and intolerance of dissent, their typologies and how they manifest in the daily lives of their citizens can vary considerably.

Absolute monarchies, in which an individual inherits single rule, have become increasingly rare, although still persist, if with an occasional nod towards some degree of wider consultation or legal constraint. Dictatorships, in which an individual is granted or (more commonly) seizes absolute power, are also less common, given that most political leaders identified as such rely on a committee process which in turn implies a mechanism for selecting the committee (if often in a top-down manner).

Authoritarian models may also exist where a state allows a degree of political competition, for examples within closed elites or between oligarchs, but elections do not meet the general criteria for being free, fair and inclusive, civil and political rights are circumscribed and extra-governmental forces such as the military or the clergy wield considerable authority or the power of veto over state affairs (see Levitsky and Way 2002:53–54). The regularising of such models through the implementation of state institutions in turn raises the idea of bureaucratic authoritarianism, which in turn can be divided between 'hard' and 'soft' models, generally related either to the extent of state capacity or the state's recognition of rule of law or other constraints.

Where authoritarian (or totalitarian) states are institutionally weak, they may employ exemplary violence, or 'terrorism', in place of bureaucratic imposition. One of the foremost examples of institutional or bureaucratic weakness resulting in exemplary violence was in the genocidal period under the regime of the Communist Party of Kampuchea, better known as Cambodia's Khmer Rouge (KR, 1975–1979). The Khmer Rouge's ideology was based on the goal of agricultural self-sufficiency, which meant that cities and large towns were emptied of their residents who were then forced to work on collective farms. However, this agricultural focus well fitted the KR's lack of bureaucratic and technocratic capacity and uneducated rural background of most KR cadres.

As the KR progressed, it murdered not just regime opponents but anyone thought to have a technocratic or creative skill or higher education, in the end killing or causing the deaths of between 1.5 and 3 million people, or around a quarter of Cambodia's then population. For a regime that could not, or had little interest in, transition to a more regularised bureaucratic state, it was remarkably adept at institutionalising and bureaucratising

death, with a standardised use of murder as a method of compliance and extensive records of those kept in its prisons. The bureaucratisation of violence is, then, a particular characteristic of the most authoritarian of states. Yet lest this be understood as a particular characteristic of developing countries, colonial powers also employed the institutional and bureaucratic use of death as a means of subjugating 'native' populations. Belgium's record in what became the DRC and France's record in Indochina were but among the more pronounced in a field in which such responses were more or less standard practice. Similarly, the employment of bureaucratic violence also characterised the 'modern' states of Nazi Germany and the then Soviet Union. Many authoritarian states do not start out using such methods but can resort to them in times of political stress; others may start with institutional violence and then lessen its use as the state becomes more bureaucratised and regularised, for example Indonesia's New Order regime after the 1965–1966 massacres.

In bureaucratic authoritarian states, the ascent of formal or recognised state institutions and the non-negotiable imposition of their development programs diminish other political institutions, including both the formal pluralist institution of 'Opposition' and the capacity of civil society (Stepan 1985:317). As it does, so do attempts to delegitimise political alternatives, most notably those essential to a successful plural policy.

If there is a difference between early and more recent approaches in thinking about institutions, particularly as they apply to developing countries, it is in appreciating them as not just associations of people with particular roles, but sets of rules and codes of behavior including, for example, rule of law, notions of equality and the value assigned to tolerance, or respect, for alternative views (e.g. Hall and Taylor 1996). The key distinctions here are between formal and informal rules or codes, with greater emphasis placed on important informal rules. An illustrative example would be the opportunity to create and maintain civil society organisations playing a central role in the open political functioning of developing states.

In this context, 'civil society' is understood to mean non-state groups that act in the public sphere in relation to 'civic' issues such as 'freedoms' (of speech, association etc.) and influence public discourse or decisions about public policy. These groups can include, but are not limited to: the media, trade unions, academia, charities, foundations, private, public and voluntary associations, religious groups and social movements. The 'rules' by which such groups structure themselves are one way in which they evolve into institutions, but the fact of their existence and their shifting social and political roles have also become institutionalised. There is an expectation that in any developing country such organisations will be found, and will from time to time contribute to public debate and decision-making.

Where legitimacy implies consent to rule, it is normative, in that it reflects a social value judgment about whether or not a ruler or government has the 'right' to occupy that political position. This in turn opens up questions of moral authority. Positive legitimacy is premised on explicit agreement about the circumstances that confer legitimacy, and so it derives from a sense of justice in social and political relations: where a sense of justice prevails, the social and political circumstances may be regarded as legitimate.

The relationship between civil society and government has been proposed as an indicator of a state's democratic health, varying according to the capacities of its institutions. Stepan posits four dynamics between the state and civil society: (1) the growth of state power and diminution of civil society power, which often occurs during the closure of political space by governments in developing countries; (2) the decline of state power (as distinct from 'state capacity') and growth of civil society power – unusual in developing countries; (3) the growth of both state and civil society power – again unusual in developing countries but

56 *Authority and democracy*

sometimes conspicuous in democratic transitions; and (4) the decline of both state and civil society power (with the variant option of civil society growth outside the state), seen as characteristic of failed-state status (Stepan 1985:318).

Stepan was primarily concerned with the growth of state power in developing countries at the expense of civil society, or the imposition of bureaucratic authoritarianism with a parallel reduction in the capacity of non-state actors to challenge state power. While Stepan was focused on Latin America, this situation could also characterise 'strong states' such as China, Vietnam or pre-civil-war Syria in which an independent civil society is relatively weak. During the transition from bureaucratic authoritarianism, state power declines and civil society is augmented as the political space opens up (for example, in the interval when military domination declined in Thailand).

Civil society may also increase in its own right and so contribute to declining state power, for example as occurred during the 'Arab Spring'. Growth of both state and civil society power can be seen as either in competition or as providing a reciprocal balance. With the former, instability stemming from competition is unsustainable: either it degenerates into internal conflict, or the state or civil society withers. More positively, state power can be defined not only as bureaucratic authoritarianism (negative state power) but also as benign state capacity or an ability to resist the influence of vested interests (positive power). In such cases, where there is strong civil society and strong positive state power, the two are likely to be mutually strengthening. The Scandinavian states are perhaps the best examples of this, with other plural democracies proving the point to a lesser extent.

Where both state and civil society power declines, the state is in jeopardy of failing, or of reverting to pre-modern methods of organisation (ASC et al. 2003:4), as neither institutional segment is strong enough to compensate for the other's weakness. A power vacuum often draws external actors into the collapsed political space. This could be seen in Iraq during the insurgency against U.S. intervention from 2003, which created a power vacuum that was then used to justify its continuing, if increasingly troubled, presence. Similarly, the political space collapsed in Afghanistan before the rise of the Taliban, and in Somalia during the early 1990s. In studying the reduced autonomy of the Brazilian state in the early 1980s, Stepan noted the view of executive branch leaders that only the reduction of state autonomy relative to civil society through a process of liberalisation could rein in the state's security apparatus.

State power is usually challenged not because it is powerful *per se*, but because it employs its power in a way that is perceived as illegitimate. As the Fund for Peace notes in relation to its Fragile States Index, a state's level – or lack – of democratic engagement is its key indicator (Call 2010). There are, of course, other criteria for state failure, including loss of territorial control and an inability to engage in international relations. But central to a state's function are its ability and intent to provide public service and its legitimate authority to make public decisions. This latter aspect of legitimacy derives from broad acceptance, which in turn requires measuring to be actually known. The only (and even then not completely) reliable method of measuring legitimacy is through voting, which in turn implies that legitimacy can be measured – if not defined – by democratic process. It is this process that many developing countries have difficulty with from time to time.

Democracy defined

Arguably the most popular term in political discourse since the beginning of the second half of the 20th century, 'democracy', has been so widely used and abused that its meaning has

become all but obscured. A vexed issue when discussing democracy is whether constrained electoral processes can be considered 'democratic' and, specifically, whether 'people's democracies' (one-party states) are actually democratic in any respect.

Not only do definitions differ, there is also the claim that the idea of democracy is culturally specific, without any claim to universality, and that its employment beyond developed western states is a form of cultural imposition (Mahbubani 2008). Notwithstanding this point, there is general agreement in the theory about minimal requirements for democratic process, as well as more substantive or complete understandings of the practice (Grugel 2002).

Yet the idea of 'democracy' continues to stand as a powerful normative force, both inspiring and often encapsulating political change in favor of human freedoms. Given its normative and aspirational power, and the misuses to which the word has been put, it is critical to understand that 'democracy' means, whether there is a single definition, a group of definitions or only a sliding scale, a range of political processes some of which share features that could be described as more or less democratic.

The West justifies the 'export' of its democratic ideals, in part, as enabling good governance in order to produce and enhance material capabilities. It is generally correct to note that an accountable government will more closely subscribe to good governance principles and seek (if not always successfully) to enhance the lives of the citizens it represents. Beyond such instrumentalist purposes, though, there is also the view that democratic environment is a good in its own right. Justifications for this belief are that it offers greater general freedoms, as well as civil and political freedoms, while protecting citizens from the arbitrary actions of government or its institutions.

In the simplest terms, democracy is a political system derived from direct collective decision-making by vote – rule by the *demos* (the people), most effectively in a relatively small society. While there have been examples of collective decision-making by vote since proto-democracy was established in ancient times, modern states are almost always too large and complex to allow direct decision-making on all issues.[1] This, then, requires the election of representatives who, in principle, act on behalf of the voters, while the administration of decisions is undertaken by an executive overseeing a bureaucracy tasked with enacting them. This is a basic, if incomplete, summary of what 'democracy' means in the conventional sense of the term.

Robert Dahl coined the term 'polyarchy' to define democracy as 'rule by the many', as opposed to 'democracy' derived from the ancient Greek for 'people power', which is a minimal or partial descriptor of the term (Dahl 1989:233). Others have equated polyarchy with liberal democracy, or democracy with a range of checks and balances, freedoms and guarantees. According to O'Donnell, polyarchies have two sets of institutions that exist in tension with each other. One is highly formalised but intermittent: elections. 'The other is informal, permanent and pervasive: particularism (or clientism, broadly defined)' (O'Donnell 1996:34). By 'particularism' as an 'institution', O'Donnell means the allocation of benefits, opportunities or resources in return for political loyalty or subservience based on particular, usually personal, relationships. Particularism can exist in an uneasy tension with the formal rules and institutions of the 'full institutional package' of polyarchy (O'Donnell 1996:34), examples of which exist in many developing states where informal hierarchy, patron–client networks and 'off-line' or non-official-cum-private budgeting remain pervasive.

Dahl ascribed seven qualities to polyarchy as he conceived it (1989:221–223, see also O'Donnell 1996:37), the first four of them essential to it and prescriptively precise. The first

58 *Authority and democracy*

of the four was that a government's policy decisions must be constitutionally vested in and controlled by elected officials; second, there must be free and fair elections; third, inclusive suffrage and the right to run for office; and fourth, citizens must enjoy the right to freedom of expression, especially political expression, including the capacity to criticise officials, the government's performance, prevailing political, economic and social systems, and the dominant ideology. Further, in polyarchies citizens have the right to form autonomous associations or political parties; elections are institutionalised (with freedom of expression undiluted during electoral campaigns); and everyone has access to alternative sources of information with neither the government nor any other body monopolising such information.

Collier and Levitsky raise the problem of defining 'democracy' with what they call 'definitional gerrymandering', in which definitions become so flexible that 'a basic consistency of meaning is lost' (1996:15). This highlights the problem of 'excessive contextualisation', bringing into definitions of democracy elements that had otherwise been excluded. By contrast is the reductionist problem of defining a single ideal democratic type on the assumption that all democratic models aspire to a singular outcome and are, or should be, headed in this direction.

Given that no two democracies are exactly alike, there can be no detailed agreement as to what constitutes the ideal or final democratic form. As Collier and Levitsky note (1996:15), democracy is a specific regime type in relation to a number of other framing or 'overarching' concepts, such as 'governance', 'order', 'society', 'state' and 'system'; and each of these characteristics, along with others, influences the shape of the democracy in question.

The so-called 'third wave' of democracy (Huntington 1991) and the extent of democratic adoption since the early 1990s have inspired attempts to classify democratic types and sub-types. Some analysts postulate minimalist requirements, adding up to what has been called proceduralist democracy, which occupies the opposite end of the spectrum to maximalist, or substantive, forms of democracy. Other definitions are tantamount to a sliding scale of sorts, with democratic iterations being 'complete' or, in greater or lesser degree, 'incomplete'.

Whether one can speak of a final or maximal form of democracy takes the debate to the teleological underpinnings of particular perspectives: whether notions of democracy necessarily lead towards a particular outcome or whether defining democracy in such terms places a restrictive frame around understanding that which exists. This teleological debate falls into two camps, the first of which regards democracy as a normative quality – the 'democratic aspirational' school – and the second as inevitable – the 'democratic fatalist' school.

Aspirationalists regard the key democratic values of popular representation and accountability as key to producing good political and development outcomes for the electorate. Democracy is, therefore, a desirable goal for achieving the best balance of social harmony and social needs within a mediated and regulated competitive political environment. The liberal elements of democracy – notions of freedoms 'to' (e.g. explore, develop) and freedoms 'from' (e.g. deprivation, repression) – are also core benefits in their own right (e.g. Sen 1999a). The 'fatalist' school looks upon democracy as a teleological inevitability, the ultimate end point of human progress (Fukuyama 1992; see also Strauss 1961, Kojeve 1969:159 and Runciman 2012:3–5). Both perspectives can be regarded as optimistic, seeing a democratic outcome as either desirable or inevitable, or both. A more pessimistic – or realistic – view might be that, while democracy is or may be desirable, it is far from

inevitable and certainly not guaranteed to be permanent; that democracies can come and go depending on the prevailing political conditions and sentiments at any given time.

Part of the debate about what democracy is concerns the methods by which it is achieved. The reason for the variety of democracies, after all, is the variety of circumstances in which democratic models arise. If political change arises primarily as a result of compelling material circumstances, there may be an argument to suggest that the form a political outcome takes will reflect the circumstances that compelled it and that continue to prevail. But if political changes arise out of a shift in thinking, or a voluntary handover of political power from one regime type to another, there may be greater scope to believe in volition or choice, as distinct from circumstantial determinism, as the driver of such changes.

Some theoretical considerations

There has been considerable debate over whether economic and material parameters (structures) determine behavior or whether humans have an existential free will (agency) that can shape events. Both Marxist determinists and a large proportion of adherents to the modernist development paradigm have subscribed to the idea that structural preconditions, or sequences of events, are prerequisites for sustained democratic outcomes (Kaplan 1997). By contrast, a smaller group of liberal and existential scholars argue for an ability to shape conditions according to will. Most commonly, the debate has been more subtle, accepting of a part for each within a variable whole (see Althusser 1969, 1970 and Giddens 1984 for perspectives on the variable whole, Unger 2004:282 for a resistance-based perspective), attended by a series of qualifications phrased in terms of 'probabilities', some accompanied by statistical substantiation (Bruckner 2011).

Accepting that there are structural influences in, if not determinants of, democratic success, it is likely that democracy will be more successful and better sustained if the following conditions obtain: prior democratic experience, a cohesive national identity, a common national language, uncontested territory, acceptance of regulated conflict resolution, detachment from internal affairs by the military, a medium to high per capita GDP, a reduced gap between rich and poor and a fairly high literacy rate (Rustow 1970; Valenzuela 1990; Desch 1999). That said, the literature does recognise that material circumstances present real constraints that have to be addressed in understanding opportunities for action and prospects for options. The success of a democratic action, thus defined, may be equated with the scope for agency to create opportunities from structural preconditions.

The relevance of this to many developing countries is that they had, and continue to have, confronting material circumstances that help shape their political parameters, raising the stakes of political outcomes and potentially leading to less nuanced political methods. Even in the presence of sincere democratic intent, material conditions may be poor and unpromising for most citizens. This can be allied to a fragile social psychology born of violence and an acculturation to authoritarian responses, features inimical to open and plural politics.

Procedural and substantive democracy

There are, in theory, over 500 types of democracy (Collier and Levitsky 1996), many more than the number of governments in the world, democratic or otherwise. Within these definitional criteria there are basic dichotomies between political models – presidential as

60 *Authority and democracy*

opposed to parliamentary models, centralised versus federal and so on. These are not democratic criteria as such, but rather different types of democracy, each of which has systemic advantages and disadvantages. The main distinctions between democratic types are around the ways and extent to which they meet some or all of the conventional democratic criteria. Each occupies the opposite end of a minimalist–maximalist, or proceduralist–substantive spectrum.

A procedural democracy is understood to be one that holds reasonably regular elections that are more or less free and fair. It has state institutions capable of instituting government policies that are accountable and under government control, boasts a strong and active civil society and applies the law equally and consistently. Democratic process under a government of this type operates without meaningful challengers (Collier and Levitsky 1996:10).

Despite the case made by Collier and Levitsky for acknowledging 'diminished sub-types of democracy' (1996:22–25), it could also be argued that there is a democratic 'cut-off point', beneath which the form of government is not actually 'democracy' but one that shares some democratic attributes, or may even be a blend of 'hybrid democratic-authoritarian' regimes.

For the purpose of the exercise, this work adopts an 'expanded procedural minimal' model as the democratic cut-off point and thus defines what democracy is in a minimal, but formal, sense. An 'expanded procedural minimal' definition of democracy includes ('reasonably') competitive elections devoid of ('massive') fraud, with universal ('broad') suffrage (Schumpeter 1947; Vanhanen 1990; Fukuyama 1992; Chee 1993), basic civil liberties such as freedom of speech, assembly and association (O'Donnell and Schmitter 1986; Diamond, Linz and Lipset 1989; Di Palma 1990) and an elected government with effective power to govern, a.k.a. institutional capacity (Schmitter and Karl 1991).

O'Donnell also notes that in a democracy elected authorities should not be subject to severe constraints, vetoes or exclusion from certain policy domains by unelected actors, especially the armed forces, which have a long history of activism and intervention, including coups, throughout developing countries, particularly between the 1960s and 1980s. O'Donnell expands upon Dahl's requirement for free and fair elections, adding a generalised expectation (1996:36–37) that such elections and surrounding freedoms will continue into an indefinite future.

Dahl's and O'Donnell's interpretations of democracy can be balanced against the preoccupations of Lijphart, who identified what he saw as a dichotomy in democratic institutions that favored singular rather than plural models (Lijphart 1999:32–34). The first pair identified by Lijphart is headed 'executive-party dichotomy', in which executive power is concentrated in single-party-majority Cabinets as opposed to power-sharing in multi-party coalitions.

Lijphart also identified a common tendency to equate democracy with executive–legislative relationships in which the executive is dominant, as opposed to an executive–legislative balance of power. This takes the debate some way towards another democratic assumption, that power in a democracy should be divided among the executive, the legislature and the judiciary (*trias politica*). This then leads Lijphart to note the common favoring of two-party as opposed to multi-party political systems. Observing that majoritarian democracies are often the product of disproportional electoral systems, Lijphart equates proportional representation – which encourages smaller parties and hence coalitions – with more democratic processes and outcomes. Few developing countries score well against this criterion.

Sartori (1987:182–185) distinguishes between 'contraries' (between which intermediate positions may exist) and 'contradictories' (where the only choices are binary); or, put

Authority and democracy 61

another way, the choices in the latter case are mutually and exhaustively exclusive (Collier and Adcock 1999:543). To illustrate: a political system such as Indonesia's elects a president as its head of state, and he or she appoints ministers. The executive president and responsible ministry function separately from the legislature. An Indonesian-style system may be regarded as 'contrary' to a system such as that of Timor-Leste which elects a legislature and that body chooses from among its members a prime minister as the chief executive, with ministers being chosen by either the prime minister or a caucus. These political systems, while contrary, are not 'exhaustively exclusive', not least because the Indonesian system places legislative restrictions around the president's executive powers while the system in Timor-Leste not only limits its elected president's powers but prescribes in advance of elections that the head of the most popular party or coalition of parties will become prime minister. In Sartori's terms, a contradictory political system might be one that either disallows elections or allows them only where, through intimidation or coercion, the result is known beforehand, such as Indonesia under the New Order.

Within the family of governments, it is quite possible for the genus of democracy and nondemocracy to have a number of species and, indeed, sub-species. It may not be possible to say whether a presidential democracy is better or more democratic than a parliamentary democracy, as each has strengths and weaknesses. So these 'species' categories exist along parallel lines and are not graded relative to each other. Such a grading might exist in relation to how compromised the ideal form is in any real-world instance. For example, if free expression or the free flow of information is said to be a quality necessary for a properly functioning democracy, then limitations upon such free flow of communication could, all other things being equal, represent a democratic grading. A democracy may enjoy a generally free flow of information, or place no restrictions upon it, but if the means of communication are held by a monopoly this might be seen to constitute a democratic reservation. Similarly, if a democratic state opts for tighter rather than more liberal defamation laws, such as removing the public-interest defence, this could also be seen as a qualification of its democratic status. So, a democracy with a monopoly or near monopoly over the free flow of information, and with more rather than less restrictive defamation laws, might be graded below a democracy that was otherwise equal but had more widely distributed sources of information and less restrictive defamation laws.

Similarly, the extent to which a professed democracy balances the formation and entrenchment of elites with the *demos* may determine whether it is deemed a species or sub-species of democracy or – if elite control is unrestricted and self-referential – as a different genus of the government family. Thus, while there will always be exceptions to absolutes, a dichotomy between what is and is not a democracy can be fairly clearly discerned. Given that the literature on democracy has wrangled over this issue without achieving much clarity (see the summary in Collier and Adcock 1999:546–561), understanding what is and what is not a democracy, and how and why, is central to understanding what it is that is being consolidated.

Collier and Adcock's critique of Przeworski and those similarly aligned arrives at the point (1999:549) where they ask why a regime that has elections for a rotational presidency but not for a legislature is 'not at least partially democratic'. Yet they do not attempt to answer their own question, the answer being that competitive presidential elections are a necessary criterion for democracy but not a sufficient one. Setting aside the fact that the presidency may have limited powers as in a semi-presidential system, or primarily a ceremonial role as in a parliamentary republic, for the state to have its laws made by a body that is not representative is inherently undemocratic – ergo, it is a different genus of government. Assuming that the presidency does otherwise enjoy full executive powers, the capacity to execute those powers would in principle be severely curtailed by legislative fiat.

62 *Authority and democracy*

Such a system would appear to be on course to self-negation but, if it did survive, would do so as a political 'mule', perhaps capable of some political action but not classifiable as a political horse or even, perhaps, a donkey.

To this end, Alvarez et al. (see also Schmitter and Karl 1991:75–88) note that

> it is one thing to argue that some democracies are more democratic than others and another to argue that democracy is a continuous feature over all regimes, that is, that one can distinguish the degree of democracy for any pair of regimes.
>
> 1996:21;

In arguing against a single definition of democracy and hence a dichotomy between democracy and non-democracy, Collier and Adcock are concerned to establish the validity or otherwise of an idea and how such ideas are used in exploring specific research questions with reference to a 'well-bounded "event" and the conceptual requirements to analysing sub-types of democracy' (Collier and Adcock 1999:540). In this, 'well-bounded' is taken to mean a specific event bounded by particular rules or circumstances. By taking a 'scientific' tack they train a lens on how government is done as opposed to how it is said to be done or should be done. This has particular relevance to developing countries that hold elections, even if the outcome is known in advance. It may also have implications for transitional developing countries that have moved away from authoritarianism and are in a mood of 'democratic self-congratulation' which may obscure democratic deficits.

Perhaps what is required is either a singular (if encompassing) definition of 'democracy' or, more usefully, a series of regime descriptors that spurn the word 'democracy', with or without additional descriptors or qualifications. Only then might the debate arrive at some minimalist definitions of democracy to which everyone can subscribe. O'Donnell and Schmitter claim that, to identify normative benchmarks for democracy, they needed to settle on a proceduralist minimum (O'Donnell and Schmitter 1986:8).

One of the qualifications, or 'adjectives', that might reasonably apply to a common acceptation of democracy is that its existence will not be fleeting, even if it is not yet consolidated. Certain conditions or guarantees would appear imperative to ensure the basic criterion of reasonably competitive elections devoid of massive fraud, based on a broad franchise. Minimally, any democracy ought to make available to its constituents basic civil liberties, including freedom of speech and other forms of communication, assembly and association. Yet these qualities alone are insufficient if they do not also include other political and civil rights, particularly the 'negative' rights 'from', including arbitrary arrest, detention and torture, or other forms of political violence or intimidation. There also needs to be a set of consistently applied laws and institutions available to ensure their maintenance. This, then, starts to look like a well-developed Lockean interpretation of democracy and to imply, indeed guarantee, vital elements of its liberal form (Locke 2010:Ch. 9).

Conclusion

The assumption that democratisation was contingent upon economic development (the 'full bellies thesis') was undermined by many post-colonial states having neither 'rice' nor 'rights'. The assumption of structural determinism bracing economic development to democratisation has since been contradicted by economically successful Singapore failing to democratise while Indonesia and the Philippines both returned to democratisation despite being in the depths of economic crisis. As Sen (1999b) has noted, there is no necessary link

between political forms and economic development (see also Przeworski 1995; Barro 1996; Przeworski et al. 2000).

Notions of democracy have in all cases been subservient to the state and its claimed needs (including in developed countries). Where a developing country has been more or less economically successful, it has been relatively easy for governments presiding over economic prosperity to tie this achievement to a specific 'cultural' heritage.

Singapore claimed 'Asian values' and then 'Confucian values' as the basis of its economic development. Some other countries simply made such claims without attendant economic success. The logic of such claims was that the claimant government's political style reflected cultural values that did not accord with western ideals of plural democracy, civil and political rights. But states could assert a 'national' pride based on economic success that countered cultural ignominy, an unwanted product of colonial imposition.

Thus an exceptionalist claim designed to foster national unity became detached from the degree of economic progress made by the nation in question and began to be used to assert the legitimacy of an often authoritarian political model. Indeed, for many post-colonial one-party states, rejecting plural democracy and civil and political rights became an additional means of asserting a non-colonial state identity. For them, the common claim of economic efficiency took precedence over civil and political rights. If the 'luxury' of those rights was to be granted, or returned, it would only be once economic success was entrenched.

Through this lens, state unity was a prerequisite for political stability, espoused as a prerequisite for economic 'success'. Weak developing-country states have tended to become anarchic, while 'strong' states have tended to be authoritarian. Where states were competent, with civil and political rights equitably respected under the consistent rule of law, economic success tended to follow; where they were not, such success was much less common. But where states have been competent and respected civil and political rights under the consistent rule of law, they have also tended to be democratic (as defined). So, too, where states are incompetent, without civil and political rights and having an inconsistent rule of law, they are invariably undemocratic and despotic.

Althusser and Giddens have reflected on the interrelation between structure and agency somewhat differently, observing that democratic developing-country states tended to be happier places than undemocratic ones. That, alone, they argued, was evidence of the normative value of 'democracy'. Sen took a slightly different approach, arguing that famine does not occur in functioning democracies because governments are accountable and hence work to ensure their causes are addressed (Sen 1999b:16). While exceptions to this claim can be found, not only does the claim broadly hold true, but its inverse also tends to hold. And that is, where there is a lack of political accountability there is also a tendency for a people to exist in more precarious circumstances. This also holds for the lack of accountability of global trading systems which, to the extent they are regulated, are so primarily to ensure their smooth functioning rather than for public well-being. This, then, is to where Chapter 5 takes us.

Note

1 The exception to this is the relatively infrequent use of referenda or plebiscites, although there is greater scope for general participation in direct voting through the use of electronic voting systems.

5 Poverty and the political economy of development

Poverty is an inherently political subject. Not only does it define the extent to which one has opportunity or access to material resources, it also defines relative power status. The poor are invariably the disempowered; they are the least able to alter their circumstances. Where they try to do so, they invariably confront the resistance of vested interests, employed in a range of subtle and often unsubtle ways. If poverty is about power, then it goes to the very heart of politics.

Broadening out from simple – but critically important – poverty, developing countries have traditionally been defined by their poor economic indicators. Finessing this, they have since been divided into least developed, less developed and developing countries, and finally those more than 100 countries that have risen to global per capita middle income, some of which now have overlap with OECD status (e.g. Brazil and Mexico). While these countries reflect a range of political styles, only some could be described as substantively democratic: the others operate limited democracies or authoritarian political systems.

Regardless of these political types, a large proportion of the world's population continues to live in poverty. How many people are living in poverty depends on how the term is defined. For some, poverty means living on $US1 a day or less while for others that would constitute extreme poverty, with a 'poverty line' set at $US2 or $US2.50. Such a measurement also needs to include the cost of living in a particular country; what goods and services might be supplied freely or subsidised by a central government (and access to those goods and services); and, not least, how income is distributed within that country. The World Bank's multi-dimensional assessment also includes access to education, health care, housing, employment, personal security and so on, as well as income (World Bank 2016a:38–44). Including these factors more than doubles the world's poverty rate, to 1.6 billion people (World Bank 2016a:40).

In 2016 the World Bank updated its monetary standard for extreme poverty, measuring it at or below $US1.90 per person per day, with even this being a composite figure based on perceived poverty levels in a particular group of countries. Moderate poverty was measured on an income of $3.10. There are a number of measurements of poverty, one of which is the relative level of poverty – poverty as a distribution of income within a society – and absolute poverty, which is an assumed amount below which a person would be unable to meet the basic daily needs, sometimes measured in calorific intake of between 2,000 and 2,500 calories a day. An early (1996) study showed that the poorest people only consumed about 1,400 calories per day (Deaton and Subramanian 1996). This is, however, an inadequate measurement, given it does not speak to the variety of food sources required to remain healthy, which are usually limited, nor other basic needs such as shelter and access to health care and education, the latter two of which in particular tend to be neglected. More

Poverty and the economy of development 65

complete measurements of poverty extrapolate on some of the implications of limited income or food intake, and include infant and maternal mortality rates, life expectancy, literacy and gender inequality and insecure or precarious livelihoods (World Bank 2016a).

On a basis of measuring poverty by income, sub-Saharan Africa remained the world's overall poorest region as it has been since at least 1990, along with Uzbekistan, South Asia (excluding Sri Lanka), Laos, Cambodia and Timor-Leste. China, Latin America and Pakistan came close behind. By 2015 the number of people living in absolute poverty worldwide stood at 700 million people, or a little under 10 per cent of the world's population of some 7.5 billion (World Bank 2016a:32).

The reduction in poverty in monetary, if not wider, terms from 37 per cent in 1990 was in large part due to the economic progress of China, with absolute poverty at an historically low 6.5 per cent. China's economic success has raised the spectre of an alternative to the dominant neo-liberal paradigm, dubbed the Beijing Consensus (discussed in Chapter 8). Also contributing to the global reduction of poverty, if less so, was India, where poverty was just above 21 per cent, although South Asia still has around a third of the world's poor (World Bank 2016a:34).

Regardless of the varied reasons for specific economic successes or failures, a number of countries – or their regimes – have identified particular political models as appropriate to their level of economic development. They have done so on the grounds that democracy is inefficient, that it permits social division (especially along ethnic lines), that it requires the consistency of economic planning which comes from a restrictive political system, that the material needs of the people take precedence over their political needs or, in some cases, competitive civilian government lacks the capacity to run a state adequately (Stockton et al. 1998; Rodrik 2016).

Thus, the legitimacy of restrictive political systems has come to be adopted by the governments of states that claim the efficacy of authoritarian political models (if they claim anything at all). In some cases, restrictive – and authoritarian – regimes are simply that, with lip-service being paid to a return to 'democracy' at some future time. Where the 'luxury' of democracy or civil and political rights is to be granted, or revived, it is often claimed that the time will be ripe for that only after the establishment of prerequisite economic success, social 'order' or something similar (e.g. Thailand's stance after its 2014 military coup).

There used to be an argument, popular in the 1970s and '80s, that the more developing countries engaged with developed countries in trade, the poorer they would become and the more dependent they would become on such trade to alleviate their growing poverty. This, then, was claimed to create a cycle in which developing countries were locked into a declining economic relationship with developed countries, elaborated upon in what became known as 'dependency theory' (discussed in Chapter 7). Though compelling at the time, this has since proved to be partly, if not completely, incorrect and, where they have become poorer in relative terms, that has often been due to factors other than simple trade matters. Conflict, political instability, poor governance, corruption, natural disaster and low levels of institutional capacity have also contributed to some countries' apparent inability to transcend a period of widespread poverty and political malaise.

Yet it is true that, while some developing countries have leapt ahead, particularly in the 21st century, many more have not, whether gauged in absolute terms or relative to increases in wealth in the (expanding) OECD. Not only has the gap between the richest and poorest grown, there has been a further concentration of wealth among economic elites in both developed and developing countries, with the richest citizens of poor countries often

66 *Poverty and the economy of development*

counted among the world's super-rich. Of the super-rich, the world's nine richest people owned more wealth than the world's poorest 4 billion, while 1 per cent of the global population has as much wealth as the remaining 99 per cent (Jacobs 2018).

As a result, per capita GDP or average incomes have become all but meaningless in understanding how poverty works relative to wealth. More important are median incomes and the proportion of the population below a (variously defined) poverty line, set by the World Bank at $US1.25 per day. Finally comes the question of the political relationship between wealth and poverty, within and between countries, and how this can be seen to be a consequence of political decisions.

The political economy of development

Between 1960 and 2015, the global economy grew from about $3,700 per capita to about $10,000 in 2010 U.S. dollar terms. But, broken down by region over the same period, the countries now in the Eurozone rose from just under $11,000 to over $38,000, while North America rose from $17,000 to $51,500. By way of contrast, East Asia and the Pacific (excluding high-income countries such as Japan) rose from $287 to $5,500 while heavily indebted poor countries rose from $612 to just $832. The least developed countries generally rose to a similar $890, if with no baseline figure (World Bank 2017a), perhaps indicating the correlation between the lowest levels of development and indebtedness.

There is no doubt that some national economies have progressed at remarkable rates over the past several decades, particularly Japan and the 'Asian Tigers' (see Vogel 1991 re the latter), and more recently China, Brazil and India (James 2008; Sorensen 2016:Chs 6, 9). These economic advances have contributed to an overall reduction in global wealth inequality, although perhaps making even more stark the situation of those countries that continue to be 'left behind'.

That some countries have developed quickly, they have done so by becoming 'factories' for the global economy and, increasingly, financial centres, while the economies of the broadly defined 'West' have diversified into services, including finance and globalised investments. This was all given a great push by the global move towards the deregulation of economies, which started in the early 1980s with the advent of the neo-liberal economic paradigm.

The problem with this grasping for greater prosperity by the West and a select group of other countries has been that vast swathes of the developing world were largely or entirely left out. Some, in particular, fared worse than others, often due to war – or creating the conditions that led to war, which in turn diminished economic opportunity – while others simply lacked access to the skills, capital or resources needed to join in the global economic party. Where a country tried or managed to 'gatecrash' its way in, this was often at a huge cost to its environment, with lost access to potable water, increased air and soil pollution and desertification. South Korea, Taiwan and China have been marked examples of the environmental costs of rapid industrialisation.

Significantly, many of the countries left out were blighted by exceptionally poor systems of governance, corruption and vast gulfs in wealth between tiny, luxury-loving elites and the overwhelming majority of the impoverished. Many were also client states for world powers, particularly until the end of the Cold War around 1991, while many others 'hosted' proxy wars or other forms of military or political intervention, which precluded transparent and accountable governance.

Greater riches, greater gap

Since World War II, which presaged decolonisation and the broadly conceived development paradigm, global wealth has increased while global distribution of that wealth became increasingly unequal. In understanding the nature of wealth, several factors arise which nuance its meaning, including: the purchasing parity power of a given unit of currency across markets; wealth distribution within states; and the reliability of data. In short, there is little or no agreement on a methodology for measuring wealth and its global distribution over time. Yet the general indicators continue to show broadly consistent trends (Nutzenadel and Speich 2011).

Between 2009 and 2017, the poorer half of the world's population accounted for 1 per cent of the total increase in global wealth. By the end of 2017, global inequality was at its most extreme in a century, with the world's wealthiest 1 per cent holding $US140 trillion, or just over half the *total* wealth on the planet (Credit Suisse 2017).

More positively, global poverty declined between 2000 and 2005 by almost half (Inequality.org 2016). The problem is that 'poverty' is a vague measurement, in this case defined as having an income of less than $US2 per day. More positively, the number of people in the 'middle income' bracket of between $10–$20 a day also almost doubled over this time (Kersley and Koutsoukis 2016).

The world has never seen a greater accumulation of wealth, or a more extensive escape from material deprivation. The fruits of human creativity – from smartphones to stem-cell reconstructions – continue to grow. But such broad conventional norms of progress cloak how unequally its opportunities are distributed: for instance, nearly half the world's income growth between 1988 and 2011 was appropriated by the richest tenth of humanity and, even in rich countries, there is a growing life-expectancy gap between classes (Mishra 2017:324).

While those at the bottom of the global economy may have improved in absolute terms, growth remains unequally shared, with 71 per cent of the world's population sharing just 3 per cent of its wealth, while the individuals (overwhelmingly in advanced developed countries) who own 84.6 per cent of the globe's wealth constitute only 8.1 per cent of its population. In another measurement, the bottom economic half of the world's population own less than 1 per cent of all the wealth, while the top 10 per cent own 89 per cent of global wealth assets (Kersley and Koutsoukis 2016).

Importantly, too, there are considerable regional variations in inequality, with the Middle East – where 10 per cent of the population hold 61 per cent of the region's wealth – registering the highest level of inequality. India is next, with 10 per cent holding 55 per cent of that country's wealth, the same as Brazil. Sub-Saharan Africa follows close behind, with 10 per cent of the population holding 54 per cent of the region's wealth (Alvaredo et al. 2018:5). India witnessed the greatest rise in inequality, most notably since 2010, reflecting a series of deregulatory measures put in place since the 1990s but increasingly since 2004, while other regions increased at a slower rate (Alvaredo et al. 2018:78).

To illustrate the inherently unequal character of de-restricted capitalism:

> Large rises in top-wealth shares have … been experienced in China and Russia following their transitions from communism to more capitalist economies. The top 1% wealth share doubled in both China and Russia between 1995 and 2015, from 15% to 30% and from 22% to 43%, respectively.
>
> Alvaredo et al. 2018:11

68 *Poverty and the economy of development*

The neo-liberal economic paradigm consists, in summary, of the IMF's 'structural adjustment' policy of reduced government spending, reduced taxation and reduced debt through higher debt repayment, following the developing-country 'debt crisis' which culminated in the 1970s and '80s but which continues, in less alarmist form, to the present.

As countries decolonised, they either owed debts to their former colonial masters under the terms of decolonisation or borrowed to establish basic state infrastructure that the liberation struggle had often dismantled or destroyed. Almost $60 billion was lent to countries at high interest rates (14 per cent) with little prospect of their being able to repay it. As a consequence, debt rapidly increased, often to despotic or corrupt governments that came to power as newly independent countries buckled under the competing pressures of state and nation formation (Shah 2007). In many cases, this debt was syphoned off to corrupt leaders, their cronies and complicit international business partners as 'illegitimate' debt, or what is known as 'odious debt' (Shah 2007). Such debt was improperly or illegally lent and should not, under normal legal principles, be the subject of repayment or, if it is, it should be the subject of limited or modified repayment (Howse 2007).

During the 1980s, the global debt crisis escalated as surplus investment funds were made available subsequent to the massive hike in world oil prices in the 1970s. The issue was thrown into stark relief when Mexico announced, in 1982, that it could not meet its international debt-service payments. Remedial action taken by donor countries staved off financial disaster including the spread of debt defaults. But the flow-on effects for other developing countries were much less positive, with economic uplift for many of their citizens either ceasing or being reversed (Sachs et al. 1988:233–234).

In many countries, excessive debt burdens and, in particular, 'odious debt' remained a profound intergenerational burden stifling economic development. Many developing countries often had to repay 'odious debt', for example Indonesia (to the tune of $US138 billion, 90 per cent of GDP), Argentina ($77 billion, around three-quarters of its total debt commitment) and Nicaragua where 'odious debt' ran at a level five times the country's GDP (Mandel quoted in Shah 2007).

Yet the increase in global inequality noted above has corresponded closely to the global decline of public capital (public assets minus public debts). 'This [decline in public capital] arguably limits government ability to regulate the economy, redistribute income, and mitigate rising inequality', according to Alvaredo et al. (2018:11). Exceptions to the general decline in public capital were in resource-rich (predominantly oil-rich) countries with large sovereign wealth funds, such as Norway at the upper end of the economic spectrum but also including Timor-Leste towards the lower end. The question, then, for many developing countries was how to escape the cycle of poverty, which returns to the earlier theme of states limiting political space in order to maximise focus on economic activity in a process known as 'developmentalism'.

Developmentalism

In response to developmental challenges, some countries have engaged in 'developmentalism', or state concentration on and intervention in economic direction and, sometimes, investment. This was particularly notable in the infrastructure-led economic development of Japan and the Asian Tigers, and in the 21st century was the model employed by China.

Developmentalism can be understood as focusing the state and its institutions on economic development, including state ownership of or investment in key industries where

capital investment is scarce or perceived as risk-averse. The partnership between the state and capital to promote particular industries runs contrary to the neo-liberal notion that free markets and tightly restricted government intervention promote greater economic performance (see Ding 2017 for discussion of the Chinese developmentalist model). State intervention in and support for industries was adopted, however, by the U.S. and some other developed countries in response to the Great Recession, where it was demonstrated to be an effective economic method.

While economic growth is seen as a principal reason for a 'developmentalist' approach to economic planning, it also serves a second and almost as important function, which is to create popular consensus around this economic model and thus legitimise the regimes of states that oversee such economic growth.

While this policy is unfashionable among the world's free-marketeers, it has seen the direct economic rise (including in median income terms) of a host of successful developing states and remains an active driver of economic policy in many of them, despite a push for states to divest themselves of state-owned enterprises (which in turn often profits cronies, related elites and foreign investors at the expense of local citizens). Former U.S. Secretary of State Rex Tillerson criticised as unfair China's penetration of Latin American markets by its state-owned enterprises, even though this appeared to contradict his assertion of 'unfairness' claiming that SOE-driven economies did not work (Reuters 2018).

More commonly, and under the IMF's Washington-driven structural adjustment program, developing-country governments slashed spending on public benefits including health and education, with consequences for human development indicators (HDIs) and the intellectual capital of those societies (as well as the non-economic benefits of both health and literacy). They also privatised numerous government services, in many cases reducing the quality of such services while enriching small elites and thus creating an even larger wealth gap than had previously existed. To that end, and perhaps marking an end to the Washington Consensus (discussed in Chapter 8), the IMF has since changed its focus to reducing poverty rather than debt.

The question 'Who benefits?' continues to define much economic decision-making, with a focus on issues of governance and transparency, and continues to drive much of the politics of developing countries. This is particularly the case where there remains limited political accountability.

Measuring economic inequality

Economic inequality has traditionally been measured by a Gini coefficient, which represents the spread of wealth from richest to poorest and the proportions in between. By such a measure, 1 is considered perfect inequality and 0 perfect equality. The graph of such a ratio, indicating the relative distribution of income, is called the Lorenz curve.

But, as *The Economist* has noted, inequality is much more inclusive than simple monetary income. There are three broad measures of economic inequality: inequality of income, of consumption and of wealth. *The Economist* suggests that, while income is easiest to measure, consumption is the more accurate indicator of social well-being, given it refers to how well or poorly people actually live rather than how much income they might have. Wealth is a separate indicator, given it can also include inherited income which in turn implies structural inequality at birth (*The Economist* 2014).

'More equal countries tend to have healthier people and be more economically efficient than highly unequal countries. And countries that invest smartly in reducing inequality

70 *Poverty and the economy of development*

today are likely to see more prolonged economic growth than those that don't' (Jim 2016). This in turn reflects an increase in demand due to greater spending power, thus spurring greater production to meet that demand.

While global poverty decreased between 1990 and 2013, from the region of 35 per cent to around 10 per cent, and the number of people living on $US1.90 or less per day decreased from around 56 per cent to around 24 per cent (Jim 2016:36), that $1.90 measurement still implied a very low threshold for escaping 'poverty'. Similarly, while the global poor, who numbered about 1.9 billion in 1990, were half as numerous at the end of that period, poverty in sub-Saharan Africa actually increased from around 250 million to almost 400 million by 2010, declining slightly thereafter (Jim 2016:38). The profile of a globally poor person varied, but he or she tended to be rural-based (80 per cent), work in agriculture (64 per cent), young (under 14 at 44 per cent) and poorly educated (39 per cent) (Jim 2016:42). Predominance of the global poor in rural areas reflects the shift of economic growth from agriculture to manufactures and services, as well as an overall decline in the price of commodities produced by agricultural workers relative to manufactures and especially services.

Running counter to global neo-liberal economic theory, experience has shown that reducing economic inequalities actually improves overall economic performance and 'lays the foundation for long-term growth' (Jim 2016:70), again reflecting the economic benefits of a demand-led economy. Not only does greater economic equality increase prospects for long-term growth, 'Evidence also suggests there are no inevitable trade-offs between efficiency and equity considerations' (Jim 2016:70). That is to say, economic policies that promote 'efficiencies' through, for example, wage or price reduction and, hence, capital accumulation not only further impoverish low-income people, they fail to produce the general prosperity claimed for free-market capital accumulation. At best, results of comparative data analysis of 'efficiency' dividends are 'inconclusive' (Jim 2016:70). Motivated by the ambiguous impact of inequality on growth both conceptually and empirically, a recent set of papers deconstructs overall inequality into components that may be especially harmful to growth (Jim 2016:71, see also Lavoie and Stockhammer 2013:29–34 for further discussion of this Keynesian approach to economics).

The outcomes of equality are not merely economic, but may well be political, the Arab Spring revolutions and rebellions being cases in point. More than half the respondents to a survey inquiring into the causes behind the uprisings cited a desire to improve economic conditions, fight corruption, and promote social and economic justice (Jim 2016:74, citing Arab Barometer surveys). Perceptions of wealth inequality were as important as its actuality, if not more so.

Importantly, what often goes undiscussed is that income inequality is not just a measure of the distribution of relative poverty and wealth, but also a reflection of government economic policy or, in some cases, inaction. Indeed, it could be suggested that the core business of government is regulating the economy and the distribution or accumulation of capital within it. This, in turn, reflects underlying ideological assumptions or positions, with the Left favoring greater economic distribution and the Right greater economic accumulation.

The Great Recession/Global Financial Crisis

The Great Recession, also known as the Global Financial Crisis (GFC), of 2008–2009 was a major global tightening of financial liquidity, which plunged most of the developed world

into a deep economic recession, resulting in the foreclosure of loans that many businesses – and some countries – could not pay. While the immediate impact of the GFC was over the period 2008–2010, it continued to reverberate over the ensuing decade. The GFC had major implications for the political economy of developing countries.

The effect and consequences of the GFC were very similar to those of the Asian financial crisis of a decade earlier, in which a number of countries, particularly in Southeast Asia, saw substantial capital flight, the value of their currencies collapse and extensive defaulting on loans. This economic convulsion saw massive job losses, rapidly increasing inflation and high levels of unemployment and underemployment, particularly in conventional sectors of affected economies such as manufacturing and services. Unsurprisingly, one key political consequence of the Asian financial crisis was the loss of legitimacy of some leaders, most notably Indonesia's President Suharto, who was forced to resign after three decades in power, as did Thailand's Prime Minister, Chawalit Yongchaiyut, while the Philippines' President Joseph Estrada was also effectively forced from office.

The onset of the GFC was similar if more widespread; the first was that the economies of aid-donor countries were beset by financial insecurity, an initial credit squeeze and, in most cases, reductions in government spending (later reversed so as to pump-prime economies). Unsurprisingly, with a crash in global financial markets, there was a marked reduction in global trade and related imports. Global trade reduced to about 2 per cent growth in 2008 but slumped to an historic low of minus 15 per cent the following year. While it recovered to about 10 per cent in 2010, there has been a steady decline in the growth of global trade since then, not least reflecting a slowdown of demand in high-income countries, which account for some two-thirds of all imports. While some of the slowdown was due to cyclical economic factors, much of it was ascribed to the lingering effects of the GFC (WEF 2015).

More important was the vulnerability of developing countries to external economic shocks such as the GFC. On balance, the poorer the country the less able it was to deal with exposure to a sudden slump in global trade (Essers 2013). According to the IMF (2011), while developed countries experienced a sharp downturn many developing countries were often hit especially hard. This was attributed to 'toxic' assets held by banks in those countries, a slump in demand for goods, particularly in commodities, and a slowdown in foreign direct investment (Essers 2013:63–65).

While the advent of freer global trade increased income for most developing countries, it did so unequally and usually with related caveats about employing wider neo-liberal deregulation and structural adjustment packages (SAPs). While neo-liberal economics produced many economic benefits, there were also negatives, including a reduction in government services, the privatisation of publicly owned profit centres, increased costs imposed by privatised suppliers to government and the growth of economic inequalities both within developing and developing countries and between them.

A key element of structural adjustment, claimed as a panacea for low levels of economic growth, has been foreign direct investment (FDI) and the foreign purchasing and/or ownership of local industry and deregulated state industry. FDI has the effect of increasing capital flows and investment in local industry. But it also increases foreign ownership of locally owned production, enabling the parent company to amass profits (usually offshore), and weakens state control over the development and exploitation of, most commonly, natural resources (Cockcroft and Riddell 1991; Agosin 1992; Campos and Kinoshita 2008).

The reduction in government services implied by SAP cuts to state spending; a widespread populist rejection of globalisation and its impact on incomes and working conditions;

72 *Poverty and the economy of development*

and a decrease in state sovereignty all set the stage for a moderation, if not rejection, of deregulated international trade and investment.

Combined with several factors – the rise of China's economy; an opportunistic rejection of democratic pressures in some countries; a global trend towards more populist politicians pandering to underlying social preferences or prejudices over carefully conceived policy; and a more inward-looking economic focus by developed countries – the neo-liberal paradigm was dealt a series of serious blows. While not quite dead, this paradigm was being seriously reassessed as the *only* mechanism for securing economic growth, fair distribution and political stability.

Elite formation

One of the effects of economic development or, indeed, economic modelling generally, has been that while its success rate at lifting people out of poverty may be mixed, it usually privileges economic elites regardless of other circumstances. That is, neo-liberal economic modelling privileges existing economic elites through a 'trickle-down' model of poverty alleviation, while developmentalist models tend to privilege existing political and economic elites as the conduits through which wider wealth creation is intended to flow.

Elites, somewhat unsurprisingly, tend to come from elite backgrounds: that is, being of the elite is more common if a person already has the advantages of wealth, education and elite connections. Some others are, regardless of their background, lucky or skilled enough to climb the ladder of success. Many then pull it up behind them. Thus elites – a small group of people who hold disproportionate power, wealth and influence – are formed and perpetuated. And, like most social groups, they tend to favor their own interests, or economic theories that benefit their own interests (Wade 2017:346), if in some cases as part of a social contract.

Shifts in the economic policies of developing states (and of developed states, for that matter) are almost entirely driven by elite interests and perceptions. Three interest groups are critical in economic decision-making: the decision-makers, those who influence decisions and those who benefit from the decisions (those who do not benefit rarely having a say in the process). All societies have demonstrated a tendency to establish elites, even nominally egalitarian societies. Reflecting observations by Pareto (1968) on the formation of oligarchies, together with Mosca (1939) and Michels (1959) on elite capture and control of political power, the choice of candidates for office is not made by the people but is part of the functioning of a political elite. The question 'Who benefits?' does not necessarily refer to the origins of elite members, who may be recruited from a range of backgrounds, and whose recruitment has sometimes been based on merit and sometimes on privilege. Rather, it is about the restrictive process of their selection and the limited openness of elite formation to broad inclusion or public selection.

Even accepting a basic democratic paradigm, elites tend to assert economic or political power out of proportion to that available to the 'common people'. This conforms with the libertarian notion of 'rights', in that all have an equal right to participate to the fullest extent of which they are capable, but all are equally entitled to be passive by exercising what has been referred to as 'rational ignorance' (Downs 1957) or, in a more politically sinister turn, an equal 'right' to become disempowered. In developing countries, popular access to elite formation has tended to be more restricted, given the widespread lack of opportunity for potential elite members to join on the basis of demonstrated merit arising from equal access to high-quality education.

Given the remoteness of many populations from decision-making centres and the relegation of urban masses to factory fodder or less, access to elite formation is arguably more restricted in most developing countries than in developed countries. Such restricted access implies something in the nature of a lock on the levers of political and hence economic power, the latter of which is particularly important in developing countries where political power rests on support from an ethnic or specific group and patron–client relations are pronounced.

Even developing countries that claim to be explicitly egalitarian (such as communist or socialist states) also have elites. In such societies, elites are, at least, 'first among equals' (Orwell 1946). However, as Mosca (1939), Michels (1959) and Pareto (1968) note, a default to elite rule, or oligarchy, is inherent in complex social structures. This is reflected in organisational capacity, as argued by Mosca and Michels, or in psychological capacity and self-interest (Pareto).

The hierarchical ordering of complex societies and the rationalising and routine of decision-making (Weber 1948), particularly around the allocation of tasks, potentiates the development of elites. While the oligarchical tendency can at times be overwhelming, its process and orientation can vary dramatically according to circumstances, not least with changes in technology and education as well as, in some cases, with revolution. Such changes suggest, if not guarantee, potential for an open and deliberative political society. Having started from an anarcho-syndicalist perspective, Michels' own acceptance of such an 'iron law' led him to believe in the inevitability of oligarchy and hence endorse it in its most extreme and opposite form, for example in organicist or fascist states, a formula that would proleptically apply to countries such as Indonesia under Suharto (particularly 1966–1986) and Brazil (1937–1945) as well as to Chile (1932–1938, 1973–1990). Many developing countries have also reflected elements of fascism (particularly under military governments), including strong authoritarian rule, glorifying the (often mythologised) past, a reified culture and the cult of the strong leader.

While the notion of oligarchies can be challenged, it would be naïve to conclude that the tendency towards their formation is other than a default position in social organisation. In a somewhat more nuanced and less 'scientific' approach, Mosca noted that, while elites exist, they are obliged to draw on the support of sub-elites (Mosca, 1939:410, see also Mill 1951; Pareto 1968), which in turn presents the option of elite replacement through renewal and, further, the interaction between elites (decision-makers), sub-elites (opinion leaders) and *hoi polloi* (the many). This interaction contains within it the seeds of the egalitarian principle of participation and a rudimentary social contract which, in a practical if more limited form, can act as a brake on the unaccountability of elites.

State capture

The unaccountability of elites, particularly in relation to their capacity to reap large, often state-assisted, profits, raises the question of conflicts of interest, avoidance of which is central to ensuring good governance; and of corruption, which is antithetical to good governance. One particular form of conflict of interest or corruption is 'state capture', a systemic form of political corruption in which private interests exercise considerable influence over, or effectively control, a state's decision-making processes to their own advantage.

Depending on the laws of a state, 'state capture' may not be illegal: it may reflect, or be claimed that it reflects, economic interests perceived as convergent with the state's interests, particularly where the state embarks on a program of neo-liberal privatisation. In any country

74 *Poverty and the economy of development*

with a relatively free economy, it is common for government ministers to hold discussions with major economic actors about significant investment decisions, including tax concessions or other forms government supports for such investments. The distinction might be said to be where a government can act independently in the overall interests of the state and its citizens, and where it acts principally in an investor's interests. This is notably so when the return to the state and its citizens is minimal and there are direct financial incentives or rewards for government representatives to advantage such investors.

'State capture' can involve relatively small numbers of investors, which is notable in oligarchic environments. However, 'state capture' is at its clearest when an investor is granted favorable outcomes to the exclusion of others, thus establishing a monopoly in relation to the business of government.

Examples of oligarchic control are found in developed as well as developing countries, with the United States and the United Kingdom both identified as having oligarchic power structures (Mount 2012; Gilens and Page 2014). Russia under Vladimir Putin is also widely characterised as an oligarchy, as is China in relation to the economic control exercised by descendants of its eight key revolutionary leaders (Dyden and Hedge 2012). Saudi Arabia (Raphaeli 2003) and India (Pardesi and Ganguly 2011; Rastello and Krishnan 2016) are also considered oligarchies, due in the former case to both politics and the economy being run by one extended family and, in the latter, the Nehru-Gandhi dynasty which, depending on how one identifies political power, started with Motilal Nehru becoming president of India's Congress Party in 1919 and, with three prime ministers and senior ministers and diplomats among them (*The Guardian* 2007), continues – at least in respect of the official Opposition party in Delhi and forming government in three states – at the time of writing.

Similar situations can be said to apply to certain developing states with one-party or dominant-party rule, sometimes manifest in a web of families exercising political and economic control. Latin America (and the Philippines) has a long history of oligarchic control, stemming from its 'hacienda' elites or families that have historically controlled large land holdings which have, in turn, been the source of political and later diversified economic power (Valencia 2015). Central America in particular was known for its family rule (e.g. the Somozas of Nicaragua and El Salvador's 'Fourteen Families'). The phenomenon has spread around the globe (Timor-Leste, though it gained independence only recently, already has its 'Forty Families'). Thailand's economy is intricately tied to the royal family's linchpin Crown Property Bureau, while Malaysia's Barisan Nasional (National Front) government – which in different formations ruled from 1957 until 2018 – had a 'close' relationship with the country's major business interests.

In terms of 'state capture', perhaps the most outstanding recent example is South Africa, where the Gupta family was said to exercise inordinate influence over government decision-making, particularly under President Jacob Zuma. The extent of the Guptas' control of the economy and political decision-making led to a deep split within the ruling African National Congress (ANC) and a revolt against the controversial Zuma. After a cabinet reshuffle in which nine ministers, including Finance Minister Pravin Gordhan, were sacked, South Africa's currency plunged, accentuating a slide that was already driving it to 'junk' status. This followed the sacking of Treasury staff opposed to official corruption, and their replacement by Zuma loyalists (Haden 2017).

The ministers' dismissal, compounding what was looking like a revolving door for finance ministers, followed the release in 2016 of a report entitled 'State of Capture' that was deeply critical of the Gupta family's control over the economy and the political process, and implicated President Zuma along with two other ministers. The Guptas and Zuma failed in

a judicial bid to block release of the report. Compiled by former public prosecutor Thuli Madonsela and her team of investigators, it revealed that the Gupta clan had a direct say in the hiring and firing of ministers, and that whether they were in or out was influenced by their attitude to the Guptas' business plans and willingness to take bribes to deliver particular benefits to their family enterprises. Examples included ministers' readiness to remove competition from airline routes, facilitate the takeover of a major coal mine that would give the Guptas a near monopoly over the provision of coal to the state-owned power company and do preferential deeds in the Guptas' favor when awarding government contracts and finalising other advantageous government–business arrangements (Madonsela 2016). In defending Zuma against corruption allegations (involving the forgiveness of a large debt in exchange for business outcomes in favor of former presidential adviser and businessman Schabir Shaik), his lawyers argued that notions of corruption were relative as they came from a 'Western paradigm' (Pillay 2014).

Despite his defence and what was widely viewed as the ANC's dominant-party status and traditional loyalty to the leader, Zuma was dumped as president of the ANC in December 2017, and replaced by the reformist Cyril Ramaphosa. Under intense pressure, Zuma resigned as President of South Africa two months later. Zuma's dumping from the ANC presidency, his personal corruption and consequent political damage to the party were widely cited by ANC members pressing for change at the top. Some even feared that, should Zuma have been able to cling to office, the 106-year-old ANC – Africa's oldest political party – could split (reflecting not only disenchantment with Zuma but a deep rift between pro-market and pro-state-intervention factions).

During his final years in office, Zuma was formally implicated in 'the arms deal' (formally the Strategic Defence Package), a multibillion-rand military acquisition project instituted by the South African government in 1999 that had been under question since just before Zuma ascended to the presidency in 2009. That scandal implicated several government officials in bribery and other corrupt dealings. Five years after stepping down, former South African president Thabo Mbeki maintained he was unaware of any bribes having been offered to, or taken by, his ministers (Corruption Watch 2014).

Corruption and mismanagement were far from limited to South Africa: neighboring Mozambique's economy collapsed in 2016 after it was discovered that ex-president Armando Guebuza borrowed $US2 billion over and above the country's IMF loan terms, triggering an end to all IMF loans to his country and, with falling export prices aggravating an already unmanageable debt burden, precipitating an official default that brought on widespread economic hardship and the collapse of the local currency. The $US2 billion, borrowed from Swiss and Russian banks, was used to buy military equipment. Up until this time, Mozambique's economic prospects had been looking up (Oliver 2017). The only question that remained for ordinary Mozambicans was whether the economic disaster was owing to corruption or plain incompetence.

Nor is the dominant-party framework that gives rise to corruption confined to Africa. The lack of accountability that is a concomitant to such a framework almost guarantees corruption, as it did in Malaysia. While that country's long-time opposition figure Anwar Ibrahim remained in his prison cell about 25km north-west of Kuala Lumpur, the Malaysian political wheel did not just turn, it spun into reverse: in early 2018 the person responsible for his being in jail became his political champion and, following the 2018 election result which saw the dumping of the National Front (BN) government, had Anwar released from jail.

76 *Poverty and the economy of development*

In the 1990s Anwar was being groomed as Malaysia's heir-apparent by then prime minister Mahathir Mohamad when his world came crashing down. He was imprisoned on trumped-up sodomy charges and, upon release, established a viable opposition alliance against Mahathir's successors – before being returned to prison, again on spurious sodomy charges.

Ironically, Mahathir – the person most responsible for sending Ibrahim to jail – was the lead candidate for Ibrahim's political alliance going into the 2018 election. Mahathir, then 92 and due to turn 93 in July 2018, was selected as prime ministerial candidate for the four-party opposition Pakatan Harapan (PH, Pact of Hope) alliance. This grouping represented a major challenge to the forty-five-year rule of the BN government.

Mahathir, who spent twenty-two years as prime minister until 2003, headed the United Malays National Organisation (UMNO), the key party in the BN government. UMNO itself was a Malay-first party formed as far back as 1946 and a leading force in the struggle for independence from Britain. In 2013 the BN government managed to retain political power through heavy gerrymandering of electoral seats and buying the support of smaller opposition parties, with embattled Prime Minister Najib Razak trying to take advantage of indecision in the Islam Mandate Party (PAS), which hoped to establish itself as a third force in Malaysian politics. Observers forecast that the opposition alliance would struggle to win government without PAS's support. In May 2018, however, the opposition alliance overcame the structural rigging of Malaysia's elections to overwhelmingly win government.

Anwar established the opposition's predecessor, Parti Keadilan Rakyat (PKR, or People's Justice Party), which remains central to the PH alliance, also headed by him. Anwar's wife, Wan Aziza, assumed leadership of both the PKR and the alliance after Anwar was re-imprisoned in 2014. Mahathir had become an increasingly outspoken critic of Prime Minister Najib, who was deeply implicated in the '1MDB' corruption scandal in which $US1 billion from the government's development fund ended up in his personal bank accounts and billions more went missing. In joining the opposition alliance, Mahathir noted, he was setting his face against a political organisation he had spent sixty years building.

During Anwar's original sodomy trial, Mahathir had openly proclaimed him guilty. Anwar had his conviction overturned in 2004, but his re-sentencing a decade later followed his opposition alliance winning the popular vote, but not quite a majority of seats, at the 2013 election.

Early in 2018 Mahathir performed a spectacular about-face, promising that if he was returned to the prime ministership – making him at 92 the world's oldest leader – he would seek his old deputy-turned-adversary's early release from prison and pass the mantle over to him. Anwar said from prison that he accepted Mahathir's selection as lead candidate. It may just have been that Mahathir came to realise that the unaccountable, self-serving political monster he had created was now out of control. After two decades of bitter rivalry – much of which time Anwar had spent in jail – Mahathir and he appeared to be 'getting the band back together'.

In the historic election of 9 May 2018, PA won a substantial majority in the 222-seat parliament, and Mahathir was sworn in as PM next day. Since this was the first time in the nation's sixty-one-year history that power had changed hands, there was significant political change in Malaysia, with the investigation and then charging of Najib for corruption. This was expected to be followed by an eventual redrawing of electoral boundaries and a reorganisation of the judiciary.

From the perspective of his jail cell, Anwar Ibrahim could have been excused for taking a slightly jaundiced view as he mused on the nature and pitfalls of his roller-coaster

relationship with the person who had now re-emerged from long retirement as his putative political savior. But, on Mahathir's first day in fifteen years as prime minister, the *Yang di-Pertuan Agong* or king (Malaysia boasting that scarcest of all types of government, an elective monarchy) issued a royal pardon and a week later Anwar was a free man, precipitating perhaps the most remarkable transition to power anywhere in the world since Nelson Mandela became head of state within five years of being the world's most celebrated political prisoner. In a related move, Mahathir appointed Wan Aziza as deputy prime minister.

The relationship between poverty and corruption

With state funds being redirected for unofficial purposes and investors reluctant to engage in volatile political environments, it would come as little surprise that some of the world's poorest countries are also among the most corrupt, and vice versa. The question arises whether poverty breeds corruption or corruption spawns poverty. From anecdotal experience in developing countries, it would seem that there is a symbiotic relationship between the two.

But there is no evidence for an absolute correlation, given that some countries are largely undeveloped but appear to be among the less corrupt cohort. Of the ten countries with the lowest inequality-adjusted Human Development Index score, the one that sits rock-bottom with the lowest IHDI – the Democratic Republic of the Congo – ranks as the twentieth most corrupt, followed by Chad, rated with the second lowest IHDI score, seventeenth most corrupt. One rung further up the scale, Niger is only the seventy-fifth most corrupt, although the next up, Guinea-Bissau, is eighteenth most corrupt. Sierra Leone has the next lowest IHDI score but has been adjudged only the fifty-third most corrupt while, next up, Burkina Faso, is credited with being relatively 'corruption free', just over halfway to the status of 'least corrupt' nations (meaning it remained very corrupt, but not as much as many others).

There is, however, a closer correlation between corruption and inequality, according to Transparency International (TI 2016): 'Corruption and social inequality are indeed closely related and provide a source for popular discontent'.

According to the World Bank (2016b), the world's most unequal society, in terms of income distribution, is South Africa, which with a ranking of 64 sits at the lower end of the corruption scale. Second most unequal is neighboring Namibia, ranked at 53 on the corruption perception scale. The world's third most unequal country, Haiti, is also among its most corrupt as well as having a very low IHDI score. Botswana, by contrast, has effective

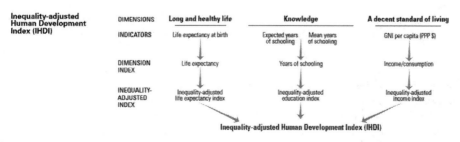

Figure 5.1 The IHDI is calibrated according to these factors
Source: UNDP 2016

IHDI	200	190	180	170	160	150	140	130	120	110	100
10											
9											
8											
								Rus			
7								Ukr,Uzb			
									Mld, Azbjn	Armna	TrnT
6					Vnz						
						Uzb		Kyg,Irn	Ecdr, DmR	VN	Gayna, Thai, Phil, Peru, Gabon
5				Irq		Tjk			Pgy, Mex		Egypt
						Camb	Nic, Bdsh	Gtm	Hon	Blv	TL
4						RCngo		Npl	Laos		
						Zim, Ug	Mdg, Kny	Nrt		Tgo,Tnza, Pak,	Niger
3				Afg, Ang, Haiti		DRC	Com	Ngra	Djb, Mlwi		
						Hti, Bur	Moz			Mali	
2		Som,SSud, NK				Com,	Guin		Sln		
		Sud	Lby, GBis			Chad, CAR					
1						Tkmn	Gmb	PNG, Mnm			Ethiopia, CtD'I, Alg,
	200	190	180	170	160	150	140	130	120	110	100

Where 10 is highest IHDI - 0 lowest IHDI, 180 most corrupt by ranking – 1 = least corruption.

Sources: Transparency International (2016), UNDP Inequality-Adjusted HDI 2016 (note: Sudan, Libya, Guinea-Bissau, Eritrea, Chad, Central African Republic, Turkmenistan, Gambia, Papua New Guinea, Myanmar, Ethiopia, Cote d'Ivoire, Algeria were assessed for corruption but did not have an IHDI ranking)

Figure 5.2 Graph illustrating the statistical association between corruption and IHDIs

anti-corruption measures in place, especially in relation to extractive industries, and so came in at 35 on the corruption list – signifying that it's relatively clean – even if it does have the fourth highest level of income inequality and occupies a spot in the lower half of IHDI rankings. Countries with a previous (or continuing) socialist orientation have tended to score better on income inequality and IHDIs despite relatively high levels of corruption, although Venezuela and Nicaragua are the least impressive performers among these states (neither having entirely shaken off its traditional moneyed elite).

As Transparency International noted, more than two-thirds of the 176 countries and territories in the 2016 index registered below the midpoint of its scale (TI 2016). What this means is that corruption was significantly more widespread than not. Countries where it remains institutionalised and endemic, such as Indonesia, ranked around the midpoint (90), so any country with a three-digit ranking was very corrupt indeed.

While there was only an approximate connection between standards of living and corruption, it was less surprising that each of those measures was closely interrelated with inequality levels. Corruption skews the distribution of economic power and socio-political positioning (Rothstein 2011:Ch. 3). This in turn implies lack of legal accountability which is a typical feature of non-accountable ('non-democratic') political systems. One critique of this situation is that capitalism by its very nature tends to accrue rather than distribute wealth and that, after the great shocks of the First and Second World Wars, this tendency has only snowballed, without the interruption of global war in the late 20th century and on into the 21st (Piketty 2014).

This gathering accumulation, at the expense of distribution and greater economic equality, has implications for the capacity of democratic states to limit excessive concentrations of wealth. But the neo-liberal capitalist paradigm presupposes that unconstrained accumulation is a 'natural' fit for 'unconstrained' politics, even though control of wealth is itself a key determinant in restricting access to political power.

Conclusion

Economic rationalists argue that economics is essentially value-free and that, left to their own devices, markets not only find their own equilibrium but operate most efficiently and produce the greatest benefit for the greatest number. Debate continues about whether unrestricted markets do in fact produce ideal economic outcomes, the counter-suggestion being that markets require some regulation to curb their excesses. In particular, the capacity of markets to drive down costs, including those of labor, may produce short-term efficiencies but at the longer-term costs of reducing consumer activity and breeding poverty, and hence human misery. Moreover, the developmentalist model has also illustrated that there is at least a viable alternative to the neo-liberal paradigm, and arguably one that performs better and more consistently in economic terms.

Global poverty since 1990 has declined, largely due to China's – and to a lesser extent India's – industrial revolution, with other countries in Asia and Latin America trailing behind but heading in the same direction. However, the income gap between the haves and have-nots both within those countries, and between them and much of the developed world, has increased over that same period. A disproportionate amount of the world's wealth is now concentrated in the hands of a tiny minority.

This brings into stark relief the reality that the practice of economics, as well as how – and how much – it is regulated, is inherently political, as is what is decided – and who decides – about the distribution or accumulation of economic benefit. The question then arises: if economic distribution is a political process, why do the majority of the world's people not demand a fairer distribution of the world's resources? The short answer is because many in the world have little or no say in how the economy operates within their countries, and those countries' governments have very little control over the structure of global trade and financial markets.

Policies adopted by such markets tend to be driven by relatively few people, both within and between countries, who just happen to endorse policies leading to outcomes that favor

80 *Poverty and the economy of development*

their own generally privileged positions. These elites then shape much of the discourse on economics and wealth distribution. Few though they be, their clout at the heart of power often drowns out the voices of the many clamoring for change.

In extreme circumstances, elites benefiting themselves at the expense of the many can capture near total control of the state, so that the state, having been 'captured', primarily serves the interests of a very small coterie of political and economic figures. This then leads to corruption, not just of the common petty type that supplements the often meagre salaries of government bureaucrats, but of the large-scale systemic type that leads to the ruination of whole countries brought about by the aggrandisement and avarice of self-serving elites.

From time to time these groups are held accountable, through political change or their excesses alienating rival self-serving elites. But, where they can, such elites tend to stretch their advantage as far as possible. Sometimes the political change driven by grassroots frustration or anger is so great that they are not only required to relinquish some or all of their ill-gotten wealth but they may also be expelled from their positions of comfort and privilege.

Thus the world of poverty, economic distribution, elite formation and capacity comes to be entwined in a tussle for ascendancy. How this tussle plays out largely determines how billions of people live, what their life opportunities are and whether they will ever be able to change their political and economic fates.

One of the key ways in which the developed world engages with these issues and, in doing so, assuages its own humanitarian conscience, is through the provision of aid, both for emergency relief and for longer-term development assistance. This aid, however, is not as simple as just giving assistance nor is it always effective and, as with much 'giving', there is often an expectation of a return. It is to these issues that Chapter 6 turns.

6 Aid, influence and development

While it is not a defining quality of developing countries, they do tend to be recipients of aid or official development assistance (ODA). During the Cold War, ODA was regularly used to buy ideological allegiance, often generating scant development and frequently contributing to high levels of state corruption.

Competition for influence has remained important since the Cold War, if with more emphasis on measuring developmental outcomes of ODA. Despite the altruism that is supposed to inform it, ODA remains a method of influencing state administrations and a key mechanism in shaping specific policy outcomes.

What also lingers is the question of how much of the ODA budget is actually spent in recipient countries, and how much of that actually reaches the projects for which it was intended. Two related criticisms are made of ODA: that it makes some states income-dependent, and that states which become prosperous receiving ODA do so because of domestic policies unrelated to that fact. A further critique involves the 'aid for trade' debate, which focuses aid programs on developing trading capacity in developing countries.

The degree of economic development, then, may be a function of how strong the desire is of state powerholders that such progress be achieved. Some states achieve it while exercising non-consensual methods of governance, as in the case of the East Asian 'Tigers', the BRICS grouping (Brazil, Russia, India, China and South Africa) and, increasingly, N11 (the 'Next Eleven') emerging economies of Mexico, Indonesia, Iran, South Korea, Egypt, the Philippines, Pakistan, Bangladesh, Nigeria, Vietnam and Turkey. Other states flourish with a higher degree of accountability and responsiveness to citizen needs.

The purpose of aid

The origins of 'aid' can be traced to the colonial period, when young colonies required financial support from their mother countries, often in order to survive their first fragile years. In other cases, colonies that had once been productive and exported wealth to their colonial masters sometimes ran out of the principal wealth-earning commodity that had attracted colonists to them, so they required financial assistance to avoid economic collapse as they sought new sources of income. Of course, the issue of capital investment by the metropolitan power was never divorced from colonial control. As with trade, the formal relationship has changed but many would argue that elements of the underlying structure, and purpose, have changed less.

The origins of 'aid' as it is currently understood began as World War II was still raging, albeit not long before the end of the war. Much of Europe had been destroyed and its economies lay in ruins as did China's and Japan's, while European colonies in Southeast

82 Aid, influence and development

Asia, the Pacific and Africa – not least their colonial administrations – had also suffered the depredations of war.

Colonial powers began to look towards the post-war environment, with economic planning and cooperation to be brought under the umbrella of two sets of organisations. The first was the soon-to-be-founded United Nations. The second organisational set was a pair of fiscal institutions spawned by the United Nations Monetary and Financial Conference at Bretton Woods, in the U.S. state of New Hampshire. The Bretton Woods Agreement of 1944 led to establishment of the International Bank for Reconstruction and Development, better known as the World Bank, and the International Monetary Fund (IMF).

The Preamble to the UN Charter, established in 1945, called for the promotion of 'social progress and better standards of life in larger freedom' and the use of 'international machinery for the promotion of the economic and social advancement of all peoples' (UN 1945). With this in mind, the World Bank was to operate primarily as a lender for state-based – usually infrastructure-development – projects, while the IMF was intended to help rebuild and financially stabilise the developing countries then or soon to be emerging. Both institutions often overlapped, especially from the 1980s onwards, particularly when it came to setting loan conditions and stipulating how governments were to restructure their economies so as to meet repayments if they were to qualify for those loans.

With the UN, IMF and World Bank, all still in their infancy and continuing an internationalist, anti-colonial tradition begun under U.S. President Woodrow Wilson after World War II, President Harry Truman outlined the United States' own post-World War II foreign policy to bolster the development of devastated and emergent states. As the ideological divisions of the Cold War rigidified, President Truman – in his inaugural address after winning the 1948 election – promised the U.S. would initiate a program to animate the economies of 'under-developed areas'.

> More than half the people of the world are living in conditions approaching misery. Their food is inadequate. They are victims of disease. Their economic life is primitive and stagnant. Their poverty is a handicap and a threat both to them and to more prosperous areas. For the first time in history, humanity possesses the knowledge and skill to relieve the suffering of these people.
>
> Truman 1949:123

Truman's optimism about the success of development aid – what was to become standardised as ODA – was based on the success of the Marshall Plan, which financed European post-war reconstruction. More particularly, the president was leveraging the high level of financial support already extended to countries on the front line of expanding communist influence or control in Europe. He was looking to support non-communist governments in the first wave of post-war decolonisation, while the Soviet bloc similarly supported Left-leaning or pro-communist regimes. Needless to say, the IMF and World Bank were swayed by these considerations, given the U.S. was their single largest financial provider.

Throughout the 1950s and '60s, battle lines were sometimes literally so, with ideological adversaries supporting governments or armed anti-government actors in a deliberate bid to tie them more firmly into their respective camps. Thus the Cold War was a crucial determinant in the provision of 'aid', with 'development' often less the key priority than was securing loyalty and political certainty, if necessary through repression. Many countries born in the post-war era had their politics shaped by competing ideological paradigms, with

concern for the welfare of their populations usually counting for far less than their adherence to one of those paradigms.

Types of aid

Generally, international aid comes in three forms: humanitarian and emergency assistance; charity; and government aid, the last of which is usually delivered to governments and via multilateral agencies.

Humanitarian and emergency assistance is a form of aid intended to alleviate immediate suffering and tackle short-term emergency needs, usually in response to a natural disaster or man-made crisis. Where a domestic government is powerless, or nearly powerless, to respond, international agencies such as the Red Cross and others may intervene until a longer-term solution can be found. Charity, by contrast, manifests as project-specific aid, typically run by non-government organisations (NGOs) and driven by a moral – sometimes religious – sense of obligation to 'do good' or increase social well-being. Structural aid or aid to governments is, with rare exceptions (e.g. one-off events such as the 2004 Indian Ocean tsunami and 2008's Cyclone Nargis that wreaked heavy destruction across Myanmar), the single largest source of aid, and the main focus for both programs and critiques of government aid.

Such aid is generally used to pay for goods, skilled staff or training, and very often much of the outlay is on external items such as foreign-sourced goods and external 'experts', meaning little is invested in the recipient country and, very often, the 'experts' and even trainers undertake local work to meet project requirements without imparting adequate skills. The premise of this type of aid is, or at least was, that developing countries rarely had sufficient capital to invest in major projects that would, in turn, underpin their economic development and prime them to escape from poverty.

Where aid has been proffered for emergency purposes, those most vulnerable to crisis already live in what might be called 'development precariousness' – where the line between poverty and disaster is already thin, resilience marginal, and disaster just one failed crop or dispossession away. This raises two issues, the first being the vulnerable community's state of development prior to the emergency, chiefly the political and economic conditions – both domestic and international – that have made it so vulnerable. The second issue is that immediate international intervention – along with all other types of aid – is part of a donor country's foreign policy, and hence calculated to achieve a certain outcome. Aid can, therefore, be a pretext for political changes. Because of the political implications of foreign aid (conditionalities, or 'strings attached', such as betterment of human rights standards), the Philippines has begun to reject it (Purushothaman 2017).

While similar examples abound, Myanmar's limitations on international emergency aid after Cyclone Nargis stand out among the most egregious, with foreign aid initially being stopped, then allowed in via restricted channels and often sold by the army rather than being distributed (Voravit et al. 2009:15, 28–34). Nargis killed at least 140,000 people and devastated the lives of another 2.4 million. With Myanmar about to go to the polls to approve a new constitution that would pave the way for a controlled political transition, the nation's repressive and deeply suspicious army was concerned foreign intervention could lead to political interference or internal pressure for greater political change (HRW 2010) or even direct intervention (Chongkittavorn 2010). It has since been argued that while gradual, if limited, political reform had been planned, Nargis and the government's failure to meet the crisis adequately had the effect of spurring on the very political changes the army had been resisting (Taylor 2012:231–232).

84 *Aid, influence and development*

Examples where foreign intervention directly led to political change include Timor-Leste in 1999, where UN-sanctioned military intervention accompanied humanitarian relief and established a mechanism for the transition from Indonesian authority to UN administration and then to independence. Similarly, in Aceh in 2005, the international community insisted on a political settlement to the province's separatist war to allow the flow of some $US5 billion in reconstruction aid after the devastating Boxing Day tsunami left 180,000 dead and brought widespread destruction to Aceh and other parts of northern Sumatra. This pressure was a significant factor in the final peace settlement which granted the province a high level of autonomy (Kingsbury 2007b:104; Aspinall 2009:200–202, 234).[1]

Such intervention, or accusations of intervention, are relatively common with aid and especially emergency aid, in places such as Afghanistan, Iraq, Sudan, much of North Africa (Shaikh and Hamid 2012) and even Russia (Carothers and Gramont 2013). Most notably, China employs foreign aid for political purposes through its 'soft diplomacy' program of 'mutual benefit' (Shimomura and Ohashi 2013:220). Needless to say, in conflict environments humanitarian aid cannot be kept separate from the conflict itself, which immediately politicises the aid as the very giving of it entails political decisions: to whom it is given, where their allegiances lie, what pressure it might remove from (or what support it might give to) one party to the conflict; and so on. To illustrate, around 40 per cent of China's aid to Pacific island countries goes on transport, 'with an eye towards incorporating the Pacific region in its global Belt & Road infrastructure-building initiative' (Boyd 2018).

China is not alone, of course, and its keen diplomatic competitor, Taiwan, also uses aid, sometimes as a trade lever but more often to buy diplomatic support. Indeed, as countries vie for diplomatic advantage, for example on UN committees – the Security Council is the most prized but the Human Rights Committee is also seen as useful – aid or other types of soft economic support are frequently a mechanism to garner support for election to such bodies (e.g. see Wang 1999; Carter and Stone 2015). This particularly applies to smaller, often island states, in which aid and other forms of support achieve greater economies of scale ('bang for their buck') on UN bodies where all votes are equal. This feature of the UN system is so widely recognised as a function of the global body's foundational structure that the only real questions it has raised concern about concerns the ethics of a process that would be illegal under the domestic law of most of the UN's member countries (Lockwood 2013).

Problems with ODA

Three sets of problems can be discerned with ODA – four including the fact that at its core ODA is a means for the developed world to assuage its collective conscience for the role it plays in perpetuating gross global inequalities. ODA can create dependence without addressing local structural or organisational issues; it can privilege particular elites who often decide where aid is spent or who its recipients are – including even themselves (Easterly 2006; Moyo 2009); and it can fluctuate in ways that make it unreliable. This is part of a larger debate about the nature, purpose and effectiveness of aid, in part played out in scholarly and public debates between Easterly and Jeffrey Sachs (2014) and a number of observers (see Engel 2014). As with many such debates, it has too often been reduced – especially by observers – to a dichotomous either/or proposition: that aid is useful and builds development (Sachs' broad position) or that aid is essentially negative (Easterly and Moyo's

position). Setting aside Moyo's legitimate critiques of aid, both Easterly and Sachs are much more nuanced than this debate, especially in public, would imply. Moreover, because the debate has been reduced, especially in the media, to a gladiatorial contest, both have occasionally fallen victim to an essentialising of understanding that is less reflective of their more considered work.

Sachs argues, with strong evidence, that good, well-targeted and sustainable aid can and has improved the lives of countless thousands, particularly in sub-Saharan Africa. In so far as aid has negative consequences, this is essentially because it is poorly designed or delivered. Sachs also acknowledges that good governance is critical for achieving development and that local governments play the key role in the process, which appears to be a point of common agreement between all but a very few, usually idiosyncratic, aid theorists (e.g. Hill 2012) and practitioners who believe it is simply a method of doing business.

Alex de Waal, as a practitioner who is also an author, has also been famously critical of aid programs, blaming them for at least allowing, and in some cases causing rather than alleviating, famine (De Waal 1997:49, 59). He identified politicians and military leaders as primarily culpable for famines in sub-Saharan Africa but noted that donors abetted their authoritarianism through aid programs that were often too small to genuinely assist those in need yet substantial enough to make powerful people wealthy through the channelling of aid, and aid funds, for their own ends.

Beyond this, De Waal notes that aid tends to be top-down, fostering centralisation and hence political control. He also said that as foreign aid has grown, the opportunities for finding effective local solutions have diminished (De Waal 1997:136). As one aid organisation that De Waal felt well disposed towards once noted, what was needed was 'change not charity'.[2]

Not all aid causes dependency. Sustainable, bottom-up aid programs can, as Sachs and others note, emancipate local communities from that status. So, too, large-scale aid programs that deliver sustainable infrastructure – often vital aid such as sanitation and water supplies – do make important contributions to the welfare of local communities. For many people in the least developed countries (LDCs), the withdrawal of aid would mean simply going without. Depending on their circumstances, the direct impacts could impinge on a range of life factors, from longevity and mortality (both infant and maternal) to nutrition, education, health care and so on. This does not take into account emergency and humanitarian relief which for many affected people may literally mean the difference between living and dying.

However, aid often forces local communities into a reliance on external 'experts' in a top-down, paternalistic pattern of power and dependency in which recipient communities are disincentivised and end up without self-sustaining development programs.[3] This susceptibility to dependency becomes increasingly noticeable the longer the initial aid program continues, and the more intensive it is. In much of sub-Saharan Africa, continuing receipt of, and hence reliance on, aid have been built into local economies over a half a century or more.

Moreover, where foreign 'experts' do establish aid programs or train local staff, such programs are commonly not sustainable once the foreign 'expert' (and their funding) leaves the project site. To deliver long-term positive benefits for local communities, aid must ultimately be owned and operated by them. Local technologies and even locally led and structured programs are the most likely to succeed after the aid convoy has moved on to the next disaster.

Dependence results when aid is used, intentionally or not, as a long-term strategy that inhibits development, progress or reform. The particular butt of this criticism is food aid,

86 *Aid, influence and development*

being a donor-driven system. Save where people's lives are in immediate peril, food aid increases dependency on imports and discourages local food production by reducing market demand. This is compounded when declining aid is replaced with commercial imports rather than locally sourced food, because of either cheaper prices or a lack of recipient-country capacity to produce its own food, due to long-term aid causing stagnation of the agricultural sector. It is also true that food aid can be driven by the domestic interests of donor countries, such as promoting government or agency purchases of domestic crops, so a conflict of interest arises in international institutions being driven by donor countries that are food exporters. In this circumstance, what can happen is that food aid becomes a foreign policy tool for donor countries. In the final analysis, food aid is seldom about 'development' and, at best, satisfies a short-term humanitarian or emergency need (Shah 2012).

Lappe and Collins (2016) argue that the so-called need for food aid is based on 'myths' created to sustain the food aid industry. These include that food aid is only exported where there is a (humanitarian) need; that nature rather than institutions is the primary driver of hunger; that free markets can end hunger (rather than create it); that the 'Green Revolution' is unsustainable; that environmental destruction is necessary to produce food; and that more food aid will help the hungry.

Food is not usually supplied as a part of general aid, but it can be, particularly where a short-term food crisis has just passed but the supply program has not yet caught up with changed conditions on the ground. In such circumstances, the lag effect of the food aid can spill over into the non-critical period, or can continue to supplement supplies of local food. In the latter case, for communities that have historically faced food insecurity the reliability of food aid can actually discourage a return to traditional food sources, thus creating a more permanent reliance on aid.

While drought (sometimes flood or pestilence) often creates local food shortages, leaving vulnerable communities requiring emergency food aid, such shortages are rarely driven by natural causes alone. Apart from true subsistence communities, a range of food is generally available from various sources, including nearby production, locally processed and imported foods (if usually from nearby countries). Hunger can arise not for lack of food as such, but because of interruptions to supply which may have diverse causes, ranging from poor roads to fuel shortages or the reluctance of drivers to travel owing to security threats and even the impounding of food.

Conflict and the concentration of a military presence in a given environment are common factors in the vulnerability of a local population to food-supply interruptions, not least where the local military commandeers food for its own use or sells what it has appropriated (and this often includes food aid) on the black market. Such was the case in Timor-Leste in 1999, Aceh in 2005 and Myanmar in 2008, following Cyclone Nargis … but many other examples could be given. Where a predatory armed non-state group is in functional control, the commandeering of food, including food aid, is common, for example in Somalia during the 1990s and again in the 2000s, in South Sudan and by the Islamic State group within Syria in 2016, again naming but three examples among many.

Finally, food may be available, but scarcity can have the perverse effect of driving up prices so the poorest and most vulnerable are excluded from access to any purchased food. During the 2000s in particular, a rapid increase in the price of grains, especially rice, caused widespread hardship for poorer communities in South and Southeast Asia.

Returning to the proposition that the free market is self-regulating and thus will meet demand, the reality is not so straightforward. Free markets generally go where prices are highest rather than where need is greatest. Increased need may raise prices and hence

provide supply, but where there is little economic capacity to outbid other, often wealthier, markets such a system often fails those in need. Accordingly, some governments have sought to subsidise basic foodstuffs, particularly during periods of hardship, or to provide temporary basic food aid. To sum up, where need has suddenly increased due to crop failure, conflict or other impediments, the market rarely meets the requirements of people in need.

Certain aid is aimed at increasing food production (or other consumables such as energy) so that target populations can better meet their own needs. While such programs may work well, especially those using renewable seeds (as opposed to genetically modified seeds which need re-purchasing with each crop) or energy sources (such as solar and water power), others work less well. High-yielding crops tend to produce more food, but they usually rely on fertilisers, pesticides and, in many cases, regular seed purchases. Thus an end-product may satisfy a particular need, but reaching that end might be unsustainable or undesirable over the long haul.

Added to this is the continued clearing of land for crops (especially for slash-and-burn agriculture) and grazing, which can reduce water quality, leach soil of its nutrients and lead to deforestation of the type that contributes to carbon build-up in the atmosphere. To illustrate, since 1970 about 19 per cent of the world's largest rainforest (originally covering 4.1 million sq.km) in the Amazon has been destroyed, degrading the environment right across the north of the continent: from Peru, Colombia and Venezuela to Suriname, Guyana, French Guiana and Brazil. Recent attempts to halt the forest's destruction were beginning to prove successful, but in 2016 logging increased by a massive 29 per cent (Fearnside 2017), with Brazil and Colombia the only two countries not to register a rise. The most marked increases took place in Peru, Suriname and Ecuador (Butler 2017).

Aid and, in particular, aid dependence undermine good governance practices by weakening accountability and inviting corruption. Sometimes conflict erupts over the control and flow of aid funds. Very often, too, aid agencies hire the best and brightest in local bureaucracies who are often lured by higher salaries, and their loss imposes a severe strain on local government and other institutional capacity (Knack 2001). As Moyo has noted, the 'vicious cycle of aid … chokes off desperately needed investment, instils a culture of dependency, and facilitates rampant and systematic corruption, all with deleterious consequences for growth' (Moyo 2009:49). It is impacts such as these that do something worse than hinder development: they guarantee under-development and economic failure. As Dragovic notes, if somewhat more generously, development projects can succeed, but tend to do so only where there is a high level of local consultation in what is needed and how it can operate, a related high level of 'ownership' of the project, and where local people work to produce the project's benefits, rather than being passive recipients. The alternative is extensive expenditure and high levels of failure (Dragovic 2018:190–201).

Absorptive capacity

The term 'absorptive capacity' originally applied to business models, referring to their ability to 'recognise', assimilate and employ new information. In ODA terms, it refers to the capacity of the recipient country or region to accept, distribute and deploy aid. Limited absorptive capacity may mean, for example, that in an emergency relief goods may be supplied but pile up at wharves or storage depots for lack of logistical infrastructure to move them; that technology is supplied but lies idle for lack of operational skills; or that funds are provided but do not reach their expected recipients due to limited bureaucratic,

88 Aid, influence and development

or other organisational, capacity. So, absorptive capacity equates to the amount of aid, capital or technical assistance a recipient country can productively use (Adler 1965).[4]

In Adler's definition, taking after Keynes, he describes absorptive capacity as the effective rate of return on invested capital, so that the lower the return on capital the lower the absorptive capacity, to a point where there is no return on capital or, indeed, capital starts to diminish. If this is considered in terms of physical rather than just financial aid, it can imply spoilage, looting and theft and, commonly, the corrupt use of aid to privilege certain client groups.

When such malpractices blight a developing country, they cannot help also affecting that country's politics, because the ODA provider is paying scant attention to the core issues its population faces – people's skills, capacity and basic infrastructure. At such times delivering ODA is merely applying a band-aid. To extend the metaphor, the answer to an underlying problem is never going to be the application of more band-aids: that will just be wasteful (Adler 1965:25). Excessive aid is worse than wasteful: it encourages diversion of that aid, theft and corruption. This may further entrench already powerful elites or patronage networks, and allow aid donors to skew the supply of aid in return for political loyalty.

Development thinking, particularly in relation to foreign aid, has shifted its emphasis from questions of quantity, traditionally expressed as a percentage of GDP (with 0.7 per cent being the ODA benchmark). Recent years have seen increased emphasis on the quality of aid (Roodman 2006). Notably, the 'administrative burden' of aid can have the reverse effect to that intended, actually restricting development by re-focusing on the need to meet aid suppliers' governance requirements rather than nurturing locally driven development programs which, since they reflect local needs and conditions, generally have a higher rate of long-term success.

> Absorptive capacity relates to the macro and micro constraints that recipient countries face in using aid resources effectively. Large additional flows of external resources can strain government capacity for macroeconomic management, planning and budgeting and service delivery to a point where additional aid may not be effective in achieving its intended results.
>
> Renzio 2007:1

Roodman (2006:28) notes a significant decline in the marginal productivity of aid above a certain threshold of aid-project proliferation. In other words, aid is useful only up to a certain point, beyond which its usefulness tapers away and it can actually limit development in the recipient country if not carefully targeted.

Aid and corruption

As Moyo has noted (2009:53), in some sub-Saharan countries as little as 20 per cent of aid earmarked for purposes such as education actually reaches the projects on the ground for which it was intended. But this phenomenon is far from exclusive to Africa. In Indonesia, it used to be common for around just 10 per cent of aid funding to reach the projects for which it was intended, with various layers of bureaucracy syphoning off 'facilitation' fees.[5] This does not include more overt criminal activities such as theft of aid supplies, fraud and charging for work not done. One Indonesian official, speaking at a corruption conference, asked rhetorically: 'What if some official says he needs to rebuild about 20 miles of road,

Aid, influence and development 89

how do we know it is not only 100 yards?' (Bonner 2005). Then there are the overpricing of goods and services[6] (particularly in 'emergency' settings), the use of 'ghost' employees (where salaries are paid into artificial accounts) and the simple misuse of funds for purposes other than those for which they were intended. Indeed, according to unofficial accounts, very occasionally the syphoning process has been so complete that no aid at all reached its intended destination.

Corruption is so bad that, in some emergency environments, state officials (usually the army) have been known to seize aid intended for free distribution to desperate people and then sell it to them. The U.S. suspended critical aid to Somalia's army in response to rampant corruption. 'It is true that some concerns have been raised on how [aid] support was utilised and distributed', according to then Somali Defence Minister Mohamed Mursal (Mumbere 2017). Most of Africa rated as 'critical' or 'very high' on Transparency International's defence corruption index, indicating a problem of continental scope (TI 2015).

Even the UN, which tends to understate its problems, acknowledged that around 30 per cent of aid was lost to corruption during the tenure of Secretary-General Ban Ki-moon. Neither peace nor development nor human rights 'can flourish in an atmosphere of corruption', Ban said (Ravelo 2012). The Secretary-General's statement on corruption came as a UN-convened panel called for a renewed commitment by countries to ratify the UN Convention against Corruption, the first legally binding anti-corruption instrument obliging states to criminalise corruption and recover stolen assets. In many cases, local police and other officials are insufficiently concerned with corruption, which is often seen as normalised by culture. Frequently they lack the resources to tackle it or the support to face politically powerful beneficiaries who can impede investigations, or worse. In some cases, police themselves are corrupt: 'Reflecting the depth of the corruption here, you even have to pay a bribe to get into the police academy, and thousands of dollars to become an officer,' a senior Indonesian official was quoted as saying (Bonner 2005). 'It is taken for granted that no one does business in Indonesia without paying bribes, routinely disguised as "consultants' fees", to government ministers and heads of agencies.'

Aid dependency

In the realm of foreign aid, the shift of focus of aid away from infrastructure – which was failing to deliver short- or even medium-term benefits – towards housing, education and health was a necessary reaction to the very low living standards of the world's poorest citizens. Yet such aid programs relieved developing-country governments of the responsibility to care for their own poor, developing an aid reliance trap from which many countries are still struggling to extricate themselves.

Dependency is never a goal of the aid paradigm, but it can occur when aid becomes a long-term strategy adopted by the agencies whose *raison d'être* is to provide it, and where recipient governments do not develop those sectors that the aid caters for.

Ironically, because such aid replaces, and in the longer term inhibits, the development of local solutions to local problems, it thwarts the development of local skills and investment in locally sustainable solutions. Thus an aid-dependent country might not see its development just stall but actually go backwards. This can create an even bigger problem than the one aid was supplied in order to solve. As mentioned, countries sometimes decide – for this or other reasons – to reduce or even stop foreign aid, as donor agencies themselves have been known to do (Moss et al. 2006).

90 *Aid, influence and development*

In the wake of the Global Financial Crisis, one area of developed-country spending to have been widely cut was ODA. There was an immediate dip in ODA from around 0.32 per cent to around 0.27 per cent of donor countries' gross national income. ODA recovered over the ensuing years, again reaching 0.32 per cent in 2016 (OECD 2016). The UN having set a global target of 0.7 per cent of Gross National Income (GNI) as a desired level of aid as far back as 1970, it speaks volumes that the proportion has been in general decline since that avowal of good intent: indeed, the closest donor countries came to the UN goal was in 1961, with 0.54 per cent of GNI.

Although there was a spike in ODA following the GFC, with it peaking in absolute terms at $US143 billion in 2016, a significant proportion of these funds was allocated to 'non-traditional' areas of 'aid', including assistance to globally displaced peoples, who by 2017 numbered a record 65 million. Between 2010 and 2015, total ODA allocated to refugees increased from 2.7 per cent of all ODA to 9.1 per cent, or from just under $3.5 billion to almost $12 billion (DAC 2016). Refugees were counted as distinct from internally displaced people, who accounted for some two-thirds of all displaced persons (UNHCR 2016:Ch. 1).

Almost by definition, the LDCs tend to have higher levels of aid dependency, along with a proliferation of aid donors, and so less focus and coordination when it comes to aid allocation (Alonso 2015:1). It stands to reason that shortcomings in a country's ability to manage aid are more pronounced when that aid is fragmented and loosely coordinated. This state of affairs is often made worse by poor governance structures and the greater risk of conflict to which LDCs are prone. These countries are invariably more exposed to potential or actual shocks and to major imbalances, including poorly conceived and targeted aid, especially from larger donors that may be reluctant to subsume their own activities to the dictates of government. Alonso writes (2015:16), 'Two of these factors, the limited coordination of donors and high levels of aid dependency, seem to be crucial and should be corrected by donors, because the two factors are mutually reinforcing and result in a vicious circle.'

While aid dependency refers directly to economic dependency, it also carries a political connotation where aid becomes enmeshed in local political processes. In their responses to incidents highlighting the misuse of aid and related corruption, aid agencies have complicated the process of delivering and auditing their largesse. These complications include direct funding of programs, attaching tighter 'strings' (conditionalities), tying them to particular purposes (such as water and sanitation, or improving the observance of women's rights) and specific-project grants. All these examples share a common goal: to give donors greater control over the direction and use of funds. Managing such aid in turn requires not only that governments work with agencies in getting aid where it is meant to go, but that aid plays a part in shaping government agendas, despite best-practice principles requiring that agencies conform their work practices to government agendas (De Waal 1997, esp. Ch. 11). The trend for recipient-country governments to tailor policies to the external agenda of aid donors has drawn an increasing amount of academic attention (Stanford 2015).

LDCs, as countries at the bottom of the development ranking, have necessarily received, and continue to receive, higher proportions of aid as a ratio of GNI than other developing countries. Over the long term, with aid as a structural part of government revenues, budgeting and investments, such countries become dependent upon aid, especially where it has stifled the potential development of home-grown sources of income (Alonso 2015:17). In extreme cases such as Liberia, aid can constitute as much as 80 per cent of a country's budget.

From 1990 to 2012, aid as an average proportion of highly dependent countries' GNI showed a steady decline, from 19.2 per cent to 12.1 per cent. African LDCs saw the greatest shift, from 21.3 per cent to 10.9 per cent, while non-African LDCs dropped less but to a level higher than the two categories just named (15.2 per cent), indicative of a structurally based intractable element in their overall aid reliance. Conversely, LDCs affected by war grew more dependent on aid – from 18.5 per cent to 23.9 per cent – underscoring just how debilitating war can be for government revenues (Alonso 2015:17).

The world's most aid-dependent countries are Liberia, Solomon Islands, Afghanistan, Tuvalu, Sao Tome and Principe, Malawi and Mozambique, all of which received aid amounting to more than 20 per cent of budget revenue in the decade 2003–2012. Over the same period, the following countries were dependent on aid for between 15 and 20 per cent of their budget: DRC, Sierra Leone, Rwanda, Kiribati, Guinea-Bissau, Haiti and Eritrea (Alonso 2015:17). This list is hardly surprising, given that conflict or state collapse afflicted many of the countries on it: DRC, Liberia, Solomon Islands, Afghanistan, Malawi, Sierra Leone, Rwanda and Eritrea. Haiti experienced a severe earthquake in 2010, compounding its prior fragility; and Kiribati is a tiny nation of 110,000 souls scattered over thirty-three atolls and reefs across 3.5 million sq.km of the Pacific Ocean straddling the Equator; while the Solomon Islands, another Pacific nation with limited economic resources, was wracked by internal conflict.

'Soft power' and influence in aid

It is said there is no such thing as a free lunch, nor is aid ever given unconditionally. Even in those rare circumstances where it is given as a 'good Samaritan' gesture, there usually remains an expectation that the grant will help the recipient country become self-sustaining (usually with some accountability mechanism), foster stronger relations between the provider and recipient or mend previously strained relations. Untied aid has become increasingly rare, given the lack of accountability and potential for mismanagement, waste and corruption it can engender. Aid donors normally expect their gift will produce a specified outcome (Boone 1996), and the donor country normally assesses that outcome against a checklist (Putnam 1988).

In the words of an academic specialist:

> If aid is to be used as a midwife for reform, conditionality seems needed, but the conditions have to be followed up and to be worked out in real partnership with the recipient. There ought to be fewer conditions, and they should be redefined with stipulated deadlines and benchmarks.
>
> Selbervik 1999:5 (see also Barya 1993)

Conditionality has, however, not always produced the desired outcomes (Nelson 1996; Collier 1997).

One area of 'reform' increasingly targeted by aid is the trade sector of developing-country economies. The assumption is that the more a country is able to trade, and the more it trades, the more likely it will be able to lift itself out of poverty (Kapuscinski 2017). According to the World Trade Organization, aid for trade is 'about assisting developing countries to increase exports of goods and services, to integrate into the multilateral trading

92 *Aid, influence and development*

system, and to benefit from liberalised trade and increased market access' (WTO 2014). There is little doubt that the countries that have moved from developing- to developed-country status have done so through trade, primarily through exports. However, not all countries that trade, or export, have developed, particularly where their exports are limited to commodities and in particular agricultural commodities.

Developing countries' participation in global trade has significantly increased since 2000, up from around a third to a half of all global trade by 2017 (Kapuscinski 2017), with rapidly industrialising countries such as China and India accounting for much of that trade. However, while trade can assist development, it is not value – or cost – free. Starting as a World Trade Organization initiative in 2005, about 30 per cent of official aid is now allocated to supporting trade initiatives (WTO 2018), including capacity building, technical support, infrastructure development and market support. While the WTO monitors the effectiveness of such allocations, that does imply that aid available for more conventional development programs such as in education, water and sanitation, and health care, is effectively reduced by that amount.

Moreover, while trade can benefit economic development, it tends to do so in ways that may not produce measurable poverty alleviation benefits. While there is evidence to support the claim that increased trade will lead to economic growth, this model relies on macro indicators to determine efficacy and thereafter relies on a 'trickle-down effect' that such growth will create jobs and more jobs will lead to increased incomes and hence less poverty. This may occur, but it may also increase jobs at low wage levels in unregulated labor markets – 'a rising tide', to use the favored term – does not necessarily 'lift all boats' evenly. In this respect, unless one has complete faith in the neo-liberal argument in favor of 'trickle-down' economics, increased trade may privilege existing elites without meaningfully reducing poverty, or may reduce poverty marginally but also increase the wealth gap in developing countries. In short, aid for trade is far from the most direct way of assisting people in poverty, and may have marginal benefits in any case. What it does do, however, to further entrench a global economic system that has, overall, seen a rise in economic inequality.

Aid is rarely, if ever, a discrete field disconnected from other foreign policy, and only in the most exceptional circumstances is it driven by humanitarian concerns alone. Indeed, one could argue that, as with all charity, even where aid is driven by a moral imperative there remains the benefit to the donor of their satisfaction at having done 'good', the wholesome benefit of a clear conscience and the capacity to parade their 'good deeds'. These benefits even accrue when prior – and sometimes concurrent – policies and considerations (e.g. the two countries' history of asymmetric relations, trade, investment/exploitation or strategic interests) favor the donor. At best, aid can be seen as 'enlightened self-interest' (Griffiths and Lucas 1996:205–208), implying an international form of 'social contract' in which support for vulnerable countries helps create more stable (Ball 1992), cooperative and (hopefully) economically successful state partners. On this view 'enlightened' aid is linked to deferred self-gratification, with help given now construed as an investment designed to reap the benefits of political stability, allegiance and/or trade in the future (see also Williamson 1994; Killick 1998).

Despite immediate and longer-term economic and political interests, such 'benefits' are seen as minor considerations compared to humanitarian motives, other than where the donor has a specific economic, political or strategic agenda (Cass et al. 1992; Lumsdaine 1993:30). Such agendas are clearest in the case of bilateral aid. Multilateral aid has less of an agenda, principally because the country-specific component and the uses to which it is put are less easily ascribed to individual donor countries. Some countries, too, are agenda-

dominated, especially in given historical circumstances such as the U.S. and the Soviet Union during the Cold War. Others, such as the Nordic countries, tend to have low expectations of return benefits to themselves but higher expectations for the communities of recipient countries: better economic management and policy outcomes beneficial to the poor in those communities being two such.

This shift to a 'good governance' paradigm has gathered pace since the end of the Cold War, which may indicate that buying strategic friendships has become less important than achieving positive local outcomes. This is particularly notable when one considers what has been termed 'donor fatigue', or growing public impatience with continuing donations when there is relatively little change in the plight of recipients, sometimes due to continuing malpractice (see Ligami 2016 re a fall in support for the East Africa Business Council; UNNC 2005 re famine relief). 'The main shift in the early 1990s appears to have been a tougher stand on the part of the bilateral donors in their criticism and conditions than that of the World Bank and the IMF' (Selbervik 1999:40).

Bilateralism and its vagaries

Bilateral – country-to-country – aid is usually the largest component of an aid donor's program, as it can be targeted to meet the specific needs and concerns of the donor country in a way that multilateral aid cannot. About 60 per cent of all ODA is bilateral.

As the new century unfolded, there was a boost in foreign aid directed to countries involved in wars, such as Afghanistan and Iraq. In 2015 United States ODA allocations of $US4.3 billion to Afghanistan and $US1.485 billion to Iraq constituted more than 18 per cent of a total ODA budget of $US31.736 billion. Three years earlier, while ODA to Afghanistan stood at around $US3.3 billion, military aid was valued at more than $US9.5 billion (Dhillon 2014). Afghanistan and Iraq received such huge aid votes from the U.S., let it be noted, overwhelmingly because of history-changing foreign policy decisions under President George W. Bush. One-fifth of U.S. non-military aid went to prop up countries that a previous administration in Washington had chosen to invade.

In some cases what counted as ODA was, as in the case of Australia, money spent on detaining and processing asylum seekers, or on offering generous – and effectively unaccountable – aid in exchange for a third country to take those who had sought asylum in Australia. In 2016 Australian ODA declined to its lowest level (0.22 per cent), with the amount of aid going abroad worth $AUS2.8 billion from a total aid budget of $AUS4.1 billion – a slight reduction on the previous year (RCA 2016). But this was not really aid; it was plainly an instance of a country prosecuting a particular aspect of immigration or 'border protection' policy by buying the favors of regional governments – in Australia's case, Papua New Guinea, Nauru and Cambodia.

So, bilateral aid is generally given when the donor state has a policy interest in the recipient country and the aid is used to achieve specific outcomes. For some donor countries, this can be as benign as showing support for nearby countries in which the donor has an interest, usually strategic. But bilateral aid can also be part of a larger agreement where the aid itself counts merely as payment.

Multilateralism

Multilateral aid – provided by agencies on behalf of larger collectives of ODA states – can often be very effective given its potential scale, influence and broadly non-partisan agenda.

94 *Aid, influence and development*

Those factors can fundamentally shift the status of an aid-recipient country, especially if, as is usually the case, its projects have international legitimacy. Multilateral aid and the organisations that deliver it have the capacity to resolve issues that bilateral aid often cannot.

To illustrate, the Horn of Africa food crisis of 2010–2011 impacted some 13 million people across Somalia, Ethiopia, Djibouti, Kenya and Uganda (WFP 2011). The World Food Programme managed to deliver humanitarian aid on a scale and with an efficiency that would have been beyond bilateral-aid donors. While the food crisis was triggered by a severe drought, in Ethiopia the famine was also used as a weapon against secessionists. In Kenya, too, politics reared its head: that part of the country worst affected by the food crisis was also the part least under the control of central government (Dorward 2011).

Given their large memberships, multilateral bodies can forge wide-ranging consensus on key international issues, including those of humanitarian assistance and development. But that can be a weakness as well: it makes the road to consensus more tortuous. When one country has a fixed agenda, it can leave any agreement very exposed to breakdown. International consensus is also susceptible to failure but it is more likely to be achieved in the first place and to be sustained by virtue of the fact that there are more countries working towards a common goal.

Multilateral aid organisations divide into two camps: regional and global bodies. Regional examples include: the African Development Bank, Asian Development Bank, Caribbean Development Bank and Development Bank of Latin America. Global multilateral aid outfits include various UN agencies (UNDP, UNICEF, WHO etc.) and the International Federation of Red Cross and Red Crescent Societies.

Even multilateral aid bodies are liable to reflect the agendas of their more dominant partner countries, especially where pro rata funding is a component of total funding (giving some countries more financial influence). What is more important, the larger an organisation the more bureaucratic it is and the more likely its staff and *matériel* will be selected on the basis of proportional representation rather than for their competence or suitability. So, while multilateral agencies are often fixated on alleviating immediate and medium-term problems, they can be very slow and remarkably incompetent – lacking prior experience of the country to which they direct aid – and their staff may be swaddled by layers of bureaucracy. UN agencies in particular are notorious for reflecting these qualities, leading to calls by some – not necessarily alarmists inveighing against 'world government' – for the UN's abolition.

Conclusion

Aid raises many questions, but there is no single answer to any of them. Clearly emergency and humanitarian relief is necessary when a country is confronted by a crisis it cannot cope with. And broad development assistance can promote good governance, better education, sanitation, water supplies and so on until a recipient country is able to provide for itself. Even broad-based aid, including soft loans for major development projects, can move a country out of poverty and away from under-development.

But, as has been discussed, aid also has pitfalls. It is intrinsically political and can be used for ulterior purposes or to make a strategic partner of an otherwise unsavory government. It can overwhelm local resources, lead to dependency and, perhaps most important of all, lull the recipient country into believing that the surest escape from under-development is through the kindness of others rather than displays of initiative and hard work by its own citizens.

Aid, influence and development 95

Finally, multilateral agencies are essential to the global institutional infrastructure, marshalling resources that very few donor countries and no recipient countries can muster. Being multilateral mitigates, while not entirely dispelling, the sometimes narrow agendas of bilateral aid programs. Perhaps most important, multilateral agencies bring critical mass to bear on global issues that single countries cannot solve, in particular around health care, illness prevention and environmental concerns such as deforestation and desertification, availability of potable water and climate change.

Aid is a necessary and important example of how the world works together, intersecting with and often reflecting different (sometimes competing) interests. Functioning smoothly in some places and poorly in others, it nevertheless forms part of what might be viewed as a global social contract whereby those 'with' assist those 'without', even if their motives are not pure. Aid may be too little, too bureaucratic, too compromised and in many cases too ineffective, but it has been shown to work too many times to be dismissed as entirely useless. The same powerful rejoinder to those who would demolish the UN is applicable to those who would abolish foreign aid. For all their imperfections, if the world had no aid programs (as for the UN) it would have to invent them.

Perhaps, though, aid would be less necessary if the structure of global economics did not rely, as it did during the colonial era, on exploiting relative economic strengths of developed countries very often at the expense of developing countries. How economies and trade are organised is, therefore, the subject of Chapter 7.

Notes

1 The author, principal adviser to the Free Aceh Movement negotiating team, saw the donor nations' document promising aid if a settlement was achieved but threatening punishment if it was not.
2 This was a catch-cry of the Australian aid organisation Community Aid Abroad, before it folded into the global Oxfam family in 1995.
3 Based on observing a plethora of aid programs over three decades.
4 This is an old, but arguably original, definition of the idea in an aid sense, and has not substantively changed.
5 Anecdotal evidence based on conversations with aid distribution monitors in Indonesia.
6 This is particularly common where external aid workers have little familiarity with the pricing and availability of goods and services.

7 Economic structuring and trade relations

A state's economic status is, conventionally, the key determinant of whether that state is counted as developed, developing, less developed or one of the least developed. Its economic organisation is therefore a definitive characteristic of the developing state. This touches on its overall economic performance, but also on how that is linked to trade. External and internal economic relations alike shape as well as reflect political relations. How a state chooses – or is permitted – to structure its economy is an inherently, and intensely, political quality.

The structure of the economy is an inherently political process because there are, in its distribution of income, clear winners and losers. It often takes a great deal of political will to undertake economic change to economic structuring, given there will almost always be considerable opposition from those who may lose in such a process, and especially when positive outcomes are not guaranteed. Yet economic change is a determinant of the shift from developing to developed status, not to mention a common requirement for economically marginal states to remain viable.

Developing countries have commonly been equated with agriculture- and minerals-based economies. In recent years, that depiction has shifted to include degrees of industrialisation, but where manufactured goods are relatively basic and cheap there is little productivity gain and little profit to show in value-adding terms. The continuing dependence of almost all developing states on primary industries makes them especially vulnerable to fluctuations in global commodity markets – especially states that rely heavily on a limited range of commodities.

In this respect, many developing countries find themselves pincered by high levels of unskilled unemployment or under-employment and low investment returns, with consequent political volatility and subsequent lack of further investment in capital-intensive industries.

Types of economy

Given that 'developing' status implies a degree of economic mobility, while a primary industrial focus is usually dominant, a developing country could be newly industrialised or have long since industrialised but at the lower end of the scale for complex manufactured goods, particularly if emerging or frontier markets are opening the country up to external trade. Another commonality of the developing-state economy is high debt relative to annual growth and GDP, in which some countries' economies continue to be undermined by a cycle of debt and a weak currency and hence struggle to escape the burden of disproportionately high debt repayments. The transition from centrally planned economies, characterised by 'communist' states, to market-driven economies has also created a new subset of developing countries. As the above remarks indicate, there is no singular definition

of a 'developing' country, with a further array of economic and human development indicators also being used to justify inclusion in this category.

While individual countries may be producers of the same primary commodity, they often differ in other respects. Such differences will be shaped by their location, geography, history, access to resources and each nation's institutional and financial capacities. The IMF's *World Economic Outlook* defines the development status of countries based on measurements of per capita income, export diversification and the extent of integration into the global financial system (IMF 2017a:Ch. 4). Beyond these criteria, non-developed countries are commonly sorted into five distinct categories based on such criteria as levels of poverty, inequality, productivity and innovation, political constraints and their degree of dependence on external trade flows.

Resources curse

Among developing countries are some with relatively high income levels but an inordinate dependence on a small number of export industries, sometimes on one alone. A prime example of such export reliance is oil and/or liquefied natural gas, although copper, gold or other minerals such as diamonds can also dominate a small economy.

In the case of high-value commodities such as oil and certain minerals, a high level of foreign ownership is common, creating *rentier* states that, along with their populations, receive little in the way of profits from the otherwise valuable resource. Where there may be opportunities for some local benefit from such income flows – and there are too many supporting case studies to list – political elites may tap into these revenue streams, either through direct corruption or through the letting of (often inflated) state contracts to family members or cronies.

In some cases these revenues are shared so as to preclude elite tensions over access to loot. This was the case under the Philippines' dictator Ferdinand Marcos and Indonesia's Suharto, if in both cases they became excessively greedy and, in centralising wealth, helped create the circumstances of their political downfall. In other cases, however, elites – particularly at the head of rival ethnic groups which are beneficiaries of patron–client relations – may compete for access to revenues or control over resources in ways that often devolve into civil conflict or war. This phenomenon of 'greed' as a driver for civil conflict has been detailed at length by Collier (and colleagues, see Collier and Hoeffler 2000; Collier and Sambanis 2007a; 2007b; Collier et al. 2003; Collier 2006) and by Berdal and Malone (2000). That is to say, while a resource income from a limited source should, in principle, provide capital for state investment and development, it more often leads to poor economic planning, corruption and violence.

What also often happens when an otherwise poor country has access to a single or limited source of high-value exports is that this then inflates the value of the national currency, beggaring its people by rendering alternative exports unprofitable. The economy of a country reliant upon a single or very few resources for its export income typically has few employment opportunities outside of the resource sector (Havranek et al. 2016). As a consequence, local manufacturing and services, and hence local employment, are commonly victims of the resource-driven rise in the currency's value. States that become reliant on a limited range of commodity exports, such as minerals, may often fail to diversify their economies, in large part due to the aforementioned uncompetitiveness, and hence when the source of income has been depleted such states find their lack of economic alternatives has rendered their state unsustainable.

98 *Economic structuring and trade relations*

Given the finite nature of resources, once they are depleted such countries commonly find other sectors of the economy are insufficiently developed even to begin filling the gap left by the decline in income after the bonanza has ceased. Avoiding this 'trap' can be managed but it does depend on a higher level of state organisation and deliberate diversification (Torvik 2009). Norway has been a solid example of harnessing resource wealth for long-term public benefit, although it is otherwise also a notably efficient, well-functioning and forward-planning developed country.

Finally, rent-seeking activity associated with valuable resources (gaining extra income from existing wealth rather than creating new wealth) often leads to corruption and nepotism. This applies in particular to large resource developers bribing officials to secure or retain contracts, letting contracts for associated supplies to 'preferred' tenderers, and so on. While corruption is not a necessary concomitant of resource development, it is common, especially in countries reliant on a sole resource, or a limited range of resources, and where other opportunities for personal enrichment are limited (Ross 2011). As the IMF notes (2017c), countries that are extremely resource-dependent do not qualify as 'developed' regardless of their overall level of wealth.

In all of this, whether a developing country derives income from a single or limited range of exports or from a range of basic commodities or simple manufactures, its capacity to generate income is determined by external markets. This then raises the question of the extent to which developing countries are able to set prices in a globalised market and the extent to which they remain vulnerable to high levels of competition for limited markets.

Dependency and its critics

Discussing the issue of 'dependency' in the 21st century might seem unfashionable. However, the 'dependency' school offered a solid critique of early globalisation and the effects of *laissez-faire* economics from a developing-country perspective. Despite the more deterministic forecasts that flowed from its argument having proved of questionable accuracy, parts of its critique continue to resonate.

This central idea of dependency analysis was that, as with colonies before them, less or least developed states were in a negative structural economic relationship with developed states as a logical consequence of the organisation of global capitalism. This was exacerbated by their being on the 'periphery' of global capitalism, reflecting their marginal economic value and political impact. Until the 1970s the persistence of poverty in developing countries due to what amounted to an international division of labor was a popular explanation for the failure of modernisation (Baran 1952; Gunder Frank 1967; Dos Santos 1970). This international division of labor was, in many cases, in turn based on earlier forms of colonial exploitation (Rodney 1972).

Within the broad 'dependency theory' paradigm, international trade relations were characterised by a set of interrelated approaches which located the economic core of such relations in an essentially exploitative relationship between developing countries and their former colonial masters. The logic of this 'dependency' approach was that, reflecting their position as supplicants, the more a developing country engaged in trade with developed countries the more developing countries would lose ground.

The dependency model was initially developed in an attempt to understand why Latin American states – failing to develop local industry and thus remaining vulnerable exporters of coveted commodities – had declined relative to the United States. Analysis by the United Nations Economic Commission for Latin America and the Caribbean (ECLAC) found that

the terms of trade, principally set by the U.S., reflected an 'unequal exchange' (Singer 1949; Prebisch 1950; Toye and Toye 2003). In short, U.S.-mandated prices produced a greater return on its own (investor) input than on its Latin American trading partners' (producer) input. The Latin American export sector grew, but not as quickly as its major export markets, forcing these Central and South American states to buy fewer industrial goods over time and hence leading to their relative impoverishment.

It has been suggested that the Singer-Prebisch thesis on unequal trade, as it came to be known, was a Marxian analysis of trade relations. There is no doubt Marxist methods of analysis were influential in much of the dependency debate, as they equally were in other critiques of capitalism during the second half of the 19th century. But the thesis also appeared to be supported by data analysed from a non-ideological perspective (see Hirschman 1981; Harvey et al. 2010). That there was a critique of the influence of Marxism in the development of dependency theory, it was used pejoratively by conservative economic analysts or, more commonly, politicians whose intent was to discredit. That said, inequalities in trade were not the exclusive outcome of capitalist modes of exchange: disaggregated analysis shows economic outcomes varying across a range of case studies (Cuddington 1992; Benita and Urzua 2016).

Growth across the region was also very unequally distributed, with large parts of national populations remaining poor, or in some cases becoming poorer, while smaller numbers in the land-owning and industrial classes grew wealthier. The view developed in the late 1960s and early '70s that Latin America's wealthy elite became wealthy by entering into trade agreements with the U.S. that enriched both them and their American collaborators at the expense of their own citizens. As 'buyers' of local labor, or the products of that labor, the dependency school christened them 'comprador [buyer] elites'.

There were debates and disagreements within the dependency school, primarily over whether developing countries had the potential to break out of their economic servility with or without first undertaking a political revolution (Gunder Frank 1969). Splits in the movement opened up between 'reformists' and 'radicals'. Regardless of such rifts, consensus held around the inability of developing countries on the 'periphery' to become technological innovators because of their dependent relationship with the 'centre'. A parallel debate later took place, with one side arguing that the 'centre' inevitably sapped the financial strength of peripheral states, limiting their self-sufficiency and increasing their dependency (Cardoso 1972; Cardoso and Faletto 1979).

The dependency school held considerable sway at the height of social and political tumult in the late 1960s and '70s, but its central premise was ultimately confounded by the success of such post-colonial or developing economies as Singapore, Hong Kong, Taiwan and South Korea, and the escape of some others from 'dependent' status.

The development of these economies was based on what has been referred to as the 'flying geese' paradigm (originated by Akamatsu 1962), in which a dynamic division of labor based on comparative advantage allows (East) Asian states to develop their economies as part of a regional economic hierarchy. The central idea of this model is that as a lead state, or 'goose', (in this case, Japan) develops its economy through government intervention and economic direction, its labor costs increase in line with increased exports and technological advance. It then sheds lower level technology industries to nearby states – second-tier 'geese' – with lower labor costs, in this case South Korea, Taiwan, Hong Kong and Singapore. They, in turn, do the same as their own economies develop in sophistication. The third tier countries in this model include Thailand, Malaysia and Indonesia, with fourth tier countries being China, Vietnam and the Philippines (see also Blomqvist 1996; Kojima 2000).

100 *Economic structuring and trade relations*

The down-side of the flying geese model is not that it has not worked, but that it assumes the necessity of a 'lead goose' (Japan), that such a 'lead goose' will continue to develop up the value chain rather than at some point stagnate, as Japan has effectively done. It also assumes that this technological advance will continuously shed lower value industries to lower order countries rather than stabilise or markedly slow at a particular level of technological development, and that other such countries will not, themselves develop quickly independently of such an approach. Singapore and China are examples of relatively quick and independent development.

Beyond this, the economic modeling built on this continued technological advance was less certain, given it relies on steady markets and reliable flows of capital. The Asian Economic Crisis of 1997–1998 in large part reflected a failure of these two assumptions; production exceeded market capacity and nervous bankers stalled the flow of capital (if to overly debt-geared economies), leading to major economic downturns and political fallout as previously discussed.

Importantly, the flying geese model, as with other forms of economic restructuring, produces winners within economies as well as losers, as some technologies – and the people they employ – become redundant. This in turn has a direct impact upon political decision-making processes and, in participatory political processes such as democracies, can produce significant political backlash. The employment of this model, then, and the economic restructuring it consistently required, was best suited to states that did not have to balance social costs against developmentalist imperatives. That is, it worked, in part, because the states that employed it – apart from Japan, which had a single party in power continuously, but for one year, from 1955 to 2009 – also employed authoritarian, sometimes brutal, political models that only gave way after some degree of economic development had been achieved. In the case of Indonesia, the model never really took off and economic progress collapsed in 1998 in any case, leading to significant political reform.

Where states did develop, local conditions – such as closed political systems – were regarded as being at least as important as external factors. The existence of exceptions gave other developing countries hope they could become less dependent also. The way forward, it seemed to them, lay with governments making 'good decisions' and resurrecting the role of national business classes that would stop exploiting and impoverishing the working class and start cooperating with it.

Yet another critique of dependency theory surfaced, dividing those observers who saw a role for the IMF and other financier institutions in alleviating poverty and those who saw such a notion as a chimera. So, too, a new wave of feminists argued that dependency theory was male-centred and should pay more attention to the role women played, particularly in the 'silent' economy of unpaid labor.

Over the past decade, the continued stagnation and regression of many developing-country economies have prompted the revival of dependency theory in what is called a 'neo-dependency' approach – more nuanced than the original in its attempt to account for successes as well as failures in the world of under-developed economies (Hearth 2008; Heller, Rueschemeyer and Snyder 2009; Wibbles 2009; Hackett 2014). 'Dependency' redux grants governments more 'agency' in yielding poor development outcomes, while acknowledging that over-reliance on commodity exports where they exercise little or no control over pricing continues to keep many a state in a straitjacket of trade imbalance and market powerlessness. A particular vulnerability of developing countries is debt, which has sometimes appeared as attractive but which has been accrued on non-viable projects on an unsustainable basis, with all too often political elites benefiting from the inflows of cash.

Economic structuring and trade relations 101

Unsustainable debt

Despite the dependency critique adapting to recognise the role played by international finance, many developing countries nonetheless borrowed heavily throughout the 1970s (including those in Latin America where the dependency school was most influential). After the 1973 oil-price crisis (sparked by an embargo on exports to the U.S.), lending institutions were awash with cash from recently enriched oil exporters (Spero and Hart 2010:25–27). Interest rates had risen but remained fairly affordable, and there was not yet a repudiation of the Keynesian view that government debt, usually for major infrastructure projects, was a means of stimulating economic activity and thus validated as an investment in the future. Such 'investments' were often poorly conceived and in many cases their funds were syphoned off by corrupt political leaders. So it was not surprising that many failed to generate returns as expected – and it was only a matter of time before swingeing debt repayments would debilitate developing-country economies.

In Latin America alone, debt soared from $US75 billion in 1975 to over $US315 billion by 1983, while in Africa it ballooned from $US2 billion in 1975 to $US8 billion by 1982 (Moyo 2009:18). In 1979 the second oil shock, sparked by abrupt price rises announced by two members of OPEC (the Organization of Petroleum Exporting Countries) and a subsequent global recession, placed insurmountable pressure on debt-laden developing countries. This was often exacerbated by falling commodity prices, particularly for agricultural goods upon which many of them relied, and the insistence of banks on 'calling in' their debts when they fell due. From stumbling forward under debt burdens, many countries began hurtling towards the precipice of default, starting with Mexico in 1982 and followed by Brazil, Argentina and almost a dozen countries in sub-Saharan Africa. In Latin America the 1980s are remembered as the 'lost decade' when nations' debt repayments often exceeded their annual income (Schaeffer 2009:83, 278).

As the decade wore on, the number of developing countries that found themselves with excessive, often unsustainable, levels of international debt led the IMF to consider the radical solution of imposing stringent 'belt-tightening' and a strict repayment schedule. Thus were born what became known as IMF-led 'structural adjustment programs' (SAPs). Amid this shift in focus towards repairing national economies, many of which were being weaned off import substitution and reoriented towards exports, the dependency school's days as the dominant analytic position drew to a close.

It would not be until the 2000s that 'neo-dependency' as a practical approach to unequal trade relations would regain anything like the pre-eminence of its predecessor. It offered a more detailed, nuanced and country-specific critique of trading relations among developed and developing countries. It also recognised, importantly, that mismanagement, corruption, insecurity, violence and inwardly focused economic policies all contributed to poor development outcomes. But it retained and re-popularised the view, in an increasingly deregulated world, that an untrammelled world market was still essentially exploitative and that, if smaller, more vulnerable states were to have any chance of growing and stabilising their economies, they needed structural buffering against the worst their trading 'partners' could do. In part this buffering has been developed through more localised preferential trading systems, or trade blocs.

Trade blocs

Forming regional trade blocs has been one method whereby developing countries have guaranteed trade without the detriments that stem from bearing the brunt of a global trade

imbalance. Trading blocs are based on inter-governmental agreement, usually to reduce or eliminate tariffs on imports. Countries in a trading bloc seek out a measure of complementarity: one country's manufacturing sector may depend on a certain commodity produced by the other; and by joining forces the pair can create internal economies of scale, allowing the volume of their trade to expand.

That is the theory, at least: there is debate about whether regional economic blocs limit free trade overall. Given that such a debate is based on counter-factuals – propositions in contrast to a given reality – there can be no clear answer to such a question. But such blocs, initially popular in the 1960s and '70s, have again become so since the collapse of the Soviet Union.

Such blocs can take several forms. They include: economic and monetary unions, employing a single currency; simple economic unions; customs and monetary unions; simple customs unions; common markets; and multilateral free-trade areas. An example of an economic and monetary union among developing countries is the Caribbean Single Market and Economy (CSME), established in 1990, in which the member countries harmonise their economic policies and refrain from imposing duties on one another – thus establishing economies of scale to the benefit of both internal and external trade.

Simple economic union is exemplified by the Central American Integration System (SICA), which treats air travel as 'internal', has a collective mobile phone and data network, operates a regional prison where criminals whose offences are committed with a disregard for national borders are incarcerated, and has founded the Central American Bank for Economic Integration. Cooperation at this level is not easy to come by: a number of prior efforts to bring about economic or financial harmonies of Central America's economies foundered.

The Central African Economic and Monetary Union (CEMAC) is an exemplar of the model that combines a joint approach on customs and currency. Apart from creating autonomous financing mechanisms, and integrating economic and monetary policy, CEMAC seeks to foster regional peace, security and stability as prerequisites for economic development.

Perhaps the world's leading example of a common market among developing countries is the Association of Southeast Asian Nations (ASEAN) Free Trade Area. ASEAN states do not have a common external tariff but, apart from sensitive commodities such as rice, they mostly cap internal tariffs at 5 per cent (although its newest members have been given more time to comply). The ASEAN Free Trade Area grew out of ASEAN, which was established to overcome regional animosities in the early 1960s.

The East African Community is a good example of a developing-world customs union, with a common tariff imposed on external countries, duty-free trade within the bloc and joint customs procedures. Plans are afoot for even closer economic integration between the member countries, including a common currency, ahead of eventual federation with a rotating presidency.

The final type of trading bloc in this summation is the multilateral free-trade area. True to type, the South Asia Free Trade Area (SAFTA) exists to remove trade and other barriers, including duties and non-tariff concessions, between member countries.

Many of these and other trading blocs have varying levels of success in implementing their programs. Delays between promise and delivery are common and, as noted in the Central American example, fresh attempts at regional cooperation may be made on the back of failed precedents. All the attempts imply some loss of state autonomy in economic policy, sparking internal political resistance. But, on balance, countries involved in such arrangements appear to prefer their continuance rather than engaging alone with the

Economic structuring and trade relations 103

global market. They are painfully aware that in their isolation under-developed countries can only benefit by clubbing together to counter the advantages often conferred upon larger or more economically advanced countries.

Most important of all, these countries' potential wealth is often tied to the exploitation of a narrow range of basic commodities for sale in markets already swamped with them. Coffee is a prime example: fifty countries, or about a quarter of the world's total, grow coffee. In 2016, exporting nations were part of a $US12 billion industry (Abbink 2016) based on beans 'mostly consumed by industrialized nations while being produced by the world's underclass' (Goldschein 2011). Coffee is the biggest export earner for Ethiopia (where it originated), Burundi, Uganda, Nicaragua and Guatemala, the second biggest for Honduras and third biggest for Kenya and Colombia.

Further reflecting the real-world inequalities of global trade, the 'farm gate' price of coffee between 1995 and 2016 averaged $US1.08 a pound, or $US2.38 a kilo. Prices spiked to over $US1.75 a pound in 1997 and peaked at $US2.25 in 2011. But these are outliers, reflecting a poor harvest from the world's largest coffee supplier, Brazil: for an entire decade beginning in 1997, a buyer's market prevailed, with prices plunging below 50 cents a pound in 2000–2003 (ICO 2016), so that to growers and marketers alike the term 'coffee crisis' (ICO 2014:2) is recognised shorthand for that dire period. While average prices fluctuated between peak and trough years, significant price disparities between market competitors coexisted with large variations in local cost inputs. 'Higher prices realized in some locations do not imply greater prosperity for growers. These will typically be locations where yields are low and operating costs high, usually due to a climate that is minimally supportive of coffee cultivation' (Abbink 2016).

Notably, global coffee prices declined from 1990 in direct relation to the deregulation of trade under what became known as the Washington Consensus period of neo-liberal economic change. The term often associated with this change is 'reform', although the word is problematic given that it has a normative value and actually means a change for the better. While changes of this period did enhance the flow of trade, their social consequences were at best uneven, privileging a global minority while leaving the global majority, relatively speaking, poorer than before.

While coffee producers earned an average of just under $US12 billion per annum between 1990 and 2012, the total value of the coffee industry was more than $US173 billion a year (ICO 2014:12). That is, coffee producers received around 7 per cent of the total value of the trade. Assuming a conventional retail price breakdown of 40 per cent to the manufacturer or grower, 20 per cent wholesale and 40 per cent retail, growers still received only a quarter of the wholesale price, with the difference going to buyers.

Overall, while global agricultural production – tracking population increases – has increased steadily since 1960, both production and consumption in sub-Saharan Africa have declined as population rose sharply. This counter-trend disadvantaged the region even further with respect to global terms of trade, compounded by a declining share of global trade for agricultural products relative to manufactures – down from 20 per cent in the 1970s to half that share by 1997 (FAO 1999).

This average figure actually conceals the much greater dependence on agricultural trade of many individual countries, as both exporters and importers. In around a quarter of developing countries, agricultural exports exceeded two-thirds of all exports in the mid-1990s, while it exceeded one-third of all exports in another 20 per cent. Low-income countries remain the most dependent on agriculture, often relying on one crop or at most a small number of agricultural items for the bulk of their foreign-exchange revenue (FAO 1999).

104 *Economic structuring and trade relations*

This reliance was particularly exacerbated by a drop in global prices for food products in the last quarter of the 20th century: in real terms they did not return to near pre-1975 levels until after 2008 (FAO 2009). The impact upon many food-producing countries – particularly those with a less diversified economic base – was severe.

Despite the equivocal value of deregulated trade for more vulnerable economies, the World Trade Organization (WTO) continued to push for the admittance of least developed countries – the most vulnerable of all – into the organisation. To join the club meant signing up to all its rules, stringent as they were:

> As well as numerous requirements in the area of non-tariff barriers and other trade rules, countries must agree to apply tariff policies consistently among all WTO members and cap their tariff rates on inbound goods, with specific rules applying to agriculture goods exports, among numerous other things.
>
> Lomas 2017

It was a moot point whether acceding to the WTO's rules would produce positive trade benefits for least developed countries, as several were themselves pushing to become members, among them Timor-Leste and Somalia.

Free-trade dispute in Central America

Free trade does not always produce the unalloyed benefits often claimed for it. One of the marks against it, according to detractors, is that it reduces state sovereignty, particularly in relation to financial flows, constructive trade and investment. Nowhere has the issue of free trade clashing with state sovereignty been more marked than in the Central American state of El Salvador.

A stream that flows into El Salvador's San Sebastian River runs bright yellow, not for the gold in the mine nearby but with the chemicals leaching into it from that mine. The stream was emblematic of the central issue in a fight between a U.S.-registered, Australian-based mining company and the Salvadorean government over whether there should be gold mining in the country. According to the company, OceanaGold, the U.S.'s free trade agreement with Central America gave it a right to mine for gold that even the government of El Salvador could not block. El Salvador's government countered that to impose free-trade rules which damaged the lives of its citizens – limiting the supply of potable water – was illegal. At stake were the preservation of a bipartisan policy on mining and a sovereign nation's right to make policy generally and protect its most vital water source. If El Salvador lost the fight, then a foreign mining company would have ridden roughshod over democratic process and prosecuted a financial claim the country could not afford.

The yellow stream that gold mining created is a consequence of 'acid mine drainage'. This contaminated tributary had already killed off all aquatic life in the Lempa River, and caused further environmental damage near its outflow into the Pacific.

Nearby San Sebastian village suffered a high rate of disease linked to arsenic poisoning as a result of this pollution. El Salvador's government believed that success for the company's attempt to force the opening of a new mine could have had devastating consequences for the country's limited supplies of fresh water.

Reacting to the government refusal to issue a gold-mining permit, OceanaGold had sued El Salvador for $US248 million in a U.S.-based court. This sum was almost half the

Economic structuring and trade relations 105

country's annual budget. OceanaGold claimed that under the U.S.–Central America free-trade agreement it had a 'right' to mine or be compensated for loss of profits. Upon acquiring the Canadian company Pacific Rim in November 2013, OceanaGold knew that the government in San Salvador had refused to grant a gold-mining permit for that company's El Dorado prospecting site but it proceeded in disregard – some would say in cavalier defiance – of that fact.

Gold mining is notorious for polluting waterways with arsenic, mercury and other toxic metals. Just 2 per cent of El Salvador's water has been deemed by its government to be of good quality and prior exploration at the El Dorado site had already befouled clean groundwater. Further pollution, especially of the country's main watershed close to the proposed mine, would have disastrous consequences for El Salvador's poor and densely packed population. El Dorado gold mine instead became a protest site, as a result of which ten people were killed and others received death threats.[1]

In 2016, the World Bank's International Centre for Settlement of Investment Disputes found for the government of El Salvador. It ordered OceanaGold to pay $US8 million to El Salvador to cover its legal costs. With other potential mining claims against El Salvador waiting in the wings, the court's decision secured a small and poor country's right to protect its environment in the face of a 'free-trade agreement'.

Africa rising?

Among developing countries and regions, sub-Saharan Africa has a long and consistent history of slow and relatively low levels of economic and political development. Indeed, Africa has been something of a byword for failure to achieve the promise held out by decolonisation. Of course, the 'promise' of decolonisation always exceeded achievable reality there as elsewhere, with such structural issues as the cost of mounting wars of liberation, under-developed institutional capacity, weak investment, ethnic divisions and (sometimes) the added burden of reparations all conspiring against successful statehood.

Soon after the dawn of the 21st century, sub-Saharan Africa was being championed by many as having entered a new phase of economic and political development. Many a past conflict had been resolved and a number of countries began to engage with self-reinforcing democratic principles (Siebrits, Jansen and Du Plessis 2015). While a reduction in civil conflict within this extensive region can be traced back to several factors, it may be that one of them is the increase in elections (Diamond 2008), which are, after all, an ideally non-violent form of conflict resolution – even if election outcomes in these states were often compromises or 'hybrids' (Lynch and Crawford 2011).

Simultaneously, and partly connected, with this political shift was a marked improvement in sub-Saharan Africa's GDP, leading to the optimistic headline 'Africa Rising' in a 2011 edition of *The Economist* magazine, which noted: 'After decades of slow growth, Africa has a real chance to follow in the footsteps of Asia'. This sense of new possibilities for the continent was based on price rises for raw commodities ('the resources mining boom', as it was known in Australia), from which a cluster of commodity-exporting countries, in Africa as elsewhere, received windfall profits. There was a sense that African states were finally escaping a long cycle of under-industrialisation, poverty and dependence.

Yet what was happening was a cyclical mineral resources boom, which like all such 'booms' could not and did not last. A key demand driver in this boom, China, saw its

106 *Economic structuring and trade relations*

economy dive from 14 per cent growth in 2007 to 6 per cent in 2008–2009 because of a sudden drop in demand on the back of the GFC, or Great Recession as it was otherwise known. Its economy revived to 12 per cent growth in 2011. It plateaued in 2013 at 7.5 per cent but has eased back towards 6 per cent since then (Eckart 2016).

Other manufacturing states continued to buy commodities but, with their economies still reeling from the Global Economic Crisis of 2008 onwards, global demand abated considerably. By 2015–2016, mineral prices had slumped and the heady days of profiteering via rent-seeking behaviors in which sovereign states received royalties from foreign companies for extracting their riches were a thing of the past.

Predictably, the resources boom was characterised by foreign investment and resource extraction. There was some investment in specific infrastructure, but little to none in value-adding. Not only had little other industrialisation taken place, but the currencies of many minerals-exporting countries were temporarily inflated (which helped explain why value-adding and industrialisation were held back). More immediately noticeable, their resources boom produced trade price barriers in those industries that did exist. For all these reasons combined, growth in sub-Saharan Africa plunged to its lowest ebb in more than two decades, according to the IMF. Chad, the DRC, Equatorial Guinea, South Sudan, Nigeria, Liberia and Burundi all went into recession in 2016 – and all but Burundi are resource-intensive countries. Nine others recorded sub-median growth, with two others straddling the 3.7 per cent median line (IMF 2017b).

Perils seldom come singly. Sub-Saharan growth was slowed not just by declining commodity prices but by drought, crop blight and security issues. Inasmuch as the resources boom promoted 'development', it implied a brief quantitative change rather than a reorientation of regional economies towards longer-term or more sustainable growth models, much less qualitative social change.

A maritime boundary dispute

Regardless of whether the 'dependency' or 'neo-dependency' argument wins out, few would dispute that larger economies exercise greater power in trade relations and access to resources than do smaller economies, El Salvador's legal victory notwithstanding. Smaller economies tend to be more vulnerable to market forces and have fewer options as to where and with whom they can trade. This is particularly so if the economy is a commodity exporter, and nowhere more so than when it is in competition with other exporters of a rare and much prized commodity.

These facts of economic life have created a global pecking order, in which the largest economies have most capacity to strike deals in their favor. Middle-income economies may be vulnerable to such deals but can exercise greater control over trade outcomes than small economies and especially micro-economies.

Of the world's ten largest economies, China, India and Brazil are included among the middle-income ranks, with China, as the world's second largest economy, having achieved, 'middle-income'[2] status (World Bank 2017c) while India was just edging into the lower-middle-income bracket. Even a wealthy country such as Australia (tenth in global per capita GDP) was vulnerable to China's setting the terms of trade for its resource exports, as well as to any downgrading of China's economic performance and hence fluctuations in demand (RBA 2017:15–16). But Australia, in turn, was able to flex its economic muscles in relation to some of its smaller neighbors, in particular the very new, and still deeply impoverished, nation-state of Timor-Leste.

Economic structuring and trade relations 107

Australia's relationship with its tiny neighbor stood as a textbook illustration of how unfair economic relations can evolve between larger powers and small, vulnerable post-colonial states. In 1975, Australia watched on as Indonesia invaded Timor-Leste, occupying it for twenty-four years and, in the process, leaving around a quarter of its population dead (Chega 2005:7.2, 7.3).[3] During this time, Australia and Indonesia struck an agreement to divide up the oil and gas resources of the Timor Sea between Australia and occupied Timor-Leste without setting a permanent maritime boundary, but it was a classic sphere-of-influence accord from which Australia benefited significantly (Timor Gap Treaty 1989).

In 1999, under domestic and international pressure, Australia led a UN-sanctioned military mission to Timor-Leste after it had voted overwhelmingly for independence. Briefly, Australia was seen as a liberating country rather than one that had turned its back on a quarter-century of horror. Yet, within three years, Australia had foisted upon Timor-Leste a replica of the agreement it had with Indonesia on the division of spoils from the Timor Sea, spoils that under the Law of the Sea belonged to Timor-Leste (Timor Sea Treaty 2003; CMATS 2006). As a newly independent state, Timor-Leste agreed to the deal simply because it had no other source of income. Oil receipts thereafter became the country's economic lifeblood, providing more than 90 per cent of government income and underpinning more than 80 per cent of the national economy, which made Timor-Leste – as previously noted – the most oil-dependent country in the world.

With the possibility of developing a new liquefied natural gas field situated partly on Timor-Leste's side of the disputed Timor Sea, Dili argued for a permanent maritime boundary to be drawn between it and Australia, which would have redeemed its claim to the (remaining) Timor Sea resources. Compelled to go before the Permanent Court of Arbitration, Australia eventually agreed a permanent maritime boundary that necessitated a compromise on future proceeds of revenue-sharing (Australia–T-L 2017).

On 30 August 2017, the two countries announced they were at one on the 'central elements' of an agreement to resolve their maritime sovereignty dispute which had ramifications for the zone's oil and gas resources. While going to The Hague had marked a low point in bilateral relations, the ensuing resolution did provide certainty for a resource-sharing arrangement in respect of the Greater Sunrise LNG field. By implication, part of the field would remain in Australian waters, contrary to Timor-Leste's original stance of fixing the common frontier at the midpoint as provided for by the UN Convention on the Law of the Sea.

The agreement's draft text referred to 'establishment of a Special Regime for Greater Sunrise, [and] a pathway to the development of the resource' (Australia–T-L 2017). While Timor-Leste's hopes of processing the LNG at a yet-to-be-built refinery on the country's south coast were not vitiated by the agreement, this was unlikely.

The lead Greater Sunrise partner, Woodside Petroleum, rejected the south coast option, instead opting for a floating processing platform. The quickest option – one likely to produce revenue for Timor-Leste in time to prop up its falling income stream – would be to backfill an existing oil pipe from the Bayu-Undan field, which is expected to run dry by 2022.

This apparent compromise was evidently in tune with the more pragmatic, conciliatory approach of Timor-Leste's recently appointed prime minister, Mari Alkatiri. It did not sit well with the previously announced position of his immediate predecessor, Xanana Gusmao, who had always argued that all of Greater Sunrise should fall within the country's territorial claim, and had advocated processing on the south coast. But, after the elections that brought him to power, Alkatiri had retained Gusmao as lead negotiator on the Timor

108 *Economic structuring and trade relations*

Sea – and that guaranteed a certain continuity since the former PM had simultaneously served as the Minister for Planning and Strategic Investment.

While Australia had long claimed that the development of Greater Sunrise was a purely commercial matter on which it had no view, Canberra had spied on a Timor-Leste Cabinet meeting to discover Dili's position on the Timor Sea negotiations. Canberra repeatedly argued that Timor-Leste could not take it to court over the matter – right up until Timor-Leste took it to court. The Australian government even raided the office of the Australian lawyer representing Timor-Leste and seized files, returning them only later under a court order. And it blocked a key Australian witness – believed to be a former intelligence officer – from testifying before the hearing. Beyond that, Australia submitted that the court's jurisdiction was invalid, an argument rejected by the arbitrators.

In the end, Australia was forced to the table and agreed to fix a permanent maritime boundary. As with El Salvador and the United States, the case of *Timor-Leste v. Commonwealth of Australia* showed that, while larger states and their businesses could exercise disproportionate influence over economic and financial arrangements (and, on this occasion, even propose to determine international frontiers), smaller states also had legitimate claims under international law.

China's ambitious trade policy

For a rapidly growing and already large economy, China was keen not just to invest internationally and strike preferential trade deals: the country, the ancient infrastructure of which included the Great Wall and the Grand Canal, now embarked on an ambitious long-term trade and investment project it dubbed the 'Belt and Road Initiative' (BRI, previously called One Belt, One Road).

The BRI is a major trade and infrastructure project aimed at increasing the 'connectivity' of Asia with Europe and parts of Africa. The project, centrepiece of President Xi Jinping's vision for China to become the world's economic and strategic 'leading power' by 2050 (Shi 2017), entailed a massive injection of funds for infrastructural development in partner countries with the goals of boosting trade, vastly expanding China's 'soft power' diplomacy and forging strategic links throughout Asia, the Indian Ocean and East Africa.

The project is based on China's state-owned enterprises (SOEs) being strengthened and extended, rebalancing the nation's significant regional economic disparities by developing its less advanced central and western regions. The aim is to construct a foundation for export trade along a reinvented version of the old Silk Road between China and the West. Known under the plan as the 'Silk Road Economic Belt', it will wind through Central Asia (Kazakhstan, Kyrgyzstan, Uzbekistan, Tajikistan and Turkmenistan) to Russia, Europe, the Middle East and as far as the Mediterranean.

Further 'belt' roads will extend south into peninsular Southeast Asia and over into South Asia (predominantly to Pakistan via the 'China–Pakistan Economic Corridor'), replicating part of the ancient south-west Silk Road which also reached as far as the historical Indian region of Kolinga, on the Bay of Bengal, thereby providing further maritime access. At the time of writing, India had not yet joined the BRI but was expected to do so for fear of becoming economically and strategically isolated. The initiative also strengthens China's economic position *vis-à-vis* India, its principal regional rival.

The 'Maritime Silk Road' would cross the South China Sea to the Pacific Ocean and Southeast Asia's littoral states – taking in the strategically vital Strait of Malacca, which will further focus China's attention on that part of the world – while extending even further

afield to India, East Africa, the Middle East and ultimately via the Suez Canal to the Mediterranean states.

The BRI is breath-taking and unprecedented in scope, being the world's largest single development undertaking. With a projected cost of anything between $US2 trillion and $US3 trillion, it will be about twelve times the magnitude of the Marshall Plan which rebuilt Europe after World War II, and will link two-thirds of the world's population, affecting one-third of its GDP and about one-quarter of all goods and services globally (McKinsey 2017).

Funding for the projects was to come from a range of external banks, but be channelled through the Beijing-based multilateral Asia Infrastructure and Investment Bank, the Chinese government's $US40 billion Silk Road Fund and the Shanghai-based New Development Bank (formerly the BRICS Development Bank).

While the BRI will very likely stimulate trade, it will do so on China's terms, not least because China will either own, or hold the mortgages over, much of its infrastructure. This inevitably raises issues of strategic purpose and reach, which cannot but be fortified by the initiative. It is in China's interests to maintain cordial relations with its string of new closer trading partners, but it is also in its interest to *protect* that interest, and maximise the benefit to Beijing. As a result: 'Many foreign policy analysts view this initiative largely through a geopolitical lens, seeing it as Beijing's attempt to gain political leverage over its neighbors. There is no doubt that is part of Beijing's strategic calculation' (Cai 2017).

A strategic element will be an ever-present corollary of the BRI, as it is in other Chinese development projects: in the Indian Ocean (the ports of Hambantota, Sri Lanka and Gwadar, Pakistan), Laos, Cambodia, Myanmar, Timor-Leste and assorted sub-Saharan states. How China deploys its ascendant trading and, by extension, economic and strategic power, is expected to shape the world in ways that could hardly have been guessed at the turn of the last century.

Conclusion

Developing countries are largely defined by their economies and, in many respects, their economic opportunities define the options available to them. Of course, careful planning and management play an important role in their economies, but they often lack the human and institutional capacity to plan with wisdom and foresight at the inception of their existence as independent nations.

Very often, the management of developing-country economies is complicated by their reliance upon raw resources. The relative simplicity of accessing them and the lure of wealth they can generate make for sub-standard governance – almost inviting bribery, corruption and nepotism. Such an unpromising outlook is further aggravated where limited or single income sources exist, stifling the prospects for economic diversification and longer-term development. What is known as the 'resources curse' undermines both – but, at its worst, has led to open warfare for control of the coveted treasure. The risk of overreliance on resources is not only that 'developing' nations will fail to develop – a cruel paradox in itself – but that they will squander those resources which, it need hardly be added, are unrenewable.

Unless a country is 'blessed' (rather than cursed) with abundant commodities for export, the developing country and its developed trading partners are liable to create an imbalance in their terms of trade. This is driven largely by lower commodity prices as well as the often limited bargaining capacity of the exporting nations.

110 *Economic structuring and trade relations*

Such unbalanced trade is a key marker of an economically unequal relationship. As the weaker trading partner becomes reliant on foreign capital to underwrite its progress – which is by no means guaranteed – the combination of poor advice, poor planning and poor governance often paves the way to extreme indebtedness.

So, as developing countries seek to improve their economic position, they often face technological shortfalls, finding themselves unable to deploy technology effectively and struggling with cost overruns. Each of these issues further traps such countries in a cycle of reliance upon commodities and low-value-added exports. The further the world surges ahead in the race for development, the further behind so-called developing countries lag.

Finally, in their quest for prosperity, many developing countries exploit their resources without proper regard for the wider environment, in particular their water, forests and air. In some cases the lure of a quick profit brings about their downfall, attended by poor governance and oversight processes. Where developing countries have exploited resources, for example clearing forests, and been criticised by governments and NGOs in the developed world, they have replied it was through just such exploitation that their critics achieved their 'developed' status.

Importantly, though, many developing countries have learnt that they need to protect their environments to bolster the sustainability of other elements of their societies. They may prove unable in the short term to resist the widespread exploitation of their natural resources – something many developed countries also practice. But as the world moves towards acknowledging the need for a more sustainable future, developing countries are also joining that discussion. The question is, however, what political and economic model will produce the most beneficial results. The argument for accountable and representative government is a compelling one for many reasons, but the idea of a centrally controlled state directing the economy has also proven to be successful in those countries that have practised it. For political leaders less inclined to share power, and to ensure consistency of policy over the longer period, the standard western model is, as the next chapter discusses, now under challenge.

Notes

1 This section on gold mining in El Salvador was drawn from a research paper 'Gold, Water and the Struggle for Basic Rights in El Salvador' written by the author and published by Oxfam Australia. http://resources.oxfam.org.au/pages/view.php?ref=1508
2 It is worth noting that 'middle income' comprises a very wide economic band, from per capita GDP of \$US1,026 to \$12,475, with 'lower middle income' up to \$3,955 and 'higher middle income' over \$3,956 (World Bank 2017d).
3 Estimates range between 102,800 and 183,000 confirmed deaths, from a population of about 650,000 at the time of the invasion.

8 The Beijing Consensus versus the Washington Consensus

For at least two decades from the end of the Cold War, the so-called Washington Consensus was the dominant paradigm in international development. A reaction against the high debt levels of the 1970s and '80s, the Washington Consensus advocated reducing government debt by cutting government spending, lowering taxes and import tariffs and encouraging foreign direct investment and export ventures.

At the time of writing, nearly three decades have passed since the end of the Cold War and, arguably, it is still the most influential economic paradigm in global politics, even if in the past decade it has not gone unchallenged.

The chief challenge came from China, and like economic models that favored government-sponsored investment, along with a high level of political stability guaranteed by a restricted political framework rather than exposure to the unpredictable vagaries of democracy. Under this alternative, social order was given priority so that civil society organisations, and especially trade unions, were debarred from pursuing economic agendas other than those supported by the government.

This challenge was effective for two reasons. Firstly, the Washington Consensus was externally imposed and hence often resented. It was not always effective and, where it was, it generated new problems, fuelling public resentment and anger over the loss of basic services. Secondly, it was (or was supposed to be) a template for good governance and 'democratisation', which did not always suit political leaders with authoritarian and rent-seeking tendencies.

The Beijing Consensus, as its chief rival perhaps inevitably came to be named – by Joshua Cooper Ramo in a slimmish book by the same name (2004) – removed these political requirements and showed economies a way forward without what was sometimes seen as western moralising. That this model worked well for China and, to a lesser extent, for some other countries made it at least as attractive as the way the U.S. ordered its economic life. Finally, with the move away from U.S. economic and strategic hegemony, the world now has multiple foci of power, so for the first time since the Cold War smaller states have choices available to them – at least as many as the trio of choices the Cold War itself offered (capitalism, communism and non-alignment).

Paradigms

China's economic and strategic ascent can be seen as a return to historical normality, reversing a centuries-long decline for what has been a major world power for millennia. Similarly, the relative economic and strategic decline of the U.S. – even if at the time of writing it remains the world's most powerful state – reflects what might be termed a faster

112 *The Beijing Consensus versus Washington Consensus*

turnover of 'empires'. There is a sense, given its population and other statistics, that China is benefiting from the notion that great powers 'take turns' to lead the world, but there is more to its rise than that alone. Changes in the nature of global economics since the mid-1990s have been accompanied, and more recently surpassed, by technological change. It may be that some states were better positioned by virtue of the relationship between their economic structuring and political culture to take advantage of these two processes of change, while others were less adaptable.

Adapting Pena's analysis of distinctions between Brazil and Argentina, those between China and the U.S. may boil down to how much transnational norm diffusion and governance have been 'adequately designed and promoted by influential and legitimate actors but ... also ... "resonate" culturally with potential users and prospective supporters' (Pena 2016:9, 40–46; see also Snow and Benford 1992; Benford and Snow 2000). China has quickly adapted to such 'norm diffusion' which, moreover, resonates with its population. In the U.S., such norm diffusion has been slower and more reactionary, with large sections of the population deploring social and economic changes deriving from broader changes in the global environment. In this sense, Pena uses the term 'cultural' to refer to internalised political norms and behaviors based on past experience. This more 'active' resonance contrasts with an 'active'-North/'passive'-South model.

Pena argues that if

> resonance conditions are positive (i.e. [there is] alignment between semantic/institutional dimensions in the incoming frame and the receiving conditions) it can be assumed that this will have an amplifying effect over the brokerage abilities of, and influence of, certain types of players.
>
> Pena 2016:46

This might apply to China's successful adaptation to changing global market conditions, initiated in the 1980s but accelerating from the mid-1990s. By contrast, low resonance 'implies limited compatibility between global norms' and local political culture, and hence reduced capacity to adapt to the 'incoming frame'. This might seem to apply more to the U.S., in which the superpower has not adapted its capacity adequately in response to global norms, or indisputable economic and strategic realities, clinging to normative reference points that ruled the roost in much of the rest of the world from 1976 until the century's end but began to fragment around the end of the forty-five-year Cold War.

From around 1990, global geopolitics went from being bipolar in terms of superpower rivalry to unipolar but, by around 2010, the trend was increasingly towards multipolarity. In 2017–2018, a number of medium global actors such as Saudi Arabia, Iran and North Korea were exercising disproportionately high levels of regional influence. Economic and strategic realignments had shifted long-recognised 'frames' of understanding – and they were not the only state actors responsible. The economic development but, more important, strategic (re)assertiveness of Russia, the economic rise of India and Brazil, the internal turmoil but economic strength of the EU and China's effective superpower status all played their parts.

For the reasons stated above, the U.S. found itself confronting a vastly more complex global economic and strategic environment, and arguably one that did not 'resonate' with many of its people nor reflect the brokerage abilities and influence of its key political and economic actors. Indeed, this lack of adaptability in which the U.S. has found itself at cross-purposes with the global Zeitgeist extends, one could say, to politics across the West,

including the political party system that first flowered in the 19th century and developed into a global template for advocates of representative democracy. The liberal-democratic model thus developed to suit a relatively stable capitalist industrial system of economic organisation. The conventional western political parties spawned by this system have, in tandem with or because of the massive dislocations caused by globalisation and the 'disruptions' of the new technologies, fallen into increasing disfavor with their electorates. This has led to the fragmentation and polarisation of voting blocs once regarded as monolithic. Before this unravelling began, the apogee of that dominant global politico-economic model – identified by Fukuyama as 'the end of history' (1992) – fell under the general rubric of the Washington Consensus.

This 'consensus' marked the victory of neo-liberal economics over more distributionist Keynesianism and the welfare state that accompanied it. At the same time this was matched with advances in industrial technology and increased international competition which undermined the unity of a western support base for such policies. Working-class solidarity – a feature of western societies for a century – has since evaporated, in tandem with challenges to the social-democratic model that had been its political expression. The sense of communal unity behind core values that had provided workers considerable stability and a high degree of political and economic certainty splintered as the base of its support – a strong manufacturing industry – shrank and in many places disappeared from the scene altogether.

Parallel to the decline of western manufacturing have been related advances in technology, with the ubiquitous use of social media just one manifestation of how technology has changed life itself in the West, even if many westerners saw no immediate link between such advances, globalisation and new-fashioned 'norm diffusion'. Peasants on the English commons also did not understand industrialisation, until the commons were enclosed and they were effectively forced into newfangled 'factories'. Add to that the disempowerment and social atomisation caused by neo-liberalism and all the elements of a perfect storm were in place to instigate the political fragmentation as noted.

Accompanying this fragmentation has been the growth of single-issue politics: on one side, politicians of the Right cater to the social isolationism manifested in a dislike or fear of foreigners, refugees and asylum seekers; the Left woos voters by showing an interest in environmental sustainability, sometimes associated with a call for broader social change.

Polarisation of the political environment has offered fertile ground to the champions of communalist responses, populist politicians unafraid to abandon the 'sensible centre'. Theirs is a catch-all reaction to a sense of social dislocation, brought about by economic uncertainty but reflecting fundamental changes in technology and patterns of trade. Meanwhile, societies where communalism had long been the norm were more nimble in adapting to this brave new techno-world.

Weakening of the U.S. middle class through the application of more or less unbridled neo-liberalism precipitated its relative decline on the global stage. But it was the inability of its key decision-makers to understand and adapt to this social weakening, particularly in a changing global climate, that proved so critical. Add to that the socio-economic implications of technological change, and the future would belong to whatever state had policies 'adequately designed and promoted by influential and legitimate actors' which also 'resonated' with a population base within the context of a political system able to implement change deftly and with few qualms or compromises. That would be China, not the U.S.

The extraordinary growth of the Chinese middle class, perhaps the most marked feature of its economic rise, stemmed from this capacity for 'resonance'. This is not to suggest that

114 *The Beijing Consensus versus Washington Consensus*

China was not responsive to the needs of its people: it was, and closely monitored their needs and desires.

But China operates in a closed corporatist manner, as do Singapore and a number of other successful economies. Here, 'corporatism' is understood to mean the diffusion of a degree of power to a limited number of officially sanctioned and supervised groups within a non-pluralistic polity. In this respect, China is not a rigid dictatorship but engages in innovative, if controlled, ways of governing, including local (village) elections and other forms of restricted voting, and with the widespread and constant use of often very sophisticated opinion polls together with state surveillance of people's internet usage (Keane 2017).

Contrast this situation with the U.S., whose middle class has been diminished and fragmented. The Chinese Communist Party, if it was to secure the support of its growing middle class, had to ensure continuous economic growth and distribute the benefits of that growth. Thus there was considerable internal pressure – if not through the ballot box – to be flexible enough to harness the conditions for durable growth in an ever-changing socio-economic environment.

In the case of the U.S., the late 1970s saw the high point of its ability to adapt – for an idea, in this case neo-liberalism, to 'resonate'. Unfortunately for the U.S., it resonated but also presaged disaster: the military adventurism it unleashed took the form of triumphalism, which for a time gave Americans a sense of security, which in the long run rang hollow.

The Washington Consensus

The end of the Cold War found the U.S. dominant astride a unipolar world. The apotheosis of a belief (or at least an expression of public wish fulfilment) that this moment represented a timeless triumph of democracy and free markets, ushering in a sort of secular nirvana for all of humankind, was Fukuyama's 'end of history' proclamation. History may have been stopped in its tracks but soon picked itself up and resumed its course in open defiance of Fukuyama's utterance.

The Washington Consensus essentially comprised a series of policy prescriptions issued by the IMF and World Bank (led by the U.S. Federal Treasury) and intended to solve the core problems of crisis-wracked developing countries. These included economic liberalisation, macro-economic stabilisation (interest-rate intervention, reduced taxation, lower centralised spending and diminished debt), floating exchange rates, reduced tariffs, privatisation of state assets and open foreign direct investment policies. These were broadly defined as the key qualities of 'neo-liberalism'. But by the middle of the noughties these policies were yielding mixed results: some countries were on the road to more rapid development; others continued to stagnate, leading to questions around good governance and state capacity.

The assumed superiority of neo-liberalism was first battered by the Asian financial crisis, and the advent of different political and economic models that lifted China, India, Brazil and, to a lesser extent, Russia out of the doldrums. Later, a near fatal blow was delivered by the Global Financial Crisis, beginning with the 'subprime' mortgage crisis of 2007 which burst into a full-blown banking crisis the following year and reverberated around the world for years after that. The loss of financial liquidity in banks, the collapse of housing markets and the closure of financially exposed industries resulted in what became known in most of the world as the Great Recession[1] (2008–2012), leading in turn to widespread unemployment and hardship. This event shook confidence in free-market capitalism, particularly of the deregulated neo-liberal variety that had been championed by the United States until that time.

When unrestrained application of neo-liberal medicine threatened to kill the patient, creating the preconditions for serious long-term economic collapse, those who offered alternative remedies found a willing audience. One suggested answer, embraced quickly by some countries but less quickly by others, was greater regulation and government intervention in markets, the imposition of controls over certain types of (particularly speculative) investment and a more graduated approach to economic liberalisation.

Even the United States, author and erstwhile champion of neo-liberalism, abandoned its key precepts and pumped money into its economy to support failing financial institutions and manufacturing industries. The printing of money (referred to as 'quantitative easing'), supplied more financial liquidity while making U.S. exports more competitive on global markets. Ironically, these measures, which would ordinarily have seen the value of the U.S. dollar decline in relative terms, impacted upon it only briefly. New-found confidence in the U.S. economic system quickly pushed the greenback back up to pre-crisis levels, with competitor currencies such as the euro suffering as a number of its own economies grappled with the fallout from the Great Recession, the worst hit being Greece, Ireland, Portugal and Spain.

The direct influence of the city after whom the eponymous Washington Consensus was named has continued to decline as the alternatives have risen. If not quite a hapless giant, the U.S. is powerful but not all-powerful, a paradox neatly captured in the view of it as

> still too powerful to possess the humility to share the load of global leadership, but not powerful enough to demand obeisance from allies regardless of the circumstances. This complex balancing act [...] is made all the more complex and fraught by [President Donald] Trump's style of governing.
>
> Curran 2017

The Beijing Consensus and developmentalism

As the Great Recession convulsed much of the western world, non-democratic countries such as China, with higher degrees of state ownership and intervention and more restrictive financial policies such as controlled exchange rates, filled the global economic vacuum. In 2009, the nadir of North America's and Europe's economic misfortunes, China recorded 8 per cent growth, eclipsing still healthy growth rates in India, Brazil and a number of smaller, less exposed economies.[2] By 2015, a subset of emerging economies – those of Brazil, Russia, India, China and South Africa (the BRICS) – had a collective GDP greater than that of the U.S., Japan, Germany, Britain, France and Italy combined.

This fresh approach of limited political participation, a state-managed economy and state ownership of key enterprises, dubbed the Beijing Consensus (Ramo 2004), had proved it could generate economic expansion and thus be credible as a viable alternative to the Washington Consensus. While there is no core definition of the Beijing Consensus (and there has been some criticism that there is no consensus as to what this consensus stands for), it has come to represent any and all measures that were unlike those of the previously unchallenged Washington Consensus. Ramo (2004) did identify three qualities of such a consensus: constant innovation, sustainability and greater distribution of wealth, and higher levels of self-determination. Yet the Beijing Consensus as it has been applied, particularly by Beijing, has been based more on copying (or stealing) others' technology copyrights, low levels of sustainability and inequitable economic distribution, if with overall improvements in per capita GDP, and self-determination as defined by a separation from U.S. influence but not that of China.

116 *The Beijing Consensus versus Washington Consensus*

Within this, China's reassertion of its economic and strategic power was neither new nor unexpected, being consistent with the historical world view that placed China at the centre of the cosmos, in what was famously self-described as the Middle Kingdom. As long ago as 1949, the expression of this intention was clear: 'Ours will no longer be a nation subject to insult and humiliation. We have stood up' (Mao 2006:17). More to the point, China's much vaunted 'hide and bide' soft power approach to extending its influence, principally through development projects and 'soft' loans, increasingly gave way to a more assertive foreign policy position, from the second decade of the 21st century, under the leadership of Chinese President and Chinese Communist Party General Secretary Xi Jinping. This was nowhere better exemplified than in China's creation of 'islands' in the contested waters of the South China Sea and then, after claiming it would not do so, militarising those 'islands'.

As China demonstrated, the advantage of a one-party state for achieving rapid development is that, as it pushes ahead, it does not have to agonise over the disruptive impacts of such development, given the lack of political challengers. This economic model has been used by a number of other political systems, most notably after World War II in Singapore under Lee Kuan Yew. To illustrate China's economic rise: in 2004 its economy was less than half as big as that of the United States; by 2017 it had, arguably, become the world's largest, and was certainly its most robust. In the period between the ascension of Deng Xiaoping as party leader and 2012, China's 'middle class', defined as earning $US9,000–16,000 a year, swelled to just over half the population, with continued, if slowing, growth projected through to the 2020s (McKinsey 2013; Iskyan 2016). In this respect, the Beijing Consensus may be seen as aligned with Chinese President Xi Jinping's rejection of 'globalism' as a value system but embrace of globalisation for trading purposes, albeit under his highly centralised one-party state.

'Globalism' and 'globalisation' are commonly conflated and, in practical terms, the distinction between them is less than absolute. But, for the purpose of the exercise, 'globalism' implies the universal adoption of the Occident's political and moral agenda, including multilateralism, democratisation, respect for civil and political rights and the scope for collective international intervention in the affairs of other states. In that these values permeated to countries which had not previously adopted them, this has been partly owing to the ethical-political requirements of the IMF and World Bank which attached them as preconditions for the receipt of any structural adjustment or infrastructure development loans.

'Globalisation', on the other hand, should be construed as referring to the interconnectedness of states, favoring the relative openness of trade and the capacity of states to pursue their political, strategic and economic agendas without external interference. In some respects, this corresponds to a *realpolitik* view of the world, which respects state sovereignty without compromising China's preferred method of dealing with interlocutors one on one. Much of its persuasiveness has been ascribed to 'soft diplomacy', whereby Beijing makes low-interest loans to smaller developing countries, and promotes trade and investment. China's growing trade links have been dominated by two phenomena: its creation of the Asian Infrastructure Investment Bank (AIIB) and the Belt and Road Initiative (BRI).

The AIIB is multilateral but dominated by China, whose creation it is. It reflects China's commitment to infrastructure-driven economic growth, rather than export-led and domestic-consumption growth. As noted by President Xi in reference to what has been called the New Great Game, 'China's investment opportunities are expanding [...] in infrastructure connectivity as well as in new technologies, new products, new business patterns, and new business models are constantly springing up. ... China's foreign cooperation opportunities are

expanding' (Firzli 2015). The AIIB plays a pivotal part in China's promotion of regional integration, on its own terms, as well as an extension of its 'soft diplomacy' foreign policy.

Through the BRI, China has established an expanded, if disputed, military presence in the South China Sea, up to what is known as the 'Nine Dash Line' and well in excess of territorial claims allowed under the UN Convention on the Law of the Sea.

While part of the project is about increasing trade, it also implies Chinese infrastructure investment in host countries, which has raised concern about Chinese control of essential infrastructure in some of them as the Asian colossus is seen to be leveraging its long-term political, economic and strategic interests. According to Das, based on a survey of trade relations with states to its south, 'China's growing economic clout with Southeast Asian countries has seen it advancing its political agenda including its strong position on South China Sea issues and negotiating for the use of Chinese technology, supplies and workers for China-financed infrastructure projects' (Das 2017:1).

Increasing its economic influence in Southeast Asia has been integral to China's larger economic and geo-strategic aspirations. Speaking to the closing session of the Chinese Communist Party's 19th Congress held in Beijing in October 2017, President Xi explicitly outlined China's goal of becoming the world's 'leading power' by 2050 (Chan 2017), with the People's Liberation Army 'being a "world-class force"' by that date (Zhao 2017).

Throughout history, whenever China has been strong, it has been the dominant Asia-Pacific power and, as its economy rebuilds after two centuries of malaise, no one should be surprised that it has sought to become so again. Within Southeast Asia there is a wide-spread view that when China is weak it contracts into itself; when strong it expands. That being so, the era of U.S. hegemony has clearly passed, with China becoming a critical global actor in a new multipolar order in which considerable political, strategic and economic power is also passing to states such as Russia, India and Brazil.

China in Africa

One area whose increased engagement with China has been phenomenal is sub-Saharan Africa. The economies of many sub-Saharan states are awash with Chinese investment, loans, infrastructure projects and businesses. Western criticism of China's rapid expansion into Africa has been vociferous, but critics have been prone to overlook that European–African relations were already envenomed by colonialism, exploitation and numerous wars of independence. That is not even to mention critiques of post-colonial economic relations between Africa and the West which, despite the provision of aid, remain characterised as exploitative (Smith 2013), leaving some countries and most Africans south of the Sahara destitute (APP 2013). To illustrate, 'It's estimated that transfer pricing [shifting company profits to low-tax jurisdictions] is costing Africa $34 billion each year' (Smith 2013).

Trade policies pursued by the EU and western states beyond Europe still preference developed countries over the sub-Saharans, marking a continuation of 'asymmetrical power relations in the new Economic Partnership Agreements (EPAs), to the detriment of regional integration and pro-poor growth' (Kohnert 2008). But, as Kohnert notes, growing competition for African resources between China and other international actors has resulted in a cornucopia for many African states. The competition for power and influence has replicated the rivalries of the Cold War.

There was never much doubt that China's array of investments in Africa was intended to increase favorable trade terms for Beijing and, more generally, to spread its influence throughout the continent (Brautigam 2010:Ch. 7; Kastner 2016). In the first decade of the

118 *The Beijing Consensus versus Washington Consensus*

21st century, Chinese–African trade increased from $US10 billion annually to more than $US100 billion, with a particularly sharp fillip to two-way trade since 2005. In 2011, with the trade surpassing $US120 billion, Africa had become the fourth largest destination for Chinese investment. The continent was also a key target for China's foreign aid program, although given its sometimes opaque processes, and links between 'aid' and investment, how much of this was actually aid is unclear. What is clear is that China invested heavily in health and hospitals, transport, storage and communications (Champonniere 2009), although it ought to be noted that about 70 per cent of 'aid' went on infrastructure development, which once it was in place would entice further Chinese investment (see also Brautigam 2010:Chs 5, 6, 11).

Some critics have accused China, and to a lesser extent India, of using direct investment and trade to undermine western attempts to foster good governance and promote both longer-term development planning and economic stability. While such trade boosted the GDP of several sub-Saharan countries, it rendered certain export industries unviable (through a resource-driven increase in the value of local currencies), generated short-term income flows through its investment policy and thereby promoted rent-seeking and corruption. 'The murky relations between governments and industry continue to cast doubt on the benefits that the recent boom in commodity prices will bring to the poorest sections of African societies' (TI 2012).

Similarly, complaints by European companies in the DRC that, compared to Chinese companies, they would be disadvantaged by transparent reporting requirements, may be misplaced. The principal explanation for Chinese companies' success in the DRC has been their high levels of infrastructure investment in return for leases and concessions (TI 2012). China's economic success in Angola was attributed to these factors (Campos and Vines 2008), in exchange for which China became the main customer for Angola's oil. China has also nurtured a strong trading relationship with Ghana and bought imports from Zimbabwe (Thompson 2012). In each case, China had long and strong ideological links with their respective Leftist governments.

Zimbabwe is China's closest and oldest client state in Africa. China supported ZANU in the late 1970s during its 'bush war', and has continued to support ZANU, and later ZANU-PF, in government. China has invested heavily in the country, agreeing in 2016 to build its new parliament house, supplying 'technical support' for state security as well as military equipment including jet aircraft and 'soft' loans. It signed off on a $US153 million loan after Robert Mugabe was deposed as president. Beijing also authorised a 2 per cent loan to refurbish Harare's main airport (Reuters 2017d). China ranks as Zimbabwe's third largest trading partner (behind South Africa and Botswana but ahead of the U.S.) (Simoes and Hidalgo 2017).

Intriguingly, Zimbabwe's military commander, General Constantino Chiwenga, visited Beijing just before other pro-Beijing top brass ousted Mugabe. In Beijing, Chiwenga met senior Chinese military leaders, including Defence Minister General Chang Wanquan and the chief of the supreme Central Military Commission's joint staff department, General Li Zuocheng (one of just seven members of the CMC, which is headed by President Xi).

Speculation that Chiwenga had asked permission from his Chinese counterparts to stage the coup was immediately dismissed by Beijing, which noted his visit had been planned months earlier (Reuters 2017c). But no one ruled out that discussions of such a possibility if the increasingly erratic Mugabe would not budge may have been held beforehand, or during Chiwenga's visit, even if that had not been its initial purpose. Indeed, as a Chinese client state, it would be very unusual for such a major political change to have been

The Beijing Consensus versus Washington Consensus 119

undertaken without Beijing's knowledge, and probably blessing. For a year or more before the November 2017 coup, China had become concerned about Zimbabwe's economic mismanagement (including arrears on a debt of $US1.8 billion to the World Bank and the African Development Bank), together with the failure or poor performance of some of its investments. During anti-government protests preceding Mugabe's forced resignation, Beijing appeared conspicuously less supportive of Mugabe than it had been.

The 'nativist' response to globalism: Indonesian case study

The Washington Consensus has also been challenged by conservative populism or 'nativism', which preferences the local over the global. While increasingly a feature of western political discourse, this phenomenon has also appeared as a growing trend in developing countries. In some cases the move has been towards a simple populism but, more commonly, it has been aligned with a 'strong' populism, such as that of Venezuela's late President Hugo Chavez and his successor, Nicolas Maduro, or with Philippines President Rodrigo Duterte; when it has not been aligned with religion, as occurred in April 2017. That was the month when, first, Turkey's conservative Islamist-leaning President Recep Tayyip Erdogan was granted executive powers in a popular referendum, and three days later the conservative, Islamist-backed Anies Baswedan was elected governor of Jakarta.

In one respect, this trend supports Kalyvas' (2006) view that populations lend support to a strong political presence that they deem more likely to ensure their security (see also Kilcullen 2010:150–152). But nativism also reflects the globally unstable economic, and hence political, environment since the GFC and the excessive neo-liberalism (in the guise of financial-market deregulation) that triggered it. This, in turn, has led to distrust and rejection of many mainstream politicians, mounting political cynicism and, very often, polarised political debate.

In the case of Baswedan, the overwhelming defeat of Governor Basuki Tjahaja Purnama marked the most divisive and religiously focused major election post-Suharto Indonesia has known. It was marked by sectarian protests. Purnama, better known as 'Ahok' – a Christian of ethnic Chinese descent – inherited Jakarta's governorship when former governor Joko Widodo ('Jokowi') stepped down to run for Indonesia's presidency. Purnama had been an efficient city governor but the anti-Ahok campaign focus was not on his achievements or merits but exclusively on his not being a Muslim.

This campaign turned particularly nasty in December 2016 when Ahok was charged with blasphemy. The charge followed his reply to opponents who had cited a scriptural allusion in the Holy Qur'an against him: Joko had said voters should not allow themselves to be duped by religious leaders. A version of Ahok's speech posted online, with some words removed, implied that the politician was criticising the Qur'anic verse Al-Maidah 51 (which exhorts Muslims not to take Christians or Jews for 'allies') as misleading, rather than the people citing it.

Indonesia has long tolerated an anti-Chinese undercurrent. Though now largely repealed, anti-Chinese legislation persisted for many years, and anti-Chinese riots broke out as recently as the late 1990s. In March 2016, Indonesian Army General Suryo Prabowo said Ahok should 'know his place lest the Indonesian Chinese face the consequences of his action', which was taken as a veiled threat to stage a re-run of such riots. As well as having a racist and sectarian element, the Jakarta election also marked a larger divide in Indonesian politics. Baswedan is supported by Prabowo Subianto, a presidential candidate, former hardline general and late president Suharto's former son-in-law, Ahok was deputy to Jokowi when he was Jakarta governor.

120 *The Beijing Consensus versus Washington Consensus*

Conservative 'strongman' Prabowo ran a disciplined campaign against the populist Jokowi in Indonesia's 2014 presidential election. With Ahok facing legal as well as political difficulties, President Jokowi abandoned his former political ally. Jokowi has been a weak president and, despite his working relationship with Prabowo ensuring the legislature runs smoothly, remains vulnerable to a future challenger.

Supported by the militant Islamic Defenders Front (FPI), which staged violent protests against Ahok's governorship, Purnama's win is likely to herald social changes for Jakarta. While it is doubtful he or his successors could impose full Islamic law (shariah) on the capital in the manner it exists in some municipalities and Aceh province, some aspects of shariah may become law, among them restrictions on women travelling alone after dark.

The election marked a shift towards a more fundamentalist Islam in Indonesia. The nation has been widely known for its tolerant Islam, primarily in reference to the nominal *abangan* Muslims of Central and East Java. Since the 1990s, however, a more religiously observant, intolerant version of the religion has been on the rise: in part due to fundamentalist Saudi funding of Indonesian schools and mosques; in part to perceptions of a growing rift between Islam and a secular West; and in part reflecting the global trend towards populist conservatism.

As Ahok represented an unpopular minority, Purnama's double-digit victory did need to be read with some caution. But there was no doubt proponents of a more radical Islamist agenda were emboldened by Purnama's overtly sectarian campaign. With the apparent failure of President Jokowi's 'soft' populism, the Jakarta elections may be a straw in the wind that Indonesia is heading into a future where hardline Islam becomes the norm.

Governance

One of the most remarkable economic ascensions of the 2000s – one that continued despite the GFC – was that of Brazil, the B among the BRICS. Brazil's economic achievement is largely due to its being a demographic behemoth, as well as to the economies of scale it has been able to attain, plus its relative competitive-cost advantage. But to credit its rise solely to these factors would be to gloss over its astute adaptation to the new world economic order. Brazil didn't become the world's ninth largest economy without overcoming hurdles to build and sustain that position.

It set out to grow its services sector, which now accounts for over two-thirds of its GDP, with its manufacturing sector contributing a little over a quarter and agriculture just 6 per cent. It has not been all smooth sailing, with growth falling into negative territory over eight quarters from 2015, but that returned to positive growth in 2017.

South America has not always been a byword for economic stragglers. As the 20th century dawned, Argentina boasted a per capita GDP around 80 per cent of the United States' (Avila 2006). By 1930 it was one of the world's fifteen richest states, although a military coup that year heralded economic decline, which was compounded by the Great Depression. Even then, Argentina's per capita GDP was similar to that of Western Europe until the mid-century, and the middle class – about 40 per cent of the Argentine population – remained an economic bulwark right through to the 1960s.

By contrast, Brazil was heavily invested in agriculture, particularly coffee and rubber, and its economy was hard hit by World War I and the Depression. It did develop light industry, but economic growth was irregular and often uncoordinated. An import substitution plan after World War II paved the way for a growth spurt but the economy

The Beijing Consensus versus Washington Consensus 121

stagnated in the early 1960s, leading to a military coup in 1964. Democracy did not return until the 1980s, and even then haltingly at first.

Argentina went down a different, more populist and indeed corporatist path, electing Juan Peron president in 1946 and increasing his popular vote in 1951, but a military putsch in 1955 forced his resignation. 'Peronism' was proscribed, leading to a deep and violent division in Argentine political society. Neither Peronists nor anti-Peronists could implement their political agenda, leading O'Donnell to characterise the next few years of party politics as 'the impossible game' (1973:181–182).

An attempt to legalise Peronism sparked a military coup in 1966, inaugurating an era of 'bureaucratic authoritarianism' (O'Donnell 1988:1–71) and the persecution of Leftists in the 'Dirty War'. The country returned to electoral politics in 1973, with Peron being allowed to return from Spanish exile. He won the elections but died the following year, whereupon his third wife, Isabel, succeeded him before herself being ousted in yet another coup, in 1976. Argentina did not return to electoral politics until the disastrous Falklands War of 1982 precipitated the military dictatorship's collapse. Even though the populist Peron won the popular vote three times, his legacy was a sharply polarised polity.

Even as the 2000s loomed, many Argentines remained under the spell of Peronist corporatist ideas about protecting labor in exchange for stability. This naturally complicated attempts to implement the Washington Consensus and damaged the country's ability to present a coherent and consistent economic agenda. Brazil moved more smoothly into the supply-side neo-liberal, high-tech paradigm in which labor was regarded as 'a commodity that had to be deregulated in order to trade freely and reach its natural clearing price' (Pena 2016:67).

The consequence of this distinction between Brazilian and Argentine political cultures has been significant differentiation in patterns of engagement with transnational regimes (Pena 2016:119). Brazil resonated positively with them while Argentina had shallow resonance and 'semantic misalignment' between aspects of global and national political cultures. In particular, Pena noted, Argentina reflected public indifference to particular global initiatives, rejecting a role for business in public affairs and opposing (neo-)liberal and market-led governance (2016:181). Brazil was 'more active, dense, and centralized', while Argentina remained 'fragmented, diffuse, and peripheral'.

What this comparison between Brazil and Argentina indicated was that the Washington Consensus could be implemented, but that its relative success would be at least as much determined by local socio-political factors as by an external 'one size fits all' policy prescription. These local factors needed to be understood and addressed if developing countries were to succeed in moving towards political and economic 'development' or maturation.

Logically, societies that reflect deep and more or less unbridgeable political divides are less likely to develop. If development is to take place, they are more likely to succeed under a politically corporatist model with a high level of international engagement. This then suggests fragmented developing-country societies are more likely to become prosperous by adopting something akin to the Beijing Consensus, a fact that goes some way towards explaining its success as an alternative to the Washington Consensus.

For those that apply normative values to politics, however, for whom civil and political rights and freedoms are at least as important as economic rights and 'freedoms',[3] the more corporatist Beijing Consensus comes with a cost – a more closed and authoritarian form of politics.

Of course, champions of the Beijing Consensus will use economic success, or the hope of it, to legitimise new or pre-existing closed power structures. Discussion of whether it is

122 *The Beijing Consensus versus Washington Consensus*

better for a country to adopt the Beijing model, however, is bedevilled by two unknowns: whether its society will be able to cohere under a plural representative political system – 'democracy' as broadly defined – and whether the political price of living under a corporatist authoritarian regime is worth paying. The reason why the answer to these questions is intrinsically unknowable is that the only people who could supply it – the state's citizens – are by definition not given the opportunity to express their political views freely.

Conclusion

As it heads towards the third decade of the 21st century, it is clear that the world has become a multipolar place. No single power can be assured of dominance, and all of them share common concerns around trade, development, equity and the environment. There is little doubt that China is close to becoming the world's largest economy, if it is not already, along with being the predominant strategic actor in its region. Meanwhile, a conflicted U.S. is torn between continuing its long dominance of the globe via a tried-and-tested free-trade mantra and taking the isolationist path marked by the start of a return to protectionist policies.

This is not to suggest that the U.S.'s global power is likely to diminish rapidly or that its relegation to the rank of ex-superpower will occur within years or even decades. But its period as the globe's master is now, unquestionably, behind it. So, too, the globalist paradigm it championed as it has been openly questioned and challenged by state corporatist approaches. There is increasingly a new iteration linking development investment with a particular, highly instrumentalist strategic vision – shades of the Cold War. This time, there is no single standard model to which all states would aspire but a variety of them, The capitalist-democratic model, like the bow waves of progress, has arisen, been pushed aside and is now receding in the wake of history.

As with any paradigm that ultimately reflects a core strategic vision which benefits one state, or grouping of states, at the expense of others, it may yet be that the Beijing Consensus – imprecisely defined though it remains – will come to dominate developing-country approaches to domestic and international politics and consequent economic decision-making. It may also come to pass that the patron and key advocate of the Washington Consensus itself moves away from the model it previously championed, at least in terms of global trade and a commitment to the global environment.

But, equally, the idea that there can be global agreement about a universal ideal for all states and their development may well be misconceived and just a reflection of an ahistorical moment of self-congratulation for a transitory moment on the world stage.

If a state is reluctant to sign on without qualification to either brand of consensus, it is still free to recommit itself to key tenets of the Washington brand, such as free trade, as exemplified by the multilateral Trans-Pacific Partnership agreement which even the U.S., marking its own retreat from the model it had championed, has declined to join. (At the time of writing, however, it should be noted that President Trump has opened the door to the U.S. re-joining a renegotiated TPP.)

It is reasonable to expect that every country, both developing and developed, will find its own way forward, sometimes in partnership, sometimes alone. But in a world shrunk by improved communications technologies, and with regional financial markets increasingly enmeshed in a global network, the impetus to find common agreement on at least some issues is bound to intensify.

For those states – or state leaders – that prefer single party or authoritarian rule, they are from time to time required to call on the state's capacity for force to compel their writ. In

some cases, too, where the state has little capacity, state institutions that have the capacity to enforce their will may step into that capacity vacuum. In yet others, there may simply be disagreement about visions for the state and its people. In such instances, partnership and agreement is less a way forward than is compulsion, sometimes at the barrel of a gun.

Notes

1 Not to be confused with the Great Depression (1929–late 1930s), the most serious previous economic crisis.
2 Australia was the only developed economy not to succumb to the GFC, in part because of strong exports to China and in part because of a policy of fiscal stimulus (Uren 2010).
3 This often implies a loss of economic 'freedoms', in the sense that a corporatist structure allows limited opportunities for external challenges to existing economic power structures.

9 The military in politics

The means by which a state attains independence does not determine its post-colonial political orientation. But where it has done so by force of arms, militaries often have a disproportionate role in the new nation-state's post-independence politics, as either an auxiliary or effective partner in government, a source of guidance on governance or, from time to time, assuming the reins of government.

The military's role can be particularly pronounced if it sees itself as the guardian or guarantor of the state (especially if the state defines itself as unitary). Militaries take a front seat in domestic politics when the state faces disturbingly high levels of internal dissent, which can be common in multi-ethnic post-colonial states. Within developing states, militaries are usually the largest recipient of government expenditure, with inordinate sums spent on them and on military hardware compared with developed countries.

While armed forces do, from time to time, relinquish their political role, their governing style – when in office – resembles the military itself: top-down, non-consultative, hierarchical and exclusionary. In developing countries, the forces are often partially self-financing (through military-owned businesses, 'grey' and illegal activities). Nowhere is this more common than among militaries that have been victorious in an independence struggle and need to be self-financing to avoid becoming indebted to a central civilian authority. By definition, such businesses were illicit during the struggle, but what often happens once the nation is 'free' is that yesterday's illegal commerce is carried over into an era where mainstream investment and other financial sources have run dry. Old habits turn into routine traditions, and these become part of the 'culture', institutionalised models of ensuring self-sufficiency often linking men and women in uniform to the civilians in government – and sometimes giving them control over the government.

What are known as hard one-party states invariably have the military or a paramilitary force as the key guarantor of their authority. Such states possess a centralised political structure that operates on the basis of top-down decision-making. They display little or no tolerance for dissent and, in most cases, tell the narrative of an official history, while boasting a controlled media and selecting political leaders through a closed-loop process. The key difference between the military as such, the military in politics and the military in government resolves into who is wearing the uniforms, when and in what context. Many a general, upon seizing power, has exchanged his uniform for a business suit.

Military-dominated states may be 'dictatorial' and coup leaders may even strive for, though few achieve, 'totalitarian' status. Some examples where national leaders have instituted totalitarian, or near totalitarian, rule include 'communist' states, such as the Democratic People's Republic of Korea (DPRK, or North Korea) and, less commonly, fascist states, although Myanmar would certainly have qualified under the Burma Socialist

Programme Party and then the State Law and Order Restoration Council (SLORC), both of which were extensions of the Tatmadaw ('Royal Armed Forces'). This is what might be described as a 'military oligarchy' (see Janowitz 1977:78–83; Siddiqa 2007:33), reflecting the military's complete permeation of the state.

Historically, most of these states have been operated by small committees (politburos or *juntas*) rather than by a strongman – so, while totalitarian, they were not necessarily dictatorships. Though such states operated a top-down political structure, they usually established mechanisms to monitor how particular programs were operating at the ground level.

Many developing countries have had, or still have, a high level of military involvement in their politics. Militaries are typically reluctant to return to barracks in states whose independence was achieved through armed struggle – in most such instances there being no functional separation between the independence movement's political and military wings. Militaries tend to entrench themselves in civil politics during times of institutional weakness, post-conflict rebuilding or internal challenges to the status quo – actual or perceived (in particular, challenges to state authority). These take various forms, from separatism and revolutionary movements to terrorism. Sometimes, troops will take preemptive action to avert socially driven radical change. As Desch has noted (1999:8–21), when militaries have an external security focus they are more likely to respect civilian authority, but when they have an internal security focus they are more likely to become involved in domestic politics.

Because militaries are hierarchical authority-driven structures, their *modus operandi* is easily transferred to post-conflict environments. This encapsulates what Huntington described as the military's exaltation of 'obedience as the highest virtue of military men. The military ethic is thus pessimistic, collectivist, historically inclined, power-oriented, nationalistic, militaristic ... and instrumentalist in its view of the military profession' (Huntington 1958:79).

Military-dominated one-party states can be classified as 'authoritarian', in that they constitute non-participatory social orders characterised by intolerance of opposition or dissent. Unfortunately, there is no single definition of 'authoritarianism', so the term covers the political styles of a range of governments that are not necessarily controlled by, representative of or politically linked to the military. Party dictatorships are a case in point, although such parties tend to mimic the structure of and often have a close association with the military. Such states usually deploy a politically active police force and, in many cases, that force is constituted as a branch of the armed services.

It is a truism, then, that all military states are authoritarian but, while not all authoritarian states are military, they do share the commonality of strict hierarchical control and mechanisms for enforcing their will. Similarly, while military regimes may be headed by a senior individual or group of individuals and there is scope for change based on retirement, promotion and ideology (Myanmar being a good illustration of such changes between 1962 and 2015), they frequently collapse when a strong leader dies or is removed from office (Spain's Franco in 1975, Indonesia's Suharto in 1998, Chile in 1990, Argentina following the Falklands War of 1982). Why and how such transitions away from authoritarianism occurs is discussed in greater detail in Chapters 10 and 11.

With this caveat, authoritarian states will be understood, for the purposes of this text, as those in which a political party or ideology filtered through the lens of a military hierarchy (even if in the form of a police force) holds a functional monopoly on political power where that power is exercised in a non-participatory or absolutist manner and brooks no opposition or dissent.

126 *The military in politics*

Types of military control

One of the most significant problems to have beset developing countries has been military involvement in civilian politics. In the era of decolonisation there have been many military coups or coup attempts, all linked to high levels of political volatility.

Military interactions with civil politics are not singular or standardised, but some typologies have been advanced that account for the fluidity of those interactions. Keeping in mind that each typology may contain elements of another, or be partially blended with another, there are five composites identified by two authors who have specialised in politico-military typologies – Janowitz (1977) and Siddiqa (2007).

First, and relatively straightforward, is 'authoritarian-personal control'. This is where a single powerful leader effectively heads the state and employs the military as both the enforcers of state power and a praetorian guard. The leader may have come from a military background or risen with military support but no longer be (at least formally) a member of the military. A few examples of such strongmen in modern times might include: Indonesia's President Suharto, who came to power in a military takeover[1] but resigned his commission in 1976, ten years after assuming effective control of the state; Cambodia's Hun Sen, who transitioned from being a Khmer Rouge divisional commander to a senior figure in the shadow-government Kampuchean United Front for National Salvation (KUFNS) and then minister in the pro-Vietnam People's Republic of Kampuchea (PRK) in 1979; Robert Mugabe, whose control of the Zimbabwe African National Liberation Army (ZANLA) underlay his political leadership of the Zimbabwe African National Union (ZANU, later ZANU-Patriotic Front); Egypt's various presidents since 1952 (save for 2012–2013) and Paraguay (1947–1989). There are other instances too numerous to identify here.

The second, and more common, type of military enmeshment in government occurs in 'authoritarian-mass party or civil-military partnership states'. In these states a political party has an armed wing that captures government and the two organisations continue to coexist: indeed the military may provide the party with its senior leadership cadre. This type abounds in Marxist post/revolutionary societies such as China, Vietnam, Laos, North Korea, Nicaragua (1979–1990) and among a host of African states at different times, e.g. Ethiopia (1974–1991), Mozambique (1975–1992), Somalia (1969–1991) and South Yemen (1969–1990).

The third type of military involvement in politics is a quasi-democratic or competitive-democratic political partnership, in which the military retains a high degree of independence from an elected civilian government and is a partner in government, for example through the allocation of portfolios. One of the clearest examples of such an arrangement has been Myanmar since 2011 and especially since 2015, with the Tatmadaw retaining 25 per cent of parliamentary seats and constitutionally mandated exclusive control over three ministries (Defence, Home Affairs and Border Affairs), the heads of which are appointed by the military commander-in-chief. Indonesia had a similar arrangement under its military's 'dual function' paradigm effectively implemented in 1957 but reorganised in 1966. Indonesia's armed forces did not formally relinquish political power as manifested by their remaining allocated seats in the legislature until 2004. Thailand passed a constitution in 2016 that reserved appointment of the country's Senate to the military, apparently its latest variation on a familiar theme – the on-again, off-again engagement of the military in Thai political life dating back to 1932.

In the fourth type, the military runs a 'parallel state'. When Indonesia's military was in 'dual function' mode, it ran a parallel administration (often appointing its officers to positions in

the civilian bureaucracy), while the Thai military between coups also operated a governing structure parallel to the state administration.

The fifth type is a civil–military coalition or a variant of one where the military is the arbiter or 'guardian' of the state. Pakistan is a prime example of this type in those periods when the military has not actively run the country but has worked closely with or had power of veto over its civilian leadership (Pervaiz 2016), including the 2018 election to government of Imran Khan's Pakistan Movement for Justice. Turkey's military as it operated between 1946 and 2002 could also be seen in this light. The military in Zimbabwe has been the main pillar of support for the ruling ZANU (later ZANU-PF) party since 1980, under Robert Mugabe until 2017 and since then under his successor, Emmerson Mnangagwa.

Militaries and civilian elites

One way in which militaries exercise effective if not explicit control is by supporting or manipulating a civilian leader. Everyone who matters will know when administration of the state takes on a khaki tinge – there may even be that praetorian guard to leave no one in doubt – but internationally the state can profess to be 'civilian', even if of an authoritarian dye, due to its non-military leader. Such is the case in Zimbabwe, where Mugabe 'reigned' as head of state until coerced into resigning in November 2017 – although he had concurrently been head of the armed forces since 1987. For all this Zimbabwe remained, as it still does, a nominally democratic state, even though its elections were deeply compromised. The state leadership's long-term goal has been for Zimbabwe to function as a one-party state, an objective assisted by the 1987 merger of ZANU-PF and ZAPU (nominally to avoid further violence between the parties), and Mugabe confirmed this aspiration in statements of his own (Blair 2002:29). Had the Cold War's end not damaged his one-party brand, it is a reasonable surmise that Zimbabwe would have long since adopted that model.

In a practical sense, Zimbabwe's military has stymied options for political change, and when the late Morgan Tsvangirai was opposition leader he taunted Mugabe with being a military puppet (*The Insider* 2013). This followed a statement by military commanders that they would not recognise any electoral victory by the Tsvangirai-led Movement for Democratic Change (Misa 2011). As with many other regimes in which the military and the government are closely aligned and resort to employing 'front' groups to provide the veneer of an arm's-length distance between them, Zimbabwean 'war veterans' in 1999 and 2000 'invaded' and occupied white-owned farms and were instrumental in Robert Mugabe's removal from office and replacement by Emmerson Mnangagwa, who also had a military revolutionary background and was later Minister for State Security and head of the Central Intelligence Organisation.

A similar, if less electoral, system applies in North Korea, where the Kim dynasty provides the state's hereditary leadership but the military tightly controls all aspects of its administration. In both cases, the political leaders appear to call the shots, but all significant state decisions are apparently vetted by the armed forces' top brass.

In Indonesia, the front groups simulating more degrees of separation than actually exist between the civilian and military cadres are politico-criminal paramilitaries. These militias entered the fray when the army did not want to be seen to be directly involved in, or controlling, local conflicts, for example in the restive provinces of West Papua, in Aceh until 2005 and in Indonesia's annexed province of East Timor ('Timor Timur') in 1999. They usually draw on army-patronised youth (usually self-defence) clubs and criminal networks

128 *The military in politics*

that in 'normal' times run gambling, prostitution and standover rackets, among others. Similarly, Indonesia's political parties employ paramilitary *satgas* (for *satuan tugas*, or task force), whose members wear combat gear and commonly engage in criminal conduct.

By 1999, the Indonesian Democratic Party, Struggle (*Partai Demokrasi Indonesia – Perjuangan*, or PDI-P[2]), had around 30,000 *satgas* personnel along with related sympathiser groups over which, by the time of the 2004 elections, the party had started to lose control. Members of Batgas, the 20,000-strong *satgas* belonging to the National Awakening Party (*Partai Kebangkitan Bangsa*, or PKB[3]), attacked the offices of a local newspaper after it published a report alleging corruption within the religious organisation to which the party was affiliated.

Despite having its own unofficial gangs, the Indonesian military objected to the growth of these political *satgas* over their use of military-style uniforms and insignia. Senior officers saw them as representing a challenge to military authority. Less symbolically, the military's objection was grounded in the fact that these front groups competed with the military's own criminal activities. The electoral commission responded by moving to limit the use of *satgas*, in particular their establishment of neighborhood command posts (Beittinger-Lee 2009:180–183; Wilson 2010:203–204).

In countries where there has been a coup or the soldiery has obtained power in some other manner, military commanders have resigned their posts to assume a solely civilian function, sometimes even being 'elected' in what are usually closely controlled electoral processes. This process is consonant with what O'Donnell (1973) and Stepan (1985) term 'bureaucratic authoritarianism', in which military rule is regularised as a civilian political process. Examples of this are: Indonesia under President (General, ret.) Suharto; Myanmar under Prime Minister Thein Sein; Thailand under Prayut Chan-ocha, who heads the National Council for Peace and Order; Egypt under Abdel Fattah el-Sisi (Field Marshal, ret.); and Libya under President Muammar Gaddafi.

Military domination or rule was particularly common among developing countries during the Cold War. In Latin America alone the following countries had military-dominated governments: Ecuador, 1963–1966 and 1972–1979; Guatemala, 1963–1985 (with a civilian interlude, 1966–1970, but the civilian president, Cesar Mendez – far from imposing any control over the military – oversaw an intensification of paramilitary operations and offensives by U.S.-supervised death squads); Brazil, 1964–1985; Bolivia, 1964–1982; Argentina, 1966–1973 and 1976–1983; Peru, 1968–1980; Panama, 1968–1989; Honduras, 1963–1970 and 1972–1982; Chile, 1973–1990; and Uruguay, 1973–1985. In El Salvador the military dominated the government, 1931–1944 and 1948–1984, leading to unremitting internecine warfare during the final years of that epoch. (From the above list, it may be observed that from the mid- to late-1970s, of Latin America's twenty nation-states the majority were under military rule.)

Military coups

The epitome of military intervention in the state and its politics is the *coup d'état* (literally 'strike of state'). A 'coup', for short, is an unconstitutional, undemocratic seizure of political power, usually by the military. Not all coups have identical causes or identical aims. This observation applies equally to palace coups (where one leader within the ruling coterie is replaced by another member of the coterie – also known as a 'guardian coup'), reform or 'veto' coups (undertaken to forestall radical political change) and revolutionary ('breakthrough') coups (Huntington 1968:32–33). The kind of coup that changes a nation's

The military in politics 129

leadership will depend on whether the elite's activists – be they in the military or some other elite – see themselves as rulers, moderators or guardians (Nordlinger 1977:22).

While almost all nations agree that they require the presence of a military, Desch (1999) has argued that civilian authority over those in uniform works best where a state faces high external threats and low internal threats. Civilian control of the military works worst, according to Desch, where a state faces high internal threats, such as separatism or revolutionary movements, and low external threats. In Southeast Asia, the latter state of affairs obtains in Myanmar, Thailand, Laos, Indonesia and the Philippines. In those conditions, the military is more likely to see – and has seen – itself as a political actor or as protector of the state.

Justification is often found in the role militaries (or their precursor guerrilla units) played in independence movements. Where the internal and external threat levels are both high or both low, Desch suggests that civilian control over the military hovers between the two extremes. But, in developed countries, the tendency has been for low internal and external threats to equate to greater civilian control over the military (Lasswell 1941; Dains 2004). Militaries in Southeast Asia, notably Myanmar, Indonesia, Thailand and the Philippines, have also interpreted civilian leaders' perceived or actual incompetence as an internal 'threat'.

Huntington (1958) argued that the most effective method of asserting civilian control over the military was to professionalise the latter, but developing countries have seldom exhibited the capacity to do so. This has been particularly so where the state could not afford the upkeep of a defence establishment, prompting troops to engage in private business beyond civilian oversight. The result has been twofold: less accountability to the civilian government of the day, and acquisition by the military of political and economic interests that compete with their defence function (see also Chambers and Waitoolkiat 2017:2).

In terms of accountability, it might be expected not to reduce if the military *is* the government, but even then there is scant internal transparency (Chambers and Waitoolkiat 2017).

Concerning the military's role in developing-country politics, attention immediately turns to the nature of any mechanisms for bringing the armed forces under civilian control. This extends not just to the military (predominantly the army) but also to other security-sector forces that may either have a role similar to the army's or be formally or functionally subservient to it. By security-sector forces are meant the military proper, armed non-state actors, paramilitary outfits, militias and the police when they undertake a military-type or military-adjunct role. This may include democratic governance of the defence and security sector, combining policy and oversight within 'a framework of democratic legitimacy and accountability' (Forster 2002; see also Cotty, Edmunds and Forster, 2002).

Security sector reform (SSR) postulates a comprehensive program for redressing a lack of civilian control over the military (and other security-sector actors) along with low levels of military professionalism. SSR is most commonly applied in fragile states, especially where they are emerging from conflict or transitioning from authoritarianism (which may include a provisional role for the military in governance).

Such reform is usually most needed where soldiers and/or police have operated within their own country, or on official operations abroad, maltreating civilians with impunity and displaying professional indiscipline. It can also apply where militaries are engaged in business or criminal activities, or where government oversight and in particular civilian government oversight is lacking and there is little or no accountability. Such instances of 'rogue behavior' erode respect for the judiciary and sap confidence in the prospects of condign justice. The implications for corruption of key state institutions are dire.

130 *The military in politics*

Where militaries have both economic and political interests, they often employ, and enjoy, a unilateral capacity to intervene in political affairs. Authoritarian governments usually pander to their wishes; conversely, during a shift away from authoritarian or military-led government, the transition is more likely to be successful if reformists in the military lead and consolidate such a transition.

When the armed forces become entrepreneurs, they tend to cross over the borders of business legality, becoming embroiled in 'grey' businesses such as private security which may practise standover tactics or extortion. This then leads those in the military engaging in business activities to form patron–client relationships with criminal civilians (in Indonesia, this extended to such enterprises as smuggling, drug dealing, gambling and prostitution), marked by decreased accountability, the use of unofficial violence to secure favorable outcomes and, in many cases, outright plunder (Siddiqa 2007:2) in which the state increasingly becomes a vehicle for the enrichment of soldiers, in particular senior officers (Brommelhorster and Paes 2003:1–4). As Siddiqa argues, not only do military business undertakings permit autonomy from government oversight but the dark art of manipulating or control of those in government becomes a useful mechanism for sustaining those benefits (2017:2, 6).

As noted at the beginning of this chapter, when military organisations influence a nation's leaders or themselves exercise political authority they are by definition hierarchical, closed and relatively authoritarian (see Huntington 1958). This is especially so where the military derives its ethos from revolutionary idealism, in which its role in the securing of independence is seen as an important milestone, but only one along the road to a wider social transformation – and such was the case for all three victorious fighting forces in Indochina – in Vietnam, Laos and Cambodia.

Where a post-independence society is for any reason disorganised, and alternative legitimate sources of power have not yet become established – or where the post-independence development project implodes – as happened at different times in Myanmar (or Burma as it was), Indonesia and the Philippines – powerholders may look to the military as essential to maintaining the apparatus of government, or even the cohesion of the state. Matters may regress to a point where the newly independent government loses legitimacy through its exclusive, non-participatory and unrepresentative ways, or where it compels ethnic minorities who are reluctant citizens to affirm themselves as subject to the state. Again, Myanmar, Indonesia and the Philippines are prime examples of this phenomenon.

In these circumstances, governments have found time and again that tensions between their self-protective moves to bring about 'political closure' and mounting frustration among citizens feeling alienated from and by their leaders have the potential to spill over into violence. Many a government in this bind has asserted, or tried to assert, its authority, as was demonstrated in Burma immediately after independence, in Indonesia soon after independence and in the Philippines during the 1950s and again from the late 1960s. Where governments have been unable to assert authority, the breakdown of state institutions has been liable to follow a process that, if unchecked, could lead to 'failure' of the state itself. A range of developing countries has reacted to the degradation of state institutions by an even stronger assertion of the *status quo ante*, while others have grown increasingly dysfunctional and descended into chaos, leading in some cases to regime change – for example in Burma, later renamed Myanmar, in 1962 and 1988, and in Indonesia in 1965–1966.

Africa has an extensive history of state incapacity and insurrection. Over the six decades from 1950, the nations of Africa – whose number grew to fifty-three over that period – experienced 169 coups and coup attempts (compared with 145 in the score of Latin

The military in politics 131

American countries over the same period) (Powell and Thyne 2011:255). But, after 2002's formation of the African Union (AU), the incidence of coups decreased. The AU's predecessor, the Organization of African Unity (OAU), had a policy of recognising whatever party or organisation held power in a country's capital, regardless of how it attained power. The new body demonstrated its opposition to coups in Mauritania in 2005, Madagascar in 2009 and Guinea-Bissau in 2012, by suspending these countries from the AU. The Central African Republic was similarly suspended in 2013 after its president had been ousted by rebels (Herbst 2014:xxiii).

At the time of writing, though, the recent policy of rejecting unconstitutional changes of government has been tested only on small or weak states. 'More importantly, the new norm is constrained. African leaders who win elections via outright fraud (e.g. Mugabe in Zimbabwe) are still accepted as legitimate' (Herbst 2014:xxiii). What is more important, in 2017 when the military withdrew its backing for Mugabe the AU did not react, even though it 'seems like a coup' (BBC 2017). It could be argued that the rejection rule didn't apply in this case, though, because Mugabe's sacked deputy, Emmerson Mnangagwa, ended up succeeding him through a constitutional process – as this chapter will shortly proceed to examine in some detail – so the AU deemed that the transition didn't amount to a coup.

Like some forces elsewhere in the world since the Cold War, African militaries have been impacted by budget reductions. This has meant 'the principal forces of order are in disorder [sic] in many countries at a time when the legitimacy of the central government (and indeed sometimes the state) is in doubt' (Thom 1995:3). Reduced funding has limited the militaries' capacity to act independently, with the result that in many cases their self-image as reserve arbiters of political power has gradually begun to change.

Zimbabwe's 'acceptable' coup

Zimbabwe's 2017 coup is an instructive case study in how the military can flex its political muscle at a moment of national crisis. Zimbabwe's military placed the country's long-standing leader, Robert Mugabe, and his wife, Grace, under house arrest in November, after Mugabe sacked Vice-President Emmerson Mnangagwa. Mnangagwa was widely regarded as Mugabe's henchman, close to the army and often viewed as the aged leader's successor.

According to army spokesman Major General Sibusiso Moyo, the army took over the state broadcaster, the Zimbabwe Broadcasting Corporation (ZBC), to read out a statement saying there had *not* been a military coup. In classic military-coup doublespeak, what had happened, he said, was a 'bloodless peaceful transition' of power. The army patrolled the capital, Harare, in tanks and positioned troops on the streets. Zimbabweans were warned by the army not to come out on to the streets because of the possibility of violence.

If it is possible to set aside the irony, what happened was that Zimbabwe's army, which had increasingly controlled the country's politics since the 1990s, decided that its geriatric 93-year-old president was no longer fit to hold office. His decision to sack his heir-apparent in favor of his unpopular wife, Grace, only confirmed them in that opinion. The coup was triggered by army commander General Constantino Chiwenga threatening to 'step in' and calm tensions over the sacking. Some within the ruling ZANU-PF party responded by accusing Chiwenga of 'treasonable conduct', an attack that appears to have precipitated the coup.

Major General Moyo said that military mobilisation was intended to target 'criminals' around Mugabe, adding that 'as soon as we have accomplished our mission, we expect that

132 *The military in politics*

the situation will return to normalcy'. This meant that Mugabe would 'resign' and allow army-friendly Mnangagwa to replace him as president.

Mnangagwa appeared to have been instrumental in the coup. In a tweet under his name, the former vice-president said:

> Zimbabweans stay calm & remain tuned to national news … I'm back in the Country & will be quite busy over the next few days. My communication with you will now be via formal broadcasting channels so I'm unlikely to use the twitter handle. Thank you all for the support & solidarity.

At the time of the coup, Zimbabwe's army was praised by Chris Mutsvangwa, chairman of the country's powerful war veterans' association and a close Mnangagwa ally, for carrying out what he called 'a bloodless correction of gross abuse of power'. According to a ZANU-PF tweet, Mnangagwa had already been named the party's interim president and, consequently, President of Zimbabwe. The party, long an extension of the army, had fallen into line.

Given the army's control of 'formal broadcasting channels', it appeared the dismissed vice-president had its direct support. Confirmation of this followed a month later when Mnangagwa appointed coup leader General Chiwenga one of the country's two vice-presidents. Towards the end of his tenure, it had become apparent that President Mugabe was no longer the power he once was. His position, it became clear, was being propped up, and his actions were largely directed by a clique of senior army officers.

When the General Assembly of the United Nations convened in 1983, just three short years after Zimbabwe achieved independence, Mugabe was at the peak of his powers – charismatic, almost mesmerising, still exuding the idealism that led to the end of colonial rule. If the media and diplomatic observers were to go from being dazzled to disillusioned with Mugabe, that was naught compared with the subsequent experience of Zimbabwe's citizens. Mugabe turned out to be just another African dictator, if perhaps starting from a higher rhetorical plane and thus having that much further to fall. When his old rival, Vice-President Joshua Nkomo, died (of natural causes) in 1999, the power of the Mugabe group was complete.

Profound economic mismanagement and corruption – and the emblematic forced removal of white landowners with consequent food shortages – led to the rise of the opposition Movement for Democratic Change (MDC) in 1999. Alternating between rigged elections and open violence, Mugabe held, indeed tightened, his grip on power. Suppressing the MDC, however, increasingly appeared to be a task for the army and ZANU-PF thugs. Mugabe was kept on because he was a useful figurehead. His advancing age only became a problem when he began to forget who the puppet-masters really were, and that he could not make questionable decisions without their approval, or direction.

In the days after the coup that dared not speak its name, South African intermediaries tried to coax Mugabe into resigning from the presidency voluntarily. He was holding out for guarantees about personal security and welfare – keeping his ill-gotten gains. Behind the scenes, China appeared to have given tacit approval to the coup.

China is Zimbabwe's principal benefactor, provider of a $US4 billion 'soft' loan, training and equipment for its army, a $100 million National Defence College and the country's new parliament building, not to mention significant investments in Zimbabwe's resources sector. China would inevitably crave reassurance that its strategic stake in Zimbabwe was not going to be challenged and want to see a new president installed who was safe. Mnangagwa was that person.

The military in politics 133

Meanwhile, MDC leader Morgan Tsvangirai returned to Zimbabwe from exile, seeing the coup as a possible opening for democratic change in the country. As prime minister from 2009 to 2013 Tsvangirai had shared power with Mugabe, an asymmetrical partnership that ended with the position of prime minister being removed from Zimbabwe's constitution. There was some hope, both within the country and abroad, that democratic change might happen. But it was a faint hope, and for many it was extinguished when Tsvangirai died from cancer in February 2018.

What the Zimbabwean coup showed, above all else, was that the army was the power in the state and no one could become president without its blessing, if not its direct appointment. Mugabe was formally removed as ZANU-PF leader two weeks after the coup and, as impeachment proceedings began, resigned as president.

Robert Mugabe, at the time of his overthrow, was not the same man as the hero of independence who delivered that powerful, idealistic speech to the UN in 1983. But what the events of November 2017 brought into sharpest relief was that the hopes of Zimbabwe's millions for 'liberation' when independence finally came in 1980 were the stuff of myth, a chimera, long before reality caught up with Mugabe.

Militant Islam and the role of militaries

Of the world's 7.6 billion people, just under 2 billion – one in four – are professed Muslims. Islam is the dominant religion in fifty-one countries (just over one in four), from North Africa and the Sahel, across the Middle East, Central Asia, parts of South Asia and in Indonesia. In twenty-five of these countries it is the state religion. In most countries and for most Muslims, Islam is simply the expression of their faith and the repository of a moral code for daily life.

In relation to militaries, Islam can be a guiding principle (in which an overtly Islamic military is one arm of an Islamic state), Iran being an example of this; the Islamic establishment may compete for power and have an ambiguous relationship with the military, as in Turkey, Pakistan and Egypt; or it can represent a challenge to the state, as it does in Iraq, Syria and Somalia.

In these respects, Islam is not just a religion but an organising principle for a people seeking political guidance or change. While this has been reflected as the ideology of Islamism – the 'Islamisation' of political parties and governments – it takes on a particular format when understood as *jihad* (struggle, or striving). '*Jihad*' can mean to strive for greater religious purity or understanding, but can also be used to signify the struggle against non-believers. Combined with a political ideology, this form of 'struggle' creates a potent political force. This is especially so when the form of Islamist ideology is derived from the most austere and fundamentalist *Salafi* or *Wahhabi* [4] traditions of Sunni Islam. The antecedents of recent jihadi Islamism have deep roots, contained in a confluence of fundamentalist *Salafist* responses to colonialism – initially towards the British in Egypt and through the development of the Muslim Brotherhood – and later opposing neo-colonialism and the relative failure of post-colonial projects in Arab states.

In some cases those failures have been due to their internal incoherence, the adoption of alien ideologies, poor governance and misguided development. In others, the nations' very existence was due to colonial domination and expediency (e.g. Syria, Iraq, Jordan, Kuwait) aggravated by subsequent interference and exploitation (Iran, Iraq, Afghanistan).

In the Middle East, creation of the state of Israel, the displacement of Palestinians, the Israeli defeat of Arab states in 1948–1949 and again in 1967 hardened regional Arab rule,

134 *The military in politics*

divided the region into Cold War camps and helping impose external or previously unknown ideologies on recently created states. The political melding of Islam and politics was, in most cases, either outlawed (in Egypt, Syria, Iraq, Libya and Algeria) or strictly controlled by the state (Saudi Arabia, the Gulf States, Jordan and Morocco).

A quarter of a century after 1953's British- and American-backed overthrow of Iran's parliamentary democracy, the Iranian opposition coalesced around Shia Islamism as a revolutionary process. What the Iranian Revolution, which ousted the Shah early in 1979, showed was that a home-grown Islamist revolution against neo-colonialism was viable. The revolution provided momentum for the development of political Islam, but the time was not yet ripe for its flowering. Political divisions within Afghanistan enabled the pro-Soviet Khalq faction of the far-Left People's Democratic Party of Afghanistan to stage a coup in 1978 (the Saur Revolution), after which some 27,000 people were executed as part of the regime's radical egalitarian and 'land reform' campaign. This campaign sparked a revolt by *mujahideen* (jihadi warriors) against the regime, prompting the Soviet Union to invade in December 1979. Supported with arms, cash and some training by the U.S. and Pakistan's military Inter-Services Intelligence (ISI) agency, the *mujahideen* groups forced the Soviet troops to withdraw *en masse* a decade later. Throughout the 1980s, Afghanistan's *mujahideen* war attracted Islamist militants from across the world, planted the seeds of Al Qaeda (the Base) and returned hundreds of well-trained and battle-hardened jihadis to a number of lands where they fomented local campaigns.

The end of the Cold War created opportunities or unleashed previously constrained tendencies, building on the reassertion of Islam's political role since the Iranian Revolution, the collapse of western hegemony in Afghanistan and, more recently, the 'Arab Spring'. *Salafi* jihadism's absolutist explanation of the world's evils, replete with an organising principle for dealing with them, has – consciously or not – followed the Marxist template applied by anti-colonial independence and revolutionary movements.

That said, violent religious extremism does need to be placed in context. The proportion of the world's violent extremists claiming an allegiance to Islam is tiny. While Muslims do define themselves, overwhelmingly, by their faith, most observe a distinction between that faith and their form of government. Even avowedly Islamic states such as Pakistan practise democracy (its failings being largely due to factors unrelated to religion). Even the Muslim-majority countries that favor Islamist models of governance – and, as has been noted, they make up roughly half the total – are pluralist. Meanwhile, Muslim scholars continue to debate the meaning of Islam and the key issues of the day, embracing rather than rejecting the tradition of scholasticism, inquiry and jurisprudence that has marked the religion since its earliest days (see, for example, the series of debates hosted by the Muslim Institute in 2017).

Salafist jihadism came to international prominence in the 1980s and '90s, tracking the rise of globalisation and accelerated by the end of the Cold War, the unchecked spread of neo-liberalism (and the economic, political and social problems these developments implied) – and coinciding with the rise of mass communications that became the internet of today. *Salafi* jihadists came to see themselves as possessing the perfect antidotes to neo-liberalism's totalising tendency. Inspired by religious zeal, they were convinced their faith was the panacea for a world whose triumphalist materialism was hollowed out by growing inequality within developed countries, and between them and the developing world. For them, this 'truth' dictated rebellion against western or globally aligned leaders within largely Muslim states; but also an appeal to small groups and individuals marginalised

The military in politics 135

within developed states. Their mission was to persuade them to join the jihadi struggle abroad or to manifest their alienation and discontent at home.

When *Salafi* jihadism produces often indiscriminate attacks against civilians, it is conventionally referred to as terrorism, or the deliberate use of terror – usually unexpected attacks against 'soft' targets such as civilians, calculated to create a general climate of fear to persuade a 'target' audience to subscribe to a political outcome it would not otherwise agree to.[5] This is distinct from, say, the Tamil Tigers who used suicide bombers primarily as a tactical method against hard (military) targets. In this, the method is less important than the intention, and such a distinction can create ambiguity over what constitutes terrorism and what is warfare (one has only to consider the purpose of generalised air attacks against cities in World War II), or crime (for example, if the intention is create fear so as to extort funds).

Faced with terrorist threats, governments understandably default to using the military – and, more specifically, specialist units within the military – in domestic counter-terrorism operations. But, even when the idea of a greater role for the military in domestic affairs has some support, it remains problematic for a number of reasons.

First of all – and it does need to be acknowledged – there is a distinction between acts of war and crimes, regardless of the methods employed. A suicide bomber in Kabul is most likely engaging in an act of war, if by unconventional means. A lone-actor attack, by contrast, often reflects an attempt to dignify an otherwise failed life, even a life that may have recently found meaning by going down an ideological 'rabbit hole'. Yet, for developing countries, occasional intelligence or military successes tend to be a default position for palliating terrorism-related concerns, even though they are necessarily reactive rather than pro-active and reflect a form of asymmetrical civil conflict rather than traditionally understood terrorism as such.

Sending in the troops to carry out conventional policing operations may have a similar appeal for desperate politicians to a hard line on capital punishment, especially where a populist (often reactionary) clamor has arisen around a specific incident. But, if the distinction between national defence and internal policing duties becomes blurred even once, there is little to ensure that calling in the army will remain a rare exception. This is so not least because 'terrorism' is so ambiguously defined. The trend, then, is for the army to be used more generally to maintain law and order.

There is broader political problem with mustering the military for domestic 'force' duties. Soldiers, and paramilitary police, default more easily than 'cops on the beat' to detaining people 'on suspicion'. Normalising such a practice is a recipe for a vastly changed domestic political landscape.

History is littered with militaries that became embroiled in their countries' domestic affairs, sometimes with the best of intentions. But involvement in domestic affairs necessarily means involvement in domestic politics. Given their superior firepower, armed forces' involvement in the public life of civilians invariably increases rather than decreases. As Cold War conservative Samuel Huntington noted in *The Soldier and the State* (1958), involving the military in politics implies authoritarianism. The history of military coups in many developing (and some developed) countries has only borne out his warning.

Once in politics, getting the military out again is extraordinarily difficult (see O'Donnell and Schmitter 1986). Action is addictive. The best indicator of whether a country is susceptible to a coup is whether it has previously had one.

Warlords

Military control of politics is not always formalised. Where the institutions of state have broken down and ceased to fulfil their conventional functions, their 'rule' collectively or in part may be usurped by non-state military leaders, or warlords (Siddiqa 2007:33). Specimens of state failure and warlordism in the 21st century include Afghanistan, Iraq, Somalia, Libya, arguably Syria and Lebanon (particularly in relation to the rise of Hezbollah as a dominant armed non-state actor). Regions controlled by warlords, or other armed non-state actors, function when they are able to establish a 'predictable, consistent, wide-spectrum normative system of control' (Kilcullen 2013:126, see also pp. 131–135).

Warlords' armed forces, as their name implies, are loyal to one person rather than the state – easy to justify if the state is no longer functioning or only partly functional, unable to exercise authority over the full extent of its proclaimed sovereign territory. While informal military leaders have existed since prehistoric times, the term 'warlord' was coined in the mid-Victorian era to describe the ancient status of the British aristocracy in the days when it imposed its rule by force of arms alone before its authority was regularised and sanctioned by the application of law (Emmerson 1866:77).

Warlords operate in conjunction (or competition) with other warlords, or with the state in exercising regional control. In feudal times this might have described the relationship between barons and kings. In more modern settings, warlords might control a portion of otherwise ungovernable territory on behalf of the state, for example Iraqi Shia cleric Muqtada al-Sadr's *Jaysh al-Mahdi* (Mahdi Army), which formed in 2003. Like other warlord outfits, the Mahdi Army filled a gap created by the breakdown of state order following the removal of Iraq's Ba'athist regime in 2003, and found a popular cause in opposing the U.S.-led invasion. While the Mahdi Army evolved into a more regularised socio-political institution after 2008, it resurfaced as *Saraya al-Salam*, which translates as Peace Companies (Loveday 2014), one of three components of the Popular Mobilisation Forces which supported Baghdad in its battle to defeat Islamic State (Mansour and Jabar 2017).

In Afghanistan, political power has long been decentralised and tribal leaders as warlords have played a prominent role in Afghan politics, notably since establishment of the modern state in 1919, but especially since the Saur Revolution of 1978. Afghani warlords came into their own with U.S. support in battling the Soviet occupier, and have operated as independent politico-military actors since the Soviet withdrawal in 1989. Kabul's control of its Afghan territory, in the face of warlord activity, declined from 72 per cent in 2016 to 57 per cent in 2017 (Rashid 2017). Ethnic militias were led by (Tajik) Ahmad Zia Massoud, (Uzbek) Abdul Rashid Dostum and (Pashtun) Gulbuddin Hekmatyar.

As a majority-Pashtun and former prime minister with a penchant for centralised control, Hekmatyar could be described as working in conjunction with the state. But his status is equivocal: he can also be seen as working against the state, or at least its formal representatives, and has expressed interest in replacing the government in Kabul. Somalia was similarly riven by tribal or clan-based warlordism after the military regime of President Mohamed Siad Barre was toppled in 1991. Somalia took an important step on the road back to statehood with establishment of its Islamic Courts Union in 2006, and yet another with international intervention in 2012. But it remains brittle, with tribalism posing a constant threat of further political fragmentation.

Warlords thrive in many other countries, including in the border areas of Myanmar (see Sadan 2016), throughout much of sub-Saharan Africa, in the post-Soviet states of Central Asia and in the Philippines where local politicians boast their own small private armies.

The military in politics 137

Of course, many separatist and revolutionary groups also control territory through armed force, impose local 'taxes', keep local order and sometimes even provide social services. Despite the common element of loyalty to a leader, though, they are not warlordist because they share an ideological goal, such as regional independence or the overthrow of an established political order. They are not there just to fill a political vacuum or occupy territory by force.

Conclusion

Military involvement in politics is a relatively common feature of developing countries, and helps explain why some of them struggle to escape the cycle of civilian maladministration and perpetual under-development. Structural fragility also militates against civilian success in the governance of many states. Where this generates opposition or dissent, accompanied by the breakdown of functioning institutions, militaries will often become political actors, feeding into a self-perpetuating politico-military cycle.

As mentioned earlier, the military's awareness of its importance in winning the struggle for independence may tempt it to remain on the political stage long after Independence Day, undermining civilian authority from the outset. Where a military leadership harbors contempt for civilian government, seeing it as either ineffective or opposed to their own interests, they often inject themselves into the political process. This they do by supporting certain, usually authoritarian, leaders or assuming the reins of government via a coup. Military discipline soon leads to dictatorship or rule by a junta, else – if the state fractures – the rise of regional warlords.

Apart from the self-aggrandisement motive referred to earlier, militaries that exploit criminal and commercial opportunities may do so to ensure a degree of autonomy from civilian oversight. This leads, finally, to questions of accountability, impunity, the ramifications of military supremacy for other pillars of the state and political reform. Developing countries without adequate civilian oversight of their armed forces, or that prove unable or unwilling to reform their militaries, risk condemning themselves to a ceaseless cycle of interference in their administration. With rare exceptions, this produces an incapacity to break the nexus between political failure and economic development. It is this question of transitioning from such closed political environments to which Chapters 10 and 11 turn.

Notes

1 There is debate as to whether Suharto came to effective power in a coup or in response to a coup. In the latter view he led a military response to an attempted Communist Party coup in 1965, although it remains unclear whether there was an actual coup attempt against then president Sukarno. A view once commonly held was that a showdown between the Indonesian Communist Party (PKI) and the army was practically inevitable and that, having seized effective power in the anti-communist putsch, Suharto then deposed Sukarno and became acting president and later president.
2 The party of Vice-President and later President Megawati Sukarnoputri, and later still of President Joko Widodo.
3 The party of Indonesia's first post-Suharto-era elected (and deposed) president, Abdurrahman Wahid.
4 To follow in the footsteps of the 'pious predecessors/forefathers', referring to Prophet Mohammad's comment that Islam's first three generations were the most pure. '*Wahhabism*' is taken as an

138 *The military in politics*

insult by *Salafis* themselves, as it glorifies Muhammad ibn Abd al-Wahhab who helped found their movement in the mid-18th century.

5 There are numerous definitions of terrorism. The one used here is perhaps the simplest to understand. Needless to say, there are also numerous sources of terrorism in both recent and historical settings (see Goodin 2006; Burleigh 2009 for an overview dating from 647 BC).

10 On democratisation

Most people, regardless of their circumstance, appear to want to live with a degree of dignity, to have their concerns listened to and acted upon and to be able to express a desire for change if that is not the case. The political system that most consistently, if far from always perfectly, provides for this is 'democracy'. However, in all the debate about this much abused term, there is little discussion as to what it actually is.

The debate about what democracy is, whether it is a political positive and whether, more controversially, it establishes a political benchmark, partly concerns the methods by which it is achieved and to what extent the means shape its political ends. For the purpose of this discussion, 'democracy' here is understood as conforming to an 'expanded procedural minimum' political model. Under this model there are 'reasonably competitive elections, devoid of massive fraud, with broad suffrage; basic civil liberties; freedom of speech, assembly, and association; elected governments have effective power to govern' (Collier and Levitsky 1996:10).

If political change arises primarily as a result of compelling material circumstances, there may be a reason to expect that change to reflect those circumstances and continue doing so. For example, a desperate but successful battle against an oppressive and brutal government may, in an apparent paradox, produce a restrictive government of the opposite political stripe, simply because the new government fears the return of, and reprisals by, former militant forces and the interests supporting them (such as Myanmar in 2015).

But, if political change arises as a result of a shift in public and elite thinking (e.g. the Philippines in 1986), or because one regime type has voluntarily handed power over to another (Indonesia 1998), there may be greater scope for volition or choice to inform the outcome of said change. Where an authoritarian regime is in decline and hands over power peacefully, for example through a democratic process which it does not contest, there is a better chance of the incoming government reflecting the benign influence of entering office without having to 'look over its shoulder'. In either case, the power of the outgoing regime has crumbled, and its legitimacy and efficacy have been fundamentally called into question, if not entirely forfeited (Linz 1990:46). When this happens, the opening is created for a political sea change or transition.

Transitioning may be from one political format to another, which often occurs in response to a specific event or a build-up of political pressure. That event may be sudden, such as a natural or human-induced disaster, such as Argentina's loss in the Falklands War, or the death or sudden decline of an autocratic leader, although this is less likely to lead to an immediate political change (see Kendall-Taylor and Frantz 2016). Or the change may be more gradual, when an evolving political environment passes a tipping point or there is a timely intervention in the normal course of events. In such circumstances a critical

140 *On democratisation*

juncture is reached, where the combination and extent of particular factors forces major, and often abrupt, change, such as in Chile in 1990. This chapter looks at why political transitions occur and what problems often accompany them.

In considering transitions from authoritarian to democratic models, a range of conditions might be perceived as essential for successful regime change. As noted by Dahl (1989:111), these include: control of the military and police by elected civilian officials; democratic beliefs and culture; and no strong interference by foreign powers hostile to democracy (for example, the USSR in Eastern bloc countries). Further, Dahl identified conditions that were not absolutely necessary but favored the establishment of democracy, including a modern market economy and society, and weak sub-cultural pluralism (or lack of opportunity for inter-ethnic conflict) (Dahl 2000:147, see also Dahl 1989:Ch. 8). According to Dahl (1971), democratisation (which he called 'polyarchy') has five features besides free and fair elections: universal suffrage, the right to run for office, freedom of expression, alternative sources of information and freedom of association.

According to Rustow, a transition to democracy is complete when the country achieves stable government, with the risk of a coup close to zero. Since coups override the rest of the political process, their elimination from the suite of possibilities signals that peaceful, procedural redistribution of political power has won out over more violent means of determining who holds power (Rustow 1999). Importantly, Rustow was not commenting on whether the transition in question was a democratic one, and so gauged a transition simply by the reduction or absence of uncertainty, usually through institutionalising an agreed set of rules, defining political roles and delineating competencies in the policy sphere after such a transition has been effected (Karl 2005:16).

The state, society and democratisation

Reflecting on the relationship between state and society within the context of degrees of freedom, Stepan noted the putative if changing focus of the state from economic to political development:

> The assumptions of modernization theory that liberal democratic regimes would be inexorably produced by the process of industrialization was replaced by a new preoccupation with the ways in which the state apparatus might become a central instrument for both the repression of subordinate classes and the reorientation of the process of industrial development.
>
> Stepan 1985:317

The ascension of what have been called 'bureaucratic authoritarian regimes' associated with, if not necessarily responsible for, economic development (along with industrialisation) in such states as Taiwan, South Korea and Singapore fragmented and inhibited political opposition to the government of the day (at least in the early stages of Taiwan and South Korea's development). The rise of official state institutions, and the non-negotiable imposition of their development programs, has diminished other political institutions, among them the pluralist institution of 'opposition' and the capacity of civil society (Stepan 1985:317). This comes back to powerholders' desire to delegitimise political alternatives, and in particular, those that are necessary for a successful plural polity but which have an imposed reduced capacity that in turn delegitimises them.

What differentiates earlier and more recent approaches in thinking about state institutions, particularly in developing countries, is that they are more recently not regarded as merely collectivities of people each with a particular role to perform, but as embodiments of rule sets or codes of behavior that embrace, for example, the rule of law and notions of equality, tolerance and respect for alternative views (see Hall and Taylor 1996). Key distinctions are drawn between formal and informal rules and codes, with greater emphasis on the informal.

One informal rule that might be considered critical to democratic outcomes is the opportunity to create and sustain civil society organisations, which play a central role in the flowering of openness in developing states. The organisational 'rules' to which such groups adhere are one of the criteria by which they are adjudged to be institutions but, over and above that, their social and political roles in an emerging democracy also become institutionalised. Thus a developing country is expected to nurture civil society organisations and, from time to time, welcome their contribution to public debate and decision-making.

Where legitimacy implies consent to rule it is normative, in that it reflects a social value judgment on whether or not a ruler has the 'right' to rule, or a government to govern. This in turn raises moral questions. Positive legitimacy implies explicit agreement about the bases on which it is conferred, such as compliance with the equal and consistent rule of law, and correspondence between such compliance and the ruler's actions. In short, legitimacy derives from a sense of justice in social and political relations.

The relationship between civil society and government has been proposed as a sort of 'thermometer', monitoring the democratic health of the state, with the capacities of individual institutions tantamount to what medical practitioners would call vital signs. Stepan (1985:318) posited the following four sets of relations between the state and civil society:

1 Growth of state power and diminution of civil society power, often occurring when developing-country governments move to 'close' the political space;
2 Decline of state power and growth of civil society power, unusual in developing countries;
3 Growth of both state and civil society, again unusual in developing countries but sometimes occurring in democratic transitions; and
4 Decline of both state and civil society (but with the variant of civil society growth outside the state), which indicates failed-state status.

Stepan was primarily concerned with the growth of state power in developing countries at the expense of civil society, or the imposition of bureaucratic authoritarianism with a parallel reduction in the capacity of non-state actors to compete with state power. While focused on Latin America, his analysis characterises 'strong states' such as China, Vietnam, Syria (at least before 2011 when its protracted civil war erupted) or Egypt (other than for the brief period 2011–2013) in which an independent civil society is relatively weak. During the transition from bureaucratic authoritarianism, state power declines and civil society strengthens as the political space opens up (which occurred in Thailand the last time the military ceded power to politicians).

Civil society may also become self-strengthening and therefore spur a decline in state power (as occurred in Poland during the 1980s). State and civil-society growth can be seen through the lens of competition or that of complementarity. In the former case, competition creates instability, which either degenerates into internal conflict or results in the state or civil society gaining the upper hand. Theorists distinguish between negative state power

142 *On democratisation*

(bureaucratic authoritarianism) and benign, or positive, state power (which they define as the ability to resist the influence of vested interests). Where civil society and positive state power are both strong, they are likely to form a synergy that stimulates their respective capacities. Perhaps the best examples of this can be seen in the Scandinavian states, and to a lesser extent in other plural democracies; and all of them contrast starkly with the politics of many, probably most, developing states.

Where both state power and civil society power are in decline, failure of the state or reversion to pre-modern methods of state organisation is a looming possibility, since neither element is robust enough to compensate for the other's frailty. Like nature itself, a collapsed political space abhors a vacuum – and external actors will quickly be drawn into filling it. That is what happened in Iraq with the insurgency against U.S. intervention from 2003 on. The intervention created the power vacuum which then led to the necessity of its continuing, if increasingly fraught, presence. Similarly, central political control of the state in Afghanistan had collapsed prior to the rise of the Taliban in 1996 (and, arguably, again following the U.S.-led invasion from 2001), as it did in Timor-Leste from late April 2006. In studying the reduced autonomy of the Brazilian state in the early 1980s, Stepan noted the view of executive-branch leaders that only the reduction of state autonomy relative to civil society through a process of liberalisation could rein in the state's security apparatus. Put another way, if the state was weakened relative to civil society, its agencies would also be relatively weaker, including those viewed as malignant (The Editors 1985:355).

State institutions

Institutions, as they have been traditionally or narrowly understood (for example, Fukuyama 2004), tend to develop a quasi-independent capacity and sense of self. The search for meaning among the individuals who work for such institutions nurtures self-regard at an institutional level, an attribute deriving from their sense of its relevance and capacity. With the burgeoning of self-regard, the self-maintenance (and expansion) of institutions may take precedence over the function they were initially designed to undertake, especially where there are low levels of capacity, oversight or accountability. In popular parlance, this phenomenon often goes by the name of 'empire-building'.

It is a familiar phenomenon in most classic institutions, especially the bureaucracy (see Weber 1948:338–341). The key yardstick for bureaucratic performance is performance assessment criteria set against 'stakeholder' interest. But, however those parties with an interest in policy implementation view performance, the self-referential character of many bureaucracies will continue to slow or otherwise curb effectiveness.

Institutional self-affirmation – the process by which bureaucracies acquire an expanding series of often unresponsive checks and processes – may not only account for bloated and slow-moving juggernauts but also explain the political role of military, police or intelligence agencies and the like, each of which tends to be more active in developing countries.

The inflation of institutional self-regard is less surprising when certain facts are considered: anybody with a modicum of organisational efficiency, if given the sole legal capacity to employ violence on behalf of the state, and the means to become economically self-supporting, may well develop a 'culture' or world view that rationalises its privilege relative to the ordinary citizen. Such an outlook is reflected in the myth of the post-revolutionary 'people's army' (China, Vietnam, Laos), the invulnerability a group feels if designated as guardians of public order, protector of the state and so on (e.g. Zimbabwe, Myanmar, Indonesia). Given the

avenues open to such institutions for preferment and enrichment through employment, promotions, quasi-official business ventures and corruption, there may well be resistance to calls for them to adapt to changing circumstances. From there it is only a short conceptual step to becoming a powerful force for reaction.

The role of institutions has been identified by the World Bank, among others, as central to the success or failure of development projects. States' capacity to channel aid where it is most needed, and to sustain the process of development generally, is seen by the World Bank, and many others, as vested in the institutions of state. This thesis was first developed by Huntington (1968) and later addressed by Fukuyama (2004).

After his earlier foray into determinist normative claims of the inevitability of democracy and free-market capitalism in developing countries, Fukuyama appeared to recognise that liberal-democratic capitalist outcomes in developing societies were not a given. Responding to his own country's assertion of military power, he recognised two sets of closely related problems. The first was that the United States had intervened in the affairs of other states for the explicit purpose of expelling undemocratic regimes and in most cases – at least rhetorically – of eliminating their military capacities (e.g. 'weapons of mass destruction') and their support for terrorist organisations. Examples since the early 1980s are legion: El Salvador, Nicaragua (via the CIA), Grenada, Panama, Sudan, Lebanon, Somalia, former Yugoslavia, Haiti, Afghanistan, Iraq, Libya and Syria.

Positive grounds cited to justify such interventions included bringing democracy to these countries or ending lawlessness. But local populations did not automatically see the benefits of a 'democratic' system of government or of U.S.-inspired 'law' when it appeared to be imposed and represented an alien ideology or value system. More to the point, it was difficult to establish a democratic framework in states that did not enjoy the range of institutions which allow democracy to exist, let alone flourish. In most cases it was the lack of these very institutions that was responsible for the state degenerating to a point where it allowed, or was powerless to prevent, the presence of terrorists on its soil.

Secondly, it was the failure of state institutions more broadly that provided fertile ground for the establishment of outfits seen as antithetical to political development, e.g. the Taliban in Afghanistan or the Islamic Courts Union in Somalia. Beyond this, the incapacity and non-performance of state institutions were increasingly blamed for states remaining mired in under-development. This re-focusing on the importance of healthy state institutions originated in the World Bank after the collapse of the Soviet Union redirected attention away from communitarian-bureaucratic systems of government (that is, 'communism') in a number of east European states towards the paradigm of free-market liberal democracy.

Institutional incapacity was perceived as the major obstacle to political transition in that direction. While the 'direction of travel', so to speak, was from Left to Right in formerly communist countries, there was simultaneous traffic, flowing Right to Left, from authoritarian rule to the open road. This applied in the Philippines, Thailand, Indonesia, Argentina and Chile. Yet not all countries simply accepted a conventional democratic model; some countries, or at least their leaders, sought to explain and legitimise their undemocratic rule by appealing to a competing set of values.

Transitions

Of all political transitions, Myanmar's stands out as one of the more prominent illustrations of a shift from authoritarian rule to have occurred in the 21st century. From being one of the most oppressive states in the world, within a few years Myanmar transitioned to having

144 *On democratisation*

a largely elected, civilian-led government, releasing most political prisoners and introducing social freedoms that would have been difficult to envisage beforehand. As noted in Chapter 3, Myanmar's transition to a civilian-led government in 2015 was in part a response to longer-term economic collapse compounded by the devastating effects of Cyclone Nargis in 2008.

Myanmar has also shown the shortcomings of such transitions, demonstrating that they rarely conform to an ideal type, often retain key elements from the previous regime, and are prone to compromise and reversal. Myanmar's failure to reach ceasefire agreements with a number of armed ethnic groups, and its persecution of the Rohingya, were stark examples of that. As Haggard and Kaufman (1997) also noted, transitions can be in the direction of authoritarian rule, not just away from it. Proof of this ranges from transitions in Thailand (most recently in 2006 and 2014) to those in Turkey (1983), South Korea (1986) and Chile (1973).

In some cases, a transition from democracy to authoritarianism may even be welcomed by many or most people, as evidenced by Egypt after the 'Arab Spring', when protests against its first democratically elected government led to a military coup and the subsequent election of coup leader General Abdel-Fattah el-Sisi. Sometimes authoritarian certainty is preferred to pluralist discord or, especially, anarchy. The extent to which transitions are consolidated, and the question of whether they can be, often remain unanswered questions. If a genuinely free and open political society is not constantly protecting its freedom and openness, the prospect of these qualities being lost is ever present, and in this respect no free and open society is ever truly 'consolidated'.

But sustaining authoritarianism has its own challenges. The longer an authoritarian or autocratic regime is in power, the more of whatever legitimacy that it may have had diminishes (Linz 1990:147). Time – more than three decades in executive control of the state – certainly wrought its revenge on Indonesia's President Suharto. While Suharto had seen off several challenges to his rule, the one that finally saw *him* off was, arguably, instigated as early as the late 1980s (Crouch 2010:18). Suharto had tried to manage the evolution of his autocratic rule, notably during the brief 'openness' period of 1991.

Among the antecedent conditions that led to the critical juncture for Suharto were mounting resentment across the nation, and particularly in Timor-Leste, at his autocratic, and sometimes brutal, rule. The national resentments simmered after more than thirty years' denial of accountability, rampant corruption and regularisation of repression as a means of controlling dissent.

In Timor-Leste's case, the Indonesian state never established widespread legitimacy or acceptance, and repression – familiar enough elsewhere in the archipelago – was employed without restraint there. The method by which Indonesia had incorporated Timor-Leste, through military invasion, and the deaths of around a quarter of the population as a direct result of its occupation, meant that the driver of change for Indonesians was reform of their state while, for the East Timorese, it was a yearning to disassociate themselves entirely from the state.

The stage was set for Suharto's exit from the scene by an assortment of factors that impinged on individuals (the ageing of the president), on institutions of state (growing discontent within sections of the military) and on the times themselves (the end of the Cold War which supplanted the incentive to prop up 'West-friendly' governments with a pro-democracy paradigm emphasising respect for human rights).

What brought all these factors together was the 1997–1998 Asian financial crisis, which crippled the Indonesian economy and mortally wounded Suharto's sclerotic leadership.

High private debt levels, often in unproductive sectors such as real estate, combined with rampant corruption and an increase in cash transfers overseas effectively hollowed out Indonesia's superficially sound economy.

Against the backdrop of a gathering mood for change, these factors converged swiftly in the end, forcing Suharto's resignation on 21 May 1998. The role of the International Monetary Fund in exacerbating some impacts of the financial crisis attracted its fair share of criticism. It has been claimed that the IMF pushed Indonesia further into U.S.-dollar-denominated debt and created conditions conducive to a reduction of confidence in the Indonesian economy (Ramli 2002; Grenville 2004:20).

The IMF was also credited with exposing the extensive failure of Indonesia's crony-ridden banking system and thus indirectly helping to discredit Suharto and hasten his demise. There was a loss of policy cohesion between the IMF and the Indonesian authorities, as well as among the Indonesian authorities themselves, prompting Suharto to take over direct negotiations with the IMF. In December 1997, the president cancelled an overseas trip to take a ten-day 'rest', sparking rumors about his health, focusing attention on the political dimension of the crisis (Grenville 2004:19) and, for the first time, openly raising the issue of political succession. Following the build-up of public protest and Suharto's eventual resignation, Indonesia's transition to democratisation benefited from an international tailwind, in particular with practical support for the first elections of the post-Suharto era, held on 7 June 1999.

Timor-Leste similarly benefited from Indonesia's economic chaos and Suharto's resignation. In response to international criticism and growing domestic financial pressure, his successor, President B. J. Habibie, announced on 28 January 1999 that Indonesia's expensive and internationally unpopular occupation of Timor-Leste would be settled by a province-wide ballot. From a civilian background, Habibie had not been one of Suharto's inner circle, who all strongly favored keeping Timor-Leste as part of Indonesia. In giving the East Timorese a say in their future, Habibie was persuaded by a mixture of economic necessity and the wish to placate both domestic and international critics of the country's human rights agenda. Once the decision had been agreed on 5 May 1999 – with Indonesia, the UN and Timor-Leste's former colonial master, Portugal, promising a 'popular consultation' – the international component of this transition proved critical.

Consistent with Linz's observation (1990:148), the period of 'openness' did not work in favor of the New Order but backfired on it. The process reduced the incentive for participation in New Order institutions and provided scope for the testing of limits, in this case through the media reporting stories that reflected poorly on Suharto's oversight of a naval-ship tendering process. When consequent embarrassment resulted in an about-face, with 'openness' replaced by old-style media censorship, frustration mounted and actually fed into the growth of opposition to the New Order. Similarly, a gesture of openness in Timor-Leste at the end of the 1980s spurred rather than dampened public protest, turning a visit by Pope John Paul II in 1989 into the scene of a melee that received considerable international attention (Haberman 1989a; 1989b) and emboldened the anti-occupation resistance.

The 'transitions' paradigm, as initially articulated by O'Donnell and Schmitter (1986, see also O'Donnell, Schmitter and Whitehead 1986), places a premium on structure over agency in the establishment of democratic forms. But no absolute answer has been found as to whether structure (the determinants of democratisation's outcome) or agency (performing an act of free will in spite of circumstances) is the more potent influence on outcomes, or on any disparities between them. As O'Donnell and Schmitter make clear, political outcomes

146 *On democratisation*

and the multiplicity of factors leading to them are not linear, usually not foreseeable and often poorly understood until the point of accomplishment approaches (1986:66).

Not only are transitions difficult to understand before the event, sometimes they cannot even be properly understood afterwards. Events are often unexpected and fast-moving. Responses are often kneejerk, or *ad hoc*. Decision-makers appear 'out of nowhere', elites adapt to uncertainties and perceived trends; the loyalty, or even utility, of social, legal and political institutions is called in question or becomes extremely unreliable. All these factors, and more, can turn political transition into a wild ride whose outcome may depend far more on the deeds that make up a process than the intent behind them and which, if not under skilled management, may be both unexpected and unwanted.

Unpredictable though transitions and their outcomes may be, different types of authoritarian regime often undergo different types of transition. Linz describes (1990:145–146) as 'sultanistic' regimes (e.g. Suharto) those that aggrandise the role of an individual powerholder for largely personal ends and where support for the leader is based squarely on personal loyalty. Transitioning from that state of affairs is notoriously problematic and either requires wholesale regime change or becomes corrupted by the continuance of pre-existing practices.

Indonesia in particular has continued to struggle with the consequences of Suharto's 'sultanism' (Winters 2011:139–192, see also Loveard 1999), although the entrenchment and evolution of the TNI as a force distinct from Suharto's power meant a controlling mechanism was in place to ensure the country's transition was fairly calm, unlike the bloodletting and subsequent social scarring of the previous regime transition in 1965–1966. The post-New Order regime did, however, share some 'characteristics similar to the one overthrown' (Linz 1990:146).

Timor-Leste cannot really be said to have suffered 'sultanistic' rule, despite criticisms of both Prime Minister Mari Alkatiri and his family's business interests and, later, of Xanana Gusmao's family business interests. While Timor-Leste faced almost a complete political vacuum after the events of 1999, elements of the Fretilin party were organised enough to provide some structure and legitimacy inherited from the generation-long independence struggle. These appurtenances, however, were rapidly squandered within a year or two of a Fretilin-led government coming to power in 2002. What little institutional basis there existed for the shift to democratic government was provided by the UN, which turned administration of the state over to the East Timorese only when it was believed (incorrectly, as it turned out) to be ready to conduct its own affairs. Unsurprisingly, the new regime continued to rely fairly heavily on those bureaucrats and other officials who remained behind after Indonesian rule so it should also be no surprise that, in some of its more dubious practices, it betrayed characteristics similar to the administration it had overthrown.

While regime change can take place through various means, these can be, and have been, systematically classified. At the critical juncture that triggers change, classificatory factors include: the primary change agents, the speed of change, the degree of control exercised by the departing authority, and the extent of accommodation or conflict exhibited in the transition. Karl (1990) identifies four 'modes of transition':

1 'pacted', in which the manner and details of the transition are incorporated in pacts reached among political elites;
2 'imposed' (whether internally or externally), in which a significant authority effects the transition without consultation;
3 'reformist', characterised by broadly approved gradual change; and

On democratisation 147

4 'revolutionary', in which there is a fundamental and quite abrupt change of regime.

Elements of each mode may be present during a transition, so more than one factor may reach a tipping point.

Assuming that regime change will usually be opposed, and that transitions – especially in the democratic direction of travel – presuppose a shift in the military's allegiance, politicisation and divisions can be expected within the military between supporters and opponents of regime change. O'Donnell and Schmitter (1986:15–17) characterise these factions as 'hardliners' (supporters of the *status quo ante*) and 'softliners' (proponents of its replacement, albeit normally at a graduated pace). Examples of softliners taking advantage of 'the military moment' (O'Donnell and Schmitter 1986:39) include Portugal and Greece in 1974, the Philippines in 1986 and Indonesia in 1998, in addition to which many examples from Latin America could also be cited.

Softliners may opt for a limited liberalisation of direct military rule while retaining a capacity to keep an elite in control without introducing democracy. This is how softliners acted in supplanting direct military rule in Indonesia from 1986 to 1988 before introducing cautious liberalisation (but without democracy) in 1991. A risk often run by softliners is that, in overestimating their popular support, they engender a backlash which sends the liberalisation process into reverse (O'Donnell and Schmitter 1986:8). Keeping the spotlight on Indonesia, President Habibie's decision to allow East Timor to vote on independence in 1999 led directly to the denouement of his political career within a matter of weeks, and his liberal successor was ousted halfway through his presidential term.

Softliners also encountered a backlash in the initial military-led steps during both Portugal's Carnation Revolution in 1974 and Turkey's return to electoral politics in 1983.

As Dahl noted (1978:208), a state is unlikely to develop a democratic political system rapidly with little or no experience of public contestation and without a tradition of tolerating political opposition. Regime change in such a state is at least as likely to default to an alternative authoritarian government, if not fully at least in part.

The process is not always followed through. An instance of incomplete regime change occurred in the Philippines in 1986 when, as discussed in Chapter 2, dictator Ferdinand Marcos lost the support of his U.S. backers and, eventually, of the country's oligarchic elite, along with sections of the military. There would appear to have been an agreement within elite circles that the time had come for cautious change (O'Donnell and Schmitter 1986:40–45). Capitalising on the 'political moment', elites – encouraged by (and encouraging) mass mobilisation – formed or revived political parties and galvanised political constituencies under the umbrella of a 'grand coalition'. This also occurred in Indonesia in 1998, though with one important inversion: instead of gradual economic decline being followed by a dramatic political moment, this time gradual economic decline was followed by a dramatic 'economic moment' (O'Donnell and Schmitter 1986:45–47). In the event of an economic crisis, such as the 1997–1998 financial collapse which hit Indonesia hard, there is an implied socio-economic pact between those most affected or economically disadvantaged and their professed 'rescuers', the ones who assume responsibility for alleviating their woes. In what Dahl (1970) has referred to as 'the democratic bargain' of trust, fairness and compromise, this pact normatively corresponds to a kind of social contract.

The operation of a certain transitional mode, or combination of modes, does not guarantee a particular kind of outcome. With tongue firmly in cheek, Rustow (1999:16) writes: 'By whip and sword we have been converted to the doctrine that there is no causation, only functional interrelation'. While the mode of transition and the nature of the regime it

148 *On democratisation*

brings to power may be related, that does not mean the genesis of change, which goes to its causation, and the result of that change necessarily will be.

Recognising the subtlety of this distinction, Rustow (1999:19) summarised his methodological position in seven points:

1 That which keeps a democracy stable may not be that which brought it into existence.
2 Correlation of factors in democratic outcomes is not the same as causation of democratic outcomes.
3 Causal links do not necessarily run from socio-economic to political factors.
4 Beliefs do not necessarily determine actions.
5 Democracy's origins are not necessarily uniform geographically.
6 Democracy's origins are not necessarily uniform sequentially.
7 Democracy's origins are not necessarily uniform socially: elites and citizens may differ about democratic desirability and outcomes.

Having noted this, Rustow argued (1999:20) that a prerequisite or 'background condition' for a democratic transition is unity of the polity making that transition: 'The vast majority of citizens in a democracy-to-be must have no doubt or mental reservations as to which political community they belong to'. In other words, national unity or a sense of bonded political community need not lead to a democratic outcome, but without it there will be internal division about how representative the state's politics is. Rustow pointed to an intriguing irony (1999:22–23), that the most strident nationalist rhetoric typically poured 'from the lips of people who felt least secure in their sense of national identity'.

On impediments to democratic transition, Di Palma noted (1991:3) that economic instability, a hegemonic nationalist culture and the absence of a strong, independent middle class all hampered such transitions. But, as Sen (1999b) noted, there is no necessary causal link between economic development and political forms (see also Przeworski 1995; Barro 1996; Przeworski et al. 2000; Papaioannou and Siourounis 2008), though there is considerable evidence of a correlation.

While a transition's provenance may ultimately bear no relation to the governing style of the regime in power at the end point of the process, Karl notes (2005:28) that transitions which issue from agreement between political elites have more predictable outcomes, due to the alignment of elite interests, the opportunity to build mutual trust, (at least nominal) respect for each other's interests and their constructive collaboration on a new regime type based upon a commonly agreed set of institutions.

Importantly, while militaries may accede to or even facilitate transitions to democratic governance, they may also insulate themselves from some or much of the scrutiny that is supposed to accompany such transitions. So, for example, the Zimbabwean military successfully managed to remove Robert Mugabe while for the most part staying out of the public eye; and the Tatmadaw in Myanmar oversaw the minutiae of that country's political transition by working assiduously behind the scenes. Military business enterprises and illicit sources of income may be left largely intact or diminish somewhat, but where militaries have been reliant upon 'off-line' income such sources of funding rarely disappear entirely (see Chambers and Waitoolkiat 2017:19 on the Thai experience). According to Transparency International, the least transparent militaries exist in Africa, with no states having thoroughly transparent militaries and thirty-nine having a 'very high' or 'critical' lack of transparency in relation to political roles, finances, personnel, operations and procurement (TI 2015).

On democratisation 149

In Zimbabwe, as noted in Chapter 9, Emmerson Mnangagwa, who had been personally close to the military throughout the thirty-seven-year rule of the president he ousted, promised a swift transition to elections and 'democracy' on assuming power. As months passed, no timetable for such a transition was announced. This did not mean elections would not take place at some stage and they could produce a democratic outcome. But it seemed unlikely that Zimbabwe's military, having installed Mnangagwa in office, would entirely forswear the role of anointing governments.

On a more positive note, Liberian elections in January 2018 elevated former professional footballer George Weah to the presidency, marking not only a peaceful transition of power but what was widely perceived as a genuinely democratic outcome. This followed decades of warfare along with brutal and corrupt rule by a string of military-backed despots, a tradition interrupted solely by Weah's immediate predecessor, Ellen Johnson Sirleaf. Indeed, Liberia had been marked as a pariah state, prone to state (and hence resource) capture by armed groups motivated by one of the clearest illustrations of the 'greed' thesis (Berdal and Malone 2000; Collier and Hoeffler 2000) although it must be said the profound mistreatment of certain groups over decades provided what many would consider ample grounds for grievance (De Koning 2007; Call 2010).

The evolution of governance from autocratic rule towards civil oversight featuring popular participation, representation and accountability requires an implied social contract between citizens and their government. An absolute ruler – whether sovereign monarch or tyrant – acts with untrammelled authority, by definition. No neutral authority exists to decide disputes between ruler and subject. Under the 'social contract' model, government cedes authority to the population, mediated by a nominally neutral authority (for example, an independent judiciary) in return for the right to rule. It is presumed that authority is ultimately vested in the citizens, on whose behalf it is provisionally held by a political leader or government, and that the authority placed in their hands can be rescinded by the citizens in an agreed and orderly manner (through regular elections).

Under this model, the political elite must be seen to be responsive to, if not satisfy, most of the public's major concerns, while not mismanaging the state's affairs to the point where public dissatisfactions erupt in collective action. As O'Donnell and Schmitter note – and experience does appear to bear this out – transitional administrations on the road from authoritarianism tend to be smoother and more successful if they deliver conservative or right-wing political outcomes, since the authoritarian elites they displace will feel their interests less threatened if they do. Democratic 'idealists', usually on the Left and centre-Left, get to engage in transitional process only if elite survivors from the previous regime are willing to negotiate the rules of the 'new game' (O'Donnell and Schmitter 1986:70).

The role played by external events in political sea changes should not be underestimated. Notwithstanding many exceptions, it appears such political transformations are most likely to occur at times of pronounced social, economic or political dislocation. (More than one type of dislocation may be present simultaneously, of course.) Tensions must pre-exist for there to be a rupture in the governance continuum, but the rupture itself appears to act as a catalyst for regime change. By way of illustration, the Russian Revolution took place after its disastrous involvement in World War I. China's nationalist revolution of 1911 was precipitated by colonial domination, and its communist revolution, which captured state power in 1949, thrived on the twin adversities of state fragmentation and Japanese occupation. In the 1970s Portugal discarded dictatorship in the wake of economic collapse and failed colonialism; and its colonies themselves sloughed off Portuguese overlordship as the fascist regime in Lisbon collapsed. Similarly, Nicaragua's revolutionary 'Sandinistas' (*Frente Sandino*

150 *On democratisation*

de Liberacion Nacional, or FSLN) deposed the country's U.S.-backed hereditary dictatorship after a destructive earthquake. Indonesia, as mentioned earlier in this chapter, removed its authoritarian leader consequent on the Asian economic crisis (while Thailand initiated its most liberal constitution in response to the same event); Greece sent its junta packing after the Turkish invasion of Cyprus; and Argentina removed its following defeat in the Falklands War. In the two latter cases, democracy was achieved by political stalemate and lack of consensus rather than by prior unity and consensus (O'Donnell and Schmitter 1986:72). Indeed, virtually the whole decolonisation era after World War II can be more or less attributed to the war's economic, military and political impacts which spared neither the colonised nor their colonisers.

Foreign powers can also play a role in regime change by supporting various parties which might, at any given time, be in external exile or working 'underground' within the country in question. It has been common practice for groups striving to overthrow regimes to receive external assistance in one or more forms: sanctuary, training, logistical support and representation in international forums. A recent example of this was Libya in 2011, when NATO conducted air strikes in support of anti-Gaddafi forces.

Transitions born of crisis are, of course, not consistent in their outcomes (witness the shifting contest between democracy and authoritarianism throughout Latin America and much of sub-Saharan Africa, as well as in countries such as Thailand and the states of the 'Arab Spring'). There are even cases of voluntary political redundancy, such as Spain's renunciation of fascism after Franco's death, although this might be ascribed to political 'shock'. In some cases, though the 'shock' is little more than an occasion for remedying long-term misgovernment: in such, admittedly rare, cases, an ossified regime may be well aware its days are numbered yet still require a pretext to ease and dignify its own departure.

As noted, not all regime changes are towards democracy. Some changes may travel only some distance along the democratic road (for example, the Philippines after 1986 and Indonesia after 1998) or they may lead to years, even decades, of conflict (Cambodia, 1975–1998). Others simply revert from one type of authoritarianism to another, as has often been the case in sub-Saharan Africa. These different experiences of regime change invariably reflect competing views of what constitutes political progress: what is fairness to some is interference in the view of others; some people's freedom is others' disorder. Everything depends on how one regards such basic concepts as freedom and equality.

Democratic consolidation

The maturation of a new democracy such that it is unlikely to revert to authoritarian ways without an external shock to the political system is known as democratic consolidation. If democracy is to take root, the political system in question needs to have built up reserves of legitimacy in the eyes of its stakeholders to the extent that, should such shocks occur, it is resilient enough to draw on and even replenish those reserves (Putnam 1993).

Initially coined in light of democracy's 'third wave' (Huntington 1991) as a term to describe processes or requirements for making new democracies 'secure', 'democratic consolidation' has since developed to include a wide range of criteria, among them:

> popular legitimation, the diffusion of democratic values, the neutralization of anti-system actors, civilian supremacy over the military, the elimination of authoritarian enclaves, party building, the organization of functional interests, the stabilization of

On democratisation 151

electoral rules, the routinization of politics, the decentralization of state power, the introduction of mechanisms of direct democracy, judicial reform, the alleviation of poverty, and economic stabilization.

Schedler 1998 (see also Linz 1990)

Here, Schedler is defining democratic consolidation as the broadly accepted and regularised institutionalisation of democratic values and practices, including the consistent application of a democratic 'expanded procedural minimum'. This would conventionally include the establishment of such anchoring institutions as an electoral commission, regular elections and consistency, both constitutional and legal – the latter administered independently of government and equally in respect of all citizens, regardless of wealth and social status. As Karl (2005:16) notes: 'Consolidation ... is characterised by an internal logic composed of interdependent conditions – not the same degree of chance or incidental events that elucidate transitions.'

Some scholars argue that democracy becomes consolidated via the creation and improvement of its secondary institutions. Linz and Stepan's thesis (1989) is, more specifically, that it is consolidated by the presence of those institutions supporting and surrounding elections (for example, the rule of law). The idea of democratic consolidation was popularised in the early 1960s after the first wave of decolonisation and the inception of challenges to democratic experiments in newly independent countries. Consolidation was then seen to inhere in the values and attitudes that emerge with, and work to sustain, participatory democratic institutions. These values and attitudes relate to how people understand their relationships with others through the prism of their own interests (Almond and Verba 1963).

One measure of democratic consolidation has been the 'turnover test', concentrating on the degree of unanimity surrounding the system of government after a change of power-holders (Lijphart 1999:6). Huntington extended this model by popularising the idea of a 'two turnover test' in which

democracy may be viewed as consolidated if the party or group that takes power in the initial election at the time of transition loses a subsequent election and turns over power to those election winners, and if those election winners then peacefully turn over power to the winners of a later election.

Huntington 1991:266

Some theorists question whether democracy can be 'consolidated' in any country, given that in all cases democratic processes and practices remain dynamic. In the 21st century, many western countries – ostensible bastions of democratic consolidation – have whittled away democratic elements, giving state agencies increased powers of surveillance and reducing information sources. Concurrent with this trend has been another, favoring populist leaders who have less regard for democratic notions such as the separation of powers. So, too, in developing countries where democracy is less deeply embedded, its survival is susceptible to political challenge through coups, authoritarianism and closed, or single-party-dominant political systems.

Democratic deficits

Almost as much as 'democracy' itself in the early 21st century, some political observers use the term 'democratic consolidation' to describe electoral outcomes they strain to see in a

152 *On democratisation*

positive light. Sometimes successful electoral processes do speak to entrenching of democratic practices, but sometimes they mask a deteriorating political environment or perpetuate a flawed system. In other words, electoral processes can burnish, or consolidate, their democratic credentials but do not always do so.

States can entrench democratic deficits or weaken existing democratic practices through various measures, and those most tempted to take this route will be weak states unable to fulfil popular expectations for personal security or of improved economic development; as well as those reluctant to permit uncontrolled dissent.

The government of such a state might decide that it is easier to delegate control of certain areas of administrative oversight to the security services, to blur the lines of responsibility for certain formal processes, to introduce informal channels of legal adjudication or to vacate the 'moral space', for example in permitting patron–client relations, corruption and nepotism to flourish (O'Donnell 1996:34, 38–40). Such democratic deficits have become entrenched in many developing countries' political practice and, while they are not necessarily permanent features of the political landscape, they do appear to be stubbornly fixed and impervious to attempts at reform.

In some cases, the institutional inexperience, and therefore incapacity, during a democratic transition can, if unresolved, give powerholders scope to narrow the democratic space, for example by passing or re-interpreting laws barring public criticism of them. The ambiguous case of Abdurrahman Wahid, displaced from the Indonesian presidency in July 2001, came close to reflecting a collapse of democracy, given that his removal as head of state was agreed to, if not orchestrated by, the Indonesian armed forces (Kingsbury 2005:94, 151, 220, 232, 306–316; see also Kingsbury 2003:269–273) and followed repeated warnings of a possible military coup (Richardson 2000). Yet, as Wahid was elected through a representative process and hence was a democratic leader, there is a case to be made that he left power by the same means, removed through a representative process (a vote of the legislature), even if there were tanks pointing their guns at his palace gates.

The idea of democratic consolidation is contested because it is not precisely clear what actually happens to new democracies that entrenches them beyond those factors that simply make their survival 'more likely'. Consolidation is one of several potentials for a new democracy, with several others normatively less desirable. These include the entrenchment of democratic deficits discussed above, democratic decline, collapse or overthrow.

As noted by O'Donnell, there is also a problem with the teleological assumptions that inform much of the 'consolidation thesis', reflecting the inaccuracy of what has been termed 'democratic fatalism' or the 'inevitability thesis'. Experience has comprehensively disproved the assumption that democracy is a natural occurrence or the mechanistic consequence of certain preconditions. By focusing on 'consolidation', warns O'Donnell (1996), democratic theory may ignore more important aspects of democracy such as its causes, its nature and how to sustain it.

O'Donnell regarded the terms 'democracy' and 'consolidation' as too variable in meaning to make a useful pairing. He thought undue attention to the institutionalisation of electoral rules distracted observers who could better spend their time examining other important, and more interesting, facets of democratic consolidation. His preferred approach was to compare the formal institutional rules (for example a constitution) with the informal practices of actors. On this view, consolidation occurs when the actors in a system follow (i.e. have internalised) the formal rules of a democratic institution (1996:34–51).

While the causes and characteristics of transitions from authoritarian rule can be multi-factorial and often unpredictable, democratisation adheres to more structured criteria. This

On democratisation 153

point is articulated by Schneider and Schmitter (2004) and Schmitter and Schneider (2004), or as Karl (2005:16) puts it, 'The factors involved in the consolidation of democracy show a strong sense of internal ordering across regions that simply cannot be found among the characteristics of transition due to its more improvised nature.'

That is to say, when elections and the freedoms or rights that give them substantive meaning are institutionalised (with elections themselves being understood as 'institutions'), democracy has a better chance of enduring and can be truly described as 'consolidated'. Added to this is Linz's qualification that consolidation should be deemed to have taken place only if none of the major

> political actors, parties or organized interests, forces, or institutions consider that there is any alternative to democratic processes to gain power, and ... no political institution or group has a claim to veto the action of democratically elected decision makers.
>
> Linz in Diamond et al. 2010:26

Translating that to the vernacular, democracy is consolidated only when all relevant political actors regard it as the 'only game in town' (Linz 1990:158).

Integral to democratisation is the 'state of the state' at the outset of the process which, while not predetermining its success, can influence it. When embarking on political change, states possessing a relatively high degree of stateness, such as Indonesia before its democratic transition, are more likely to be able to utilise qualities of state such as the rule of law (notwithstanding Indonesia's weakness in this regard, in a formal sense). Timor-Leste, on the other hand, had almost no stateness when it began adopting formal democratic processes, most of that capacity being assumed by the UN mission in the territory at the time. After that mission left, in 2003, the weaknesses of the state, in particular its limited capacity to control a range of internal political forces, led to a series of confrontations that culminated in the effective collapse of the state three years later.

Caught between the devotees of democratic consolidation and 'inevitability sceptics', true wisdom may lie in viewing democracy as having no consolidated end point but as a fluid balance (on a spectrum either side of, and including, equilibrium) existing in an otherwise impermanent and sometimes vulnerable political context. Taking this view, then, consolidation might be either positive or negative, the latter equating to democratic survival while positive consolidation denotes the extension of democratic legitimacy across the entire breadth of a political community (Diamond et al. 2010:72).

Conclusion

Political transitions between one type of government and another usually mark a significant break, or at least a hiatus, in elites' mastery of power. Transitions can take a society away from political closure and repression towards greater freedom and openness. Of course, transitions are not confined to developing countries. In recent decades, movement from the communist bloc to the 'Free World' may have supplied the prime illustrations of transitioning, but in the 1970s journeys of similar significance from the opposite ideological perspective were undertaken in Greece, Portugal and Spain.

Yet, on balance, developing countries have generated the most – and most frequent – such transitions, given their propensity from time to time to fall prey to authoritarian, dictatorial or military rule. Even when these transitions have been attempted, underlying structural weaknesses in many such states' economies and societies – qualities that earned

154 On democratisation

them their 'developing state' designation in the first place – have often conspired to return them to less open realms of political being.

Political transitions promise better success in the presence of certain preconditions. There is no end in sight to the argument over whether a certain ordering, or sequencing, of those preconditions is more likely to (a) produce such transitions; and (b) produce change that ends well, with stable outcomes, than would be the case if those preconditions were absent.

Recognition that political transitions are more likely to succeed if they don't unsettle former powerholders can frustrate the ambition of a state (and its people) to fully escape the gravitational pull of one political format in its desire to substitute another. To sum up, the less of a change is attempted, the more likely it is to be successful. An argument could be made that the most successful transitions, therefore, are not really transitions at all.

While this could be true, it also misses the point that some of the more successful political transitions have started out gradually but gathered momentum over time, yielding substantial – even fundamental – change, eventually if not immediately. Then again, complete ruptures with the past, such as revolutions, can also be quite successful in consigning old regimes to the dustbin of history.

11 Timing and sequencing of political transitions

It was understood at the time that the collapse of the then Soviet Union would usher in a period of change. It is unlikely that anyone at that time had any overarching understanding of just how great that change would be. Combined with a pre-existing trajectory towards economic globalisation and a fundamental re-ordering of technology and related communications, the world of the early 21st century has seen a fundamental political paradigm shift.

Reflecting these changes, arguably the most remarkable corresponding political shift of the post-Cold War era has been the generalised movement towards 'democracy' among developing countries. Where once there were authoritarian regimes, military dictators and assorted other despots, there has been a globalised embrace of democracy as a benchmark of political maturity even if, in some instances, it has been faltering, incomplete or has ultimately failed. Where governments have explicitly chosen other than democratic paths, such as in Egypt and Thailand, they have done so with a mix of bluster and embarrassment, in one case reverting to a circumscribed electoral system and in the other promising to do so.

While there has been a comprehensive trend in the direction of democracy among developing countries, it has not been linear, easy, complete or, in many cases, always sustainable (O'Donnell 1996). In some cases, too, there have been political transitions but these have been towards authoritarianism, not least mimicking elements of the 'Beijing Consensus' model which supposes that the state is able to build, and economic development occurs more quickly and consistently, when there is less opportunity for dissent. However, while authoritarian models have their champions, and occasionally the support of a majority of their people (but can't be proven, given they can't establish the point by voting in their favor), they tend towards repression and sometimes brutality, corruption due to a lack of accountability and the continued benefit of elite or oligarchic interests. It is also debatable as to whether they are necessarily more economically successful, as previously discussed, or whether a few authoritarian states have been economically successful simply through good management while many others have not, without the option of choosing a better economic manager.

Regardless of the arguments for and against authoritarianism, any transition away from authoritarianism or one-party rule generally requires a set of pre-existing circumstances, including the capacity for a political elite to transfer its primary allegiance, a sympathetic military, a conservative yet reform-minded leader and a comparatively cohesive population. When one or more of these elements are missing, transitions may not eventuate or may not be sustainable if they do. The Arab Spring revolutions, with one exception, and Thailand's experimentation with democracy are 21st-century examples of abortive transitions.

Within this framework, there is room for debate on whether political change needs to coincide with other factors such as a rise in literacy or per capita GDP, or with external

156 *Timing and sequencing of transitions*

events and – ultimately – whether there is a particular sequence to ensure the 'building blocks' of a stable political order are in place.

This chapter suggests that, while there is considerable evidence in support of the sequencing proposition, it constitutes a tendency, not an absolute prerequisite. Many exceptions to the argument may be found in developing countries, in both directions. The structuralist argument, put in the negative, could be summarised as 'People can be too poor for good government' (or, to put that round the other way, only wealthy – i.e. 'developed' – societies can afford properly functioning representative government). This suggests a lack of agency in good government and, in effect, condemns people in poor countries to bad government and, hence, limited development opportunities. This is not only not necessarily the case, it cannot be allowed to be the case if the project of developing countries is to generally succeed. It also assumes that good government is not a 'good' in its own right, and that societies that have not achieved economic development – understood as industrialisation – are necessarily condemned to despotism.

Moreover, it can be argued that there is a direct relationship between poor government and conflict, and good government and peace. Good government will be more adept at finding peaceful solutions to political problems before they escalate into conflict and will be more able to resolve conflict if it does arise. Poor government will more likely engender conflict and be less able to adequately address its drivers, which are quite often itself. To that end, transitions towards good government and transitions towards peace can be understood as two parts of the same process.

Timing and sequencing

Many political scientists have argued that for political transitions from unstable or authoritarian forms of rule towards stable government or democratic political models, certain prior conditions must be present. According to Dankwart Rustow, transitioning is complete when the country has a stable form of government. For a successful transition to democracy, Rustow made four broad assertions of what he insisted were necessary preconditions, amounting to transitional phases. To start with, the process must be based upon an agreed polity or sense of common political identity; then there must be an entrenched conflict within society but on which compromise was possible, acting as a spur to the formation of competing parties – yet the conflict must be serious enough to minimise the opportunity for consensus giving rise to a one-party environment; thirdly, there must be a conscious adoption of democratic rules; and fourthly, politicians and citizens alike must become habituated to these rules. These qualities, Rustow maintains, must be assembled one at a time and in that particular sequence. Rustow rejected other preconditions such as higher literacy levels (which he posited were more likely to result from a democratic society), socio-economic development or a prior consensus on political fundamentals or rules of political operation (Rustow 1999:28–29).

One can see in Rustow's conditions some basic building blocks for political stability and, ultimately, democracy. But, since Rustow first outlined this thesis in 1970, a number of states have made political transitions without necessarily meeting all of his criteria and, even where they did, sometimes the transitions have been accomplished 'out of sequence'. One of the more successful and, in some respects, most remarkable transitions was in the Indonesian province of Aceh, once an independent sultanate which, since the first Dutch offensive began in 1873, was in a state of war or civil strife almost without break until 2005. Not until after 2005 was Aceh in any way run via a democratic process, nor could it have been

considered stable until just after then. Given that Aceh did not meet many, or arguably any, of the preconditions for successful democratic change, and the related end of war, it is a useful case study (and has been used as such in a number of other countries).

Towards peace via democratisation

In July 2005, a peace agreement was signed in Helsinki between the Indonesian government and the Free Aceh Movement (*Gerakan Aceh Merdeka*, or GAM), which ended three decades of secessionist warfare in the north Sumatran province and, after decades of authoritarian rule, created a democratic government. The Aceh peace settlement has since been acclaimed as an exemplary model for achieving conflict resolution through the introduction of democratic processes.

This case study explores the key factors in societies moving from war to democracy, sometimes through the establishment of peace which can create a democratic space. It considers the issues of timing (both macro at the planning stage and micro during implementation) and sequencing – the circumstances that might allow a peace agreement to be achieved and the political context within which it must be sustained. Given the incomplete implementation of conventional micro-timing and sequencing in Aceh's case, the question arises whether this case study disproves the connection between sequencing and the achievement of sustainable peace within a politically viable framework.

The case study contains two underlying assumptions. The first is that to resolve a conflict it is, *prima facie*, necessary to understand its key causes. The second is that the establishment of a government that is 'legitimate' in the eyes of a disaffected community is a prerequisite to the resolution of conflict and that such legitimacy can principally be derived from a democratic process.[1]

Timing

In regard to the timing of conflict resolution and the introduction of democracy, only so much can be planned: sometimes the opportunity of success arrives via unforeseen events, or from 'luck'. One of the negotiators in the Aceh Helsinki talks, Nur Djuli, remarked that Aceh's peace agreement was 10 per cent hard work and good ideas and 90 per cent luck.[2] The 'luck' concerned the talks' timing, in that they followed political reform in Jakarta coinciding with a move by GAM itself towards a more accountable political process.

Another view might have it that 'luck' is no accident but is created, stemming from a confluence of factors. Each of these factors might arise from drivers that were themselves not accidental but the result of much hard work. This may reflect different understandings of causes of events, reflecting a world view in which 'passivity' and 'activity' are cyclical rather than a consequence of agency.

Whether coincidental or consequential, the framework for the 'macro', or foundational, timing and sequencing of a democratically sustainable peace was forged by one staggering unforeseen event. The 2004 Boxing Day tsunami, which killed about 180,000 people in Aceh, devastated the province's infrastructure and focused the international community on its conflict. Prior to this event, the Aceh conflict was little known and even less understood. This tsunami, a natural consequence of the island of Sumatra sitting alongside a major tectonic fault line, heightened the sense of urgency around the process and its outcome. It was not, however, the instigator of the talks, which had been agreed to just days before the tsunami struck, or of the subsequent agreement which could have been derailed on any of several occasions, including at the very final moment of negotiations.

158 *Timing and sequencing of transitions*

One key idea reflected in most of the conflict resolution literature concerns the issue of timing, or 'ripeness' (e.g. see Conciliation Resources 2008). GAM had been under intense military pressure in the two years before the negotiations were agreed to and, while able to maintain its core strength, was suffering in the field, so was more inclined to seek an 'honorable' way forward. The Indonesian government, meanwhile, was intent on ending the country's internal conflicts on one hand and reining in its quasi-independent armed forces on the other. In Aceh, it is therefore arguable that the time was ripe for a peace agreement and both the micro-timing and micro-sequencing of each element in the settlement's implementation flowed from that fact. Indonesia had been democratised and liberalised over the preceding six years, even allowing that both trends were patchy in their application and appeared not to apply at all in peripheral areas such as Aceh, East Timor (in 1999) and West Papua.

GAM, for its part, harnessed the rhetoric of 'democracy' to its own ends, using the Indonesian government's own claims to argue for a fundamentally different political arrangement in the province to that which had previously prevailed. It was the agreement to, and application of, this 'macro' political arrangement which fundamentally paved the way for peace. This macro-arrangement did consist of several steps taken in sequence, though they were not predicated on any particular order but were introduced as soon as each could be practically implemented.

The most fundamental macro issue which preceded – and this one had to precede – peace in Aceh was the election, in October 2004, of Susilo Bambang Yudhoyono as Indonesia's president. Yudhoyono introduced a significant reforming element to the nation's democratisation process. As a reformist military officer (see O'Donnell and Schmitter 1986 on the role of reformist military officers in democratisation), Yudhoyono was keen on pursuing a fundamental reorientation of the Indonesian military (*Tentara Nasional Indonesia*, or TNI) away from its involvement in internal state affairs, and wean it off business and criminal sources of income (which in the late 1990s accounted for up to 70 per cent of its total operating budget). Turning the TNI into a professional, externally focused defence force had only positive implications for accountability and the extension of civilian authority.

Ultimately, Yudhoyono was only partly successful, with reform of the TNI stalling around 2007 (HRW 2006; Hamid and Misol 2007). But resolving the Aceh conflict went a long way towards reducing the TNI's role within the state and its capacity to have an income independent of the government (Kingsbury and McCulloch 2006). Whatever sequence of steps ensued, the first to be taken on this democratic journey had to be Yudhoyono's election as president.

GAM's own prior 'democratisation' was, perhaps, less important, given the relative shallowness of the claim (see the Stavanger Declaration 2002). During the peace negotiations, GAM 'prime minister' Malik Mahmud even expressed reservations about the possible outcome of an open electoral process not favoring GAM. This lack of a clear commitment to respecting the result of a plausibly free and fair election was later reflected in the troubling, if limited, violence that accompanied Aceh's 2009 and 2014 elections.

On the matter of timing and sequencing, the peace agreement that ended the war, the Memorandum of Understanding (MOU 2005), did contain a series of stipulations in regard to both aspects when it came to implementing the agreement. With one or two key exceptions, none of these stipulations was followed according to the prescribed timelines or pattern foreseen in the MOU. Like much of the document, the MOU's requirements were aspirational, relying largely on the goodwill of the parties to the agreement, as had been

envisaged at its initialling. While the MOU did lead to peace and a democratic process, the failure adequately to implement a number of its provisions provoked longer-term resentment and further, if limited, political violence.

Sequencing

The 'sequencing thesis' essentially argues that the preconditions for a democratic peace, including institutions such as the rule of law, justice and a government recognised as legitimate, need to be established before, or at least aligned with, its advent. Indeed, the sequencing argument proposes that if state institutions are not established, the state – and the peace – will likely fail. This argument is advanced by considering the key contributing elements of peaceful democratic states, and the failure of both peace and democratic processes in developing states, notably in but not limited to sub-Saharan Africa.

In relation to the introduction of elections, it has been argued that a process which holds them 'before either accountability or nation-building [has been established] has been fundamentally flawed' (Collier 2009:186; see also Gow 2010). This argument is based on the premise that certain conditions are more conducive to embedding a democratic process and that these must be addressed so as to establish the conditions in which a successful peace can be maintained (see Braithwaite et al. 2012). Such conditions were not in place in Aceh in 2005, nor were they in place in Cambodia in 1992 or Timor-Leste in 2002. Aceh and Timor-Leste showed that such conditions were not absolutely necessary, even if Timor-Leste's democratic experiment retains elements of fragility, while Cambodia's retreat from democracy to authoritarianism reflected the continuing influence of a pre-democratic powerholder – Hun Sen – who, with the benefit of hindsight, regarded the democratic transition as merely a temporary political obstacle to be overcome on his path to retaining power.

As with democratisation, there is considerable statistical evidence to suggest peace is more likely to find deeper roots under 'the right' conditions. The first condition, according to this thesis advanced by political scientist Robert Dahl in 1989, is the historical sequence of events that led to democracy's contemporary development (for a discussion of sequencing in the democratic context, see Mansfield and Snyder 2007; Carothers 2007b on why sequencing can be an excuse for delaying democratisation; Fukuyama 2007b on how democratisation does not sit well with the early stages of state-building within a conflict setting; and Berman 2007 on the different paths that democratisation can take).

Analysts sceptical or pessimistic about peace outcomes, or who insist on drawing a distinction between an absence of violence and actual peace (see Zakaria 1997:22–43), have identified certain preconditions – the rule of law and a high level of state capacity leading the list – they say must obtain if peace is likely to take root (Chua 1998; Zakaria 2003; Mansfield and Snyder 2005). On this view, post-conflict environments are by their nature not propitious for peace or democratisation (as noted by O'Donnell 1996:36) because they are most unlikely to possess either rule of law or high levels of state capacity. In this sense, state capacity is understood as distinct from a 'strong' state (Migdal 1988), which implies the imposition of authority or power, usually in an undemocratic or illiberal environment, rather than high levels of state organisation and efficiency which can only function with the equal and consistent application of rule of law. Of this, Cambodia remains a salient example.

A debate parallel to that around the necessity of certain conditions existing if democracy is to take root has been held around the necessity of sequencing events. On balance, a consensus has emerged that, while such a sequence may enhance and sustain democracy

160 *Timing and sequencing of transitions*

better, it is not essential to democratic transition, let alone a teleological inevitability. The counter-argument is that the main prerequisites for peace can be implemented more or less simultaneously with the peace, or even that the institutions necessary to maintain peace can arrive afterwards. On this view, they may be easier to introduce after the fighting has stopped and do not, therefore, need to be 'sequenced'.

Introducing democratic norms, by way of contrast, can be proposed as a process of building stages rather than deferring democracy until all preconditions have been met. This course of action is referred to as democratic gradualism. Some regimes exaggerate the extent of their 'gradual' approach to reform and democratisation: in some cases they choose to halt it at a point where it can be contained or limited, with Myanmar's partial democratisation being an example of that limited approach. This may result in a variety of democratic 'sub-types' (discussed below) or semi-democracies, although this raises the issue of the term 'democracy' being over-used or abused to a point where it can lose meaning.

Democratic gradualists place great stock in ensuring that military forces neither get the chance, nor become accustomed, to intervene in political affairs, as has regularly been the case in Thailand's abortive transitions. Dahl (1989:221) believes a certain level of socioeconomic development is also required, along with fairly high levels of public literacy; more widespread education; equally widespread and free communication; a pluralistic, non-hegemonic social order; mechanisms that limit social inequalities and prevent legal ones; political activism, sub-cultures and social cleavage patterns that do not fundamentally divide a community but allow it to contest ideas within a common framework; efficient and effective government; and freedom from foreign control or domination. Conversely, there is evidence that while favorable material and social circumstances may make democratisation easier, they are not a precondition for it (see Przeworski 1991; Bratton and Van de Walle 1997; Cornwell 1999; Snyder and Mahoney 1999; Englebert 2000; Luis 2000; Keohane 2002; Unger 2004; OECD 2007; Collier 2009; Chandler 2010; Power 2012).

In post-Suharto Indonesia, election turnout was initially high, in spite of the fact that most voters lived in conditions of relative material hardship. In the first post-New Order elections, held in July 1999 and adjudged relatively free and fair, 93.3 per cent of registered voters participated. That rate declined to just over 84 per cent in 2004 and slid again, to almost 71 per cent, in 2009 (International IDEA 2013). The extraordinary turnout in 1999 can be ascribed to the importance of ensuring political change, which is an implicitly agency-driven social decision. The decline in voter participation at subsequent elections – both held in a more stable and predictable political environment – indicates an awareness that those polls were less important, or could be construed as a sign of greater cynicism as a consequence of their material circumstances changing little. Turnouts in Cambodia confirm this general tendency. Almost 87 per cent voted in 1993, possibly indicating residual fear about combatant (especially Khmer Rouge) retribution: five years on, this rose to almost 94 per cent, if in a post-coup environment, but it declined to 83 per cent in 2003 and 75 per cent in 2008. Throughout this period the Cambodian People's Party consolidated its grip on the political process, ahead of its monopolising of political power by 2017. By way of contrast, in the 'established' or 'old' democracies average turnout peaked at 80 per cent in the 1960s and has since steadily declined to 70 per cent by the early 2000s (Ferini 2012).

As Lipset (1959) notes, democracy has its 'requisites': certain essentials without which democracy is not worthy of the name. But he is careful not to call them '*pre*-requisites', and thus delineates his view of democracy in a descriptive rather than predictive fashion. Lipset does not underrate the probability of democratic practices arising, and even flourishing,

under certain circumstances – but he mixes the known element of democratic conditionalities with the unknown of 'chance'.

Similarly, a gradualist approach to the timing and sequencing of steps for peace might abate some forms of conflict while allowing others to continue. Events in West Papua tend to correspond with this understanding. There, a range of political changes have been effected with the intent of producing peace, and large-scale violence has reduced significantly although low-level violence persists. Similarly, Aceh from 1976 to 2005 was marked not by the occasional absence of conflict but by its continuation, if at fluctuating levels of intensity.

As with peace-making, so with democratisation, it has been found that while favorable material and social circumstances make both processes easier, and those circumstances can be sequenced, they don't amount to preconditions for success in either pursuit. The commonality of arguments for and against sequencing in both domains has led some democratic theorists to conclude that sustainable conflict resolution should imply democratisation and that, vice versa; successful transition to democracy creates ideal conditions for conflict resolution, as it did in the case of Aceh.

While democracy appears to be linked to peace processes, as either a facilitating condition or an outcome, the term – as has been pointed out earlier – is sometimes misapplied. In company with some others (e.g. Carothers 2007a), Tornquist has argued that it is not only possible to jump the 'sequencing' phase of democratic implementation but that, specifically in the case of Aceh, it was just such a jump that created the conditions for a sustainable peace. Drawing on the commonalities referred to above, Tornquist et al. (and also co-writing with Stokke), further argued that the non-sequenced introduction of democracy can transform post-conflict societies or, if the conflict remains active, can act as a catalyst for its resolution (Stokke and Tornquist 2013).

Evidence from Aceh suggests that the sequencing of prescribed steps, or implementation of mechanisms designed to reinforce a desirable outcome, was not absolutely necessary to secure the peace. But evidence also shows that a lack of sequenced reinforcing mechanisms can weaken the final outcome, spark friction and put the resultant peace accord under constant pressure. The teleological assumption that once peace has been established, as with democracy, it will necessarily be sustained may be undermined by a range of continuing or new challenges.

Greed and grievance

Personal and group behavior comes together in a key element about the causes of conflict, and therefore demand the attention in conflict resolution and the establishment of political order in developing countries, in what is known as the 'greed and grievance' thesis (Berdal and Malone 2000; Collier and Hoeffler 2000). There is no doubt grievance plays a considerable role in intra-state conflict, notably where ethnic minorities or other self-identifying groups feel marginalised, excluded or victimised (Kingsbury 2012a).

Aceh is a case in point where, although the initial impetus for separatist violence was due to mixed motives, at the height of the conflict from 1999 to 2005 a clear sense of grievance was being articulated by many, probably most, Acehnese. In 1999 a rally in support of a pro-independence referendum drew up to a million people, from a population of about 4.5 million (Miller 2009:32), a firm indication that their sense of grievance was widespread. According to Keen, a separatist aspiration may arise because 'Abuses against civilians

162 *Timing and sequencing of transitions*

frequently create their own justification' (see Keen 2000:31–32 on the role of grievance, as well as material gains, in fuelling civil wars). Though not specifically timed or sequenced, the establishment of a human rights court (MOU 2005:2.2) and a truth and reconciliation commission (MOU 2005:2.3) was intended to address the 'grievance' element which the parties recognised as both a conflict driver and a barrier to political stability.

The 'greed' element of this thesis, which was primarily based on sub-Saharan case studies (Collier 2006), was not so applicable in Aceh's case and was thus not addressed in the peace agreement. There is some evidence that the Aceh rebellion was precipitated in 1974 when GAM's founder, Hasan di Tiro, was outbid on a contract to build a pipeline for the Arun LNG project on Aceh's east coast. Di Tiro himself, and many other Acehnese, felt the contract excluded them from jobs and other benefits, which lends some support to the 'greed' element of the thesis (if not in the sense originally intended by Berdal and Malone).

There was also anger at the project's displacement of local people, which harks back to the 'grievance' element of the thesis. It is worth noting that Di Tiro had earlier been an activist on behalf of Aceh's role in the Darul Islam rebellion (1953–1959, although the revolt continued in Aceh until the early 1960s) and that his initial team of separatists comprised former Darul Islam rebels (Aspinall 2009:63–64).

To the extent that 'greed and grievance' came to the notice of those tasked with resolving the Aceh conflict and establishing political stability there (or at least greater stability than had existed during the conflict and under martial law), the MOU did include several key economic provisions. But these were intended to ensure the autonomous province remained economically viable rather than to reward individuals in preference to the wider society. After the MOU was signed, there was considerable exploitation of political office for personal gain, but this was not contemplated in the agreement and, indeed, incited resistance to its implementation. (Indonesian Vice-President Jusuf Kalla argued that economic incentive was key to resolving the Aceh conflict: see 'Accord Aceh: Interview with Jusuf Kalla' [in Large and Aguswandi undated].) While economic issues did require resolution, they were among the pact's least contested provisions and designed to promote the viability of a 'self-governing' province.[3]

Despite the necessity of establishing a viable economic foundation, the establishment of genuine, democratic autonomy, referred to as 'self-government', was overwhelmingly more crucial to the talks' success. The term 'autonomy' on its own was unacceptable to the GAM team, which considered this a sticking-point given its association with past military abuses under a supposed 'Special Autonomy' arrangement. The term 'self-government' was seized upon as offering a different rhetorical frame within which the talks could progress towards a negotiated outcome.

Consideration of this new term arose as a result of a public statement by UN mediator and former Finnish prime minister Martti Ahtisaari, in which he used the Finnish word for self-government rather than the word for 'autonomy'. He asserted that the terms had the same meaning, but accepted GAM's argument that only the former was acceptable as the basis for a settlement. The Indonesian delegation agreed to use of the term given its own understanding that, semantically, doing so made no substantive difference.

The macro-timing of a peace agreement can, as it had in Aceh, as well as the Philippines' Mindanao, also hinge on a conflict having exhausted its possibilities for victory by one side or the other, in what is known as a 'hurting stalemate' (Zartman 2000). When the cost to both sides of sustaining a conflict exceeds the presumed advantages of continuing it, peace may become possible. In Aceh, both GAM and the Indonesian government (less so the TNI) found themselves in a 'hurting stalemate'. GAM was surviving in mountainous

Timing and sequencing of transitions 163

terrain but on the defensive after two years of fierce military assaults. GAM commanders took the view, conventional among guerrilla organisations, that survival equals success. For its part, Jakarta recognised that an absolute military victory was unlikely and prolonging the fight against GAM threatened the nation's young democracy by further involving the military in affairs of state (see Desch 1999) and increasingly alienating the country's international supporters.

Finally, and perhaps most important, while both sides were edging towards a resumption of talks, and in fact had agreed on 22 December 2004 to meet in Helsinki the following month, the 26 December 'Boxing Day tsunami' that swept across the littoral states of the Indian Ocean fundamentally altered the context and hence the dynamic of those talks and influenced their outcome. This unforeseeable – and hence not sequenced – catastrophe had such an impact on the Aceh peace talks that their positive outcome would have been very much less likely had it not occurred.

GAM's leadership saw the tsunami as a terrible blow to the people of Aceh and therefore called an immediate ceasefire to allow humanitarian aid to be delivered. The TNI ignored the ceasefire and continued its attacks, and initially even tried to block, and then control, the flow of foreign aid. At that point, international donors and then its own government put pressure on the TNI, forcing it to allow in foreign aid, aid workers and – of great importance, for the first time in many years – journalists. This sequence of events meant an otherwise unpublicised war suddenly became international news. Major donor governments soon brandished both carrot and stick, promising more aid if the war was ended and threatening to withdraw aid if it continued.

It was at this juncture that GAM's hopes of receiving the laurel of legitimacy for its claim to independence were dashed: the international community made it clear that it regarded Indonesia as an indivisible sovereign state. GAM would be not just isolated but ostracised should it continue pressing its claim to independence. Indonesia was also under pressure to compromise, especially by improving its very poor human rights record in Aceh and extending its acceptance of democratisation. Both parties, then, recognised that the 'timing' of peace and the related democratic outcome was driven by external as well as internal factors.

Micro-timing and sequencing

Once the Aceh MOU was initialled, on 7 July 2005, fighting effectively stopped. The conflict formally ended on the day the peace accord was signed, 15 August 2005. The signing ceremony ushered in the period for implementing a series of activities either stipulated in the MOU or implied by it. The international, non-partisan Aceh Monitoring Mission (AMM) was created to oversee the fulfilment of all pledges made by the signatories. Such an independent guarantor of agreements is often necessary to verify the signatories' trustworthiness where mistrust has historically been the norm. The handover and destruction of GAM weapons, along with a TNI troop drawdown, commenced within weeks of the agreement being signed (formally from 15 September, a month after the signing ceremony).

Establishment of the AMM was followed by a succession of envisaged steps: the formal disbanding of GAM as a military organisation; limited attempts at the social reintegration of its members; the holding of elections; passage of enabling legislation by Jakarta; and the creation of a political party, *Partai Aceh*. In 2010, the year after he lost an election for governor, Irwandi Yusuf established a second major Acehnese political contender, *Partai Nasional Aceh* (the Aceh National Party, or PNA). Several smaller parties were also established, along with national parties prepared to contest regional as well as local elections.

164 *Timing and sequencing of transitions*

The AMM comprised both unarmed military and civilian representatives, drawn primarily from EU states but alongside a contingent from a handful of ASEAN countries (Thailand, Malaysia, Brunei, Singapore and the Philippines) as a sop to Jakarta's concerns that the mission could be stacked against Indonesian interests. While its initial mandate ran for six months, this was extended for shorter intervals through to 2012, underscoring that the short term is seldom long enough to bed down a peace settlement or to oversee and help consolidate a democratic process. As a sequenced arrangement, this was necessarily the first post-agreement step, one that was a precursor to others prescribed by the accord – most important being GAM's disarmament.

In theory, GAM was to be dissolved upon the MOU being signed. In reality, the reintegration of GAM members into civil society was far from complete even a year down the track (World Bank 2006) and, more than a decade on, many were still not reintegrated. Returning former combatants to civilian life after peace is an obstacle common to post-conflict environments around the world. If not addressed, it can lead to banditry, lawlessness and even a return to conflict by disgruntled veterans.

In part, this problem in post-accord Aceh was of GAM's own making: the lack of adequate funds to bankroll social reintegration was due to GAM's having understated how many active members were in its ranks. GAM officially put the figure at 3,000, in part to under-count the number of weapons it would have to hand over. In reality, it had about 8,000 active members plus many thousands more unarmed activists and dependents. As a result of this subterfuge, not all GAM ex-fighters received full funding entitlements, or they received them late, making it impossible for many to re-establish themselves as small-business operators or landowners. But as Barron (2009) noted, Aceh's reintegration programs did not play a big part in maintaining the peace. Rather, that outcome could be credited more to the commitment of senior leaders on both sides of the conflict.

In October 2005, given the sluggish pace of reintegration, GAM established the Aceh Transitional Committee (*Komite Peralihan Aceh*, or KPA) to represent GAM's ex-combatants. This move was not envisaged in the MOU, nor did it form part of any particular sequence of events. Rather, the KPA was an *ad hoc* arrangement by GAM's leadership to manage former combatants pending reintegration. The KPA was intended to evolve into a future political party, with a view to competing in the elections mandated under the MOU.

A timetable had been set for this part of the agreement. Aceh would be permitted to hold elections for all executive positions, including governor, vice-governor and district and city heads. Initially scheduled for April 2006, the elections were not held, as it transpired, until the following December. After a dispute within GAM over who its candidate for governor would be, former GAM intelligence chief Irwandi Yusuf – who had overseen the decommissioning and demolition of GAM's weapons – stood and won as an independent against a candidate nominated by former GAM 'prime minister' Malik Mahmud.

Parties formed faster than anticipated. While the MOU stipulated that legislation permitting the establishment of local-level political parties be passed within eighteen months of the pact being signed (MOU 2005:1.2.1), such legislation took almost two years to be enacted, with parties already having been formed. Disagreement within Aceh festered from the outset over how such parties could form and operate. In 2013 a heated dispute, in the national capital, flared over MOU provision 1.1.5 which allowed Aceh to have its own flag. The Indonesian government claimed that the flag used in Aceh was the GAM military flag and thus violated that part of the MOU stipulating GAM would cease to use military insignia or symbols (MOU 2005:4.2). *Partai Aceh* responded by arguing that the flag was not a GAM military flag but the flag of Aceh that predated GAM, a claim given credence by

Timing and sequencing of transitions 165

historical evidence of a similar flag being flown in the 16th century, at the time of the first European incursions into the region.

Under points 2.2 and 2.3 of the MOU, Aceh – as noted earlier – was to have a human rights court and a truth and reconciliation commission. During the peace negotiations it had been recognised that establishing the first of these institutions would be a formidable task given Indonesia's long history of avoiding genuine accountability for military abuses. Indeed, towards the conclusion of the talks the court proposal was omitted from one draft of the agreement, only to be reinstated prior to its signing. GAM's senior leadership took a 'realistic' view about the chances of ever having human rights cases formally heard or acted upon and understood the hostility such a court would generate within the TNI. But the view more generally held – that such a court was necessary to restore an element of justice to Acehnese society – eventually prevailed.

The court's *raison d'être* was to oversee retributive justice, regarded as a necessity if ordinary Acehnese were to gain confidence in the rule of law; a truth and reconciliation commission would oversee restorative justice, helping former adversaries to reconcile and move on from past events. The Human Rights Court was established in mid-2006 under the Law on the Governing of Aceh (LoGA), but its authority was limited to investigating human rights abuses that took place after its creation. The original intent of investigating a catalogue of past abuses was abandoned, a decision that predictably fuelled considerable resentment.

The truth and reconciliation process was itself hampered by a conventional reliance on cultural tradition (*adat*) but the destruction of most of Aceh's *adat* systems in the conflict, its lack of application to non-Acehnese and often the gravity of the crimes committed (see Avonius 2007; 2009) rendered that purported remedy inappropriate and ineffective. Reconciliation, therefore, was at best implemented in part. For many, the mechanism that ended up in place was insufficient and only compounded the failure to establish a human rights court competent to deal with the plethora of pre-existing cases. A number of other points agreed to in the negotiations that produced the MOU – clauses covering financial compensation, the provision of farming land and rehabilitation funding, to name but three – ended up being dishonored, or at best only partly implemented.

Passage by the national legislature of the LoGA, replacing the 2001 law on 'Special Autonomy' for Aceh, was another exercise in compromise. Pro-government parties had to negotiate with non-government and anti-MOU parties, resulting in a watered-down version of the MOU being passed as national law. While the LoGA enacted the MOU, many former GAM members noted that it neglected or diluted a number of key MOU provisions. After being introduced in December 2005, it finally passed into law in July 2006, almost four months after the deadline stipulated in the MOU. Dilution of the MOU reflected the political reality that to convert a peace agreement into law would require compromises with a range of political interests, few of which shared the perspective of Aceh's 4 million inhabitants.

Although not stipulated and hence not sequenced, a new body – the Aceh Reintegration Board (*Badan Reintegrasi Aceh*, or BRA) was established in February 2007, one of the first substantive decisions of newly elected Governor Yusuf, and one he made in response to the failure of reintegration initiatives to help many former combatants. While the creation of this organisation was soundly based, it was never properly funded and ended up having little real authority. The KPA, meanwhile, formally reconstituted itself as *Partai Aceh* in May 2007, having agreed to do so at an internal leadership meeting in 2006. This transformation belied a haphazard approach to implementing the MOU's election-related sub-clauses rather than reflecting any prearranged timing.

166 *Timing and sequencing of transitions*

More concretely, the MOU provided for: a 70:30 division of resources income between the regional and central governments (MOU 2005:1.3.4); a curb on the number of TNI troops that could be stationed in Aceh and restrictions upon their movement (MOU 2005:4.6, 4.7, 4.8); placing the police under Acehnese command (MOU 2005:1.4.4); internationally monitored local elections; and, most important of all, the creation of local political parties (MOU 2005:1.2.1). In the end, the MOU looked a lot like the type of political arrangement Aceh had initially wanted after Indonesia declared independence from the Netherlands. It was, by citing the agenda of the Darul Islam movement whose heyday was half a century previous, that GAM rebels, who in many cases saw themselves as the linear descendants of that movement, came to accept the MOU as an honorable outcome.

The basic premise that democracy can transform post-conflict society rests on the assumptions that democracy provides a regulated and agreed framework for the non-violent channelling and resolution of competing interests. As with other post-conflict societies, this assumption was only partly applicable in Aceh. The first elections following the peace agreement, held on 11 December 2006, were fairly peaceful.

After the first election for governor, stronger forces came into play than GAM solidarity, with the scene set for a more confrontational election in 2012. It is not uncommon that, in post-conflict settings, combatants previously united by a common enemy subsequently see their interests diverging or even competing. If it is going to happen, it is after their common foe has been subdued or the threat resolved that comrades fall out.

In 2010, GAM's direct successor, *Partai Aceh*, split, with the pro-Irwandi faction morphing into the *Partai Nasional Aceh* (PNA). Inter-party violence increased, with three people killed and many more injured in a series of attacks instigated by PA cadres (groupings of former GAM fighters) against PNA cadres. While this violence cast a pall over the local political process, it was par for a post-conflict society transitioning to electoral politics. On this occasion, though, the conflict was contained between these two electoral rivals: it did not portend a return to broader armed conflict.

Perhaps more important, in the final analysis, is that a genuine democratic process tends to produce political outcomes that are generally respected and confer a high degree of legitimacy on the successful candidate or party (see Buchanan 2002; 2003; Peter 2008; Collier 2009:18–24 on such legitimacy). Legitimacy, in turn, implies acceptance of the political status quo, which reduces the motivation for action (including violence) aimed at overturning it. So, although there were questions around how the electoral process proceeded, particularly over the conduct of the 2012 poll, this was widely understood to be an internal Acehnese matter rather than one warranting the involvement of external entities.

Teleological assumptions

An assumption exists that a given set of conditions will produce a given set of outcomes and that when peace is achieved it will yield its own self-reinforcing 'dividend'. This teleological sensibility has a long history, but was particularly reprised after the Cold War, when there was a widespread assumption that liberal democracy, seen as victorious, would be established as the global norm (e.g. see Fukuyama 1992; Petersen 2008). Running counter to this, O'Donnell (1996) warned against assuming teleological inevitabilities in relation to democratisation, adducing principles that can apply equally to peace processes. He emphasised that just because a democratic process, or a peace agreement, will have resulted from intricate planning, with preconditions all laid out, that was no guarantee the process

Timing and sequencing of transitions 167

would be successful. Nor did it logically follow that, if it succeeded to begin with, either a democratic process or a peace process would remain successful.

O'Donnell started with a series of conceptual clarifications, the first being to determine the 'cut-off' point before which something can still – and after which it can no longer – be accepted as what it claims to be. O'Donnell was careful not to regard democracy as a permanent state of affairs, but as a variable the components of which may be present in a greater or lesser degree at one point in time and in different proportions at any point thereafter.

So, too, peace can exist without some of the conditions whose fulfilment imply a fuller measure of peace (such as disarmament, demobilisation and reintegration, each only partially present in Aceh). Failure to perfect the components of a more durable peace might signal danger for the chances of its ever becoming entrenched, but they do not in and of themselves imperil the absence of war any more than they preclude the establishment of a legitimate government. Yet in this sense, 'Peace is not merely an absence of war but the presence of justice, of law, of order – in short, of government' (Einstein 1988).

That is to say, the introduction of a democratic process may, without prior conditions, establish the fundamental underlying conditions required to sustain peace. Whether democracy is consolidated or not may be determined, or influenced, by other preconditions. What appears to matter more is the commitment of former adversaries to the political process in question, whether or not they truly perceive it as a viable alternative to war and recognise that it has built in robust enough mechanisms to subvert the key drivers of war.

Conclusion

The Aceh peace process was, in many respects, remarkably successful, and nearly a decade and a half after it was undertaken it stands as a respectable and widely studied and employed illustration of how to negotiate an end to civil conflict. While no two conflicts are identical, the fact that its lessons have been absorbed in other parts of the world stands as testament to its strengths.

More than a decade after the signing of the MOU and the establishment of a locally elected autonomous government, Aceh remained a hotbed of social tensions and the scene of occasional outbreaks of political violence, just like many other post-conflict and developing countries which have competitive elections. If, as a celebrated Prussian military strategist noted, 'War is the mere continuation of politics by other means' (Von Clausewitz 1976:Ch. 1, section 24), then politics can also take on the characteristics of war. Peace is not, therefore, the mere absence of war, just as 'democracy' is not merely the act of voting.

The Aceh peace process has been a source of considerable satisfaction to its participants, and to the people of Aceh, although it is also fair to point out that, had the contracting parties to the MOU upheld all their commitments, it could have been very much better. How circumstances evolve depends very much on how the agents in any place at any time choose to behave. There are always choices. The fate of Aceh's Helsinki peace agreement was always predicated on trust that the parties to it would act in good faith and, as the years have passed, that trust has been honored for the most part – sufficiently, if not completely.

The key lesson from Aceh has been that the macro-timing of peace talks is critical so that, if at the same juncture in history and in their affairs, the desire to engage genuinely with one's foes is lacking – on either side of the equation – the so-called peace talks will be a futile exercise from the outset. It may be that the time is 'ripe', that circumstances so

168 *Timing and sequencing of transitions*

arrange themselves as to create a catalyst for peace that had not previously existed (democratisation on a national scale may be one such circumstance, natural disaster on a regional scale another) or that both foes are less enthusiastic about ending conflict than they are exhausted by prolonging it. In Aceh, each of these factors was present. But they also required a compelling end point, and that proved to be the introduction of a plural electoral ('democratic') process.

In contrast to Timor-Leste, for example, while Aceh's state institutions had been severely compromised by the military occupation, and physically destroyed by the 2004 tsunami, they continued to function throughout. Changes already underway in Indonesia helped make the timing for talks auspicious but, unlike Timor-Leste, Aceh remained part of the unitary state and hence benefited from Indonesia's own democratic evolution. In Timor-Leste's case, the UN was required to engage in its most ambitious ever (to that time) state-building exercise, to establish institutions that had ceased to exist and to lay out ground rules – agreed to by the main political actors – for the running of the state along democratic lines. In doing so, the UN was partially successful, although the near collapse of the state amid violence in 2006 was a reminder of just how fragile such processes remained.

In Aceh's case, some macro-sequencing steps fell into place, preparing the ground for the process both parties took up. Yet the peace, and the political outcome, could not be ascribed to sequencing alone. Good, experienced mediation; the demand for a comprehensive solution rather than a ceasefire; and support from, allied with demands by, the international community all culminated in the historic Aceh accord. But perhaps the one element that accomplished more than any other by transforming the agreement into one that would stand the test of time was the last point to be negotiated – that Aceh be allowed to represent itself to itself, in the form of local political parties.

Agreement on this gave genuine voice to the aspirations of the Acehnese people, a sense of integrity to the decisions made on their behalf (be they sensible or otherwise) and legitimacy to the political process. More than any single thing, it was this legitimation of the subsequent political process that not only brought thirty years of warfare to an end but ensured it did not restart.

Since 2005, old grievances have been compounded by newer ones – specifically, the conviction among a number of Acehnese residents that the MOU was not properly implemented, that Indonesia had tricked, or tried to trick, them – and those who feel most aggrieved have from time to time called for a revival of Aceh's original demand for independence. To date, however, such calls have been limited and they have not managed to derail the peace agreement which, at the time of writing, had been in place for thirteen years.

Overwhelmingly, the people of Aceh perceive their communal life today as much better than it was before 2005 yet not as good as they were led to believe it would be. Such disappointment is common when post-conflict reality does not live up to the (often unrealistic) aspirations held for it. But in Aceh today people are free to go about their business more or less without fear and, while their elected governments have been marked down as not having fulfilled their aspirations, their disenchantment must be attributed in part to the fact that those aspirations were unrealistically high to begin with.

And so the people of newly democratic Aceh are confronted by the same conundrum that faces citizens in the world's best-run and longest-established democracies: one votes in a government, is disappointed that the government does not live up to expectations; one then votes them out and chooses a replacement, which may turn out to be little better or perhaps even worse. Acehnese could be forgiven for thinking that democracy, as it has seen

practised, is less wonderful than the theory might propose. But it has, on balance, served as a means for legitimately channelling their grievances and aspirations, and – no mean feat, this – it has regularised and regulated political competition. If Aceh has remained at peace, at least in Einstein's minimalist sense, that is primarily because democracy – while manifestly imperfect – is still seen as necessary, functional and, considering the alternative, greatly to be preferred.

Notes

1 Much of this study derived from the author's participation in the 2005 Aceh peace process but its conclusions were reinforced, or in some cases modified, by other involvements in conflict resolution attempts, political reorganisations – and discussions about both – ranging beyond Aceh to include West Papua, Sri Lanka (focusing on the Tamil Eelam movement), the Philippines island of Mindanao and the Indian state of Nagaland.
2 Private conversation, 2010, Banda Aceh.
3 The author was directly involved with GAM's decision-making process during the negotiations.

12 Sovereignty and strategic relations

Often regardless of their domestic politics, developing countries have often had close strategic relations with, or been client states of, dominant world powers. While the contours of those relations have changed, particularly in the post-Cold War era, close strategic relations between developing countries and major powers remain, if sometimes in more complex and nuanced ways. How countries align themselves in turn reflects their access to Official Development Assistance (ODA, or foreign aid) and multilateral aid programs; the orientation of their regional relations; their colonial legacies; strategic alliances and positioning; and their vulnerabilities to various types of interference or intervention.

In a world of increasingly globalised communications, trade, finances and international law, notions of sovereignty often become compromised by factors beyond the control of particular governments. While notions of 'sovereignty' can be pronounced, the extent to which governments in developing countries can make entirely independent decisions is, especially in relation to major matters, sometimes quite limited. The extent to which they are so limited tends to be in inverse proportion to how developed the country happens to be.

There has also been some effort to develop regional security blocs, the better to control regional affairs and limit 'external' interference. Leading examples of this trend are the African Union and the ASEAN Regional Forum (whose geographical remit is wider than just the ASEAN states).

Sovereignty

Running somewhat contrary to close strategic relations and the requirements this can imply for the actions of some independent states, such states continue to assert their claim to sovereignty. The notion of sovereignty exists to establish the legitimate exclusive jurisdiction in, and employment of, state institutions over a specific, delineated territory by a recognised government. Within the contemporary context, however, sovereignty is far from absolute, with most countries being required to bend domestic considerations to suit the shape of external imperatives.

Chapter VII of the United Nations Charter explicitly addresses limitations to sovereignty posed by threats to peace, breaches of the peace and acts of aggression. So, while the first condition of international law is that independent states be sovereign (UN 1945:2.1), no state is entirely sovereign. Beyond this explicit option for international intervention, international trade and communication places some degree of conditionality on all states. Apart from supranational bodies such as the UN, its agencies and the IMF and World Bank, as well as the World Trade Organization and World Economic Forum, multinational corporations and global currency flows – all part of the larger process of globalisation – shape

national responses in ways that national governments often cannot curb. The governments of developing countries are especially susceptible to such influences, reliant as they often are on aid, assistance and the vagaries of international trade.

The UN also recognised the limits on absolute sovereignty in 2005 when it endorsed a doctrine entitled the Responsibility To Protect (R2P). This doctrine asserts that sovereign states have a responsibility to protect their own populations from genocide, war crimes, ethnic cleansing and crimes against humanity in the first instance. But it also allows for the international community to take 'timely and decisive action' when sovereign states fail to protect their populations (UNGA 2005). To the extent that R2P was developed, has been employed, or proposed to be employed, it has been in relation to otherwise sovereign but developing countries.

Sovereignty has also been employed by states or people to claim the right of defence against what they perceive to be external interference, such as with matters of external criticism. Yet the *de jure* concept of sovereignty, critical though it is in international relations, has been much overstated when considered against its practice *de facto*, particularly in developing countries. Sovereignty originally applied to the state (realm) under a sovereign, but has since come to include the land of the state and its airspace. Territorial waters, and in some cases the continental shelf, are also included up to that equidistant point where they meet the sovereign waters or land shelf of another sovereign state.

The main argument about sovereignty concerns who it applies to, with the original position being that it was absolutely vested in a monarch – which is still the case in a very few countries, such as Saudi Arabia, Oman, Swaziland and Brunei, and is very nearly so in Morocco and somewhat less so in Bhutan – or vested in the people but deputed to the monarch, as identified by Hobbes (2009). In theory, constitutional monarchies and in practice the heads of one-party states claim sovereignty; or it may simply be vested in the people, as postulated by Rousseau (1992).

In contemporary terms, sovereignty is commonly vested in citizens. That is, the state exists in principle to manifest the wishes of its citizens. How this works in practice can vary widely according to the capacity and intention of whatever government runs the state at a given time. It is possible, for example, for a state to remain independent but lose functional sovereignty, as was the case in Iraq between May 2003 and December 2005, when a Coalition Provisional Authority ran the country. Similarly, Vietnam achieved formal independence in 1945, Laos in 1949 and Cambodia in 1953, before functional sovereignty was granted to all three by the Geneva Accords in 1954 (with the caveat that Vietnam was to be temporarily divided until national unification elections scheduled for 1956 that never took place) (Talmon 1998:50, n.b. 28). Even then, South Vietnam functioned initially as a puppet state of the French and later of the U.S. before its defeat in 1975 in what Vietnam refers to as the Resistance War against America.

Claims to sovereignty resound most forcefully when a state is attacked or invaded. To illustrate, when Vietnam invaded Cambodia in 1979, Cambodia's Khmer Rouge regime sought international protection on the basis that its territorial sovereignty had been violated, even though that invasion ended the Khmer Rouge's genocidal rule. In the case of Iraq's invasion of Kuwait in 1991, the latter called on the U.S. and its allies, which responded by pushing Iraqi forces back into Iraq. The U.S. later established a 'no fly' zone over Iraq's northern Kurdish region, thus limiting Iraq's sovereignty and helping to establish what was, in effect, a *de facto* state of Kurdistan administered by the Kurdistan Regional Government (KRG). In 1999, NATO attacked Serbia to bring an end to the Kosovo War (UNSC 1999), and in 2011 helped bring about regime change in Libya, among other instances.

172 *Sovereignty and strategic relations*

Claims to sovereignty can also be used to try to blunt external criticism, such as Sri Lanka's recourse to claiming the right to defend its sovereignty in a bid to limit foreign criticism of the way it was prosecuting its war against LTTE separatists (see Dayasri 2010). Sri Lanka was particularly sensitive to foreign criticism given that India had intervened in Sri Lanka, in 1987, by sending a military force to try to resolve the Tamil separatist conflict (an attempt that failed). Yet claims that criticism compromises sovereignty are overstated, given that they alone can have no material effect. Defensiveness about sovereignty – the claim that it must be protected at all costs – assumes, incorrectly, that sovereignty is an absolute. Developing countries do tend, however, to be sensitive about issues of sovereignty, given that the functional sovereignty of many of them is, often relatively easily, compromised.

Client-statism

A client state is one that is economically, politically or militarily subordinate to another, more powerful state within the wider realm of international relations. Once this would have been described as a formal relationship between the 'patron' and client states, but it has since come more commonly to mean its effective subordination to a more powerful state via trade, investment, elite political models or alliances.

Historically, what functioned as colonies (often 'protectorates') were in effect client states of colonial powers, and this was one characteristic that shaped their successor states, often in political terms as well as in fixing their geographical boundaries. The rise of the Muslim Brotherhood, for instance, was a direct consequence of British clientism in Egypt, while the ultimate split of Sudan and South Sudan was a long-delayed end-product of a British protectorate incorporating two peoples into one 'protected' space. So, too, the 'mandate' states of the Middle East gave rise not just to the states of Iraq, Syria, Jordan and Israel, but also to their political styles, not least in retaining political control (usually through force) over often quite disparate peoples. After World War II, clientism was a by-product of the Cold War, commonly manifested in economic, diplomatic and military support for sympathetic regimes.

In economic terms, not only have some states served the interests of 'patrons' in terms of investment and trade, but they have connived at the compromise of their sovereignty in smoothing the political path for foreign investors and sometimes acted supinely in facilitating economic rapacity by their patron states. Oil-producing states have been at the forefront of such aggressive projection of patron-state interests, even if this was sometimes presented as being in the interests of the client state.

That the Middle East has been such a site of superpower contestation and remains volatile today is in large part due to the projection of their economic interests by patron states, beginning with the United Kingdom and France and followed in later years by the (now defunct) USSR and the U.S., among others. Other countries producing precious resources have, from time to time, known the heavy hand of patron-state interference, for instance in externally organising armed rebellions aimed at overthrowing uncooperative regimes or heads of state.

Many of the world's less accountable or more authoritarian leaders have owed their positions to more powerful patron states, if in some cases they pay lip-service to 'democracy' by going through electoral processes. By way of illustration, the government in Kabul is nominally chosen by the people of Afghanistan, even though the electoral process is deeply corrupt, but it remains heavily reliant upon the U.S., despite occasional tugs at the

leash. Syria's Assad regime relies heavily upon support from Russia, principally of three kinds: direct military intervention, $US1 billion in military aid and $20 billion in investment, and is dependent on Moscow to stay in power. In tacit recognition of that reality, it leases back to Russia a strategically important naval base at Tartus by way of part-compensation for that support.

Client-patron relations in the Middle East

When it comes to international politics, the United States might still be the world's greatest power, but Russia's intervention in Syria showed it was equally accomplished at strategic manoeuvring. Russian warplanes tilted the balance of the Syrian Civil War against anti-regime forces but, unlike the U.S., did so in response to Syria's official invitation and hence entirely within the framework of international law.

Ironically, Russia's intervention was portrayed in the U.S. and Britain as 'defying' the West's warnings not to intervene. Yet the pro-U.S. position of air strikes in Syria under the rubric of 'collective self-defence' for Iraq was marginal by comparison. The war in Syria was an opportunity for Russia to demonstrate its continued strategic influence in the region and its support for Syria as a client state. Along with involvement in Ukraine and the establishment of eastern Ukraine and Crimea as client rump states, this was part of a larger narrative about reasserting Russian 'greatness' (Zygar 2018) after the collapse of the Soviet Union and its largest successor state Russia's consequent sense of ignominy.

The Syrian Civil War quickly developed into a proxy war, with Russia, Iran (and its client Hezbollah in Lebanon), the U.S. and its allies, Saudi Arabia and Turkey each backing one or more of the rival participants. Assuming an end to the Syrian – and Iraqi – civil wars, more likely following the battlefield defeat of the Islamic State group (IS), Russia was positioned as a critical actor in determining the region's future political shape. France and Britain were the critical actors in the region a century earlier. In 1916 they forged the Sykes–Picot Agreement that it is only a slight exaggeration of the truth to say drew up the contemporary map of that region. One question when this conjoined conflict finally ended would be whether the states of Syria and Iraq were to continue in their longstanding form, or as devolved federations, or whether there might emerge new states in the region (notwithstanding a general, if not absolute, international aversion to creating new states). When France and British shaped the region 100 years ago, they did so as allies. Although Russia and the U.S. were a long way from being allies, they seemed to be agreed on one thing – the desirability of retaining the states and their frontier in this 20th-century form.

For a time, the U.S. developed a patron–client relationship with the Iraqi government, as well as with the KRG in northern Iraq. Support for the KRG was initially given to enable it to resist attacks by the Syrian army, then controlled by Saddam Hussein, and then the KRG region was used as a springboard from which to launch attacks against Saddam's Ba'athist regime. This relationship then evolved into an armed alliance combating anti-U.S. Iraqi militants, and from that base the KRG's Peshmerga forces emerged to spearhead the fight against IS.

Salafi Islamism as clientist disjuncture

In the second decade of the 21st century the internal cohesion of client-state relationships has been disrupted by several forces, each inspired by the ideology of *Salafi* Islamism we

174 *Sovereignty and strategic relations*

explored in Chapter 9. These groups proved a powerful disruptor, to a greater or lesser degree. What they did have in common were goals that aimed at creating a new global order, at least so far as the *umma*, or predominantly Muslim powers of the Middle East, were concerned.

The two best-known manifestations of *Salafi* jihadism are Al Qaeda (The Base, AQ) and the Islamic State (IS) group, each of which has a number of 'franchises' operating more or less independently under the rubric of 'leaderless resistance'. These groups, cognate with the mission stated above, hew to a common ideology but do not necessarily coordinate their actions. In many respects, IS supplanted AQ, although both gained notoriety through what war historian Max Boot branded 'grotesque displays designed to frighten adversaries into acquiescence' (2013:20).

On the Arabian Peninsula, Sunni Saudi Arabia has long been at odds with Shia Iran and, by way of asserting regional authority, has sought to dominate the foreign policy and strategic alliances of its immediate neighbors. Qatar and Yemen have been the principal holdouts. In Yemen, the country is riven between northerners and southerners, Shia and Sunni Muslims, opposing tribal groups, 'democrats' and militant Islamists, as well as along more conventional Left–Right ideological lines familiar to people in modern western states. Saudi Arabia has been determined – and backed this determination up with intensive air attacks – to ensure that compliant Sunnis remained in power and has in recent years been moderately successful in frustrating Shia, if less so Sunni Islamist, militants.

Qatar, however, was more problematic. This small, hydrocarbon-rich emirate openly supported the Muslim Brotherhood which, while Islamist in outlook, sought to achieve power primarily via elections in Egypt and in Gaza. In 2013 Saudi Arabia's ally Egypt outlawed the Muslim Brotherhood – and the same year overthrew popularly elected President Mohamed Morsi, leader of the Muslim Brotherhood there – while Saudi Arabia also trenchantly opposed this transnational organisation.

Qatar had diplomatic relations with Iran, if not a formal alliance. It did, however, establish a military alliance with Turkey which, as a Sunni, increasingly Islamist and potentially expansionist state, also supported the Muslim Brotherhood and was on good diplomatic terms with Iran. Qatar also owns the global news network Al Jazeera, the closest thing to a free media outlet in that part of the world, and its English-language service is arguably the highest-quality provider of international news among television networks. Egypt, Saudi Arabia and not a few others hate it with a passion reserved for the type of journalism that makes autocrats find it appealing to shoot the messenger, as it were. Further complicating matters, the U.S. has military bases in both Saudi Arabia and Qatar. From mid-2017 on, though, U.S. President Donald Trump appeared to be veering towards Saudi Arabia's position against Qatar.

Beyond breaking off diplomatic ties with Qatar, Saudi Arabia and its allies were likely to remain reluctant to use military force against Riyadh's small neighbor. Saudi Arabia was vulnerable to its own *Salafist* militants who wanted to oust their pleasure-loving and only lately reformist royal rulers, the House of Saud. Starting a difficult war with a pious neighbor could have inspired a substantial fifth column within the kingdom and was thus avoided.

Kurdistan

The Kurds have long harbored aspirations for independence (see McDowall 2004; Mansfield 2014; Gunter 2017), with the Kurdistan Regional Government (KRG)

holding a ballot in 2017 on whether it should become independent, a poll predictably producing an overwhelming majority in favor. When the KRG then declared independence, the otherwise autonomous region was attacked by U.S.-armed (predominantly Shia) Iraqi forces, and Washington showed its displeasure by terminating military support for the KRG.

Conversely, the U.S. supported the Syrian Kurdish People's Protection Units (YPG) as the principle bulwark against IS, in the practically autonomous region of Rojava. But, when this support was formalised by the creation of a 30,000-strong 'border force', the Americans' NATO ally Turkey attacked from across the border, on the basis that the YPG (along with its political wing, the Democratic Union Party) was the Syrian branch of the Kurdistan Workers Party (PKK), which is banned in Turkey. To carry out this attack, Turkey used its own client group, a breakaway faction of the larger YPG-dominated Syrian Democratic Front (SDF). The U.S. responded by curtailing support for its YPG client, in favor of mending relations with its NATO ally, Turkey.

Kurdish control of much of Turkey's border territory was a thorn in the side of Turkish leader Recep Tayyip Erdogan's ambition to expand his country's influence in the Middle East. One manifestation of Turkey's aspirations in this direction was its forming an alliance with Qatar in 2017 and sending troops to the Gulf state. On issues such as support for, or opposition to, the Muslim Brotherhood, Turkey and Qatar were now in the former camp, Saudi Arabia and Egypt in the other. Other regional flashpoints where these powers were on opposite sides included the role of Hamas in Gaza, warring factions in Yemen's civil war and, not least, the tangled plethora of combat groups fighting in Syria.

Apart from the continuing horrific implications for civilians on the ground and the demonstrated fragility of arbitrarily drafted state borders, all these convulsions left the United States in an awkward position in the Middle East. Its alliances with Turkey (via NATO), Saudi Arabia, Qatar and Iraq, and its support for the YPG and the Free Syrian Army, were already complex. It would have taken very little at this point to see U.S. interests in the region caught up in, and consumed by, a three-sided fight for regional supremacy.

It was a long time coming but, when it happened, unsurprising; Turkey was never going to tolerate an independent Kurdish military on its border. As a result of the U.S. helping the YPG establish its 'border security force' in northern Syria, Turkey massed forces along the northern Syrian border in early 2018, started shelling Kurdish-Syrian territory and then invaded, capturing the key Kurdish city of Afrin. That attack split the Kurdish-controlled area and placed the whole region from A'zaz to the border town of Jarabulus under the control of ethnic Turkish fighters. Afrin is a key city previously held by the Democratic Federation of Northern Syria. The federation's 'capital', Kobane (officially Ayn al-Arab), sits hard against the southern Turkish border and was alleged by Turkey to be a key route for PKK fighters crossing back and forth between Syria and Turkey.

A little under 20 per cent of Turkey's population is Kurdish, concentrated in its east, and Turkey has long resisted attempts at attaining Kurdish independence, sometimes brutally. There is also a small ethnically Turk population in northern Syria, which Turkey has armed and supported against other groups, including Islamic State and the YPG.

The bid by Iraqi Kurdistan to establish an independent state could also have tested Turkish resolve, until conventional Iraqi forces pushed Kurdish Peshmerga from the key city of Kirkuk in October 2017. According to sources within Iraqi Kurdistan, attempts to seize other Kurdish strongholds were repulsed and a ceasefire was later reached. The KRG returned to its autonomous status within Iraq, no doubt biding its time for another

176 *Sovereignty and strategic relations*

opportunity to create a separate state. According to a Peshmerga source in November 2017, Russia filled the gap left by the U.S. support for Iraq by providing military support to Iraqi Kurdistan.

An autonomous Kurdish state, along with an independent Armenia, was detailed in the 1920 Treaty of Sèvres. This treaty was supplanted by the 1923 Treaty of Lausanne, which carved out the region's present borders and in so doing prolonged the centuries-old fragmentation of the Kurdish people, whose current 35 million are cast between Turkey, Iran, Iraq and Syria, along with small pockets dotted elsewhere.

Both the YPG and Peshmerga were the most competent military forces in Syria and Iraq battling IS, with both forces prominent in inflicting defeats on it. But, as a mountain people, and separated by modern state boundaries, the Kurds have not been politically united. The Kurdish situation was complicated by shifting alliances. In Iraq, as noted, Peshmerga were supported by the United States until 2017, when it withdrew its support following the KRG's declaration of independence. But in Syria the U.S. continued to back the Kurdish YPG.

In Syria, Russia had supported the YPG, particularly in its battles against Islamic State, but then sided with its client state, Syria, when the YPG tried to formalise its military status. So the Kurds in both Syria and Iraq have swapped supporters from opposing camps, with each of the patrons in the patron–client relationships leveraging advantage in each other's areas of strategic concern. For the Kurds, however, it was a case of battling the outsiders with whatever help was available, from whomever, however cynical its purpose or short-lived its support. When Turkish forces, formally allied with the U.S. through NATO but increasingly friendly with Russia, crossed the Syrian border, it again reinforced an old Kurdish saying: 'The mountains are our only friends'.

Apart from Russia and the U.S., Saudi Arabia and Qatar – this time not at loggerheads – supported clientist factions in the Syrian Civil War, shifting between Al Qaeda-inspired Jabhat al-Nusra (later Jabhat Fateh al-Sham) and the Islamic State group (another Al Qaeda derivative), as well as groups within the Free Syrian Army. Turkey supported non-Kurdish sections of the Syrian Democratic Forces and, allegedly, al-Nusra. Iran, meanwhile, supported the Alawite minority government directly (with a subvention of more than $1 billion) and through its client group in Lebanon, Hezbollah, which participated in the Syrian Civil War on the government's side and, with Russian air support, helped bring the conflict close to conclusion. Because of the various parties that supported different groups in this complex, multi-faceted conflict, it was widely regarded as a proxy war between regional and more distant powers, if somewhat more confused and fragmented on the ground than the proxy war in Cambodia (1978–1991), which was triggered when Vietnam invaded 'Kampuchea', as the Khmer Rouge had renamed it.

Other client states (with patrons in parenthesis) might be said to include: many former Soviet republics in Central Asia (Russia); and Sri Lanka, Myanmar and Cambodia, plus, increasingly, Laos (China), even though Laos has a second client relationship (Vietnam) under a continuing Treaty of Friendship and Cooperation. China has also made economic clients of several Pacific island and sub-Saharan states, as noted earlier in this work. Latin America has or had a cluster of client states such as El Salvador, Nicaragua, Guatemala, Honduras and Chile, together with Cuba before the revolution (U.S.). In their time, South Vietnam, the Philippines and Iran under the Shah, among others, have attempted to move away from more direct economic and strategic control by their patron (U.S.). Importantly, even developing countries can have client-state relations with smaller neighbors. The clients don't have to be state actors: particularly in sub-Saharan Africa, they are armed non-state groups.

Other 'peace talks'

If one was to believe U.S. Ambassador to the UN Nikki Haley's statement in early 2018, the war in Afghanistan was going well for the U.S.-backed government which in concert with the Taliban was moving towards peace. The reality at that time was somewhat different.

Haley's statement came at almost the same time that a bomb blast in Kabul killed almost 100 people and injured scores more, following an attack against charity Save the Children's office in Kabul, which itself followed a suicide attack against the city's main five-star hotel. These were not the signs of a war going well or an enemy ready to concede.

In reality, these attacks represented the first wave of the Taliban's annual spring offensive. It probably also included elements of attacks by Islamic State in Afghanistan but, while the two organisations were not linked and even occasionally attacked each other, both were fighting to end the reign of the 'democratically elected' Afghan Prime Minister, Ashraf Ghani. Afghanistan's electoral process is notoriously corrupt. Observers often give the country's elections the dubious accolade of being the world's the most fraudulent.

The endgame of this strategy of mounting attacks inside Kabul was to show that nowhere was safe, ultimately to remove the U.S.-backed elected government in Kabul and install a leadership reflecting an austere singular Islamist vision for the deeply fragmented state. While the Taliban are the key players among opponents of the Kabul government, that opposition is not tightly united.

Afghanistan was long known for its tribal warlords and, while many were unenthusiastic about the government they were also ambivalent about the Taliban. Most tribal leaders just wanted to be able to preserve their age-old despotic traditions without external interference (see Kilcullen 2013:158 on shifting warlord allegiances). As a result, tribal leaders switched their allegiance back and forth between the Taliban and the government. The recipient of that allegiance at any given time largely depended on whether Kabul was including them in the division of spoils from the elite's corrupt wealth-sharing practices.

At one level, corruption was all but out of control in Kabul; at another, it was just a variation on traditional methods of retaining loyalties and doing business. In the Taliban's favor was that, as a religious organisation, it had a strict policy against corruption and did provide consistency in its judicial outcomes, albeit they were harsh (Kilcullen 2013:149, 157). Indeed, predatory crime and corruption by the government drove many into the Taliban's arms, assuring it a steady flow of recruits (Felbab-Brown 2017).

In 2015, the Afghan government controlled 72 per cent of the country. A year later, this had fallen to a little under 60 per cent. By the end of 2017, there was a permanent Taliban presence on 54 per cent of the nation's territory, while another 38 per cent had a substantial Taliban presence (SIGAR 2017), strongly indicating – unless one was Nikki Haley – that the Kabul government was losing the war.

Even with the backing of 4,000 extra U.S. troops and 3,000 NATO troops with extended rules of engagement, its future looked problematic. The Taliban did engage with the government in internationally brokered 'peace talks'. But, if they were to succeed, the conditionalities on any agreement were expected to mean regime change in Kabul, whether through negotiation or outright victory.

The international rules-based order

If war is essentially a failure of agreement around the rules of resolving differences, the 'rules-based order' has been a mechanism that has otherwise avoided such conflict. The

178 *Sovereignty and strategic relations*

period since World War II, which has seen worldwide decolonisation and the birth of new, independent developing states, has spawned such an international rules-based order. At one end of the rules-based spectrum has been the UN, and its Security Council as the formal arbiter of international security affairs, while at the other end states have adopted various capitalist models for their economy – models underpinned by global trade, the World Trade Organization (following on from the General Agreement on Tariffs and Trade), the IMF and the World Bank. This rules-based order has also been seen to endorse democratic processes and self-determination for colonised peoples, even though the former have often been absent and the latter imperfectly applied (Western Sahara remains occupied by Morocco, while there are twenty-three other non-self-governing territories).

This order has acted as guarantor to western states and the OECD, and to those developing countries that subscribed to similar economic and, to a lesser extent, political values. It has also acted as a retardant, if not an outright brake, on interventions by one country against another (with the exception of Security Council-mandated interventions under Chapter VII).

After the Cold War ended, this rules-based order became increasingly dominant, though its preferred economic paradigm favored less government involvement in national economies, supplanting the previous Keynesian orthodoxy of economic stability and redistribution. The rules-based order has afforded an impressive degree of certainty in trade and international relations, although it has preferenced more developed states, many of which happened to be patron states or former colonisers.

In part, this rules-based order was underpinned by U.S.-western economic dominance. While the Cold War served to offer strategic alternatives, with China and the then USSR providing development and strategic support to a number of friendly developing countries, it was not able to rival the growth in capitalist economies. The USSR subsequently collapsed, resolving into its constituent parts, while China switched from a command economy to a free-market economic model even as it perpetuated political control under a single-party 'communist' state. In the early 21st century, Russia emerged as an oligarchic economic state that has tested the limits of international rules through its intervention in the Ukraine (Chatham House 2015), involvement in the Syrian Civil War and strategic challenges to the Baltic states.

The problem for many states going through enormous developmental and political change in this post-unipolar world – particularly with respect to powers such as Russia – was that they had not yet determined their 'place' in the new world order. In cases like Russia, which could be said to be have only half-changed – given its tendency to continue a centuries-old pattern of looking to an autocratic leader – a reluctance to abandon old ways was compounded by the Kremlin's preoccupation with the preservation of sovereignty, its distinctive culture and status as an influential power (even if in reality this has been much diminished), added to a long-held mistrust of western machinations.

Russia in the early 21st century is thus the product of reconstruction (*perestroika*, a term first used by the last leader of the Soviet Union, Mikhail Gorbachev in the mid-1980s) since the 'humiliation' of the old USSR's collapse, even if that was internally driven. Vladimir Putin has promoted his mission as overseeing Russia's 'return to greatness', which as some of the tendencies of the new century became established was a popular phrase among many politicians. The Kremlin's perception that the Russian Federation was being disrespected and demeaned was fuelled when the West demanded Russia forgo some of its sovereign rights (particularly in terms of economic independence and complying with global norms of business behavior) and accept as a *fait accompli* its uncomfortable strategic proximity to NATO and the EU, swollen by the addition of several former Soviet-bloc states.

Sovereignty and strategic relations 179

These external factors were exacerbated by Russia's internal politics, in which those favoring closer alignment with the West were pitched against nationalist neo-Slavophiles and neo-imperialists bent on the reassertion of Russian power. Neo-Slavophiles share the imperial vision but stress the importance of developing the country's identity. Judith Zimmerman argued that the fundamental divide – in a reprise of 19th-century debates – was between westernisers and Slavophiles, with the neo-Slavophiles intent on counterbalancing American hegemony and finding an autonomous developmental path (Sakwa 2008; Radin and Reach 2017). Putin, who as president or prime minister has led the country since 1999 and was, at the time of writing, projected to lead it until 2026, could be defined as a neo-Slavophile with imperialist tendencies. Putin's economic policy of a Russian-led regional-bloc alternative to the EU and his assertion of Russian power into neighboring regions, including Ukraine and Syria, mark him as 'imperialist' in external outlook, if less so in terms of planning.

In large part, Putin could have been understood as reacting to rekindled historical concerns with national security, as well as to strategic and economic challenges that he and others of his tendencies read as unreasonable and belittling for a state with Russia's unique history and role in the world. The outcome of this evolution was frustration in both the West and Russia, and the attempted or actual marginalisation of Russia and some other emerging states. As a consequence, a variation on a Cold War theme emerged, and these marginalised states felt forced to legislate security. Their solution often looked, and largely was, authoritarian.

This was not to suggest that Putin had a grand plan: rather he responded to circumstances he was presented with and his foreign minister, Sergei Lavrov, made the most of situations that arose. Sometimes he did so well, for example in the case of Syria, that it could look like careful long-term planning. How typical of imperialism it is, when expansion becomes its own justification with stasis spelling failure and, ultimately, diminution (that is, if one is not expanding then one is contracting). This does not sit easily with the international rules-based order that has characterised the global environment since World War II.

Similarly, the U.S. has been criticised for violating the rules-based order when convenient, for example in overt interventions not sanctioned by the United Nations Security Council (UNSC), notably in Cuba, Vietnam, Cambodia, Panama, Iraq (Chatham House 2015) and Haiti (despite an attempt at providing each with a fig leaf of legitimacy). A full list would embrace many other covert operations, including some that toppled governments.

The U.S. also tested the limits of a rules-based order by stretching the parameters of the NATO bombing campaign in Libya beyond those authorised by the UNSC and by using unmanned drones to kill suspected terrorists in countries such as Pakistan and Somalia, where it had no legal authority to operate. From 2016, it also started to move towards more protectionist trade policies, in contravention of WTO principles, although from 2017 the inconsistency of the incoming Trump Administration meant those policies could easily be reversed.

Although relatively diminished since its brief period as the world's only superpower, the U.S. has maintained a global presence, attacking or supporting those interests it sees as opposing or aligned to its own. Its interventions in Afghanistan and Iraq, and in a more circumscribed way in Syria, were obvious examples of the U.S. asserting its global power. At the same time, Washington maintained a strategic presence – and activity – in a number of other parts of the world.

Africom (the United States Africa Command) was one such assertion of far-reaching strategic interest. Headquartered in Germany, Africom maintained military-to-military contacts with fifty-three African states, virtually the entire continent. It also intervened when

180 *Sovereignty and strategic relations*

and where it chose to do so, ranging from anti-piracy activities off the Horn of Africa to direct military intervention on the ground.

An example of this was Africom's drone attacks in Somalia, intended to strike the jihadi militant al-Shabab organisation (Goldbaum 2017), which followed on from that country's Islamic Courts Union which controlled Mogadishu until its defeat there by Ethiopian troops in 2006. Al-Shabab was linked to Al Qaeda, although a small breakaway faction was aligned with Islamic State. The U.S. attacks in Somalia were part of the wider Enduring Freedom campaign that also included a trans-Saharan focus and came under the aegis of the Washington's 'global war on terrorism'. In principle, Enduring Freedom concluded in 2014; in practice, a number of its operations continued.

China also challenged the rules-based order, manipulating its domestic currency in support of its export market (in contravention of WTO rules). This ensured massive growth in China's wealth, establishment of its status as the 'world's factory' and its demand for resources underpinning economic growth and stability in resource-exporting states. Perhaps more directly, China has also challenged the rules-based order through its strategic expansion into the South China Sea, over which it claims historical rights. That claim is contestable – and contested – but instead of submitting it to international arbitration China took actions that contravened the UN Convention on the Law of the Sea. At stake was access to rich fishing grounds for China's massive population, along with oil and gas deposits and control of critical sea routes. This expansion pushed China's strategic reach closer to western-aligned developing countries and created a 'buffer zone' should China feel strategically challenged in the future.

Related to China's strategic expansion in the South China Sea is the U.S.'s apparent reduction of military involvement on the Korean Peninsula as a part of President Trump's commitment to North Korean leader Kim Jong-un. While this move may be part of a larger plan to reduce military tensions in the region, potentially ahead of a denuclearisation of the peninsula, it also diminishes the U.S.'s strategic engagement in the region, creating an effective vacuum to be filled by China. Added to increasing trade tensions between China and the U.S., with China increasingly ascendant and the U.S. attempting to stave off the challenges to its economic and strategic dominance, it has been suggested that the logical outcome of this competition will be conflict. This is what has been termed the 'Thucydides Trap' (Allison 2017, see also McGregor 2017; Friedberg 2018). The U.S. had secured its global economic and strategic primacy since the end of World War II by creating international institutions such as the World Bank and the IMF and establishing the Marshall Plan. As the 21st century rolled out, China's sense of importance and entitlement has grown, and it has called to be given a bigger role in these international institutions. This has created a sense of uncertainty and insecurity on the part of the U.S., with a concomitant determination to defend its economic and strategic status. China has responded by massively increasing its international programs, its own globally aspiring institutions and by creating massive investments through the Belt and Road Initiative, along with its strategic grab in the South China Sea. How these two global powers resolve these tensions within the context of a multipolar world, and how smaller and especially developing countries navigate between the two superpowers, can be expected to cast the political shape of the world well into the 21st century.

In part, how developing countries respond may be shaped by developing a new 'non-aligned' movement, perhaps shaped around more localised trading blocs. Well within the international rules-based order but constructing a regional iteration of it have been precisely such regional trade, monetary and security blocs. Of those blocs, some have failed to

Sovereignty and strategic relations 181

realise their formative aspirations, or have struggled to find a credible contemporary *raison d'être*. The Organization of African Unity (OAU) was abandoned in 2001 and, reborn as the African Union (AU), was given a new name for the new century in an attempt to re-establish some foundational political architecture, in a bid to consign to history the previous structure's 'seeming willingness to accept any transgressions by an African government in the name of sovereignty' (Herbst 2014:xv).

Similarly, the Association of Southeast Asian Nations (ASEAN) has often looked like an organisation in search of a purpose, although this has since started to cohere around closer economics relations and strategic linkages. However, ASEAN's foundational 'non-interference' clause has been tested by tensions involving member states, such as between Thailand and Cambodia, and occasional criticisms, once unheard of, over group sympathies (for example, Indonesian and Malaysian expressions of concern of the plight of Myanmar's Rohingya refugees). With the AU in particular, revising regional rules has tended to compromise notions of state sovereignty, particularly in the case of failed or failing states, what Herbst referred to as 'the palpable inability of a great many African countries to physically defend their boundaries' (Herbst 2014:xv), which he contrasts with their commitment to those boundaries. Since the OAU's creation just over half a century ago, only one boundary change has been accepted – that caused by South Sudan's secession from Sudan.

North Korea

Among states that flouted the rules-based order, few have been as blatant as North Korea (the Democratic People's Republic of Korea, or DPRK), which continued to develop strategic missile and nuclear weapons programs in defiance of a series of UNSC rulings. As North Korea's key trading partner and strategic backer, China has only slowly moved to impose sanctions on Pyongyang. On one hand China did not wish to see a collapse of the North Korea economy precipitating an exodus across their common border. But, at least as important, China wished to have a strategic buffer between itself and South Korea and Japan, as well as to have a metaphorical 'mad dog on a leash' in case of strategic challenges elsewhere, such as the East or South China Seas.

North Korea was, in some respects, an unusual study in the issue of sovereignty and strategic relations, given that this small and isolated state caused a disproportionate amount of international anxiety which, in 2017, appeared to be worsening rather than improving. Although not entirely typical of anything, especially client-statism, North Korea's history is very much rooted in the first moments of the Cold War, when the Soviet Union occupied the previously Japanese-ruled northern half of the Korean Peninsula in August 1945, in the dying weeks of World War II.

The peninsula was divided into Soviet and U.S. spheres of control at approximately the 38th parallel, with the entire territory placed under the trusteeship of the Soviet Union, the U.S., the Republic of China and Britain. Talks on unification failed and, by May 1946, it was illegal to cross the border between the U.S. and Russian zones without a special permit. A UN Security Council proposal for elections was boycotted by the Soviet Union and hence invalid, but elections proceeded in the south in May 1948, establishing a government in August that was not recognised by the Soviet Union. About three weeks later, North Korea – led by Kim Il-sung – was declared the government of the north.

Numerous border clashes between the two sides ensured an unremitting state of hostilities with no solution in sight. In June 1950, North Korea launched an offensive across the

182 *Sovereignty and strategic relations*

border, occupying much of the south until pushed back by a U.S.-led UN force. The Soviet Union had not supported the offensive though nor had it blocked the relevant UN motion in the Security Council, where it could have cast its veto, because the Soviet Ambassador to the UN was off duty with an illness on the day of the critical vote. Once the war was joined, Moscow did send matériel and medical staff to support Pyongyang's cause. China – now under communist rule – initially showed its colors by releasing Korean volunteers who had fought for the Chinese communist cause back to North Korea to offer fraternal help on the battlefield. When UN forces pushed North Korean forces back across the 38th parallel, China intervened by sending its 'People's Volunteer Army' streaming south in October 1950. Initial military successes were matched and the war quickly bogged down into a stalemate. In July 1953, both sides agreed to an armistice – a ceasefire but not a formal end to hostilities, so that technically even today North and South Korea are still at war.

Drawing on Stalinist rhetoric and organisation as well as the influence of communist China, North Korea long had a reputation for bellicose rhetoric and this was stepped up following the ascension to the 'throne' of third-generation Kim dynasty member Jong-un. To believe North Korea state media, in 2017 the world was but a step or two away from a military showdown, including the possibility of nuclear war. The threat from North Korea was serious enough, if overstated.

North Korea had been long on confrontational commentary but, as of 2017, despite threatening to use nuclear weapons had not yet developed nuclear or missile delivery technology sophisticated enough to be more than a tactical threat. Its conventional military forces were significant relative to its population of about 25 million and its impoverished economy and, although it had a larger standing army, its military capacity remained less developed than South Korea's (GFP 2016).

North Korea has a proven nuclear capacity, with six underground nuclear tests detected – in 2006, 2009, 2013, two in 2016 and one in 2017 at its Punggye-ri Test Site in the country's north. The September 2016 test marked an escalation of nuclear yield, from under 2 kilotonnes of equivalent TNT capacity (kt) in 2006 to more than 20 kt capacity a decade later (Grierson 2016).

The country's missile capacity was less developed, if growing quickly throughout 2017. North Korea had operationally effective short-range 'Scud'-type missiles and, with improved guidance systems, could easily target South Korea (Republic of Korea) and Japan (KBS World Radio 2016). These missiles were used as a platform for developing the country's longer-range missiles (Dewey 2016), which eventually extended their range to include an arc extending from much of the continental U.S. to its east across to Australia in the south.

North Korea long had a belligerent defence posture, in part because the country's regime was forged in warfare but also because it had been so grossly unable to compete in economic terms with its southern neighbor (UN 2015b). North Korea's external posturing is matched internally by a repressive internal political system. China's response to this missile and nuclear weapon testing reflected a longer and more nuanced understanding of why North Korea pursued these joint programs.

Notoriously brittle in the face of any sign of threat or pressure, both North Korea and the U.S. began imposing preconditions on future negotiations which scuppered existing talks aimed at stopping its missile and nuclear development programs. Since inheriting North Korea's leadership, Kim Jong-un has stamped his absolute personal authority on the leadership. This has included disposing of potential rival relatives and others in senior leadership positions thought to be less than completely loyal. One view has it that the third-

generation Kim has been obliged to take such a hard line, internally and externally, to placate even more hardline generals. It is their day job to keep the totalitarian state in existence, and quite possibly that remit includes keeping the Supreme Leader in office.

Under Kim Jong-il, father of the country's current ruler Kim Jong-un, North Korea entered into negotiations over scaling back its nuclear development program in exchange for security guarantees, dropping economic sanctions and extending aid. Although those negotiations were only marginally successful, they did demonstrate a capacity for dealing with North Korea, and that country's willingness to look for non-military solutions. The longer-term breakdown in relations between North and South Korea began in 1993 when North Korea began its missile-testing program as part of a deal with Iran to exchange missiles for oil.

This was supported by North Korea's neighbor and economic lifeline, China, which wanted to retain a potentially hostile DPRK as a bargaining chip, as well as having a buffer between itself and South Korea and Japan. But an economically booming China did not want North Korea to become a complication for business. To that end, China wanted to return to the *status quo ante*, and if possible to do so while not betraying current relations with its otherwise isolationist neighbor (Carpenter 2017).

When 'Dear Leader' Kim Jong-il died in 2011, the system he had inherited from his father and, in turn, bequeathed to his son, Jong-un, was centred on the Kim family bloodline. This system of political inheritance in the face of external threat only worked if other key decision-makers, and beneficiaries of the system, also had their positions protected. So North Korea's posturing largely reflected the concerns of a small elite, supported by a strong party system, within the context of a failed 'self-sustaining' economy. It refocused public attention away from local privations and towards the time-honored political distraction of an external enemy. To remove any hint of internal challenge to this system, the elite cohort has authorised the murder of any relatives who could forge an alternative political narrative; first an uncle by marriage and security chief, then a half-brother (AP 2013; *The Economist* 2017), along with around 140 other less trusted officials. Increasingly isolated, falteringly 'self-reliant' and brittle, the Kim regime presented as confident and belligerent.

Relations between the North and the United States in particular reached a dangerous low in 2017 as President Donald Trump ramped up his rhetoric against Pyongyang and, most notably, Kim and both of them were soon trading personal insults. This was matched by an increased tempo in U.S.-led war-gaming in anticipation of a possible strike on North Korea. North Korea responded by accelerating the pace of its intercontinental missile development, with its Hwasong 15 missile demonstrating its potential to strike the mainland United States.

As tensions appeared to peak, North Korea held out a small olive branch when Chairman Kim announced on New Year's Eve 2017 that his country would be prepared to open a dialogue with its southern neighbor over the possibility of participating in the 2018 Winter Olympics at Pyeongchang, South Korea. The talks about the games were successful and a joint Korean team competed, opening the way for further talks. The success of this process led to the Supreme Leader announcing he would be prepared to meet President Trump, who immediately agreed, leaving his advisers scrambling to construct a negotiating agenda.

Echoing the strategy of a generation before when Secretary of State Henry Kissinger offered to be accommodating while threatening the Democratic Republic of Vietnam (North Vietnam) with a much more hardline President Richard Nixon, it may be that

184 *Sovereignty and strategic relations*

Trump's threats towards North Korea, along with South Korea's more accommodating position, created a necessity and an opportunity for Pyongyang to shift its own rigid position. On the other hand, this may have been its strategy all along, to escalate its arms program in order to return the U.S. to the negotiating table over aid. Either way, the Korean Peninsula remained a very long way from being secure, much less united, but it did appear the region had been moved back from the brink of an immensely destructive war and that two leaders who had shown a remarkable talent for brinkmanship would get a chance to see if, ultimately, they could score a victory for reason.

A meeting between Kim and Trump in Singpore in June 2018 promised much but may have delivered little in concrete terms. What it did do, however, was de-escalate tensions in a way that allowed something like the status quo to remain, if without the associated threats of a nuclear exchange that some analysts were taking seriously.

Conclusion

Notions of sovereignty and strategic relations will vary according to perspective, capabilities and *realpolitik*. It is, however, reasonable to say that one of the qualities of developing countries is, with a few notable exceptions, that they tend to be subject to others defining their capacity for sovereign assertion. This is so for their economies, their exposure to global capital and its markets, and finally to the strategic interests of greater powers, as well as in some cases other developing countries.

Notably, elements of the colonial past continue to inform the type of sovereignty that is practised within a country, by way of either example or reaction, as well as in post-colonial relations that might extend from the use of an official language to a legal code for investment and trade. In many cases, colonialism may have disappeared in a formal sense, but forms of neo-colonialism linger, from a soft and fairly benign version to something far more pervasive.

Similarly, a patron state may develop a clientist relationship with a more economically or strategically subservient country or, in more malignant circumstances, might be responsible for the ascension of a client or puppet leader or government at the expense of conceptions of sovereignty where it is assumed to be vested in the collective will of a state's citizens. In this sense, patron–client state relations suggest, as with people, a mutually useful arrangement within the context of highly unequal power relations.

If and when the usefulness of a mutual arrangement is on the wane from the client's perspective, a patron may have the economic or strategic capacity to compel compliance. Conversely, where the usefulness of such an arrangement no longer suits the patron, it usually has some capacity to alter it for the better or withdraw from the relationship. A client state usually lacks that second option.

How this plays out can vary, but the Middle East has long been a venue for external interests to embroil themselves in local disputes or conflicts. In part this might be due to simple strategic competition or leveraging for advantage, in part due to the Middle East's central position *vis-à-vis* Europe, Russia, Africa and the rest of Asia. Of major importance, though, the Middle East is also the location of the world's largest known oil reserves, demonstrably the reason for at least some external interventions harking back almost a century (in the early 1920s, Great Britain defined the boundaries of the new state of Iraq, largely the work of one Winston Churchill, to include the northern oil fields and dismantling all hope for a prospective state of Kurdistan in the process and the U.S.'s assertion of its own need to secure supplies of oil). Similarly, for other oil-producing regions or

Sovereignty and strategic relations 185

countries or those with valuable commodities (such as the Congo or West Papua in Indonesia), the needs and aspirations of the local people very often take a back seat to larger global interests.

How these interstate relations are played out is, or is supposed to be, within the 'rules of the game' of the international systems of norms and collective prescriptions. At one level this system works to maintain reasonable order and harmony within a commonly understood framework. But, returning to *realpolitik*, some states do not just have the capacity to impose their will on others but may do so by stepping well outside the rules-based system. The largest states may do so with flimsy or transparent justification, but their economic or strategic strength, or both combined, means that there is little that can be done to dissuade them. This is particularly so for the Permanent Five members of the UN Security Council – the U.S., Russia, China, the U.K. and France – each of which retains veto power over UNSC resolutions.

Faced by these realities, developing countries align themselves or are 'adjusted' to align with particular economic and strategic interests, their sole defence against incursions on their sovereignty lying in the strength of their economies and the power of their armed forces. Although North Korea was long seen by the international community as a 'rogue state' for pursuing its nuclear-weapons and long-range-missile programs, it was a startling example of a small state with a weak economy challenging the rules-based system which, it believed, was inimical to its interests, or those of its regime.

Thus the health of a rules-based order is at least partly determined by a capacity to make or alter the 'rules'. If this cast North Korea as a rogue state, it was a practice that had been commonplace among much greater powers in the past as they managed relations with developing countries with the lofty aim of securing the greatest advantage for themselves.

13 Critical reflections on politics in developing countries

If one were to characterise the politics of the early 21st century, there are two key characteristics. The first is that the world has gone from Cold War proxy competition to a unipolar world in which the U.S. was, briefly, the sole superpower, to a multipolar world in which there are competing strategic and economic poles of power reflecting competing, mutually exclusive, paradigms. That this has occurred at a time of unprecedented communication, capacity for human movement and the end of strategic, economic and political certainty has created a retreat to a second quality, which might be termed 'politics of identity'. 'Identity' can be understood in a number of ways, including as ethnicity, nationalism and religion, as well as in a more personal sense. The politics of identity stands in contrast to the politics of class or an understanding of one's community as defined by economic or material relations.

One way of construing this distinction has been to define the politics of identity as 'vertical' social divisions, where communities are sorted by commonalities despite economic distinctions. In contrast, the politics of economic distinction implies 'horizontal' social or class-based divisions. Of course, no such political forms are absolute and elements of one are often found in aspects of the others. It is quite possible, for example, to conflate one's social identity with one's economic identity, such as being sub-Saharan African and poor, or Muslim and marginalised. But there are also wealthy sub-Saharan Africans (if in a small minority), while an Islamic sense of marginalisation might be understood in a global context but less so in a community context.

As noted above, a confluence of elements have contributed to the growth of this greater emphasis on 'identity'. Neo-liberalism, under the guise of the Washington Consensus, has diminished the role of government agency in state affairs and deregulated barriers between states, particularly in areas of trade. This has meant the freer flow of goods and services between states, but has also pitted states against each other in terms of competitive advantage – who does what best, or cheapest.

Very often, being competitive is defined not by quality but by cost, which then implies that competitive advantage means who does what cheapest. This in turn has the effect of either maintaining low incomes for those people in work, or reducing those incomes. Industrial change, to the extent it has occurred in developing countries, implies a reduction in manual labor and the disruption of traditional working and social patterns. A further aspect of industrial change has been in transport, which has never been more available, extensive or relatively cheap, thus facilitating social movement (see also Czaika and de Haas 2014). Technological change has also facilitated the mass production of inexpensive weapons, particularly small arms, which have changed the social and political dynamics of many developing countries (UN 2015a).

Technological change also, and increasingly importantly, extends to communications, with individuals across the world being more connected to one another than ever. This has enabled the exchange of ideas, the formation of social and political groups beyond one's immediate community, increased knowledge of other parts of the world, interpretations of those other places and regions, together with their behaviors and actions, and widely socialised responses to that shared knowledge.

The facilitation and liberalisation of trade and transactions, the movement of capital and international investment, as well as of people, and the growth of shared knowledge have been defined by the IMF as the key elements of recent understandings of 'globalisation' (IMF 2000). The pace and extent of change have disrupted many communities and replaced many traditional understandings with new, more global or trans-state perspectives. This has had two consequences: the creation of communities of understanding or perceived commonality across previously unbridgeable distances; and new options for expressing resistance to what is sometimes seen as the imposition not just of a homogenised global culture but also of new methods of global economic exploitation.

Two manifestations of this can be seen within what were formerly common communities in North Africa and the Middle East. On one hand, the more positive aspects of shared ideas led to the 'Arab Spring', a series of uprisings starting in 2010 that were initially intended to remove authoritarian political actors and systems. Widely viewed as more negative aspects of shared ideas across the same region, and often arising within formerly cohesive communities, have been *Salafi* jihadist organisations and their 'franchises', such as Islamic State or Al Qaeda and their affiliates.

In a more exposed world in which state power is less absolute, some sub-state ethnic groups have retreated to and emphasised their ethnic distinction, or found new opportunities to express their old identity. This has often resulted in inter-ethnic conflict, sometimes exacerbated by a plentiful supply of inexpensive small arms. As a result of these disruptions and actuated by increased mobility, the world has set a global record for the displacement of people – more than 67 million of them at the time this is being written. Such a flight of refugees and internally displaced people has in turn, in some places, led to further disruption and reaction, creating new pressures on states and their governments' ability to tackle this issue.

All of this is then set against the growth of a new political paradigm, based around the notion that a closed and generally authoritarian political system is able to legitimise itself by overseeing economic growth. This 'Beijing Consensus' stands in direct contrast to neo-liberal notions of regular competitive elections and the logic of greater personal and social freedoms that inform it.

Within the context of the strategic and economic rise of China (and the reassertion of regional Russian power) and less predictable policy responses from Washington, the world is more fragile and prone to political change in ways that do not always, or even often, suggest a consistency of direction as was hoped for in the early 1990s. This is to say, the world has never been richer, but similarly never have so few people held such a large proportion of global wealth; countries may move in democratic directions but the extent and permanence of those changes are, at best, inconsistent while those that move away from democratic processes are more easily accommodated than they were in the early post-Cold War period. In all of this, various interests within and between states compete for power and influence in ways that can challenge global norms and rules, within an environment of greater global uncertainty and, hence, insecurity.

188 *Critical reflections*

Legacies

The physical shape of developing countries is, overwhelmingly, a product of their colonial legacies or the impact of colonialism, reaching even the few states that were not colonised (Ethiopia and Thailand, for example). Colonisation had a profound impact on how non-western societies were organised, with traditional methods of social organisation either disrupted or rearranged to suit colonial interests. Even where post-colonial states managed to organise themselves, they were again disrupted by what were often unequal post-colonial trading relations, by superpower rivalry and, more recently, by tensions within a multipolar world in which the rules-based order is being challenged.

While all states are, to some extent, arbitrary in their geographic scope, most developing countries tend to have more arbitrary boundaries than do developing countries, simply because of their prior existence as colonies. The boundaries of such colonies reflected the needs and conveniences of colonising powers at the expense of any pre-existing cultural or territorial identity. Beyond this, the 'hard' borders of colonies and the successor states often failed to correspond to pre-existing forms of social, cultural and political organisation.

In particular, the creation of multi-ethnic or multi-nation colonies and hence successor states had and still has a particular impact on the institutional shaping and political organisation of developing countries. In theory, such mixed societies could have cohered around shared civic values, in the first instance that of liberation from colonialism. This anti-colonialism was the wellspring of much political rhetoric that inspired a host of ideals, including greater egalitarianism underpinned by a sharing of national resources, and freedom from colonialism evolving into more broad freedoms.

Yet the reality was usually quite different. Independence marked material decline more often than advance, a lack of investment rather than a sharing of resources, reduced technical and organisational skills and political competition incompletely formed around economic interests such as farmers, laborers and business owners, instead focused on language and kinship groups. Political leaders thus found themselves appealing not to civic 'national' interests but to specific ethnic interests, often preferencing one to the exclusion of all others in exchange for political support. This then fomented political tensions that were often irresolvable via still poorly formed and inadequately understood 'rules of the political game'. All this has left a lasting legacy in terms of how post-colonial and other developing states have engaged with their own communities, with each other and with the West, and the character of their subsequent economic and strategic relations. Apart from this, new types of relations between former colonial powers and their old colonies developed, especially in relation to trade and security, but these in many respects reflected aspects of their prior relations that qualified the 'new' footing on which these relations evolved as neo-colonialism.

The failure or inability of newly independent developing countries to satisfy their citizens' expectations can lead to high levels of disappointment, alienation and protest. As previously noted, developing states may not resonate with their citizens due to failures of inclusion, equity or the rule of law, and so fail to establish the legitimacy of their administration. Questioning of, and potential challenges to, state authority then ensue as a matter of course.

Under the umbrella of a state's legitimacy, such challenges are often mounted by civil society groups acting as an alternative opposition or a catalyst for political change. But legitimate states may nevertheless be insecure states and those with low levels of institutional capacity may regard an active civil society not as a legitimate form of socio-political

expression or the sign of a 'loyal opposition' but as a dangerous challenge to their inherent authority. This can especially be so where, after a successful independence movement or regime change, the regime now in office has defined itself as the sole 'legitimate' representative of the people. That claim definitely rules 'illegitimate' all challenges to its authority, so that none may be tolerated.

This raises the question of a key division among developing countries, between those considered 'strong' states, defined as authoritarian and hence with a weak civil society or scant social protections; and those with weak or barely functional state institutions, which creates more scope for the development of 'strong' centres of power outside the formal framework of the state. Such strong non-state groups can act as a threat to the state, by either subverting its function or replacing it in particular areas. In such circumstances, the state might be classified as fragile, failing or failed. This is often the case following lengthy civil wars or other civil strife in which the authority of the state is diminished.

The politics of economics

Poverty, and the distribution of income, are not simply conceptual fodder for an appreciation of how economics works in the abstract, but the product of conscious decisions to allocate resources in particular ways within and among countries. Deeper study of these concepts reveals a longstanding tension between need, which is often extreme, and the desire for accumulation, which can also be extreme in its manifestations. It is a cliché that 'the poor will always be with us', but they are 'with us' because 'we' allocate resources in ways that perpetuate poverty by creating the structural preconditions for it not just to exist but to be exceptionally difficult to escape. Moreover, as the world progresses through the first decades of the 21st century, the gap between wealthy elites and the poor based on global share of income has increased rather than diminished. The world may be becoming richer, but it is also becoming more unequal, less fair.

As a nominal part of the effort to address that unfairness, it is normal, as recipients of aid, for many developing countries to find themselves pushed and pulled by the needs and requirements of donor countries and organisations in ways that do not always accord with their own economic plans or preferences. This may be positive, in that the governance requirements for aid have become increasingly strict and thus require recipient governments to meet higher governance benchmarks. But such requirements may also push countries into types of economic development or economic relations they do not necessarily regard as being in their long-term interests, particularly where that aid requires a fundamental re-ordering of their economy.

Over and above this is the question of aid dependency, in which developing countries may come to rely on aid and not develop their own financial resources towards becoming self-sustaining, which is the key purpose of development aid. Also, in aid-dependent societies there can be a tendency to syphon off aid funds or goods for corrupt purposes, or allocate aid in ways that maximise personal benefit, such as political patronage, rather than make choices according to need. In this way, the aid industry builds a 'need' for aid, which justifies its existence even as it enhances the well-being of particular recipients without necessarily helping build a non-aid-dependent society.

Beyond this, aid continues to be used, as it was during the Cold War era, to influence developing countries or to buy economic or strategic favor. Very little development assistance in untied and that which is given, especially on a bilateral basis, will usually have the effect of sustaining a broader relationship that suits the donor state's interests.

190 *Critical reflections*

Militaries

One of the common and enduring features of developing countries is that their militaries often appear more prominent in their political processes than they do in developed countries. With relatively low levels of state capacity, militaries have in the past often been the functionally best organised facet of the state, with a clear command and logistical structure and mechanism for enforcing their will.

But militaries are very often antithetical to notions of development, particularly in a political sense, since they are necessarily closed networks, hierarchical and authoritarian. A developing state can be endowed with its military because of an armed struggle for liberation and, in such circumstances, the military and the dominant liberation party are often one and the same. This may mean that when a state achieves independence its military (or its senior officers) are also the country's main political leaders.

Even where militaries step back from the political process, they can still act as an internal arm of government, not least in quelling domestic dissent or opposition. In such circumstances, the state can very quickly retreat to a closed political model which does not allow for alternative voices and reacts harshly when such voices are raised. As 'guardians of the state', militaries can and do step in from time to time to remove elected civilian governments which do not correspond to their understanding of how the state should be run.

Add to disproportionate budgets and a tendency to be engaged in private and sometimes illegal business activities, often as a legacy of their pre-independence history of having to be self-sufficient, and militaries in developing countries may be less accountable than when they rely entirely on the government for their budget. This potential for illegal business activities, plus the lack of civilian oversight and accountability, means that militaries in some developing countries remain problematic, their defence function too often subservient to, or overwhelmed by, their primary role of retaining domestic relevance and continued existence.

What makes militaries efficient, assuming this is a common principal quality (which in some cases it may not be), is also what may make it undesirable, in all but the most extreme circumstances, for them to be in government.

Competing models

Until the end of the Cold War, the developing world was essentially able to choose from two broad political models: capitalism (until the 1980s marked by Keynesian intervention and thereafter by neo-liberalism) and centrally planned economies (variations on the 'communist' or 'socialist' state-centric economic model). Many developing countries chose a mix of the two or, quite often, one or the other but modified to also reflect rent-seeking behavior and corruption. From the end of the Cold War onwards, though, the centrally planned model largely fell by the economic wayside, to be replaced by a 'universal' neo-liberal model, albeit one still marked by elements of rent-seeking and corruption. This move towards neo-liberalism was especially marked in countries that received aid from the World Bank and IMF.

While this post-Cold War neo-liberal Washington Consensus was the dominant international development paradigm for a couple of decades, by the early 21st century it was beginning to be challenged by the rise of China, an economic success story offering a different, and in many respects a competing, model. Removing the window-dressing of democracy, the Chinese model (or Beijing Consensus) has validated a one-party state that,

moreover, retains a strong hand in directing the development of its capitalist economy. This permitted greater and more certain economic planning and approved the strategic position by government of industries in relation to markets, rather than allowing market forces to find industry linkages more or less by happenstance.

This model has been effective because the Washington Consensus was usually 'encouraged' externally or imposed, and hence often resented. Also, the model was not always effective: it did not always raise median standards of living, for instance, and where it was effective it sometimes created new problems with public resentment and anger over the loss of basic services due to government budget cuts. At the same time, pre-existing economic inequalities were frequently aggravated. That it also promoted good governance and 'democratisation' did not always sit well with political leaders who had authoritarian and rent-seeking tendencies.

Conversely, the Beijing Consensus, such as it exists, removed these political requirements and showed a way forward for economies that did not rely on what was sometimes seen to be western moralising. That this model worked well for China (and Singapore, which also has a dominant-party state structure and favors active government intervention in the economy) as well as, to a lesser extent, a number of other countries, made it at least as attractive as the U.S.-led Washington model of economic ordering. And, as the world moved away from U.S. economic and strategic hegemony, it developed multiple foci of power, so that smaller states again had choices available to them that had been practically non-existent since the end of the Cold War.

The movement away from a unipolar to a multipolar world and the rise of new economies in countries such as Brazil, India and South Africa, as well as China, and regrowth of the Russian economy all conspired to challenge the United States' claim to have the sole solution to development, in both economic and attendant political processes. As such, the Beijing Consensus may have implied less a specific 'consensus' than a range of other formulae for opting out of a Washington-directed approach to economic political organisation.

Democracy

Since the Cold War ended, more states than before define themselves as 'democracies', even if their array of democratic accoutrements has been startlingly incomplete in some areas and marred by reversals of democratic process in others. This pro-democracy tendency is in part due to momentum in the acceptance of electoral processes in formerly authoritarian client states which lost the patronage of one or the other of the two superpowers, owing to the fact that without a rival the surviving superpower had no interest in playing patron to the client state in question. However, not all regime change has been democratic: democratic change is not inevitable and the reversion of democracies to other, less democratic or thoroughly undemocratic, forms of political organisation is not only possible but remarkably common. And what is claimed to be 'democratic' may not be that, or it may be a procedural democracy, employing a relatively free electoral contest but failing to provide a range of more substantive democratic qualities such as the separation of powers between government institutions, equitable and consistent rule of law, civil and political rights such as freedom of speech and assembly, or the opportunity to participate fully in the political process (see Schumpeter 1976; Dahl 1986; Burton et al. 1992:1; Grugel 2002:6).

In debates about democracy and democratisation, Fukuyama (among others) argued that there is only one final form of democracy – liberal democracy associated with free-market

192 *Critical reflections*

economics (Fukuyama 1992). Such 'democratic absolutism' has frequently run counter to political experience or preferences in developing countries, even where they accept a substantive democratic model, for example with a higher degree of economic intervention. As a result, there has been considerable debate over the value and appropriateness of a 'one size fits all' democracy, not least in such developing countries where 'democracy' is often still a poorly understood, much less internalised, concept.

There has, similarly, been a long-expressed view that notions of democracy are culturally specific and not transferrable to non-western societies (e.g. see Zakaria 1994). 'With few exceptions, democracy has not brought good government to new developing countries ... What Asians value may not necessarily be what Americans or Europeans value' (Lee Kuan Yew quoted in Han et al. 1998).

Where democracy has been established in developing countries, there can also be a democratic tension around the acceptance of a plurality of views, some of which might be antithetical to furthering such openness (e.g. pushing for the majority's imposition of its will, or voting to end voting) and which may set up points of conflict within a society still struggling to come to grips with low levels of institutional and organisational capacity. Some developing countries have had difficulty in overcoming these tensions and sometimes slipped into chaos, often ending with the military or another authoritarian party imposing its own undemocratic will. This then raises the issue of regime change, which in developing-country contexts may take society towards or, possibly, away from open, plural political models.

Transitions

One of the most remarkable events to occur in any country, but more common in developing countries, is when the polity shifts from a closed or authoritarian form of government to a more open and participatory one. There has been a marked increase in such transitions since the Cold War, even if many of those transitions have been partial or 'procedural' rather than 'complete' or substantive.

Even where there has been a broad shift towards democracy, that trajectory has often not been linear, easy, complete or sustainable. Political transitions away from authoritarianism or one-party rule tend to work better when a wider range of circumstances surround them, so as to create an environment conducive to such transition. This might include a transfer of elite allegiance and a military sympathetic to such a change, or at least not opposed to it. Too often, however, such a transition is away from an unworkable, failing or excessively narrow model of authoritarianism to a different form of elite control, sometimes under the guise of 'democracy' but sometimes not.

Similarly, such changes are likely to be more successful if the citizens of the state are relatively well off and well educated. That said, people will usually vote, sometimes repeatedly and in good numbers, if they believe that by so doing they might be able to free themselves from brutal authoritarianism.

If political change arises primarily as a result of compelling material circumstances, then there may be an argument to suggest that the form the political outcome takes will reflect the circumstances that compelled it and continue to prevail. To illustrate, if widespread poverty is the key driver for political change, the subsequent regime is more likely to favor redistributive economic policies; if alienation of an economic elite is the main driver, then any ensuing change is likely to strengthen that elite's political authority. Similarly, the overthrow of an oppressive government might be marked by counter-oppression, although

the option of greater openness has also been shown to be possible in some instances, if usually with elements of the former regime or political interests continuing to be represented in the new political order. Having noted that, political changes following upon changes in public sentiment and a voluntary handover of political power from one regime type to another may produce a more plural, less oppressive successor government.

Whatever the circumstances that lead to change, a point is reached where former political models are, and are seen to be, unsustainable. But, embarking on political change, the only certainty is that change will occur. Whether it is to be benign or malignant, a success or a failure, depends on a wide range of factors, few if any of which may be known at the outset.

The environment

Everything that happens in the world, be it in developed or developing countries, occurs within – and impacts upon – the wider natural environment. Environmental issues have, as such, increasingly been at the forefront of much political thinking in developing countries, in part because environmental sustainability has been firmly fixed on the global political agenda. Also, many developing countries are looking more closely at the environment because they have suffered the loss of potable water or fallen victim to deforestation or desertification, air pollution and, in some cases, the more immediate effects of climate change.

How this is manifested in the politics of developing countries has varied according to geography and human-induced environmental circumstances. The issues affecting countries bordering the Sahel, for example, where an expanding desert has eliminated previously viable pastures, are different to those in industrialised or overpopulated lands. Then there is the issue of Pacific island states facing the prospect of rising sea levels amounting to an existential threat to their future.

Not all states have responded equally to environmental challenges or matched their rhetoric with action. But environmental issues have gained traction across borders and beyond any one region, as is obvious from observing the agendas of the world's multilateral forums.

A particular bone of contention, within debates about climate change but also those on deforestation and other transnational issues, has been what portion of the cost of environmental protection or repair should developing countries bear, relative to the developed world. The former often argue that the latter attained their developed status largely through despoiling the environment of developing countries along with the global environment.

The corollary of this argument is that developed countries, having already achieved a relative degree of economic security, should do proportionately more to protect the environment than developing countries should. The dispute on this point has been at the heart of international negotiations on how to tackle climate change and the issue of excessive carbon emissions. Developed economies have been among the largest emitters but they also face domestic political pressure to perpetuate economic growth and prosperity for their citizens, even if, as noted earlier, the second decade of the 21st century has witnessed stagnation or a decline of real median incomes in many developed economies.

The more political accountability there is in a developing country, the more its politicians have sought to ensure better economic outcomes for their constituents, which is why they have called for a recalibration of global responsibility. Even where governments are

194　*Critical reflections*

not directly accountable to their citizens, stagnant or declining incomes in a globally connected world where the pleasures of the rich are ever more on display constitute a recipe for political discontent and instability.

Underpinning all of this is a notion of human security against not just immediate threats and dangers but more structural and contextual challenges including consistently adequate (and varied) nutrition, freedom from basic health challenges and access to at least a basic education. Time and again, education has been shown to help people improve their own lives, and their community life, in a way nothing else can. Human security presupposes an environment in which such needs can be met and sustained, and by inference this requires careful planning and adequate allocation of resources. By this logic, environmental sustainability is the bedrock upon which many forms of development can be built.

How the world works

All countries, even the most reclusive such as North Korea, engage with the wider world and, in so doing, shape and are shaped by their interactions with it. Larger, more economically and strategically powerful countries tend to do more of the shaping and can, at different points in their histories, be less aware of or accommodating to how the rest of the world understands them and their actions. China, India, the United States and Russia might all fall into this category and, importantly, two of them are still developing countries and, moreover, strategic rivals of each other. Indeed, all such countries might be considered strategic rivals, with varying degrees of cooperation when set against a *realpolitik* framework.

More important, for the vast majority of developing countries, is how they position themselves relative to each other, to great powers and to international forums. All these factors shape their ability to put their claims, promote their interests and defend those interests. In many cases, developing countries have seen their interests best represented, or protected, by larger powers and have benefited from such relationships via aid, trade and strategic protection. But such closeness usually comes at a price.

Larger, more powerful or 'patron' countries may support client states for a range of reasons, but rarely do so entirely out of altruistic goodwill. At best, such support reflects enlightened self-interest, whereby a client state's welfare is in synchronicity with the more general welfare of the patron state. Less positively, such support might be for a section of society in the client state, to the exclusion of – or even in opposition to – other parts of that society.

A mitigating factor in such relations is the standardising qualities of globalisation which, while still favoring larger and more powerful states, in theory at least establishes a 'level playing field' for all countries. Related to this has been the international rules-based order that, while preceding globalisation (particularly in its financial and technological senses) did create a global set of norms by which countries were expected to operate, in turn providing some security to smaller states and greater consistency in bilateral and multilateral relations.

Needless to say, such rules have been applied only where they suited the interests or preferences of more powerful states, or where it has been in the interest of patron states to have their clients comply with such 'rules'. In other circumstances, such 'rules' may be flexible, interpretable, ignored or transgressed altogether. There may be global agreement around particular matters, be it trade or the conduct of war, but the ability of larger powers to adopt or ignore such rules at will reflects a harsh reality as old as politics itself.

The politics of developing countries is, therefore, multi-faceted, complex, variable, sometimes inconsistent and always intriguing, given that it reflects the ways in which the

world's peoples organise themselves, or are organised by others. Political processes within and among countries wax and wane, improve and too often diminish in ways that allow – or restrict – human freedoms.

There is, of course, in all of this no indisputable right and only a few absolute wrongs. Circumstances that may make one thing seem positive or an abomination might be very different within another context or from a different perspective. Seldom are interests evenly shared, so that satisfying one will likely be at the expense of another, if not always as a zero-sum game. In all of this, there is no prescriptive model that works for everyone. While perhaps some broad norms might be identified as pertinent to the quality of being human (freedom from torture and other first-generation human rights, for example), people are usually more complex and nuanced than that and the societies they live in, contribute to and are shaped by mirror that complexity, for better and sometimes for worse.

Perhaps most important, the idea of 'development' is nothing if not about a process of change, presumably for the better if not always so. Developing countries are those that, through a variety of means and often against great and sometimes structural obstacles, seek to be better than they are. Sometimes such countries are brought low by predatory elites or the effects of self-interested powerful states. Sometimes they are a product of the circumstances they inherited from the outset and very often there is play between these two sets of circumstances.

But the human tendency is to want there to be less disruption and disorder rather than more, for tomorrow to be a little better than today, and for one's children to have better rather than worse lives than oneself. Perhaps viewing political processes in developing countries with those basic concerns as a reference point, a better understanding might be achieved of those countries and their experience of 'development'.

Bibliography

Abbink, J. 2016. 'Winners and Losers in the Coffee Economy', *Frontera*. 13 December 2016. https://fronteranews.com/news/global-macro/winners-and-losers-in-the-coffee-economy/ accessed 25 June 2017.

Abizadeh, A. 2004. 'Historical Truth, National Myths, and Liberal Democracy', *Journal of Political Philosophy*, Vol 12, No 3, pp 291–313.

Acemoglu, D. and Robinson, J. 2006. *Economic Origins of Dictatorship and Democracy*. Cambridge University Press, New York.

Adler, J. 1965. *Absorptive Capacity: Its Concepts and Its Determinants.* The Brookings Institution, Washington DC.

Adorno, T. 1991 (1974) 'The Essay as Form', trans. S. Nicholsen, *Notes to Literature*, Vol 1, Columbia University Press, New York.

Agosin, M. 1992. 'Structural Adjustment and Foreign Direct Investment: The Case of Chile', Economic Commission for Latin America and the Caribbean, Santiago de Chile.

Ahearn, L. 2011. *Living Language: An Introduction to Linguistic Anthropology.* John Wiley & Sons, Hoboken.

Akamatsu, K. 1962. 'A Historical Pattern of Economic Growth in Developing Countries', *Journal of Developing Economies*, Vol 1, No 1, pp 3–25, March–August 1962.

Akyeampong, E., Bates, R., Nunn, N. and Robinson, J. eds. 2014. *Africa's Development in Historical Perspective.* Cambridge University Press, Cambridge.

Allison, G. 2017. *Destined for War: Can America and China Escape the Thucydides Trap?* Houghton Mifflin, Boston.

Almond, G. and Verba, S. 1963. *The Civic Culture.* Sage Publications, New York.

Alonso, J. 2015. 'Supporting LDCs´ Transformation: How Can ODA Contribute to the Istanbul Programme of Action in the Post-2015 Era?', Committee for Development Policy, CDP Background Paper No 28, Department of Economic & Social Affairs, United Nations, New York.

Althusser, L. 1969. *For Marx* trans. B. Brewster. Allen Lane, London.

Althusser, L. 1970. *Reading Capital* trans. B. Brewster. New Left Books, London.

Alvaredo, F., Chancel, L., Picketty, T. and Saez, E. eds. 2018. *World Inequality Report 2018*. World Inequality Lab, Paris.

Alvarez, M., Cheibub, J.A., Limongi, F. and Przeworski, A. 1996. 'Classifying Political Regimes', *Studies in Comparative International Development*, Summer 1996, Vol 31, No 2, pp 3–36, p 21.

Amsden, A. 2001. *The Rise of 'The Rest': Challenges to the West From Late-Industrializing Economies*. Oxford University Press, Oxford.

Anderson, B. 1983. *Imagined Communities*. Verso, New York.

Andrews, E. 2010. 'Christian Missions and Colonial Empires Reconsidered: A Black Evangelist in West Africa, 1766–1816', *Journal of Church and State*, Vol 51, No 4, 1 October 2009, pp 663–691.

Andvig, J. 2008. 'Corruption in Sub-Saharan Africa and its Sources of Evidence', Working Paper 744, Norwegian Institute of International Affairs, Oslo.

AP 2013. 'N Korea Executes Kim Jong Un' Uncle', *Associated Press*, 13 December 2013.

APP 2013. *Equity in Extractives: Stewarding Africa's Natural Resources for All: Africa Progress Report 2013*. Africa Progress Panel, United Nations, Geneva.

Bibliography 197

Armstrong, J. 1982. *Nations Before Nationalism*. University of North Carolina Press, Chapel Hill.

ASC, TI, CSS, PRC. 2003. *Failed and Collapsed State in the International System*, The African Studies Centre, Leiden, The Transnational Institute, Amsterdam, The Centre for Social Studies, Coimbya University, The Peace Research Centre-CIP-FUHEM, Madrid, December 2003.

Aspinall, E. 2009. *Islam and Nation: Separatist Rebellion in Aceh, Indonesia*. National University of Singapore Press, Singapore.

Australia T-L 2017. Press release: 'Timor-Leste and Australia Reach Agreement on Treaty Text Reflecting 30 August Comprehensive Package Agreement', The Hague, 15 October 2017.

Avila, J. 2006. 'Ingreso per cápita relativo 1875–2006', 25 May 2006. *Jorge Avila Opina*. www.jorgea vilaopina.com/?p=61, accessed 1 December 2017.

Avonius, L. 2007. 'Aceh Peace Process and Justice', paper to the First International Conference on Aceh and Indian Ocean Studies, Banda Aceh, 24–27 February 2007.

Avonius, L. 2009. 'Reconciliation and Human Rights in Post-Conflict Aceh', in B. Brauchler ed. *Reconciling Indonesia: Grassroots Agency for Peace*, Routledge, London.

Ball, N. 1992. *Pressing for Peace: Can Aid Induce Reform?* Overseas Development Council: Washington DC.

Bappenas 2004. 'Preventing and Overcoming Separatism', *The National Medium-Term Development Plan 2004–2009*, Badan Perencanaan dan Pembangunan Nasional (BAPPENAS, National Development Planning Agency), Government of Indonesia.

Baran, P. 1952. *The Political Economy of Growth* 2nd ed. Prometheus Books, New York.

Barro, R. 1996. *Getting It Right: Markets and Choices in a Free Society*. MIT Press, Cambridge.

Barron, P. 2009. 'The Limits of DDR: Reintegration Lessons from Aceh', *The Small Arms Survey: Shadows of War*. Cambridge University Press, Cambridge.

Barya, J-J. 1993. 'The New Political Conditionality of Aid: An Independent View from Africa', *IDS Bulletin*, Vol 24, No 1.

Basic Law 1987. 'Basic Law of the Hong Kong Special Administrative Region of the People's Republic of China', 1987. Beijing.

BBC 2017. 'Zimbabwe Takeover Seems Like a Coup, African Union Says', *BBC*, 15 November 2017. www.bbc.com/news/world-africa-42004816, accessed 12 March 2018.

Beittinger-Lee, V. 2009. *(Un)civil Society and Political Change in Indonesia: A Contested Arena*. Routledge, London.

Belkin, A. and Schofer, E. 2003. 'Toward a Structural Understanding of Coup Risk', *Journal of Conflict Resolution*, Vol 47, No 5, pp 594–620.

Benford, R. and Snow, D. 2000. 'Comment on Oliver and Johnston: Clarifying the Relationship between Framing and Ideology', *Mobilization*, No 4, pp 55–60.

Benita, F. and Urzua, C. 2016. 'Mirror Trade Statistics Between China and Latin America', *Journal of Chinese Economic and Foreign Trade Studies*, Vol 9, No 3, pp 1173–1190.

Berdal, M. and Malone, D. eds. 2000. *Greed & Grievance: Economic Agendas in Civil Wars*. Lynne Rienner, Boulder.

Berlin Conference, 1885. General Act of the Berlin Conference on West Africa. 26 February 1885, Berlin.

Berman, S. 2007. 'The Vain Hope for "Correct" Timing'. *Journal of Democracy*, Vol 18, No 3, July 2007, pp 14–17.

Bevan, A. 1952. *In Place of Fear*. Simon and Schuster, New York.

Bird, G. 2001. 'IMF Programs: Do they Work? Can they be Made to Work Better?' *World Development*, Vol 29, No 11, 2001.

Blair, D. 2002. *Degrees in Violence: Robert Mugabe and the Struggle for Power in Zimbabwe*. Continuum, London.

Blomqvist, H. 1996. 'The "Flying Geese" Model of Regional Development: A Constructive Interpretation', *Journal of the Asia Pacific Economy*, Vol 1, No 2, pp 215–231.

Bodea, C. and Elbadawi, I. 2007. 'Riots, Coups and Civil War: Revisiting the Greed and Grievance Debate', World Bank, Policy Research Working Paper 4397.

Bonner, R. 2005. 'Corruption in Indonesia Is Worrying Aid Groups', *The New York Times*. 13 January 2005.

Boone, P. 1996. 'The Politics and Effectiveness of Foreign Aid', *European Economic Review*, No 40.

Boot, M. 2013. *Invisible Armies: An Epic History of Guerrilla Warfare from Ancient Times to the Present*. W.W. Norton and Co, New York.

198 *Bibliography*

Bourchier, D. 2013. *Illiberal Democracy in Indonesia.* Taylor and Francis, Abingdon.

Bourchier, D. and Legge, J. eds. 1994. *Democracy in Indonesia: 1950s and 1990s.* Centre of Southeast Asian Studies, Monash University, Melbourne.

Boyd, A. 2018. 'South Pacific Looks to China as West Turns away', *Asia Times*, 19 February 2018. www.atimes.com/article/south-pacific-looks-china-west-turns-away/, accessed 19 February 2018.

Braithwaite, J. 2010a. *Pillars and Shadows: Statebuilding as Peacebuilding in Solomon Islands.* ANU E Press, Canberra.

Braithwaite, J. 2010b. *Reconciliation and Architectures of Commitment: Sequencing Peace in Bougaineville.* ANU E Press, Canberra.

Braithwaite, J. 2010c. *Anomie and Violence: Non-truth and Reconciliation in Indonesian Peacebuilding.* ANU E Press, Canberra.

Braithwaite, J., Charlesworth, H., Reddy, P. and Dunn, L. 2012. *Reconciliation and Architectures of Commitment.* ANU E Press, Canberra.

Bratton, M. and Van de Walle, N. 1997. *Democratic Experiments in Africa: Regime Transitions in Comparative Perspective.* Cambridge University Press, New York.

Brautigam, D. 2010. *The Dragon's Gift: The Real Story of China in Africa.* Oxford University Press, Oxford.

Brautigam, D. and Knack, S. 2004. 'Foreign Aid, Institutions, and Governance in Sub-Saharan Africa', *Economic Development and Cultural Change*, Vol 52, No 2, January 2005, pp 255–285.

Bremmer, I. and Taras, R. eds. 1997. *New States, New Politics.* Cambridge University Press, Cambridge.

Brommelhorster, J. and Paes, W-C. eds. 2003. *The Military as an Economic Actor: Soldiers in Business.* Palgrave, London.

Bruckner, M. 2011. 'Population Size, Per Capita Income and the Risk of Civil War: Regional Heterogeneity in the Structural Relationship Matters', *World Institute for Development Economics Research*, No 2011/18, United Nations University, Helsinki.

Brundige, E., King, W., Vahali, P., Vladeck, S. and Xiang, Y. 2004. 'Indonesian Human Rights Abuses in West Papua: Application of the Law of Genocide to the History of Indonesian Control', Allard K. Lowenstein International Human Rights Clinic, Yale Law School.

Brundtland Report 1987. *Our Common Future.* United Nations World Commission on Environment and Development, New York.

Buchanan, A. 2002. 'Political Legitimacy and Democracy', *Ethics*, Vol 12, No 4, pp 689–719.

Buchanan, A. 2003. *Justice, Legitimacy and Self-Determination.* Oxford University Press, Oxford.

Burleigh, M. 2009. *Blood and Rage: A Cultural History of Terrorism.* Harper Perennial, New York.

Burton, M., Gunther, R. and Higley, J. (eds). 1992. *Elites and Democratic Consolidation in Latin America and Southern Europe.* Cambridge, Cambridge University Press.

Butler, R. 2017. 'Amazon Destruction', *Mongabay*, 26 January 2017. https://rainforests.mongabay.com/amazon/amazon_destruction.html, accessed 16 February 2018.

Cai, P. 2017. 'Understanding China's Belt and Road Initiative', *Analysis*, Lowy Institute for International Policy, Sydney, 22 March 2017.

Call, C. 2010a. 'Beyond the "Failed State": Toward Conceptual Alternatives'. *European Journal of International Relations*, US Institute of Peace, Washington DC.

Call, C. 2010b. 'Liberia's War Recurrence: Grievance over Greed', *Civil Wars*, Vol 12, No 4, pp 347–369.

Campos, N. and Kinoshita, Y. 2008. 'Foreign Direct Investment and Structural Reforms: Evidence from Eastern Europe and Latin America', IMF Working Paper, IMF Institute, International Monetary Fund, Washington DC, January 2008.

Campos, I. and Vines, A. 2008. 'Angola and China: A Pragmatic Partnership', Working Paper, Centre for Strategic and International Studies (Washington DC), Conference Prospects for Improving U.S.-China-Africa Cooperation, 5 December 2007, Chatham House, London, March 2008.

Cardoso, F. 1972. 'Dependency and Development in Latin America', *New Left Review*, No 74, pp 83–95.

Cardoso, F. and Faletto, E. 1979, *Dependency and Development in Latin America.* University of California Press, Berkeley.

Bibliography 199

Carothers, T. 2007a. 'How Democracies Emerge: The "Sequencing" Fallacy', *Journal of Democracy*, Vol 18, No 1, January 2007.

Carothers, T. 2007b. 'Misunderstanding Gradualism', *Journal of Democracy*, Vol 18, No 3, pp 18–22.

Carothers, T. and Gramont, D. 2013. 'The Prickly Politics of Aid', *Foreign Policy*, 21 May 2013.

Carpenter, T. 2017. 'Why China's Xi Is Reluctant to Bring Kim Jong Un to His Knees', *Newsweek*, 5 April 2017.

Carter, D. and Stone, R. 2015. 'Democracy and Multilateralism: Vote Buying in the UN General Assembly', *International Organization*, Vol 69, No 1, Winter 2015, pp 1–33.

Cass, F., Nelson, J. and Eglinton, S. 1992. *Encouraging Democracy: What Role for Aid?* Overseas Development Council, Washington DC.

CDHRI 1990. *Cairo Declaration of Human Rights in Islam*. Organisation of the Islamic Conference, Cairo.

Chambers, P. and Waitoolkiat, N. 2017. *Khaki Capital: The Political Economy of the Military in Southeast Asia*. NIAS Press, Copenhagen.

Champonniere, J-R. 2009. 'Chinese Aid to Africa, Origins, Forms and Issues', in Van Dijk, M. ed. *New Presence of China in Africa*. Amsterdam University Press, Amsterdam.

Chan, T. 2017. 'Xi Jinping declares China's Intent to be a "Leading Power" by 2050', *Business Insider*, 18 October 2017.

Chandler, D. 2010. *International Statebuilding: The Rise of Post-Liberal Governance*. Routledge, London.

Chatham House 2015. 'Challenges to the Rules-Based International Order', background paper, Session One, 'The Search for Global Leadership', London Conference 2015, The Royal Institute of International Affairs.

Chee, C. 1993. 'Democracy: Evolution and Implementation, an Asian Perspective', paper to the Conference on Asian and American Perspectives on Capitalism and Democracy, Asia Society/Institute of Policy Studies/Institute of Southeast Asian Studies/Singapore International Foundation, Singapore.

Chega 2005. *Chega: The Commission for Reception, Truth and Reconciliation in East Timor (CAVR) Report*. Commission for Reception, Truth and Reconciliation in East Timor, Dili.

China Daily 2016. 'Top 10 FDI Sources for Chinese Mainland in Jan-April', *China Daily*, 23 May 2016.

Chongkittavorn, K. 2010. 'Burma and Asean: Beyond Electoral Challenges', *The Nation*, 26 March 2010.

Chua, A. 1998. 'Markets, Democracy and Ethnicity: Toward a New Paradigm for Law and Development', *Yale Law Journal*, No 108, Summer 1998, pp 5–38.

CIA 1948. *The Kurdish Minority Problem*. Central Intelligence Agency, Langley.

von Clausewitz, C. 1976. *On War*. Princeton University Press, Princeton.

CMATS 2006. Treaty between Australia and the Democratic Republic of Timor-Leste on Certain Maritime Arrangements in the Timor Sea. Sydney, 12 January 2006.

Cockcroft, L. and Riddell, R. 1991. *Foreign Direct Investment in Sub-Saharan Africa*. International Economics Department, World Bank, Washington DC.

Colletta, N., Lim, T. and Viitanen, A. 2001. *Social Cohesion and Conflict Prevention in Asia: Managing Diversity through Development*. The World Bank, Washington DC.

Collier, D. and Levitsky, S. 1996. 'Democracy "With Adjectives": Conceptual Innovation in Comparative Research', Working Paper No 230, The Helen Kellogg Institute for International Studies, August 1996.

Collier, D. and Levitsky, S. 1997. 'Democracy With Adjectives: Conceptual Innovation in Comparative Research', *World Politics*, Vol 49, No 3, April 1997, pp 430–451.

Collier, P. 1997. "The Failure of Conditionality", in C. Gwin and J. Nelson, eds. *Perspectives on Aid and Development*. Overseas Development Council, Washington DC.

Collier, P. 2006. 'Economic Causes of Civil Conflict and their Implications for Policy'. http://users.ox.ac.uk/~econpco/research/pdfs/EconomicCausesofCivilConflict-ImplicationsforPolicy.pdf, accessed 22 February 2015.

Collier, P. and Adcock, R. 1999. 'Democracy and Dichotomies: A Pragmatic Approach to Choices about Concepts', *Annual Review of Political Science*, vol 2, pp 537–565.

Collier, P. 2009. *Wars, Guns and Votes: Democracy in Dangerous Places*. Harper, New York.

Collier, P. and Hoeffler, A. 2000. *Greed and Grievance in Civil War*. World Bank, Policy Research Working Paper 2355, accessed 25 October 2011.

200 Bibliography

Collier, P. and Sambanis, N. 2007a. *Understanding Civil War, Vol 1 Africa*. The World Bank, Washington.

Collier, P. and Sambanis, N. 2007b. *Understanding Civil War, Vol 2, Europe, Central Asia and Other Regions*. The World Bank, Washington DC.

Collier, P., Elliot, L., Hegre, H., Hoeffler, A., Reynal-Querol, M. and Sambanis, N. 2003. *Breaking the Conflict Trap: Civil War and Development Policy*. World Bank and Oxford UP, Washington DC and Oxford.

Commission for Africa. 2005. *Commission for Africa Report: Our Common Interest*. Penguin, Harmondsworth.

Cooke, M. 2011. *The Lionel Bopage Story: Rebellion, Repression and the Struggle for Justice in Sri Lanka*. Agahas Publishers, Colombo.

Cornwell, R. 1999. 'The End of the Post-Colonial State System in Africa?' *African Security Review*, Vol 8, No 2.

Corruption Watch 2014. 'The Arms Deal: What You Need To Know', 22 January 2014. www.corruptionwatch.org.za/the-arms-deal-what-you-need-to-know-2/, accessed 14 February 2018.

Cotty, A., Edmunds, T. and Forster, A. 2002 'The Second Generation Problematic: Rethinking Democratic Control of Armed Forces in Central and Eastern Europe', Transformation of Civil-Military Relations, paper 1.7, December 2002.

Cowen. M. and Shenton, R. 1996. *Doctrines of Development*. Routledge, London.

Credit Suisse 2017. *Global Wealth Report*. Credit Suisse, Zurich.

Crook, P. 1998. 'Social Darwinism and British "New Imperialism": Second Thoughts', *The European Legacy: Towards New Paradigms*, Vol 3, No 1, pp 1–16.

Crouch, H. 2010. *Political Reform in Indonesia After Soeharto*, ISEAS, Singapore.

Crumpton, H. 2013. *The Art of Intelligence*, Penguin, New York.

Cuddington, J. 1992. 'Long-run Trends in 26 Primary Commodity Prices: A Disaggregated Look at the Prebisch-Singer Hypothesis', *Journal of Development Economics*, Vol 39, No 2, pp 207–227.

Curran, J. 2017. 'Mugged by Sentiment: Revamping the US Alliance and Surviving the Forty-fifth President', *Australian Foreign Affairs*, Issue 1, October 2017.

Czaika, M. and de Haas, H. 2014. 'The Globalization of Migration: Has the World Become More Migratory?', *International Migration Review*, Vol 48, No 2, Summer 2014, pp 283–323.

DAC 2016. 'ODA Reporting of In-Donor Country Refugee Costs', DAC Secretariat, Development Assistance Committee, Organisation for Economic Cooperation and Development, Paris.

Dahl, R. 1971. *Polyarchy and Opposition: Participation and Opposition*. Yale University Press, New Haven.

Dahl, R. 1973. 'Pluralism Revisited', *Comparative Politics*, Vol 10, No 2 (Jan., 1978), pp 191–203.

Dahl, R. 1986. *Democracy, Liberty and Equality*. Toyen, Norwegian University Press.

Dahl, R. 1989. *Democracy and its Critics*. Yale University Press, New Haven.

Dahl, R. 2000. *On Democracy*. Yale University Press, New Haven.

Dains, R. (2004), 'Lasswell's Garrison State Reconsidered: Exploring a Paradigm Shift in US Civil-military Relations', PhD thesis, University of Alabama, Tuscaloosa.

Das, S. 2017. 'Southeast Asia Worries over Growing Economic Dependence on China', *Perspective*, Issue 2017, No 81, ISEAS Yusof Ishak Institute, Singapore, 3 November 2017.

Dayasri, G. 2010. 'ICG Report: The Lying Game', Ministry of Defence, Sri Lanka, 10 April 2010.

Deaton, A. and Subramanian, S. 1996. 'The Demand for Food and Calories', *Journal of Political Economy*, Vol 104, No 1, pp 133–162.

Desch, M. 1999. *Civilian Control of the Military: The Changing Security Environment*. Johns Hopkins University Press, Baltimore.

Dewey, K. 2016. 'North Korea's Musudan Missile Launch Ends in Failure', *IHS Janes*, 29 April 2016.

Dhillon, K. 2014. 'Afghanistan Is the Big Winner in U.S. Foreign Aid', *Time*, 31 March 2014.

Diamond, L. 1999. *Developing Democracy: Towards Consolidation*. Stanford University Press, Stanford.

Diamond, L. 2008. 'Progress and Retreat in Africa: The Rule of Law versus the Big Man,' *Journal of Democracy*, 19 (April 2008), pp 138–149.

Diamond, L.. Lintz, J., and Lipset, S. 1989. *Democracy in Developing Countries*, Vols 1–4. Lynne Reiner Publishers, Boulder.

Diamond, L., Plattner, M. and Costopolous, P. eds. 2010. *Debates on Democratization*. John Hopkins University Press, Baltimore.

Dimant, E. 2014. 'The Nature of Corruption: An Interdisciplinary Perspective', Working Paper 2014–2016, Centre for International Economics, Paderborn University, Paderborn.

Ding, F. 2017. 'Worlding Developmentalism: China's Economic Zones Within and Beyond its Border', *Journal of International Development*, Vol 29, No 6, pp 825–850.

Diokno, J. 1981. Untitled Lecture, International Council of Amnesty International, Cambridge. 21 September 1978, mimeo in Alston, R. ed. *Development, Human Rights and the Rule of Law*. Pergamon Press, London.

Di Palma, G. 1990. *To Craft Democracies: An Essay on Democratic Transition*. University of California Press, Berkeley.

Di Palma, G. 1991. *To Craft Democracies: An Essay in Democratic Transition*. University of California Press, Berkeley.

Dorman, S. 2006. 'Post-Liberation Politics in Africa: Examining the Political Legacy of Struggle', *Third World Quarterly*, Vol 27, No 6, pp 1085–1101.

Dorward, D. 2011. Quoted in 'When Drought Becomes Famine: The Role of Politics in the Horn of Africa', *The Conversation*, 1 August 2011. https://theconversation.com/when-drought-becomes-famine-the-role-of-politics-in-the-horn-of-africa-2610, accessed 22 February 2018.

Dos Santos, T. 1970. 'The Structure of Dependence', *The American Economic Review*, Vol 60, No 2, pp 231–236.

Dowd, D. 1967. 'Some Issues of Economic Development and Development Economics', *Journal of Economic Issues*, Vol 1, No 3, pp 149–160.

Downie, S. and Kingsbury, D. eds. 2001. 'The Independence Ballot in East Timor: Report of the Australian Volunteer Observer Group', Monash University Centre of Southeast Asian, Studies Working Paper No 113, Melbourne.

Downs, A. 1957. *An Economic Theory of Democracy*. Harper, New York.

Dragovic, D. 2018. *No Dancing, No Dancing: Inside the Global Humanitarian Crisis*. Odyssey Books, Melbourne.

Dyden, T. and Hedge, Z. 2012. 'The Octagon of Oligarchy: Meet China's "Eight Immortals" – An Infographic', *Bloomberg*. www.bloomberg.com/graphics, accessed 1 May 2017.

Easterly, W. 2006. *The White Man's Burden: Why the West's Efforts to Aid the Rest Have Done So Much Ill and So Little Good*. Penguin Books, New York.

Eckart, J. 2016. '8 Things You Need to Know about China's Economy', World Economic Forum, 23 June 2016.

The Economist 2002. 'A Row over Rocks', *The Economist*, 18 July 2002.

The Economist 2011. 'Africa Rising', *The Economist*, 3 December 2011.

The Economist 2014. 'A Three-headed Hydra', *The Economist*, 16 July 2014.

The Economist 2015. 'The Most Persecuted People on Earth?', *The Economist*, 13 June 2015.

The Economist 2017. 'Why Kim Jong Un's Brother was Murdered', *The Economist*, 18 February 2017.

Ehrlich, P. 1968. *The Population Bomb*. Ballantine Books, New York.

Einstein, A. 1988. Quoted in Sandy, L. and Perkins, R. 2002. 'The Nature of Peace and Its Implications for Peace Education', *The Online Journal of Conflict Resolution*, Vol 4, No 2, pp 1–8.

Ekpo, M. 1979. *Bureaucratic Corruption in Sub-Saharan Africa: Toward a Search for Causes and Consequences*. University Press of America, Lanham.

Ekurd.net 2012. 'Turkey May be Divided by 2030, a Kurdish State Could Become a Reality: U.S. Intelligence Report', *Ekurd Daily*, 11 December 2012. http://ekurd.net/mismas/articles/misc2012/12/turkey4356.htm, accessed 21 June 2017.

Emerson, R. 1866. *English Traits* in (1956) Volume II, *The Complete Works of Ralph Waldo Emerson: Comprising His Essays, Lectures, Poems and Orations, in Two Volumes*. Bell and Daldy, London.

Engel, S. 2014. 'The No-so-great-aid Debate', *Third World Quarterly*, Vol 35, No 8, pp 1374–1389.

Englebert, P. 2000. 'Pre-Colonial Institutions, Post-Colonial States, and Economic Development in Tropical Africa', *Political Research Quarterly*, Vol 53, No 1, March 2000, pp 7–36.

Erikson, E. 1968. *Identity: Youth and Crisis*. Faber & Faber, London.

Essa, A. 2017. 'G5 Sahel Counterterrorism Force Explained', *Al Jazeera*, 3 November 2017.

202 *Bibliography*

Essers, D. 2013. 'Developing Country Vulnerability in Light of the Global Financial Crisis: Shock Therapy?', *Review of Development Finance*, Vol 3, No 2, April–June 2013, pp 61–83.

Evans, P. 1995. *Embedded Autonomy*, Princeton University Press, Princeton.

Evans, P., Rueschmeyer, D. and Skocpol, T. 1985. 'On The Road Towards a More Adequate Understanding of the State', in Evans, P, Rueschmeyer, D and Skocpol, T. eds. *Bringing the State Back*. Cambridge University Press, Cambridge.

Fanon, F. 2005 (1961). *The Wretched of the Earth*. Grove Press, New York.

FAO 1999. Salient Trends in World Agricultural Production, Demand, Trade and Food Security, FAO Symposium on Agriculture, Trade and Food Security: Issues and Options in the Forthcoming WTO Negotiations from the Perspective of Developing Countries, Geneva, 23–24 September 1999.

FAO 2009. *The State of Agricultural Commodity Markets 2009–8*. Food and Agriculture Organization of the United Nations, Rome.

Fearnside, P. 2017. 'Business as Usual: A Resurgence of Deforestation in the Brazilian Amazon', *Yale Environment 360*, 18 April 2017.

Felbab-Brown, V. 2017. 'How Predatory Crime and Corruption in Afghanistan Underpin the Taliban Insurgency', *Brookings*, 18 April 2017.

Ferguson, N. 2008. *Empire: How Britain Made The Modern World* 3rd ed. Penguin Books, London.

Ferini, L. 2012. 'Why is Turnout at Elections Declining Across the Democratic World?' www.e-ir.info/2012/09/27/why-is-turnout-at-elections-declining-across-the-democratic-world/, accessed 16 April 2013.

Fernandes, C. 2006. *Reluctant Indonesians*. Scribe Publications, Melbourne.

Firzli, M. 2015. 'China's Asian Infrastructure Bank and the "New Great Game"', *Revue Analyse Financière*, No 57, October–December 2015.

Forson, J., Baah-Ennumh, T., Buracom, P., Chen, G. and Peng, Z. 2016. 'Causes of Corruption: Evidence from sub-Saharan Africa', *South African Journal of Economic and Management Sciences*, Vol 1, No 4, www.scielo.org.za/scielo.php?script=sci_arttext&pid=S2222-34362016000400007&lng=pt&nrm=iso, accessed 30 October 2017.

Forster, A. 2002. 'New Civil-Military Relations and its Research Agendas', *Connections: The Quarterly Journal*, Vol 1, No 2, Summer 2002.

Frantz, E. and Stein, E. 2017. 'Countering Coups Leadership Succession Rules in Dictatorships', *Comparative Political Studies*, Vol 50, No 7.

Fried, M. 1975. *The Notion of Tribe*. Cummings Publishing Company, Boston.

Friedberg, A. 2018. 'Competing with China', *Survival*, Vol 60, No 3, pp 7–64.

Fukuyama, F. 1992. *The End of History and the Last Man*. Free Press, New York.

Fukuyama, F. 2004. *State-Building Governance and World Order in the 21st Century*. Cornell University Press, Ithaca.

Fukuyama, F. 2007 'The History at the End of History', *The Guardian*, 3 April 2007. www.guardian.co.uk/commentisfree/2007/apr/03/thehistoryattheendofhist, accessed 29 April 2013.

Fukuyama, F. 2007b. 'Liberalism Versus State Building', *Journal of Democracy*, Vol 18, No 3, July 2007, pp 10–13.

Gellner, E. 1983. *Nations and Nationalism*. Cornell University Press, Ithaca.

GFN 2017. *Ecological Footprint Explorer*. Global Footprint Network. http://data.footprintnetwork.org/#/, accessed 20 December 2017.

GFP 2016 'Military Power Comparison Results for North Korea vs. South Korea', www.globalfirepower.com/countries-comparison-detail.asp?form=form&country1=north-korea&country2=south-korea&Submit=COMPARE, accessed 24 April 2017.

Giddens, A. 1984. *The Constitution of Society: Outline of the Theory of Structuration*. Polity Press, Cambridge.

Gilens, M. and Page, M. 2014. 'Testing Theories of American Politics: Elites, Interest Groups, and Average Citizens', *Perspectives on Politics*, Vol 12, No 3, September 2014, pp 564–581.

Gloppen, S., Gararella, R. and Skaar, E. eds. 2004. *Democracy and the Judiciary: The Accountability Function of Courts in New Democracies*. Frank Cass Publishers, London.

Goldbaum, C. 2017. 'US Ramps up Military Strikes in Somalia', *IRIN*, 8 November 2017. www.irinnews.org/feature/2017/11/08/us-ramps-military-strikes-somalia?utm_source=IRIN+-+the+

inside+story+on+emergencies&utm_campaign=59bb247169-RSS_EMAIL_ENGLISH_ALL&utm_m edium=email&utm_term=0_d842d98289-59bb247169-15702989, accessed 27 December 2017.

Goldschein, E. 2011. 'Briefing: 11 Incredible Facts About The Global Coffee Industry', *Business Insider Australia*, 15 November 2011.

Goodin, R. 2006. *What's Wrong with Terrorism?* Polity Press, Cambridge.

Gow, J. 2010. 'Kosovo: The Final Frontier? From Transitional Administration to Transitional Justice', in A. Hehir ed. *Kosovo, Intervention and Statebuilding: The International Community and the Transition to Independence*. Routledge, London.

Grano, S. 2015 *Environmental Governance in Taiwan: A New Generation of Activists and Stakeholders*. Routledge, London.

Grenville, S. 2004. 'The IMF and the Indonesian Crisis', Independent Evaluation Office, International Monetary Fund, May 2004.

Grierson, J. 2016. 'North Korea Nuclear Test: "Warhead Explosion" Confirmed by Pyongyang – as it Happened', *The Guardian*, 9 September 2016.

Griffiths, M. and Lucas, J. 1996. *Ethical Economics*, Palgrave, London.

GRP 2003. Commonwealth Act No 456 ('Public Land Act'), 1903, amended 1939, Government of the Republic of the Philippines, Manila.

Grugel, J. 2002. *Democratization: A Critical Introduction*. Palgrave, Houndsmills.

The Guardian. 2007. 'The Making of the Gandhi Dynasty', *The Guardian*, 9 May 2007.

Gumede, W. 2007. 'Africa: How We Killed Our Dreams of Freedom', *New Statesman*, 2 April 2007.

Gunder Frank, A. 1967. *Capitalism and Underdevelopment in Latin America: Historical Studies of Chile and Brazil*. Monthly Review Press, New York.

Gunder Frank, A. 1969. *Latin America: Underdevelopment or Revolution*. Monthly Review Press, New York.

Gunter, M. 2017. *The Kurds: A Modern History* 2nd ed. Markus Weiner Publishers, Princeton.

Haberman, C. 1989a. 'Melee Erupts as Pope Speaks in East Timor', *The New York Times*, 13 October 1989

Haberman, C. 1989b. 'Fears Expressed for 40 East Timorese Protesters', *The New York Times*, 19 October 1989.

Hackett, C. 2014. 'The Rebirth of Dependence: Offering an Alternative Understanding of Financial Crisis', *International Journal of Law and Management*, Vol 56, No 2, pp 121–135.

Haden, A. 2017a. 'Junk Status Looms for South Africa after Zuma Reshuffles Cabinet', *The South African*, 31 March 2017.

Haden, A. 2017b. 'Maimane: This is an Act of Complete State Capture', *The South African*, 31 March 2017.

Haggard, S. and Kaufman, R. 1995. *The Political Economy of Democratic Transitions*. Princeton University Press, Princeton.

Haggard, S. and Kaufman, R. 1997. 'The Political Economy of Democratic Transitions', *Comparative Politics*, Vol 29, No 3, April 1997, pp 263–283.

Hall, P. and Taylor, R. 1996. 'Political Science and the Three New Institutionalisms', *Political Studies*, No XLIV, pp 936–957.

Halper, S. 2010. *The Beijing Consensus: How China's Authoritarian Model Will Dominate the Twenty-First Century*. Basic Books, New York.

Hamid, U. and Misol, L. 2007. 'Presidential Push Needed on TNI's Internal Reform', *The Jakarta Post*, 27 February 2007.

Han, F., Fernandez, W. and Tan, S. 1998. *Lee Kuan Kuan Yew: The Man and His Ideas*. Singapore: Times Editions.

Harris, B. and Buseong, K. 2017. 'South Korea Joins Ranks of World's Most Polluted Countries', *Financial Times*, 29 March 2017.

Harvey, D., Kellard, N., Madsen, J. and Wohar, M. 2010. 'The Prebisch-Singer Hypothesis: Four Centuries of Evidence', *The Review of Economics and Statistics*, Vol 92, No 2, May 2010, pp 367–377.

Hasmath, R. 2014. 'White Cat, Black Cat or Good Cat: The Beijing Consensus as an Alternative Philosophy for Policy Deliberation? The Case of China'. *Barnett Papers in Social Research*, University of Oxford Department of Social Policy and Intervention 2014, No 2, pp 1–19.

204 *Bibliography*

Havranek, T., Horvath, R. and Zeynalov, A. 2016. 'Natural Resources and Economic Growth: A Meta-Analysis', *World Development*, No 88, pp 134–151.

Hearth, D. 2008. 'Development Discourse of the Globalists and Dependency Theorists: Do the Globalisation Theorists Rephrase and Reword the Central Concepts of the Dependency School?', *Third World Quarterly*, Vol 29, No 4, pp 819–834.

Hedstrom, P. and Ylikoski, P. 2010 'Causal Mechanisms in the Social Sciences', *Annual Review of Sociology*, Vol 36, pp 49–67.

Heller, P., Rueschemeyer, D. and Snyder, R. 2009. 'Dependency and Development in a Globalised World: Looking Back and Forward', *Studies in Comparative International Development*, Vol 44, pp 287–295.

Herbst, J. 1989. 'The creation and maintenance of national boundaries in Africa', *International Organization*, Vol 43, No 4, October 1989, pp 673–692.

Herbst, J. 2014. *States and Power in Africa: Comparative Lessons in Authority and Control*. Princeton University Press, Princeton.

Herodotus in Roisman, J. and Worthington, I. eds. 2010. *A Companion to Ancient Macedonia*, John Wiley and Sons, Chichester.

Hill, H. 2012. 'Corruption and Development: The Indonesian Experience', in S. Khoman ed. *A Scholar for All: Medhi Krongkaew*. Thammasat University Press, Bangkok, pp 150–164.

Hirschman, A. 1981. *Essays in Trespassing: Economics to Politics and Beyond*. Cambridge University Press, New York.

Hirschmann, D. 1987. 'Early Post-Colonial Bureaucracy as History: The Case of the Lesotho Central Planning and Development Office, 1965–1975', *International Journal of African Historical Studies*, Vol 20, No 3, pp 455–470.

Hobbes, T. 2009 (1651) *The Leviathan* ed. J. Gaskin. Oxford University Press, Oxford.

Hobsbawm, E. 1999. *Nations and Nationalism Since 1870: Programme, Myth, Reality*. Cambridge University Press, Cambridge.

Hobsbawm, E. and Ranger, E. eds. 1983. *The Invention of Traditions*. Cambridge University Press, Cambridge.

Hochschild, A. 2005. 'In the Heart of Darkness', *The New York Review of Books*, 6 October 2005.

Hodal, K. 2014. 'Coup Needed for Thailand "To Love and Be at Peace Again" – Army Chief', *The Guardian*, 23 May 2014.

Horkheimer, M. and Adorno, T. 2002. *Dialectic of Enlightenment* ed. G. Noerr, trans. E. Jephcott. Stanford University Press, Stanford.

Horowitz, D. 1985. *Ethnic Groups in Conflict*. University of California Press, Berkeley.

Howard, R. 1983. 'The Full-Belly Thesis: Should Economic Rights Take Priority over Civil and Political Rights? Evidence from Sub-Saharan Africa', *Human Rights Quarterly*, Vol 5, No 4, November 1983, pp 467–490.

Howse, R. 2007. 'The Concept of Odious Debt in International Law', The United Nations Conference on Trade and Development No 185, July 2007.

HRW 2006. 'Too High a Price: The Human Rights Cost of the Indonesian Military's Economic Activities', *Human Rights Watch*, June 2006, Vol 18, No 5(C).

HRW 2009. *DR Congo: Chronology*. Human Rights Watch. www.hrw.org/news/2009/08/21/dr-congo-chronology#_A_New_Government, accessed 15 June 2017.

HRW 2010. '"I Want to Help My Own People": State Control and Civil Society in Burma after Cyclone Nargis', *Human Rights Watch*, New York, 29 April, 2010.

Huntington, S. 1958. *The Soldier and the State*. Bellknap Press, Cambridge Mass.

Huntington, S. 1968. *Political Order in Changing Societies*. Yale University Press, New Haven.

Huntington, S. 1991. 'Democracy's Third Wave', *Journal of Democracy*, Vol 2, No 2, pp 12–34.

Hutchcroft, P. 1998. *Booty Capitalism: The Politics of Banking in the Philippines*. Cornell University Press, Ithaca.

ICO 2014. 'World coffee trade (1963–2013): A Review of the Markets, Challenges and Opportunities Facing the Sector', International Coffee Council, International Coffee Organization, London, 24 February 2014.

ICO 2016. 'ICO composite and group indicator prices', International Coffee Organization, London.

Bibliography 205

IMF 2000. *Globalization: Threat or Opportunity*. International Monetary Fund, Washington DC, 12 April 2000. www.imf.org/external/np/exr/ib/2000/041200to.htm, accessed 10 December 2017.

IMF 2011. World Economic Outlook International Monetary Fund, Washington DC.

IMF 2017a. Quoted in 'China – Key Economic Indicators', *The Guardian*. https://docs.google.com/spreadsheets/d/1y41WVbvc-GDJ54yN6NtW-o9Ir-W0cPNIHg18J_srCzY/edit#gid=0, accessed 11 May 2017.

IMF 2017b. 'Sub-Saharan Africa: Restarting the Growth Engine', *IMF News*, International Monetary Fund, Washington DC, 9 May 2017.

IMF 2017c. 'Frequently Asked Questions: World Economic Outlook', International Monetary Fund, October 2017. www.imf.org/external/pubs/ft/weo/faq.htm#q4b, accessed 27 February 2018.

The Insider 2013. 'Tsvangirai Says Mugabe is a Puppet of the Military', *The Insider*, 29 July 2013.

Inequality.org. 2016. https://inequality.org/facts/global-inequality/, accessed 13 December 2018.

International IDEA 2013. 'Voter turnout data for Indonesia'. www.idea.int/vt/countryview.cfm?id=101, accessed 16 April 2013.

IRIN 2013. 'Armed Groups in Eastern DRC', *IRIN*, 31 October 2013. www.irinnews.org/report/99037/briefing-armed-groups-eastern-drc,accessed 18 December 2017.

Iskyan, K. 2016. 'China's Middle Class is Exploding', *Business Insider*, New York.

Jacobs, S. 2018. 'Just Nine of the World's Richest Men Have More Combined Wealth than the Poorest 4 Billion People', *Independent*, 17 January 2018.

James, H. 2008. 'The Rise of the BRICS: And the New Logic in International Politics', *The International Economy*, Summer 2008.

James, P. 1997. 'Post-Dependency: The Third World in an Era of Globalism and Late Capitalism', *Alternatives: Global, Local, Political*, Vol 22, No 2, April–June 1997, pp 205–226.

James, P. 2006. *Globalism, Nationalism, Tribalism: Bringing Theory Back In*. Sage, London.

Janowitz, M. 1977. *Military Institutions and Coercion in the Developing Countries*. University of Chicago Press, Chicago.

Jim, Y.K. 2016. 'Forward', *Poverty and Shared Prosperity 2016: Taking on Poverty*. World Bank, Washington DC.

Kalyvas, S. 2006. *The Logic of Violence in Civil War*. Cambridge University Press, Cambridge.

Kaplan, R. 1997. 'Was Democracy Just a Moment?', *Atlantic Monthly*, December 1997, pp 55–80.

Kapuscinski, P. 2017 'Aid for Trade', World Bank, Washington DC, 29 August 2017.

Karl, T. 1990. 'Dilemmas of Democratization in Latin America', *Comparative Politics*, Vol 23, No 1, October 1990, pp 1–21.

Karl, T. 2005. 'From Democracy to Democratization and Back: Before Transitions from Authoritarian Rule', Center on Democracy, Development, and the Rule of Law, Stanford Institute on International Studies, Working Paper No 45, September 2005.

Karl, T. and Schmitter, P. 2002. 'Concepts, Assumptions and Hypotheses About Democratization: Reflections on "Stretching from South to East"', Workshop on Regime Transitions: Transitions from Communist Rule in Comparative Perspective, sponsored by the Center for Democracy, Development and the Rule of Law, Institute for International Studies, Stanford University, 15–16 November 2002.

Kastner, S. 2016. 'Buying Influence? Assessing the Political Effects of China's International Trade', *Journal of Conflict Resolution*, Vol 60, No 6, pp 980–1007.

Kaufmann, D., Kraay, A. and Mastruzzi, M. 2010. 'Political Stability and Absense of Violence', in *Worldwide Governance Indicators*. http://info.worldbank.org/governance/wgi/index.asp, accessed 5 November 2011.

KBS World Radio 2016. 'Experts Suspect Chinese Assistance in N. Korean Submarine Missile Development', *Korean Broadcasting Service*, 3 September 2016.

Keane, J. 2017. *When Trees Fall, Monkeys Scatter*. World Scientific, London.

Keen, D. 2000, 'Incentives and Disincentives for Violence', in M. Berdal and D. Malone eds. 2000. *Greed and Grievance: Economic Agendas in Civil Wars*. Lynne Reiner, Boulder.

Kendall-Taylor, A. and Frantz, E. 2016. 'When Dictators Die', *Journal of Democracy*, Vol 27, No 4, pp 159–171, October 2016.

Keohane, R. 2002. *Power and Governance in a Partially Globalized World*. Routledge, London.

Kersley, R. and Koutsoukis, A. 2016. *The Global Wealth Report 2016*. Credit Suisse, Zurich.

206 *Bibliography*

Kilcullen, D. 2010. *Counterinsurgency*. Oxford University Press, Oxford.

Kilcullen, D. 2013. *Out of the Mountains: The Coming Age of the Urban Guerrilla*. Oxford University Press, Oxford.

Kilcullen, D. 2016. *Blood Year: The Unraveling of Western Counterterrorism, Quarterly Essay*. Black Inc, Melbourne.

Killick, T. 1992. *Explaining Africa's Post-Independence Development Experiences*. Overseas Development Institute, Regent's College, London.

Killick, T. 1998. *Aid and the Political Economy of Policy Change*. Routledge, London.

Kingsbury, D. 2003. *Power Politics and the Indonesian Military*. Routledge Curzon, London.

Kingsbury, D. 2005. *The Politics of Indonesia* 3rd ed. Oxford University Press, Melborune.

Kingsbury, D. 2007a. *Political Development*. Routledge, London and New York.

Kingsbury, D. 2007b. 'Peace Processes in Aceh and Sri Lanka: A Comparative Assessment', *Security Challenges*, Vol 3, No 2.

Kingsbury, D. 2009. *East Timor: The Price of Liberty*. Palgrave-Macmillan, London.

Kingsbury, D. 2012a. 'Identity, Belonging and the State', in M. Miller ed. *Ethnic and Racial Minorities in Asia: Inclusion or Exclusion?* Routledge, New York.

Kingsbury, D. 2012b. *Sri Lanka and the Responsibility to Protect: Politics, Ethnicity and Genocide*. Routledge, London.

Kingsbury, D. 2015. 'Aceh's peace agreement under threat', *Deakin Speaking*, 2 April 2015. https:// blogs.deakin.edu.au/deakin-speaking/2015/04/02/acehs-peace-agreement-under-threat/, accessed 27 April 2015.

Kingsbury, D 2017. 'Indonesia on Notice – West Papuans Still Want Independence', *Crikey.com*, 28 September 2017. www.crikey.com.au/2017/09/28/west-papuans-present-independence-petition-against-overwhelming-odds/, accessed 29 October 2017.

Kingsbury, D. and McCulloch, L. 2006. 'Military business in Aceh', in A. Reid ed. *Verandah of Violence*. University of Washington Press, Washington.

Knack, S. 2001. 'Aid Dependence and the Quality of Governance: Cross-Country Empirical Tests', *Southern Economic Journal*, Vol 68, No 2, October 2001, pp 310–329.

Kohnert, D. 2008. 'EU-African Economic Relations: Continuing Dominance Traded for Aid?', German Institute for Global and Area Studies, Working Paper No 82, July 2008.

Kojeve, A. 1969. *Introduction to the Reading of Hegel: Lectures on the Phenomenology of Spirit*. Basic Books, New York.

Kojima, K. 2000. 'The "Flying Geese" Model of Asian Economic Development: Origin, Theoretical Extensions, and Regional Policy Implications', *Journal of Asian Economics*, Vol 11, No 2, Autumn 2000, pp 375–401.

De Koning, R. 2007. 'Greed or Grievance in West Africa's Wars?', in W. Jong, D. Donovan and K. Abe eds. *Extreme Conflict and Tropical Forests: World Forests*, Vol 5. Springer, Dordrecht.

Krader, L. 1976. *Dialectic of Civil Society*. Prometheus Books, New York.

Kymlicka, W. 1995. *Multicultural Citizenship*. Oxford University Press, Oxford.

Lappe, F. and Collins, J. 2016. *World Hunger: 10 Myths* 2nd ed. Grove Atlantic, New York.

Large, J. and Aguswandi, 'Accord Aceh: Interview with Jusuf Kalla', *Accord: Reconfiguring Politics: The Indonesia-Aceh Peace Process*, Issue 20. Conciliation Resources, London.

Lasswell, H. 1941. 'The Garrison State' *American Journal of Sociology*, Vol 46, No 4 (Jan., 1941), pp 455–468.

Lavoie, M. and Stockhammer, E. 2013 *Wage-led Growth: An Equitable Strategy for Economic Recovery*. Palgrave Macmilan, London.

Lev, D. 2005. 'Conceptual Filters and Obsfucation in the Study of Indonesian Politics', *Asian Studies Review*, Vol 4, No 9, December 2005, p 349.

Lev, D. personal communication, 20 December 2005.

Levitsky, S. and Way, L. 2002. 'The Rise of Competitive Authoritarianism', *Journal of Democracy*, Vol 13, No 2, April 2002, pp 51–65.

Ligami, C. 2016. 'East African Business Council's Funding', *The East African*, 28 May 2016. www. theeastafrican.co.ke/news/Donor-fatigue-leads-to-fall-in-EABC-funding-/2558-3222682-id0u5bz/ index.html, accessed 5 January 2018.

Lijphart, A. 1999. *Patterns of Democracy: Government Forms and Performance in 36 Countries*. Yale University Press, New Haven.

Linz, J. 1990. 'Transitions to Democracy', *Washington Quarterly*, Vol 13, No 3.

Linz, J. and Stepan, A. 1989. 'Political Crafting of Democratic Consolidation or Destruction: European and South American Comparisons', in R. Pastor ed. *Democracy in the Americas: Stopping the Pendulum*. Holmes and Meier, New York.

Linz, J. and Stepan, A. 1989. *Problems of Democratic Transition and Consolidation*. Johns Hopkins University Press, Baltimore.

Lipset, S. 1959. 'Some Social Requisites of Democracy: Economic Development and Political Legitimacy', *American Political Science Review*, Vol 53, No 1, pp 69–105.

Locke, J. 2010 (1689). *Two Treatises of Government and a Letter Concerning Toleration* ed. I. Shapiro. Yale University Press, New Haven.

Lockwood, N. 2013. 'International Vote Buying', *Harvard International Law Journal*, Vol 54, No 1, Winter 2013, pp 97–156.

Lomas, U. 2017. 'WTO Seeks to Support LDCs to Join the WTO', *Tax-News*, 14 December 2017. www.tax-news.com/news/WTO_Seeks_To_Support_LDCs_To_Join_The_WTO____75998.html, accessed 18 December 2017.

Loveard, K. 1999. *Suharto: Indonesia's Last Sultan*. Horizon Books, Traverse City.

Loveday, M. 2014. 'Shiite "Peace Brigades" Send Signal of Aggression with Major Rally in Baghdad', *New York Times*, 22 June 2014.

Luis, J. 2000. 'The Politics of State, Society and Economy', *International Journal of Social Economics*, Vol 27, No 3, pp 227–244.

Lumsdaine, D. 1993. *Moral Vision in International Politics: The Foreign Aid Regime, 1949–1989*. Princeton University Press, Princeton.

Lynch, G. and Crawford, G. 2011. 'Democratization in Africa 1990–2010: An Assessment', *Democratization*, Vol 19, No 2, pp 275–310.

Madonsela, T. 2016. 'State of Capture Report Number 6 of 2016/17', Office of the Public Prosecutor, South Africa, 14 October 2016.

Mang, Lun Min 2016. 'State Counsellor Urges Avoidance of Words "Rohingya" and "Bengali"', *Myanmar Times*, 23 May 2016.

Mahbubani, K. 2008. *The New Asian Hemisphere: The Irresistible Shift of Global Power to the East*. Public Affairs, New York.

Mansfield, E. and Snyder, J. 2005, *Electing to Fight: Why Emerging Democracies Go to War*. MIT Press, Cambridge.

Mansfield, E. and Snyder, J. 2007. 'The Sequencing "Fallacy"', *Journal of Democracy*, Vol 18, No 3, July 2007, pp 5–9.

Mansfield, S. 2014. *The Miracle of the Kurds*. Worthy, Brentwood.

Mansour, R. and Jabar, F. 2017. 'The Popular Mobilization Forces and Iraq's Future', Carnegie Endowment for International Peace, 28 April 2017.

Mao, Z. 2006. *Selected Works of Mao Tse-tung*, vol 5. Foreign Language Press, Beijing.

Matthews, J. 1996. 'Current Gains and Future Outcomes: When Cumulative Relative Gains Matter', *International Security*, Vol 21, No 1, Summer 1996 1996, pp 112–146.

May, R. 2002. 'The Moro Conflict and the Philippine Experience with Muslim Autonomy', Paper for Centre for Conflict and Post-Conflict Studies, Asia-Pacific Workshop, Canberra, September 2002.

McCarthy, T. 2009. *Race, Empire and the Idea of Human Development*. Cambridge University Press, Cambridge.

McDowall, D. 2004. *A Modern History of the Kurds* 3rd ed. I.B. Taurus and Co., London.

McGregor, K. 2007. *History in Uniform: Military Ideology and the Construction of Indonesia's Past*. NUS Press, Singapore.

McGregor, R. 2017. *Asia's Reckoning: The Struggle for Global Dominance*. Allen Lane, Toronto.

McKinsey 2013. 'Mapping China's Middle Class', *McKinsey Quarterly*, McKinsey and Company, New York.

McKinsey 2017. *China's One Belt, One Road: Will it Reshape Global Trade?* McKinsey and Company, New York.

Meadows, D.H., Meadows, D.L. and Beherens, J. 1972. *The Limits to Growth*. Potomac Institute, Washington DC.

Meadows, D.H., Meadows, D.L. and Beherens, J. 1992. *Beyond the Limits: Confronting Global Collapse*, Chelsea Green Publishing, New York.

208 Bibliography

Medard, J-F. 1996. 'Patrimonialism, Neo-patrimonialism and the Study of the Post-Colonial State in Africa', in H. Marcussen, 'Improved Natural Ressources Management: The Role of Formal Organizations and Informal Networks and Institutions', Occasional Paper No 17, International Development Studies, Roskilde University, Denmark, 1996, pp 76–97.

Memmi, A. 1967 (1957). *The Colonizer and the Colonized*. Beacon Press, Boston.

Meredith, M. 2002. *Our Votes, Our Guns: Robert Mugabe and the Tragedy of Zimbabwe*. Public Affairs, New York.

Michels, R. 1959. *Political Parties: A Sociological Study of the Oligarchical Tendencies of Modern Democracy*. Dover, New York.

Migdal, J. 1988. *Strong States and Weak Societies: State-society Relations and State Capabilities in the Third World*. Princeton University Press, Princeton.

Mill, C. 1951. *White Collar: The American Middle Classes*. Oxford University Press, New York.

Miller, D. 1995. *On Nationality*. Oxford University Press, Oxford.

Miller, M. 2009. *Rebellion and Reform in Indonesia: Jakarta's Security and Autonomy Policies in Aceh*. Routledge, London.

Miller, T. and Kim, A. 2017. *Index of Economic Freedom*. The Heritage Foundation, Washington DC.

Ministry of Foreign Affairs, People's Republic of China 2010. 'Article of Yang Jiechi: A Decade of FOCAC Fruitful Achievements and A New Chapter of China-Africa Relations', 11 October 2010, Beijing.

Misa 2011. 'Army General, Nyikayaramba Vows Not to Salute Tsvangirai', *The Zimbabwean*, 29 May 2011.

Mishra, P. 2017. *Age of Anger: A History of the Present*. Farrar, Strous and Giroux, New York.

Montevideo Convention 1933. *Montevideo Convention on the Rights and Duties of States*. Montevideo.

Mosca, G. 1939. *The Ruling Class* trans. A. Livingstone. McGraw-Hill, New York.

Moss, T., Pettersson, G. and Van de Walle, N. 2006. 'An Aid-institutions Paradox? A Review Essay on Aid Dependency and State Building in Sub-Saharan Africa', Centre for Global Development, Working Paper No 74.

MOU 2005. Memorandum of Understanding between the Government of the Republic of Indonesia and the Free Aceh Movement. news.bbc.co.uk/2/shared/bsp/hi/pdfs/15_08_05_aceh.pdf, accessed 13 February 2015.

Mount, F. 2012. *The New Few: Or a Very British Oligarchy*. Simon & Schuster Ltd, New York.

Moyo, D. 2009. *Dead Aid: Why Aid Is Not Working and How There Is Another Way for Africa*. Allen Lane, London.

Mumbere, D. 2017. 'U.S. Suspends Aid to Somalia's Army Over Corruption', *Africanews*, 14 December 2017. www.africanews.com/2017/12/14/us-suspends-aid-to-somalia-s-army-over-corruption//, accessed 4 January 2018.

Muslim Institute 2017. 'The Muslim Debate'. http://muslim-institute.org/Publications, accessed 7 May 2017.

Nelson, J. 1996. 'Promoting Policy Reforms: The Twilight of Conditionality', *World Development*, Vol 24, No 9.

Nordlinger, E. 1977. *Soldiers in Politics: Military Coups and Governments*. Prentice-Hall, Englewood Cliffs.

North, L. and Clark, T. 2017. *Dominant Elites in Latin America: From Neo-Liberalism to the 'Pink Tide'*. Palgrave, Abingdon.

Nurbati, A. 2011. '"NKRI harga mati", or Peace for Papua?', *The Jakarta Post*, 13 November 2011.

Nutzenadel, A. and Speich, D. 2011. 'Editorial – Global Inequality and Development after 1945', *Journal of Global History*, No 6, pp 1–5.

Nuyts, J. and Pederson, E. 2000. *Language and Conceptualisation*. Cambridge University Press, Cambridge.

Oakford, S. 2017. 'What One of the Deadliest Ever Attacks on UN Peacekeepers Means for Congo', *IRIN*, 8 December 2017. www.irinnews.org/news/2017/12/08/what-one-deadliest-ever-attacks-un-peacekeepers-means-congo?utm_source=IRIN+-+the+inside+story+on+emergencies&utm_campaign=37b0f0d296-RSS_EMAIL_ENGLISH_ALL&utm_medium=email&utm_term=0_d842d98289-37b0f0d296-15702989, accessed 18 December 2017.

OAU 1963. Charter of the Organization of African Unity, 25 May 1963.

OAU 1969. 'Resolution on Nigeria', Resolutions adopted by the Sixth Ordinary Session of the Assembly of Heads of State and Government Held in Addis Ababa from 6 to 10 September 1969, Organization of African Unity, 6–10 September 1969.

O'Donnell, G. 1973. *Modernization and Bureaucratic-Authoritarianism: Studies in South American Politics.* Institute of International Studies, University of California, Berkeley.

O'Donnell, G. 1988. *Bureaucratic Authoritarianism: Argentina, 1966–1973, in Comparative Perspective* trans. J. McGuire. University of California Press, Berkeley.

O'Donnell, G. 1996. 'Illusions about Consolidation', *Journal of Democracy*, Vol 7, No 2, April 1996, pp 34–51.

O'Donnell, G. and Schmitter, P. 1986. *Transitions from Authoritarian Rule: Tentative Conclusions about Uncertain Democracies.* John Hopkins University Press, Baltimore.

O'Donnell, G., Schmitter, P. and Whitehead, L. eds. 1986. *Transitions from Authoritarian Rule: Comparative Perspectives.* John Hopkins University Press, Baltimore.

OECD 2007. *Concepts and Dilemmas of State Building in Fragile Situations: From Fragility to Resilience.* Organisation for Economic Co-operation and Development Assistance Committee, Paris.

OECD 2016. 'Statistics', OECD Datalab, Organisation for Economic Co-operation and Development, Paris.

Oliver, G. 2017. 'Mozambicans Pay Dearly for a President's Financial Mistake', *IRIN*, 16 May 2017. www.irinnews.org/feature/2017/05/16/mozambicans-pay-dearly-president%E2%80%99s-financial-mistake?utm_source=IRIN+-+the+inside+story+on+emergencies&utm_campaign=d1abf57ebe-RSS_EMAIL_ENGLISH_ALL&utm_medium=email&utm_term=0_d842d98289-d1abf57ebe-15702989, accessed 27 December 2017.

Osborne, R. 2002. *Megawords: 200 Terms You Really Need To Know*, Sage, London.

Orwell, G. 1946. *Animal Farm.* Penguin, Harmondsworth.

Oxfam 2016. 'An Economy for the 1%'. Oxfam Briefing Paper 210, London, 18 January 2016.

Papaioannou, E. and Siourounis, G. 2008. 'Democratisation and Growth', *Vox*. http://voxeu.org/article/democratisation-and-growth-within-country-comparison-approach, accessed 1 December 2016.

Pardesi, M. and Ganguly, S. 2011. 'India and Oligarchic Capitalism', *The Diplomat*, 26 April 2011.

Pareto, V. 1968 (1901). *The Rise and Fall of Elites: An Application of Theoretical Sociology.* Bedminster Press, Totowa.

Park, K., Min, S. and Kim, M. 2012. 'Environmental Law and Practice in South Korea: Overview', *Practical Law*, October 2012.

Peeler, J. 2001. 'Elites, Structures, and Political Action in Latin America', *International Review of Sociology*, Vol 11, No 2, pp 231–246.

Pena, A. 2016. *Transnational Governance and South American Politics: The Political Economy of Norms.* Palgrave, London.

Pervaiz, F. 2016. 'Pakistan's Military-Democracy Complex', *Stratfor Worldview*, 2 February 2016. https://worldview.stratfor.com/article/pakistans-military-democracy-complex, accessed 28 November 2017.

Peter, F. 2008. *Democratic Legitimacy.* Routledge, New York.

Petersen, N. 2008. *The Principle of Democratic Teleology in International Law.* Max Planck Institute for Research on Collective Goods, Bonn, 2008/16.

Petersen, R. 2002. *Understanding Ethnic Violence: Fear, Hatred and Resentment in 20th Century Europe.* Cambridge University Press, Cambridge.

Phillips, D. 2015. *The Kurdish Spring: A New Map of the Middle East.* Transaction Publishers, New Brunswick.

Piketty, T. 2014. *Capital in the 21st Century.* Harvard University Press, Cambridge.

Pikiran Rakyat 2012. '90 Persen Bahasa Ibu di Dunia Terancam Punah' ('90 per cent of the World Mother Languages Threatened with Extinction'), *Pikiran Rakyat*, 27 June 2012.

Pillay, V. 2014. 'Seven Ways You Know You're an African, According to Jacob Zuma', *Mail and Guardian*, 14 October 2014.

Poesponegoro, M. and Notosusanto, N. 1992. *Sejarah Nasional Indonesia*, vols 1–8. Departemen Pendidikan dan Kebuduyaan, Jakarta.

210 *Bibliography*

Powell, J. and Thyne, S. 2011. 'Global Instances of Coups from 1950 to 2010: A New Dataset', *Journal of Peace Research*, Vol 48, No 2, pp 249–259.

Power, T. 2012. 'Theorizing a Moving Target: O'Donnell's Changing Views of Post-Authoritarian Regimes', paper to conference Guillermo O'Donnell and the Study of Democracy, Buenos Aires, 26–27 March 2012, PRCMFA.

Prebisch, R. 1950. *The Economic Development of Latin America and its Principal Problems*. United Nations Department of Economic Affairs, New York.

Przeworski, A. 1986. *Capitalism and Social Democracy*. Cambridge University Press, Cambridge.

Przeworski, A. 1991. *Democracy and the Market; Political and Economic Reforms in Eastern Europe and Latin America*. Cambridge University Press, New York.

Przeworski, A. 1995. *Sustainable Democracy*. Cambridge University Press, Cambridge.

Przeworski, A., Alvarez, M., Cheibub, J. and Limongi, F. 2000. *Democracy and Development*. Cambridge University Press, Cambridge.

PST 2016. *Indeks Pembangunan Manusia menurut Provinsi, 2010–2016 (Metode Baru)*. Badan Pusta Statistik, Jakarta.

Purushothaman, C. 2017. 'Why Is the Philippines Turning Away Foreign Aid?', *The Diplomat*, 25 May 2017.

Putnam, R. 1988. 'Diplomacy and Domestic Politics: The Logic of the Two-level Game', *International Organization*, Vol 42.

Putnam, R. 1993. *Making Democracies Work: Civic Traditions in Modern Italy*. Princeton University Press, Princeton.

Radin, A. and Reach, C. 2017. *Russian Views of the International Order*. Rand Corporation, Santa Monica.

Ramli, R. 2002. 'The IMF's Indonesian Myths', International Development Economic Associates, 24 May 2002. www.networkideas.org/featart/may2002/fa24_Indonesian_Myths.htm, accessed 6 May 2013.

Ramo, J. 2004. *The Beijing Consensus*. Foreign Policy Centre, London.

Raphaeli, N. 2003. 'Saudi Arabia: A Brief Guide to its Politics and Problems', *Middle East Review of International Affairs*, Vol 7, No 3, September 2003.

Rashid, A. 2017. 'Trepidation at the Return of the Afghan Warlords', *The Financial Times*, 31 May 2017.

Rastello, S. and Krishnan, U. 2016. 'Modi and Rajan: Unlikely Allies Battling India's Oligarchy', *Bloomberg*. www.bloomberg.com/news/articles/2016-02-24/modi-and-rajan-unlikely-allies-battling-against-india-oligarchs, accessed 1 May 2017.

Ravelo, J. 2012. '30 Percent of Aid Lost to Corruption – Ban Ki-moon', *Devex*, 10 July 2012.

RBA 2017. *Statement on Monetary Policy*, Reserve Bank of Australia, November 2017.

RCA 2016. *2015–16 Federal Budget in Brief: What it Means for Refugees and People Seeking Humanitarian Protection*. Refugee Council of Australia, Sydney.

Renzio, P. 2007. 'Aid Effectiveness and Absorptive Capacity: Which Way Aid Reform and Accountability?', Africa after the Africa Commission: What priorities for the German G8?, G8 Meeting, Germany, 6–8 June 2007.

Reuters 2017a. 'China Has the Right to "Step In" to Hong Kong Election, Top Official Says', *Reuters*, 6 March 2017.

Reuters 2017b. 'Italy PM Plans to Shift Military Forces from Iraq to Niger', *Reuters*, 26 December 2017.

Reuters 2017c. 'Zimbabwe Military Chief's China Trip was Normal Visit, Beijing Says', *Reuters*, 15 November 2017.

Reuters 2017d. 'Zimbabwe Agrees First Post-Mugabe Loan Deal with China', *Reuters*, 7 December 2017.

Reuters 2018. 'Latin America Should not Rely on China: U.S. Secretary of State Tillerson', *Reuters*, 2 February 2018.

Rhanema, A. 1998. *An Islamic Utopian: A Political Biography of Ali Shariati*. St. Martin's Press, New York.

Richardson, M. 2000. 'Coup Rumors Prompt Strong Show of U.S. Support for Wahid', *New York Times*, 17 January 2000.

Richmond, O. 2011. *A Post-Liberal Peace*. Routledge, London.

Rodney, W. 1972. *How Europe Underdeveloped Africa*. Bogle-L'Ouverture Publications, London.

Rodrik, D. 2016. 'Is Liberal Democracy Feasible in Developing Countries?', *Studies in Comparative International Development*, Vol 51, No 1, March 2016, pp 50–59.

Roisman, J. and Worthington, I. eds. 2010. *A Companion to Ancient Macedonia*. John Wiley and Sons, Chichester.

Rojanaphruk, P. 2017. 'Prayuth: Those Who Believe Junta Will Hold Power 20 Years Not Thai', *Khaosod*, 8 July 2017.

Roodman, D. 2006. 'Aid Project Proliferation and Absorptive Capacity', Research Paper No 2006/04, United Nations University, World Institute for Development Economics Research, January 2006.

Ross, M. 2011. 'Does Oil Hinder Democracy?', *World Politics*, Vol 53, No 3, pp 325–361.

Rostow, W. 1960. *The Stages of Economic Growth: A Non-Communist Manifesto*. Cambridge University Press, Cambridge.

Rousseau, J-J. 1754. *Discourse on the Origin and Basis of Inequality among Men*. University of Adelaide, Adelaide.

Rothstein, B. 2011. *The Quality of Government: Corruption, Social Trust, and Inequality in International Perspective*. University of Chicago Press, Chicago.

Rousseau, J.J. 1992. *Julie, or the New Heloise* trans. P. Stewart and J. Vache in *The Collected Writings of Rousseau*, No 6. University Press of New England, London.

Runciman, D. 2012. 'Will We Be Alright in the End?' *London Review of Books*, Vol 34, No 1, 5 January 2012, pp 3–5.

Rustow, D. 1999. 'Transitions to Democracy: Toward a Dynamic Model', in L. Anderson ed. *Transitions to Democracy*. Columbia University Press, New York (reprinted from Rustow, D. 1970. 'Transition to Democracy: Towards a Dynamic Model', *Comparative Politics*, April, pp 358–360).

Sachs, J. 2014. 'The Case for Aid', *Foreign Policy*, 21 January 2014.

Sachs, J., Solomon, A., Ogden, W., Weisner, E. and McNamar, R. 1988. 'Developing Country Debt', in M. Feldstein ed. *International Economic Cooperation*. University of Chicago Press, Chicago.

Sadan, M. ed. 2016. *War and Peace in the Borderlands of Myanmar: The Kachin Ceasefire 1994–2011*. NIAS Press, Copenhagen.

Said, E. 1978. *Orientalism*. Pantheon Books, New York.

Sakwa, R. 2008. '"New Cold War" or Twenty Years' Crisis? Russia and International Politics', *International Affairs*, Vol 84, No 2, March 2008, pp 241–267.

Salih, M. 2005. *African Parliaments: Between Governance and Government*. Palgrave, Abingdon.

Sapir, E. 1925. 'Sound Patterns in Language', *Language*, Vol 1, No 2, 1925.

Sapir, E. 1944. 'Grading: A Study in Semantics', *Philosophy of Science*, No 11, pp 93–116.

Sartori, G. 1965. *Democratic Theory*. Praeger, New York.

Sartori, G. 1987. *The Theory of Democracy Revisisted*. Chatham House, London.

Schaeffer, R. 2009. *Understanding Globalization: The Social Consequences of Political, Economic, and Environmental Change* 4th ed. Rowman & Littlefield Publishers, Lanham.

Schedler, A. 1998. 'What is Democratic Consolidation?', *Journal of Democracy*, Vol 9, No 2, April 1998, pp 91–107.

Schmitter, P. and Karl, T. 1991. 'What Democracy Is … And Is Not', *Journal of Democracy*, Vol 2, No 3, Summer 1991.

Schmitter, P. and Schneider, C. 2004. 'Conceptualising and Measuring the Liberalization of Autocracy and the Consolidation of Democracy Across Regions of the World and From Different Points of Departure', Istituto Universitario Europeo, Florence. www.eui.eu/Documents/Departmentscentres/.../Schmitter/Salamanca2.pdf, accessed 7 May 2013.

Schneider, C. and Schmitter, P. 2004. 'Liberalization, Transition and Consolidation: Measuring the Components of Democratization', *Democratization*, Vol 11, No 5, December 2004, pp 59–90

Schumpeter, J. 1947. 'The Creative Response in Economic History', *The Journal of Economic History*, Vol 7, No 2, November 1947, pp 149–159.

Schumpeter, J. 1976. *Capitalism, Socialism and Democracy*. Allen and Unwin, London.

212 Bibliography

Searle, G. 1977. *The Golden Age: A History of the Colony of Victoria 1851–1961*. Melbourne University Press, Melbourne.

Sekhri, S. 2009. 'Dependency Approach: Chances of Survival in the 21st Century', *African Journal of Political Science and International Relations*, Vol 3, No 5, pp 242–252.

Selbervik, H. 1999. 'Aid and Conditionality: The Role of the Bilateral Donor: A Case Study of Norwegian–Tanzanian Aid Relationship', Report submitted to the Norwegian Ministry of Foreign Affairs, Chr. Michelsen Institute, July 1999.

Sen, A. 1989. 'Development as Capability Expansion', *Journal of Development Planning*, No 19, pp 41–58.

Sen, A. 1999a. 'Democracy as a Universal Value', *Journal of Democracy*, Vol 10, No 3, pp 3–17.

Sen, A. 1999b. *Development as Freedom*. Oxford University Press, Oxford.

Shah, A. 2007. 'Causes of the Debt Crisis', *Global Issues*, 3 June 2007. www.globalissues.org/print/article/29, accessed 27 June 2017.

Shah, A. 2012. *Food Aid, Global Issues*. www.globalissues.org/article/748/food-aid, accessed 4 December 2017.

Shaikh, S. and Hamid, S. 2012. *Between Interference and Assistance: The Politics of International Support in Egypt, Tunisia, and Libya*. Brookings Institute, Doha.

Shi, T. 2017. 'Xi Plans to Turn China into a Leading Global Power by 2050', *Bloomberg Politics*, 18 October 2017.

Shimomura, Y. and Ohashi, H. 2013. *A Study of China's Foreign Aid: An Asian Perspective*. Palgrave, London.

Siddiqa, A. 2007. *Military Inc.: Inside Pakistan's Military Economy* 2nd ed. Pluto Press, London.

Siebrits, K., Jansen, A. and Du Plessis, S. 2015. 'Democratisation in Africa: The Role of Self-enforcing Constitutional Rules', African Centre for the Constructive Resolution of Disputes, Paper 2015/1, 9 March 2015.

SIGAR 2017. 'Quarterly Report to the United States Congress', Special Inspector General for Afghan Reconstruction, US Department of Defense, 30 January 2017.

Simoes, A. and Hidalgo, C. 2017. 'Zimbabwe', *Atlas of Economic Complexity*. The Economic Complexity Observatory, Massachusetts Institute of Technology, Boston. https://atlas.media.mit.edu/en/profile/country/zwe/, accessed 6 January 2018.

Singer, H. 1949. *Post-war Price Relations between Under-developed and Industrialized Countries*. United Nations Department of Economic Affairs, New York.

Singh, K. 1982. *Economies of the Tribes and Their Transformation*. Concept, University of Michigan, Ann Arbour.

SMH 1851. 'Population of Victoria', *Sydney Morning Herald*, 29 August 1851.

Smith, A. 1986a. 'State Making and Nation-Building', in J. Hall ed. *States in History*. Basil Blackwell, Oxford.

Smith, A. 1986b. *The Ethnic Origins of Nations*. Blackwell Publishers, Oxford.

Smith, A. 2001. *Nationalism: Theory, Ideology, History*. Polity, Cambridge.

Smith, C. 2009. 'The LTTE: A National Liberation and Oppression Movement', in L. Gayer and C. Jaffrelot eds. *Armed Militias of South Asia: Fundamentalists, Maoists and Separatists*. Columbia University Press, New York.

Smith, S. 2013. 'Business or Plunder: International Corruption Robbing Africa's Poor', Australian Strategic Policy Institute, Canberra, 21 May 2013.

Snow, D. and Benford, R. 1992. 'Master Frames and Cycles of Protest', in A. Morris and C. Mueller McClurg eds. *Frontiers in Social Movement Theory*. Yale University Press, New Haven.

Snyder, R. and Mahoney, J. 1999. 'The Missing Variable: Institutions and the Study of Regime Change', *Comparative Politics*, Vol 32, No 1, October 1999, pp 103–122.

Sorensen, G. 2016. *Rethinking the New World Order*. Palgrave, London.

Spero, J. and Hart, J. 2010. *The Politics of International Economic Relations* 7th ed. Wadsworth, Cengage Learning, Boston.

Stanford, V. 2015. 'Aid Dependency: The Damage of Donation', *This Week In Global Health*, 31 July 2015. www.twigh.org/twigh-blog-archives/2015/7/31/aid-dependency-the-damage-of-donation, accessed 22 February 2018.

Bibliography 213

Stansifer, C. 1967. 'Application of the Tobar Doctrine to Central America', *The Americas*, Vol 23, No 3, January 1967, pp 251–272.

Stavanger Declaration 2002. Gerakan Acheh Merdeka, Stavanger, Norway, 21 July 2002.

Stearns, P. and Langer, W. eds. 2001. 'The Middle East', *The Encyclopedia of World History* 6th ed. Houghton Mifflin Books, Boston.

Stearns, J. and Vogel, C. 2017. 'The Landscape of Armed Groups in Eastern Congo: Fragmented, Politicized Networks', *Kivu Security Tracker*, December 2017.

Stepan, A. 1985. 'State Power and the Strength of Civil Society in the Southern Cone of Latin America', in P. Evans, D. Rueschemeyer and T. Skocpol eds. *Bringing the State Back In*. Cambridge University Press, Cambridge.

Stockton, H., Heo, U. and Ro, K. 1998. 'Factors Affecting Democratic Installation in Developing Countries: An Empirical Analysis', *Asian Perspective*, Vol 22, No 3, pp 207–222.

Stokke, K. and Törnquist, O. 2013. 'Experiences and Strategic Interventions in Transformative Democratic Politics', In K. Stokke and O. Törnquist eds. *Democratization in the Global South: The Importance of Transformative Politics*. Palgrave Macmillan, London.

Strauss, L. 1961. *On Tyranny*. University of Chicago Press, Chicago.

Talbot, I. and Singh, G. 2009. *The Partition of India*. Cambridge University Press, Cambridge.

Talmon, S. 1998. *Recognition of Governments in International Law*. Oxford Monographs in International Law Series, Clarendon Press, Oxford.

Tambiah, S. 1976. *World Conqueror and World Renouncer*. Cambridge University Press, Cambridge.

Tamir, Y. 1993. *Liberal Nationalism*. Princeton University Press, New Haven.

Tan, P. 2008. 'Teaching and Remembering', *Inside Indonesia*, 4 May 2008.

Taras, R. and Ganguly, R. 2010. *Understanding Ethnic Conflict* 4th ed. Pearson, Boston.

Taylor, A. 2016. 'Congo Government: Elections are Too Expensive, So We May Not Have One This Year', *The Washington Post*, 16 February 2016.

Taylor, R. 2012. 'Myanmar: From Army to Constitutional Rule', *Asian Affairs*, Vol XLII, No II, July 2012, pp 221–236.

The Telegraph 2017. 'Islamic State Claims Responsibility for Deadly Las Ramblas Terror Attack', *The Telegraph*, 17 August 2017.

Thom, W. 1995. 'An Assessment of Prospects for Ending Domestic Military Conflict in Sub-Saharan Africa', *CSIS Africa Notes*, No 177, October 1995.

Thomas, A., Viciani, I, Tench, J.R., Hall, M., Martin, M. and Watts, R. 2011. *Ending Aid Dependency*. Action Aid, London.

Thompson, R. 2012. 'Assessing the Chinese Influence in Ghana, Angola, and Zimbabwe: The Impact of Politics, Partners, and Petro [*sic*]' Center for International Security and Cooperation, Stanford University, 21 May 2012.

Thornton, J. 1977. 'Demography and History in the Kingdom of Kongo, 1550–1750', *The Journal of African History*, Vol 18, No 4.

TI 2012. 'Will the Fruits of Africa's Commodity Boom be Lost to Corruption?', Transparency International, Berlin, 4 April 2012.

TI 2015. 'Africa', *Government Defence Anti-Corruption Index*. https://government.defenceindex.org/#close, accessed 27 November 2017.

TI 2016. *Corruption Perceptions Index 2016*. Transparency International, Berlin.

Timor Gap Treaty 1989. *Treaty between Australia and the Republic of Indonesia on the Zone of Cooperation in an Area between the Indonesian Province of East Timor and Northern Australia*. Australian Government Publishing Service, Canberra, 11 December 1989.

Timor Sea Treaty 2003. *Timor Sea Treaty Between the Government of East Timor and the Government of Australia*. Dili, 20 May 2002.

Törnquist, O. and Uning, D. 2010. 'Lost in Translation, Lost in Elections', in O. Törnquist, S. Prasetyo and T. Birks eds. *The Role of Democracy for Peace and Reconstruction* 2nd ed. PCD Press, Jakarta.

214 *Bibliography*

Törnquist, O. and Uning, D. 2010. 'Lost in Translation, Lost in Elections', in Törnquist, O, Prasetyo S. and Birks T. eds. *The Role of Democracy for Peace and Reconstruction*, 2nd ed. PCD Press, Jakarta.

Torvik, R. 2009. 'Why Do Some Resource-abundant Countries Succeed While Others Do Not?', *Oxford Review of Economic Policy*, Vol 25, No 2, pp 241–256.

Touval, S. 1966. 'Treaties, Borders, and the Partition of Africa', *The Journal of African History*, Vol 7, No 2, pp 279–293.

Toye, J. and Toye, R. 2003. 'The Origins and Interpretation of the Prebisch-Singer Thesis', *History of Political Economy*, Vol 35, No 3, pp 437–467.

Truman, H. 1949. 'Four Point Program', *Bulletin*, US Department of State, 30 January 1949.

Turner, T. 2013. *Congo*. Polity Press, Malden.

TVTL 2012. Comments by Brig. Gen. Lere to Televizaun Timor-Leste, 12 April 2012.

UN 1945. *United Nations Charter*. United Nations, New York.

UN 2015a. 'Consequences of Small Arms Claim Attention in First Committee, as African Nations Underscore Dangers of Terrorist Use', First Committee, United Nations General Assembly, 13 October 2015.

UN 2015b. 'GDP/Breakdown at Current Prices in US Dollars (All Countries)', United Nations Statistics Division, December 2016.

UNGA 2005. 2005 World Summit Outcome Document A/RES/60/1, UN General Assembly, New York, 14 September 2005.

Unger, R. 2004. *False Necessity: Anti-Necessitarian Social Theory in the Service of Radical Democracy* revised ed. Verso, London.

UNHCR 2016. *Global Trends: Forced Displacement in 2016*. United Nations High Commissioner for Refugees, New York.

UNIDO 2016. United Nations Industrial Development Organization, High-Level Conference of Middle-Income Countries, San Jose, Costa Rica, 12–14 June 2013.

UNDP 2016. *Human Development Index*.

UNDP 2017a. *World Population Prospects: Key Findings and Advance Tables (Revision)*. United Nations Population Division, New York.

UNNC 2005. 'Donor Fatigue, Cynicism Could Lead to Millions of Deaths in Ethiopia, UN Children's Agency Warns', UN News Centre, 6 July 2005.

UNPD 2017b. 'The End of High Fertility is Near', Populations Facts, United Nations Population Division, New York, 3 October 2017.

UNPO 2014. 'West Papua', United Nations Unrepresented Nations and Peoples Organization, New York, 15 October 2014.

UNSC 1999. *United Nations Security Council Resolution 1244*. United Nations, New York, 10 June 1999.

UNSC 2011. *United Nations Security Council Resolution 1973*. United Nations, New York, 17 March 2011.

UNSG 2017. 'Note to Correspondents: Update on Investigation into the Tragic Death of Dag Hammarskjöld and of the Members of the Party Accompanying Him', United Nations Secretary-General, United Nations, New York, 2 May 2017.

Uren, D. 2010. '"No Doubt" Fiscal Stimulus Supported Economy', *Australian Financial Review*, 19 February 2010.

Valencia, M. 2015. Consolidacion de la Hacienda y la Elite Criolla (Consolidation of the Hacienda and Creole Elite). https://prezi.com/wfeeglklqkxm/consolidacion-de-la-hacienda-y-la-elite-criolla, accessed 2 May 2017.

Valenzuela, J.S. 1990. 'Democratic Consolidation in Post-Transitional Settings: Notion, Process and Facilitating Conditions', Kellogg Institute Working Paper 150, Kellogg Institute for International Studies, University of Notre Dame, Notre Dame.

Vanhanen, T. 1990. *The Process of Democratization: A Comparative Study of 147 States, 1980–88*. Crane Russak, New York. http://www.cavr-timorleste.org/en/chegaReport.htm, accessed 2 September 2013.

Van Der Merwe, J. 2016, 'Seeing Through the Mist: New Contenders for the African Space', in J. Van Der Merwe, I. Taylor and A. Arkangelskaya eds. *Emerging Powers in Africa: A New Wave in the Relationship*. Palgrave, London.

Bibliography 215

Vellut, J. 2005. *Memory of Congo*. Tervuren Museum/Royal Museum for Central Africa.

VIG 1851. *Immigration: Report from the Immigration Agent upon Immigration*. Victoria Immigration Agent, Melbourne, State Library of Victoria.

Vogel, E. 1991. *Four Little Dragons: The Spread of Industrialisation in East Asia*. Harvard University Press, Cambridge.

Voravit, S., Mahn, M., Maung, C., Daniels, B., Murakami, N., Wirtz, A. and Beyrer, C. 2009. *After the Storm: Voices from the Delta*. John Hopkins Bloomberg School of Public Health, Baltimore.

De Waal, A. 1997. *Famine Crimes: Politics and the Disaster Relief Industry in Africa*. African Rights and The International African Institute, London.

Wade, R. 2003. *Governing the Market: Economic Theory and the Role of Government in East Asia's Industrialization*, 2nd ed. Princeton University Press, Princeton.

Wade, R. 2017. 'Global Growth, Inequality and Poverty: The Globalization Argument and the "Political Science of Economics"', in J. Ravenhill *Global Political Economy* 5th ed. Oxford University Press, New York.

Wang, T. 1999. 'US Foreign Aid and UN Voting: An Analysis of Important Issues', *International Studies Quarterly*, Vol 43, No 1, pp 199–210.

Weber, M. 1948 'Politics as a Vocation', in H. Gerth and C. Mills trans. and eds. *From Max Weber: Essays in Sociology*. Routledge and Kegan Paul, London.

Weber, M. 1958. 'The Three Types of Legitimate Rule', trans. H. Gerth. *Berkeley Publications in Society and Institutions*, Vol 4, No 1, pp 1–11.

WEF 2015. 'Why Has Global Trade Slowed Down?', World Economic Forum, 19 January 2015.

Weisbord, R. 2003. 'The King, the Cardinal and the Pope: Leopold II's Genocide in the Congo and the Vatican', *Journal of Genocide Research*, Vol 5, No 1, pp 35–45.

Wembridge, M. 2016. 'Direct Investment Access to China Threatens Hong Kong', *The Financial Times*, 3 June 2016.

Wesseling, H. 1996. trans. *Divide and Rule: The Partition of Africa, 1880–1914 trans. J. Pomerans*. Praeger, Westport.

WFP 2011. 'Horn of Africa Crisis', World Food Programme, United Nations, New York. www.wfp.org/crisis/horn-of-africa, accessed 22 February 2018.

Whorf, B. 1956. J. Carroll ed. *Language, Thought, and Reality: Selected Writings of Benjamin Lee Whorf*. MIT Press, Boston.

Wibbles, E. 2009. 'Cores, Peripheries, and Contemporary Political Economy', *Studies in Comparative International Development*, Vol 44, No 4, pp 441–449.

Williamson, J. 1989. 'What Washington Means by Policy Reform', in J. Williamson ed. *Latin American Readjustment: How Much has Happened*. Institute for International Economics, Washington.

Williamson, J. ed. 1994. *The Political Economy of Policy Reform*. Institute of International Economics, Washington DC.

Williamson, J. 2004. *A Short History of the Washington Consensus*. Peterson Institute for International Economics. https://piie.com/publications/papers/williamson0904-2.pdf, accessed 10 October 2017.

Wilson, I. 2010. 'The Rise and Fall of Political Gangsters in Indonesian Democracy', in E. Aspinal and M. Meitzner *Problems of Democratisation in Indonesia: Elections, Institutions and Society*. Institute of Southeast Asian Studies, Singapore.

Winters, J. 2011. *Oligarchy*. Cambridge University Press, New York.

Wolters, O.W. 1999. *History, Culture and Region in Southeast Asian Perspectives*. Institute of Southeast Asian Studies, Singapore.

Woo, M. 1999. *The Developmental State*. Cornell University Press, Ithaca.

World Bank 2006. *GAM Reintegration Needs Assessment: Enhancing Peace through Community-level Development Programming*. World Bank, Washington DC.

World Bank 2016a. *Voices of the Poor*. World Bank, Washington DC.

World Bank 2016b. 'Gini Index', Development Research Group, World Bank, Washington DC.

World Bank 2017a. World Bank National Accounts Data, and OECD National Accounts Data Files. http://data.worldbank.org/indicator/NY.GDP.PCAP.KD, accessed 20 June 2017.

216 *Bibliography*

World Bank 2017b. Quoted in 'China – Key Economic Indicators', *The Guardian*. https://docs.google.com/spreadsheets/d/1y41WVbvc-GDJ54yN6NtW-o9Ir-W0cPNIHg18J_srCzY/edit#gid=0, accessed 11 May 2017.

World Bank 2017c. 'Data for China, Upper Middle Income'. https://data.worldbank.org/?locations=CN-XT, accessed 14 December 2017.

World Bank 2017d. 'The World Bank in Middle Income Countries'. www.worldbank.org/en/country/mic, accessed 14 December 2017.

World Bank Group 2016. *Global Monitoring Report 2015/2016: Development Goals in an Era of Demographic Change*. World Bank, Washington DC.

World Conference on Human Rights, Regional Meeting, Bangkok, 29 March 1993.

WTO 2014. 'Aid for Trade Fact Sheet', World Trade Organization. www.wto.org/english/tratop_e/devel_e/a4t_e/a4t_factsheet_e.htm, accessed 15 June 2018.

WTO 2018. Aid For Trade, World Trade Organisation, Washington. https://www.wto.org/english/tratop_e/devel_e/a4t_e/aid4trade_e.htm, accessed 13 December 2018.

Yeates, C. 2010. 'Economy to Ride on Asia's Back, Says the Reserve', *Sydney Morning Herald*, 19 February 2010.

Zakaria, F. 1994. 'A Conversation with Lee Kwan Yew', *Foreign Affairs*, March/April 1994.

Zakaria, F. 1997. 'The Rise of Illiberal Democracy', *Foreign Affairs*, No 76, November–December 1997.

Zakaria, F. 2003. *The Future of Freedom: Illiberal Democracy at Home and Abroad*. Norton, New York.

Zartman, W. 2000. 'Ripeness: The Hurting Stalemate and Beyond', in P. Stern and D. Druckman eds. *International Conflict Resolution After the Cold War*. The National Academic Press, Washington DC.

Zhao, L. 2017. 'PLA to Be World-class Force by 2050', *China Daily*, 27 October 2017.

Zygar, M. 2018. 'Putin Believes He's Destined to Make Russia Great Again. And He's Just Getting Started', *Time*, 19 March 2018.

Index

absolute monarchies 54
absolute poverty 64, 65
absorptive capacity 87–88
Abu Ammar Jununi 47
accountability 6, 10, 63, 69, 75, 158, 193; and
 aid 87, 91; and aspirationalists 58; and the
 military 129, 130, 165, 190; and state
 institutions 52, 142
Aceh 84, 86, 156–166, 167–169
Aceh Monitoring Mission (the AMM) 163, 164
Acehnese 12, 31
Aceh Reintegration Board (BRA) 165
Aceh Transitional Committee (KPA) 164, 165
Adcock, R. 61, 62
Adler, J. 88
Afghanistan 35, 56, 134, 136, 142, 172–173,
 177; and aid 91, 93; and U.S. 172–173
Africa 41, 44–46, 51, 67, 74–75, 105–106, 115,
 187; agriculture 103; and authority 52; and
 China 117–119; and corruption 77–78, 88, 89;
 and coups 130–131; debt 101; and
 democratisation 10; famines 85; food crisis of
 2010–2011 94; and militaries 148; and poverty
 65, 70; 'scramble for' 13; and warlords 136
African National Congress (ANC) 74, 75
African Union (AU) 131, 181
African Union Mission in Somalia (AMISOM) 23
Africom 179–180
Afrin 175
agency 59, 63, 100, 145, 156, 157, 160, 186
agriculture 103–104
Ahok (Basuki Tjahaja Purnama) 119, 120
Ahtisaari, Martti 162
aid 18, 81–95, 118, 163, 170, 189
Alkatiri, Mari 107–108, 146
Alonso, J. 90
Althusser, L. 63
Alvarez et al 62, 67
Amazon rainforest 87
anarchy 23, 144
Andrews, E. 21
Angola 118
Anwar Ibrahim 75–77

Aquino, Corazon 28
Arabic language 40
Arab Spring 70, 144, 155, 187
Arakan Rohingya Salvation Army (ARSA)
 47, 48
Argentina 68, 101, 120, 121, 143, 150
armed forces 124–137; *see also* militaries
ASEAN (Association of Southeast Asian
 Nations) 181
ASEAN Free Trade Area 102
Asia 13, 86, 99, 136; *see also* Southeast Asia
Asian Financial Crisis, 1997–1998 71, 100,
 144–145, 150
Asian Infrastructure Investment Bank (AIIB)
 109, 116–117
aspirationalists 58
Aung San Suu Kyi 47
Australia 93, 106–108
authoritarianism 54, 125, 128, 144, 155, 192;
 bureaucratic 56, 141, 142
authoritarian-mass party states 126
authoritarian-personal control 126
authoritarian regimes 146
authority 52, 54, 56, 124, 159, 182, 188, 189;
 and absolute ruler 149; and Africa 52; civilian
 129, 137, 158; and militaries 125; moral 55;
 political 130; state 49; and warlords 136
autonomy, state 49, 142

Ba'ath Party 42
Balochistan 35
Bangladesh 41, 47, 48
Ban Ki-moon 89
Barron, P. 164
Barzani, Masoud 44
Baswedan, Anies 119
Batgas 128
Beijing Consensus 5–6, 19, 65, 111, 115–117,
 121–122, 155, 187, 190–191
Belgian Congo 24
Belgium 55
Belt and Road Initiative (BRI) 108–109, 116,
 117, 180

218 *Index*

Berdal, M. 29
Berlin Conference 13
Biafra 41
bilateral aid 93
Black July 38
bonded political identity 39
Boot, Max 174
'booty capitalism' 9
borders 37, 48
Botswana 77–78
Braithwaite, J. 29
Brazil 56, 67, 73, 87, 101, 106, 112, 115; and
 coffee 103; and the economy 120–121; and
 state autonomy 142
Bretton Woods Agreement 82
BRICS 115
Britain 173
bureaucracies 50, 52–53
bureaucratic authoritarianism 54, 56, 128,
 141, 142
bureaucratic authoritarian regimes 54, 140
Burkina Faso 77
Burma 35; *see also* Myanmar
Burma Socialist Programme Party 124–125
Burundi 103, 106
Bush, President George W. 42, 93

Cambodia 54–55, 126, 130, 159, 160, 171
capitalism 190
Caribbean Single Market and Economy
 (CSME) 102
causal mechanisms 28
Central African Economic and Monetary Union
 (CEMAC) 102
Central America 74, 104–105
Central American Integration System
 (SICA) 102
Central Asia 13, 136
centrally planned economies 190
Chad 77, 106
charity 83
Chawalit Yongchaiyut 71
Chile 73, 143, 144
China 9, 40, 65, 74, 79, 100, 111–112, 115–119,
 122, 178, 190–191, 194; and Africa 105–106;
 and aid 84; and client states 176; and Latin
 America 69; and middle class 113–114; and
 Myanmar 48; nationalist revolution, 1911
 149; and North Korea 181, 182, 183; and
 rules-based order 180; and trade 108–109;
 and Zimbabwe 132
Chiwenga, General Constantino 118, 131, 132
Christians 35
circle model of state organisation 13
citizens 16, 171, 188
citizenship 11, 16, 17, 47
civic failure 28–32

civic opportunity 26–28
civic responsibility 29
civic unity 32
civil–military coalition 127
civil-military partnership states 126
civil rights 63
civil society 49, 55–56, 141, 142, 188–189
civil wars 30, 45–46, 50, 173
client-patron relations 173, 184
client state 172–173, 176, 184, 194
climate change 193
coffee 103
Cold War 82–83, 178
Collier, P. 29, 30, 58, 60, 61, 62, 97, 139
Collins, J. J. 86
Colombia 87, 103
colonialism 20–32, 34
colonisation 188–189
common markets 102
communism 143
Communist Party of Kampuchea 54–55
competition 141
competitive advantage 186
conditionality 91
conflict trap 29
Congo Crisis 24
Congo Free State 24
Congress Party 74
consolidation, democratic 150–152, 153
consumption 69
contradictories 60–61
contraries 60–61
corruption 6, 77–79, 88–89, 98
coups 16, 52, 128–133
Cowen, M. 3
Crook, P. 21
culture 7
Curran, J. 115
Cyclone Nargis 83, 86, 144

Dahl, Robert 57–58, 140, 147,
 159, 160
Darfur 50
Das, S. 117
debt 68, 96, 100, 101
definitional gerrymandering 58
deforestation 87
democracy 55–62, 63, 139, 148, 153, 159–161,
 191–192
democratic consolidation 150–152, 153
democratic deficits 152
democratic fatalism 152
democratic gradualism 160
Democratic Republic of the Congo (DRC)
 24–25, 55, 77, 91, 106, 118
democratisation 10, 54–56, 62–63, 140–143,
 152–153, 159, 160; and conflict resolution

Index 219

161; and Indonesia 145, 157, 158, 163; and O'Donnell 166–167
dependency 9, 65, 85–86, 89–91, 98–100
Desch, M. 125, 129
developmentalism 68–69
de Waal, Alex 85
dictatorships 54, 125
Dinkas 45
Diokno, Jose 7
Di Palma, G. 10, 148
Di Tiro, Hasan 162
'donor fatigue' 93
Dragovic, D. 87
Druze 35
'dual function' paradigm 126–127

East African Community 102
East Asia 99
Easterly, W. 84, 85
eastern Europe 10
East Timor 31, 107, 147
economic and monetary unions 102
economic crisis 10
economic dependency 90
economic growth 69
economic inequality 69–70
Economic Partnership Agreements (EPAs) 117
economic unions 102
The Economist 69
economy 96–101, 120–121
economy of development 66
Ecuador 51, 87
education 194
Egypt 126, 141, 144, 174, 175
Eighty Years War 37
El Dorado 105
elections 57, 58, 60, 159, 160
elites 15, 23, 61, 72–73, 79–80, 97, 99, 147
El Salvador 104–105, 128
Enduring Freedom 180
English language 38
'enlightened' aid 92
environment 193–194
Equatorial Guinea 106
Erdogan, President Recep Tayyip 119, 175
Eritrea 41, 91
Estrada, President Joseph 71
Ethiopia 94, 103
ethnic groups 17
ethnicity 35–36, 37–38, 45
ethno-nationalism 11
EU 112
Eureka Stockade 3
executive-party dichotomy 60

famines 85
fascism 73

fatalist school 58
Federally Administered Tribal Areas 35
Ferguson, N. 21
First Congo War 24
'flying geese' paradigm 99–100
food aid 85–86
foreign direct investment (FDI) 71
Fragile States Index 56
France 55, 173
free-market economics 30, 69, 70, 86–87, 114, 178; and Fukuyama 53, 143, 191–192
Free Syrian Army (FSA) 42
free trade 104–105
Fretilin party 146
Fukuyama, F. 22, 53, 143, 191–192
Fund for Peace 56

GAM 157, 158, 162–163, 164, 165, 166
Garang, John 45
Geneva Accords 171
Ghana 118
Giddens, A. 63
Gini coefficient 69
Global Financial Crisis (GFC) 70–72, 90, 106, 114
globalisation 116, 187, 194
globalism 116
global multilateral aid bodies 94
global trade 71
gold miners' rebellion 3
gold mining 104–105
government: aid 83; good and poor 156
Greater Sunrise 107, 108
Great Recession 70–72, 106, 114
Greece 150
'greed and grievance' thesis 161–163
gross domestic product (GDP) 4, 5, 29, 51, 88, 96, 120; Africa 105, 118; BRICS 115
Gross National Income (GNI) 90, 91
Guatemala 103
Guebuza, Armando 75
Guinea-Bissau 77, 91, 131
Gukurahundi 16
Gupta family 74–75
Gusmao, Xanana 107–108, 146

Habibie, President B. J. 145, 147
Haggard, S. 10, 144
Haiti 77, 91
Haley, Nikki 177
Halper, S. 5
hardliners 147
Hashemite Faisal 35
Hekmatyar, Gulbuddin 136
Herbst, J. 13, 51, 52, 131, 181
Hezbollah 176
Hobbes, T. 171

220 *Index*

'Homestead' program 30
Honduras 103
horizontal distinction 29
Horn of Africa 94
human development indicators (HDIs) 4, 69
humanitarian and emergency assistance 83
human rights court 165
human security 194
Hun Sen 126, 159
Huntington, Samuel 27, 53, 125, 129, 135, 143, 151
'hurting stalemate' 162–163
Hutus 24

identity 39, 48, 186
IMF (International Monetary Fund) 71, 82, 98, 106, 114, 178, 180; on globalisation 187; and Indonesia 145; and structural adjustment programs 69, 101; *World Economic Outlook* 97
income 69, 70, 71
independence movements 40–44, 45
India 14, 40, 74, 79, 106, 108, 112, 194; and growth 115; and inequality 67; and poverty 65; and Sri Lanka 172
Indochina 55, 130
Indonesia 10, 13, 28, 31, 62, 73, 100, 146; and Aceh 156–159, 160, 161, 161–166, 167–169; and Asian financial crisis 71, 144–145, 147, 150; and corruption 88–89; and East Timor 107; and elite 15; ethnicity 119–120; and the military 126–128, 129, 130; and New Order 55, 61; 'odious debt' 68; official language 40; resources 97; and state institutions 143; and stateness 153; and use of civilian militias 50; and Wahid 152
Indonesian Democratic Party, Struggle (PDI-P) 128
industrial change 186
industrialisation 4
inequality 67, 69–70
Inequality-adjusted Human Development Index (IHDI) 77–79
inevitability thesis 152
informal rules 141
institutional self-affirmation 142
institutional self-regard 142
institutions 52–53, 142–143
Iran 134, 174, 176
Iranian Revolution 134
Iraq 23, 35, 56, 142, 173, 176, 184; aid 93; civil war 50; and the Kurds 42–43, 44; and Kuwait 171; and Mahdi Army 136
Iraqi Kurdistan 175, 176
Islam 120, 133–135
Islamic Defenders Front (FPI) 120
Islamic State (IS) 42, 86, 173, 174, 175, 176, 177
Islamist Allied Democratic Forces (IADF) 25

Israel 23, 133
ita possideatis 34

Janatha Vimukthi Peramuna (JVP) 30
Japan 99, 100
Al Jazeera 174
Jemaah Islamiyah 47
jihad 133
Jim, Y.K. 69–70

Kabila, Laurent-Désiré 24–25
Kalyvas, S. 119
Kampuchean National Front for National Salvation (KNUFNS) 126
Karl, T. 146–147, 148, 151, 153
Katanga 25
Kaufmann et al 28–29
Kaufman, R. 10, 144
Keen, D. 161–162
Kenya 46, 94, 103
Khmer Rouge (KR) 54–55, 171
Kiir, Salva 45, 46
Kilcullen, D. 136
Kim Jong-il 183
Kim Jong-un 182–183, 184
Kiribati 91
Kirkuk 43
Kohnert, D. 117
Korea: North 127, 181–184, 185; South 140, 144, 182
Korean Peninsula 180, 184
Kosovo 41; War 171
Krader, L. 14
Kurdish People's Protection Forces (YPG) 43
Kurdistan 41–44, 171, 174–176
Kurdistan Regional Government (KRG) 42, 43, 44, 171, 173, 174–176
Kurds 35
Kuwait 171

language 37–38, 40, 48
Laos 129, 130, 171, 176
Lappe, F. 86
Latin America 15, 51, 52, 69, 74, 98–99, 176; bureaucracy 50; debt 101; and the military 128
Lausanne, treaty 176
Law on the Governing of Aceh (LoGA) 165
least developed countries (LDCs) 85, 90, 91
Lebanon 36
Lee Kuan Yew 192
legal accountability 79
legitimacy 51–52, 55, 56, 141, 144, 166, 188–189
Leopold of Belgium, king 24
Levitsky, S. 58, 60, 139
liberal democracy 191–192
Liberia 90, 91, 106, 149

Libya 150, 171, 179
Lijphart, A. 57, 60
Linz, J. 145, 146, 151, 153
Lipset, S. 160–161
Locke, J. 62
Lomas, U. 104
Lord's Resistance Army 25
Lorenz curve 69
LTTE separatists 172
luck 157

Machar, Riek 45
macro-sequencing 168
macro-timing 163, 167–168
Madagascar 131
Madonsela, Thuli 75
Mahathir Mohamad 76
Mahdi Army 136
Mahmud, Malik 164
Malawi 91
Malaysia 74, 75–77
Malone, D. 29
'mandala' (circle) model of state organisation 13
Mao, Z. 116
Marcos, Ferdinand 28, 97, 147
maritime boundary 106–108
Maritime Silk Road 108–109
Marshall Plan 82
Masum, Fuad 43
matériel 44
Mauritania 131
Mbeki, Thabo 75
McCarthy, T. 21
Medard, J-F. 8
Melanesians 31
Memmi, A. 51
Memorandum of Understanding (MOU)
 158–159, 162, 163, 164, 165, 166, 167, 168
Mexico 68, 101
Michels, R. 72, 73
Middle East 35–36, 67, 133–134, 172–173, 174,
 184, 187; *see also* Iran; Iraq; Syria
middle income status 106
militant disruption 23
militaries 15–16, 19, 124–137, 148, 158, 165, 190
military oligarchy 125
military rule 147
Mindanao 13, 30
Mnangagwa, Emmerson 127, 131, 132, 149
modernism 27, 29
monarchies, absolute 54
Moros 30, 31
Morsi, Mohamed 174
Mosca, G. 72, 73
Movement for Democratic Change (MDC)
 127, 132
Moyo, D. 85, 87, 88

Moyo, Major General Sibusiso 131–132
Mozambique 75, 91
Mugabe, Robert 118–119, 126, 127, 131, 132,
 133, 148
mujahideen 134
multi-ethnic colonies 188
multi-ethnic societies 39, 40
multilateral aid 93–94, 95, 170
multilateral free-trade areas 102
Mursal, Mohamed 89
Muslim Brotherhood 172, 174, 175
Mutsvangwa, Chris 132
Myanmar 10, 46–48, 83, 86, 143–144, 148, 160;
 and the military 124–125, 126–127, 129, 130;
 and warlords 136

Najib Razak 76
Namibia 77
Nargis, cyclone 83, 86, 144
nation 11–14, 25–26
National Awakening Party (PKB) 128
'National Defence Force,' Syria 50
national identity 12, 17
nationalism 12, 39, 48
national unity 63
nation-building 38–40
nativism 119
NATO 171
natural resources 22
Nehru-Gandhi dynasty 74
Nehru, Motilal 74
neo-dependency 100, 101
neo-liberalism 114–115, 186, 190
neo-Slavophiles 179
New Development Bank 109
New Order 55, 61, 145
Nicaragua 68, 78, 103, 149–150
Niger 77
Nigeria 41, 46, 106
el-Nimeiry, President Jaafar 45
'Nine Dash Line' 117
Nkomo, Joshua 132
norm diffusion 112
North Africa 187
North Kivu 25
North Korea 127, 181–184, 185
Norway 98
nuclear weapons 182, 183
Nuers 45, 46

OceanaGold 104–105
ODA (official development assistance)
 81–95, 170
'odious debt' 68
O'Donnell, G. 60, 62, 145–146, 147, 149, 152,
 166–167; on Argentina 121; and bureaucratic
 authoritarianism 128

222 *Index*

oil 45, 101, 107, 184–185
oligarchy 73, 74
OPEC (the Organisation of Petroleum Exporting Countries) 101
organisational capacity 73
Organisation of African Unity (OAU) 41, 131, 181
orientalism 20–23
Orientalism (Said) 21
othering 21
Ottoman Empire 35

Pacific island countries 84
Pacific Rim 105
Pakatan Harapan (PH, Pact of Hope) alliance 76
Pakistan 35, 127
Paraguay 126
parallel state 126
Pareto, V. 72, 73
Partai Aceh 163, 164, 165, 166
Partai Nasional Aceh (PNA) 163, 166
particularism 57
Parti Keadilan Rakyat (PKR) 76
party dictatorships 125
PAS (Islam Mandate Party) 76
Patriotic Union of Kurdistan (PUK) 43
patron–client relationships 17, 31, 45, 73, 130, 176
patrons 176, 194
patron states 172–173, 184
peace 159, 160, 161, 167
'Peacebuilding Compared' 29
'Peace of Westphalia' 36–37
Pena, A. 112, 121
People's Republic of Kampuchea (PRK) 126
Peronism 121
Peron, Juan 121
Peru 87
Peshmerga 42, 43, 176
Philippines 10, 13, 28, 30, 50, 62, 143, 147, 176; and aid 83; and Asian Financial Crisis 71; and elite 15; and the military 129, 130; and regime change 147; and resources 97; and warlords 136
pipelines 43–44
PKK (Kurdistan Workers Party) 175
political economy of development 8–10
political identity 48
political rights 63
political transitions 143–150, 153–154, 192–193
politics, definition 1–2
politics of identity 186
polyarchy 57–58
Portugal 147, 149
Portuguese language 38
post-colonial experience 7–8
poverty 64–65, 66, 67, 68, 70, 77–79, 189

power 55–56, 141–142
power vacuum 56, 142
Prabowo Subianto 119, 120
presidency 61–62
primordialism 13
Principe 91
procedural democracy 58, 60, 191
proportional representation 60
psychological capacity 73
Purnama, Governor Basuki Tjahaja (Ahok) 119, 120
Putin, Vladimir 74, 178, 179

Al Qaeda (AQ) 134, 174
Qatar 174, 175, 176
quantitative easing 115

radical verticalism 30
Rakhine state 47
Ramaphosa, Cyril 75
Ramo, J. 115
'rational' state model 23
regime change 27–28, 146–147, 150, 171, 192
regional multilateral aid bodies 94
rentier states 97
Renzio, P. 88
resources 22, 97–98, 109, 110
Responsibility To Protect (R2P) 171
rights 72
Rohingyas 46–48, 144
Rojava 43
Roodman, D. 88
Rostow, W. 4, 22, 27
Rousseau, J.J. 23, 171
rule of law 159
rules-based order 177–181, 185, 194
Russia 74, 112, 115, 173, 176, 178–179, 194
Russian Revolution 149
Rustow, D. 39, 140, 147–148
Rustow, Dankwart 156
Rwanda 15, 24, 25, 36, 91

Sachs, Jeffrey 84, 85
Sahel 193
Said, Edward 21
Salafi Islamism 173–174
Salafi jihadism 134–135
Salafi jihadist organisations 23, 187
Sandinistas 149–150
San Sebastian River 104
Sao Tome 91
Saraya al-Salam 136
Sartori, G. 60–61
satgas 128
Saudi Arabia 74, 174, 175, 176
Schedler, A. 151
Schmitter, P. 62, 145–146, 147, 149, 153

Schneider, C. 153
'Scramble for Africa' 13, 34
Second Congo War 25
security, human 194
security sector reform (SSR) 129
Selbervik, H. 91, 93
self-affirmation 142
self-determination 22
self-government 162
self-interest 73
self-regard 142
Sen, A. 6, 10, 62–63, 148
separatism 40–48
sequencing 159, 163–166, 168
Serbia 171
Sèvres, treaty 176
al-Shabab 180
shariah 120
Shenton, R. 3
Shia Islamism 134
Shia Muslims 42, 174
Siddiqa, A. 130
Sierra Leone 77, 91
Silk Road Economic Belt 108
Silk Road Fund 109
simple economic unions 102
Singapore 10, 62, 63, 100
Singer-Prebisch thesis on unequal trade 99
Sinhalese 36, 38
Slavophiles 179
social contract 149
softliners 147
The Soldier and the State (Huntington) 135
Solomon Islands 91
Somalia 23, 56, 86, 89, 136, 180
South Africa 74–75, 77, 115
South Asia 86
South Asia Free Trade Area (SAFTA) 102
South China Sea 117, 180
Southeast Asia 13, 86, 117, 129
Southern Sudan Liberation Movement (SSLM) 45
South Korea 140, 144, 182
South Sudan 41, 44–46, 86, 106, 172, 181
South Vietnam 176
sovereignty 170–172, 184
Soviet Union 134, 181, 182
Spanish language 38
SPLM/A-Nasir 45
Sri Lanka 13, 14–15, 29–30, 38, 172
Stanley, Henry Morton 24
the state 14–17; authority 49; autonomy 49, 142;
 bureaucracy 50; capacity 49, 159; intervention
 69; power 55–56, 141–142; unity 63
state capture 73–77, 80
state institutions 52–53, 142–143
State Law and Order Restoration Council
 (SLORC) 125

stateness 153
state-owned enterprises (SOEs) 108
Stepan, A. 27, 54, 55–56, 128, 140, 141,
 142, 151
strategic relations 170
structural adjustment programs (SAPs) 5, 69,
 71, 101
structure 145
sub-Saharan Africa 10, 13, 41, 44–46, 51, 52,
 67, 105–106; agriculture 103; and aid 88; and
 China 117–119; debt 101; famines 85; pov-
 erty 65, 70; and warlords 136
Sudan 44, 86, 106, 172, 181
Sudanese Defence Force 44
Sudan People's Defence Force/Democratic
 Front 45
Sudan People's Liberation Movement/Army
 (SPLM/A) 45
Suharto, President 71, 73, 97, 126,
 144–145, 146
Sukarnoputri, Megawati 28
Sumatra 84
Sunni Arabs 35
Sunni Islam 133
Sunni Muslims 42, 174
Suriname 87
Sykes–Picot Agreement 35, 173
Syria 23, 35, 36, 42, 43, 50, 141, 175; and
 Russia 173, 176
Syrian Civil War 173, 176
Syrian Defence Force (SDF) 42, 175

Tahrir al-Sham 42
Taiwan 10, 84, 140
'take-off' 4
Taliban 177
Tamils 36, 38, 172
Tamil Tigers 38, 135
Tanzania 46
Tatmadaw 148
tax 51
technological change 113, 186–187
Thailand 71, 74, 127, 143, 144, 155, 160; and
 the military 126, 129
Thirty Years War 36–37
Thucydides Trap 180
Tillerson, Rex 69
timing 157–159, 167–168
Timor-Leste 29, 84, 86, 142, 144, 145, 146, 159;
 and Australia 106–108; and independence 41;
 and national consciousness 13; political system
 61; and stateness 153; and UN 168
TNI 158, 163, 166
Tobar, Carlos 51
'Tobar Doctrine' 51
Tornquist, O. 161
trade 71, 91–92, 104–106, 108–109, 122

224 *Index*

trade blocs 101–104
trade unions 3–4
tradition 23
transitions, political 143–150, 153–154, 192–193
Trans-Pacific Partnership 122
Transparency International 77, 79, 89, 148
Treaty of Lausanne 176
Treaty of Sèvres 176
tribe 26
'trickledown' economics 92
Truman, President Harry 82
Trump, President Donald 21, 183, 184
truth and reconciliation commission 165
tsunami, 2004 157, 163
Tsvangirai, Morgan 133
Turkey 42, 119, 127, 144, 147, 174, 175, 176
Turkish Kurdish Workers Party (the PKK) 43
Turkmen 35
'turnover test' 151
Tutsis 24–25
Tuvalu 91

Uganda 103
United Malays National Organisation (UMNO) 76
United Nations Charter 170
United Nations Economic Commission for Latin America and the Caribbean (ECLAC) 98–99
United Nations (UN) 84, 89, 90, 94, 168, 171, 178; peacekeepers 25
U.S. 194; and Afghanistan 172–173; and China 111–113; gold mining in El Salvador 104–105; interventions in other states 143; and Iraq 42, 171; and Korean Peninsula 180; and Kurdistan 175; and the Kurds 43; and Latin America 98–99; and the Middle East 174; and neo-liberalism 114; and North Korea 182, 183–184; and quantitative easing 115; and rules-based order 178, 179; and trade 122
USSR 178
uti possidetis 15, 20, 34

Venezuela 78
Victoria, Australia 3–4
Vietnam 130, 171
violence 49–50, 54–55

Wahid, Abdurrahman 28, 152
Wan Aziza 76, 77
warlords 136–137
Washington Consensus 103, 111, 113, 114–115, 119, 121, 122, 190, 191; ten key principles 4–5
Weah, George 149
wealth 69, 70, 79
Weber, M. 49
West Papua 12–13, 31, 161
Westphalian state 36–37
Widodo, Joko ('Jokowi') 119, 120
Williamson, J. 5
Woodside Petroleum 107
working-class solidarity 113
World Bank 77, 82, 105, 114–115, 143, 178, 180; on poverty 64, 66; and structural adjustment programs 5
World Economic Outlook 97
World Food Programme 94
World Trade Organisation (WTO) 91–92, 104, 178
World War II 150, 181

Xi Jinping 116–117

Yemen 174
YPG (Kurdish People's Protection Units) 175, 176
Yudhoyono, Susilo Bambang 28, 158
Yusuf, Irwandi 163, 164, 165

Zaire 24
ZANU-PF (Zimbabwe African National Union-Patriotic Front) 16, 118, 127
ZANU (Zimbabwe African National Union) 16, 118, 126, 127
ZAPU (Zimbabwe African People's Union) 16, 127
Zimbabwe 16, 118–119, 127, 131–133, 148, 149
Zimbabwe African National Liberation Army (ZANLA) 126
Zimbabwe Broadcasting Corporation (ZBC) 131
Zimmerman, Judith 179
Zuma, President Jacob 74–75